Public Sculpture and the Civic Ideal in
New York City, 1890–1930

Public Sculpture

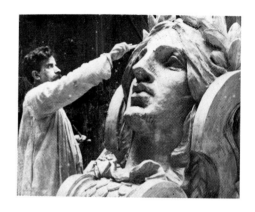

SMITHSONIAN INSTITUTION PRESS
WASHINGTON AND LONDON

and the Civic Ideal in New York City, 1890-1930

Michele H. Bogart

First Smithsonian edition 1997

Library of Congress Catalog-in-Publication Data

Bogart, Michele Helene, 1952–
 Public sculpture and the civic ideal in New York City, 1890–1930 /
Michele H. Bogart. – 1st Smithsonian ed.
 p. cm.
 Originally published: Chicago : University of Chicago Press, 1989.
 Includes bibliographical references and index.
 ISBN 1-56098-766-9 (paper)
 1. Public sculpture–New York (State)–New York–Themes, motives.
2. Art patronage–New York (State)–New York. I. Title.
NB235.N5B64 1997
731'.76'09747109041–dc21 97-839

British Library Cataloging-in-Publication data available

03 02 01 00 99 98 97 5 4 3 2 1

⊗ The paper used in this publication meets the minimum requirements of
the American National Standard for Permanence of Paper for Printed
Library Materials Z39.48-1984.

For permission to reproduce any of the illustrations, correspond directly
with the sources. The Smithsonian Institution Press does not retain repro-
duction rights for these illustrations individually or maintain a file of
addresses for photo sources.

To Philip, my parents, and
baby Nicholas

Contents

Illustrations

Acknowledgments

My interest in the problems of public sculpture was first piqued in 1978, when I worked as a research assistant to George Gurney on the exhibition Sculpture and the Federal Triangle at the National Museum of American Art. As curator, Dr. Gurney sensitized me to the complexities of the sculptural process and to the concerns of twentieth-century academic American sculptors. His high standards and thorough scholarship became an important model for me as I embarked on my own work.

I began the book in earnest in 1983. The Research Foundation of the State University of New York and the Office of the Vice Provost for Research of the State University of New York at Stony Brook generously provided a Joint Award, travel grants, and a Faculty Summer Fellowship. I am especially grateful to Don Ihde, dean of the College of Arts and Sciences, and Melvin Pekarsky, chairman of the Art Department of the State University of New York at Stony Brook, for their support, advice, and assistance. An NEH–Winterthur Research Fellowship in 1984 permitted me to advance my research, to refine my conceptual framework, and to write a rough draft. I completed my research with the help of a Grant-in-Aid from the American Council of Learned Societies. A Nuala McGann Drescher Affirmative Action Leave from the United University Professions and the State University of New York enabled me to prepare the manuscript for publication. I would like to express my appreciation to these organizations.

I owe a special debt to the staff members of the Winterthur Museum for making their expertise and collections available to me. Neville Thompson provided indispensable help with reference materials. Conversations with Kenneth Ames, Richard Bushman, Catherine Hutchins, Ian Quimby, and the students in the Ph.D. Program in American Civilization at the University of Delaware made my stay at Winterthur especially rewarding.

My research was greatly facilitated by the cooperation and assistance of the staffs of the Archives of American Art, the Art Commission of the City of New York, the Landmarks Preservation Commission, the Library of Congress Manuscript Division, the Library of the State University of New York at Stony Brook, the Museum of the City of New York, the National Sculpture Society, and the New-York Historical Society. I would like to thank in particular: Millie Daghli, AT&T Historical Archive; Janet Parks, Avery Art and Architectural Library, Columbia University; Mary Beth Betts and Deborah Wythe, the Brooklyn Museum; Wendy Shadwell, the New-York Historical Society; Theodora Morgan and Claire Stein, National Sculpture Society; Michele Cohen, Art Commission of the City of New York; Melissa Smith, Rockefeller Archive Center; Jeanie M. James, the Metropolitan Museum of Art; Gaye Brown and Migs Grove, National Museum of American Art. I also benefitted greatly from the recollections of Thomas Lo Medico.

Numerous individuals have helped to make this book possible. Kathy and Rob Jacob offered kind hospitality on my research trips to Washington. Anita Moskowitz and Stephen Polcari have been patient and much-appreciated colleagues. I am especially indebted to Wanda Corn, Elizabeth Johns, Karal Ann Marling, Katharine Martinez, and Richard Shiff for their encouragement, suggestions, and unfailing support. George Gurney, Catherine Hutchins, Garnett McCoy, Gary McDonough, Margaret Olin, Richard Shiff, and Ian Stewart generously read and commented on portions of the manuscript. Leo Bogart, Philip Pauly and David Schuyler commented on different versions of the entire text. Their insightful and constructive criticisms and suggestions have been invaluable. Agnes Bogart assisted with editorial improvements.

I am pleased to dedicate this book to my parents and to my husband Philip Pauly. Agnes and Leo Bogart have always encouraged me to explore New York City's artistic riches. They urged me to write this book and provided advice, opinions, and good cheer from start to finish. Philip has been, and remains, the ideal spouse and colleague. Even while under the pressures of preparing his own book, he spent hours listening to me thrash out ideas and offering reassurance when the going was rough. He has taken on far more than his fair share of housework, and always ungrudgingly. His confidence in me and my work have been crucial in helping me to negotiate my way from "rough sketch" to completed project.

Introduction

Contemporary public sculpture is in a controversial and even a precarious position. There is little consensus about its function and meaning, its place in society, and the responsibility of the artist toward his audience. Social groups that otherwise have had little in common have frequently formed alliances to protest public art projects. Those who oppose a given work are usually pitted against its creator and against the professional art community, all of whom view challenges to the artist's authority and freedom of expression as serious threats to culture and society. One result of these controversies has been that many people in urban areas have become aware of the complexities surrounding the production of sculpture. They have also become more conscious of the organization of patronage, and especially of the role of government with respect to public art.

Disputes over public sculpture have occurred nationwide during the past generation. In 1967, for example, debates erupted over the *Chicago Picasso* in the city's Civic Center. In New Haven, irate Yalies protested Claes Oldenberg's *Lipstick* when it was first placed on campus. More recently, San Francisco mayor Dianne Feinstein refused to accept for the city hall Robert Arneson's memorial bust of the late George Moscone. Arneson had modified the design of the pedestal, which in his winning competition drawings was undecorated, to incorporate graffiti images that made explicit reference to Moscone's violent death.[1]

Richard Serra's *Tilted Arc*, commissioned in 1979 and installed in lower Manhattan in 1981 as part of the federal government's Art in Architecture program, exemplifies the contemporary public sculpture dilemma. The work, a 120-foot-long, 12-foot-high curved wall of steel, cut through the bland plaza of the Federal Building complex at Foley Square, blocking vistas of the surrounding area and preventing easy passage from the building to the street. As Janet Malcolm noted in the *New Yorker*, "as time went on its surface acquired a patina of rust [and]

graffiti. . . . [I]t looked less and less like a work of art to the federal workers and more and more like a forgotten piece of industrial debris that someone would eventually come and cart away."[2]

Opponents of the work attacked Serra for his lack of sensitivity to the site, and for his creation of public art that did not affirm any sense of civic community.[3] After more than one thousand employees in the building signed a petition for the sculpture's removal, the General Services Administration held a hearing in March 1985 to determine its fate. Despite an outpouring of testimony on the merits of the sculpture by artists, critics, curators, and art historians, the GSA recommended that the sculpture be moved elsewhere. Serra threatened to leave the country were the sculpture to be relocated. (As of 1988 *Tilted Arc* still stood in Foley Square.)

The controversialism of contemporary public sculpture seems in sharp contrast to the situation in the Progressive Era, between 1890 and 1920, when major projects were constructed throughout the country. The years between the Civil War and World War I were the great age of public sculpture in America. Nowhere was this more evident than in New York, the nation's largest city. Numerous monuments and elaborate architectural sculpture, such as the *Maine Memorial* and the United States Customs House programs, structured urban public spaces. These projects have been interpreted as visible and explicit assertions of the high cultural status of sculptors, as well as of both aesthetic and social unity.

Over the last decade, a new fascination with New York's heritage has led to a resurgence of interest in these architectural sculptures and monuments. Cleaned and restored due to efforts of private groups such as the Central Park Conservancy, they have reemerged as symbols of civic pride, and as testaments to the revival of Manhattan's glamor.[4] Seen through a veil of nostalgia, works like the *Pulitzer Fountain* are often regarded as models of an era of harmony. The sheer quantity of monuments and architectural sculpture seems to provide vivid evidence of both government and private support of public art in New York around 1900. To what extent was this the case?

We know relatively little about how New York's civic sculptures were created, who created them, or why the majority of the important public projects were produced during the years from 1890 to 1920. In the case of *Tilted Arc*, the details of the artist's contract and the commissioning process all came out in the hearing, and became major issues. The facts that the sculpture was commissioned through a federal program, opposed by white-collar federal workers (and others),

and created by an artist who had come from a working-class family all became relevant to the debate. By contrast, people generally look at the older American sculptural forms without thinking about matters of patronage, the role of institutions and power hierarchies, or the relationship of artistic representation to meaning.

Within the art historical profession, academic American sculpture has in fact been considered worthy of serious study for only about the last twenty years. Recent studies of American public sculpture have greatly enriched our knowledge of the artists and their works. A major scholarly concern has been to establish that the works have aesthetic merit, and to locate them within the broad framework of art history. Thus this pioneering scholarship has been limited in the issues it has addressed. Monographs have examined specific statues, monuments, or architectural decorative programs. In these instances, the works have been considered in relation to the individual artist's oeuvre or career. Some studies have traced the sources of a given monument's iconography; others have interpreted the sculptures as expressions of "American" values.[5] Given these priorities, relatively few people have addressed questions about the broader social context of American monuments.[6] It is now possible and important to investigate the circumstances of the production, reception, and meanings of this turn-of-the-century public art.

This book examines the sustained and organized effort to create in New York a body of municipal sculpture that would express the civic ideal: an urban vision of patriotism, civilization, and good government. It also attempts to explain why sponsorship for these sorts of projects lasted only for a limited period. We shall look at the works of art not simply as individual monuments, but as the outcome of a self-conscious movement. This crusade represented an important element of the social and cultural life in New York during the period. The encouragement, support, and organization of architects, intellectuals, politicians, and businessmen were crucial to the endeavor. What caused this drive to produce public art to take place? How did the commissioning process work? What factors led to the gradual loss of interest and to the disintegration of this enterprise?

Most explanations of the rise and decline of enthusiasm for academic forms of public monuments have focused on changes in style. From this perspective, the public sculptures of this period represented the "Beaux-Arts" phase of a broader stylistic progression. Accounts of shifts in style are often written as though the changes were inevitable. In this case, at least, they were not. A unique set of

circumstances resulted in the creation of the sculptural works that remain the city's landmarks to this day. Public sculpture as a continuing enterprise was a social, as well as an aesthetic, process. In the case of American academic sculptors, the rise and decline in both professional and aesthetic status were closely linked.

Institutions affect values and standards, professional aspirations and failures, and the allocation of resources among services and products.[7] In the case of art, such "services" and "products" are exemplified both by artistic practices and by works of art. To understand public sculpture it is necessary to examine how a broader institutional framework shaped sculptors' professional identities, creative processes, sociopolitical and aesthetic values, and modes of representation.

This book will probe the relationship between New York's economic, political, and cultural elites and the production of a body of public works expressly intended to assert that certain values were shared and American. We will examine why this relationship did not last, and what in the New York context contributed to the rise and decline of interest. We will focus on specific projects created by artists who conceived of themselves as expert professionals, and who acquired their individual and collective artistic identities through large-scale public works. The large and organizationally complex projects we will examine were created as part of a sustained effort to incorporate programs of architectural sculpture and monuments into a comprehensive city plan. The works include the *Maine Memorial*, the *Pulitzer Fountain*, and the sculpture programs of the Brooklyn Institute of Arts and Sciences, the New York Public Library, the New York City Hall of Records, the New York State Supreme Court, First Appellate Division, and the United States Customs House. While they were not the only public commissions executed at the time, they were the most artistically and politically notable. Their histories allow us to understand the workings of patronage and art production.

Prior to 1865 there was little public sculpture, but several factors altered the status of sculptors and later changed attitudes toward architectural adornment and large monuments. These considerations included the revitalization of nationalist sentiment and the development of close personal, social, and professional relationships within a core group of diverse and well-regarded sculptors. The 1893 World's Columbian Exposition in Chicago provided the first major opportunity for American sculptors to demonstrate their talents to a mass audience and to form the networks that would prevail through the coming years.

Sculptors' attempts at professionalization also affected the development of an organizational structure for the production of civic monuments. Although relatively unexplored by historians of art, the theme of professionalization has been central in the study of late-nineteenth-century America. Until fairly recently, the emergence of specialized disciplines and professional "experts" was explained as a function of post–Civil War modernization and urbanization. Some scholars have sought to downplay the "uniformity of development" that these terms suggest. Focusing on the diversity of the scientific professions and academic disciplines, historians have emphasized their importance as "political institutions." They argue that professions form the framework for a given organization of practice. Like academic disciplines, they also "allocate the privileges and responsibilities of expertise and structure claims on resources." [8]

Art also merits examination from this perspective. This study is not intended to be an exhaustive investigation of the sculptors' profession. However, it does address the development of turn-of-the-century public sculpture in relation to sculptors' efforts to establish themselves as professionals. The standards for what constituted good public sculpture were defined, if not always realized, by artists who took great pains to present themselves as experts and to distinguish their capabilities from those of earlier sculptors. The breakdown of the sculptors' authority in the 1920s was directly linked to their inability to attain professional autonomy.

After 1893 sculptors sought to follow architects, doctors, and other groups who had already attained reputations as experts in their fields. These other entities had founded organizations to advance their interests. Sculptors and other artists began to see the value of developing a similar institutional base. Nudged by influential nonartist enthusiasts, the sculptors founded their own professional body, the National Sculpture Society. While not all leading sculptors were active members, the NSS played a central role in the development of public sculpture and the built environment of New York City.

The society and its alliances with other professional groups broadened sculptors' base of support, occasionally involved them in decision making in municipal affairs, and facilitated their attempts to make sculpture an integral part of the New York cityscape. But for the most part, New York sculptors did not initiate large artistic ventures independently. They themselves were not leaders. Their standing as public artists grew out of, and depended upon, the encouragement

and backing of architects and other groups, including the Municipal Art Society and the Fine Arts Federation, as well as Republican politicians, who were in a position to assist them.

Just as sculptors were part of, and dependent upon, a broader social and cultural framework, their ideals of harmony and civic beauty were also part of a broader scheme. The sculptors' concerns were inspired by an urban vision promoted by select groups of architects, artists, reform politicians, lawyers, intellectuals and businessmen. Their interest in organization, consolidation, and specialization reflected a larger, and recently much discussed, "search for order." In the wake of the Civil War, numerous institutions and interest groups were formed in an effort to bring about a more unified, stable society. Although different interest groups emphasized different aspects of "order" and "unity," many members of the upper middle class expressed a common desire for political reform, social harmony, and a common culture. They believed that such a development was the logical, inevitable manifestation of the unity of the Republic, confirmed by the outcome of the Civil War. These groups sought to attain their goals through the organized institutionalization of culture (the establishment of universities, museums, and libraries), science (university departments, professional societies, journals, and laboratories), and politics (centralization of government agencies, city planning, and municipal reform).[9]

In New York, consolidation of great fortunes, growth and reform in government, and the influx of southern and eastern European immigrants led the New York elites to become increasingly interested in public sculpture.[10] As dominant urban groups actively attempted to assert American values, they encouraged sculptors' efforts to create heroic, uncontroversial myths of civic community: statements of order and unity in the form of magnificent monuments and architectural sculptures. In their minds, such works would be expressions of public culture, a well-defined sphere of national values and shared ideals presumed to be both desirable and pervasive.

Indeed, sculptors' efforts became part of a larger attempt both to construct an appropriate physical and didactic setting in which public culture could flourish, and to hasten moral reform among city dwellers through transformation of the environment.[11] The artists contended that civic sculpture could help improve the beauty and arrangement of city thoroughfares as well as socialize the working classes and new immigrants. The content of the images and their technical excellence would establish high ideals and standards of workmanship for the public to

emulate. Sculptors' notion of "unity" also had an additional, aesthetic significance. The artists believed that aesthetic harmony, manifest in their designs, technique, and subject matter, was an extension of national, cultural, and professional harmony.

Although each sculptor added his own personal touch when designing and modeling, most sculptors employed a particular set of stylistic conventions. However, many of them believed that certain methods and solutions worked better than others to achieve their desired conception of art and urban culture. In many cases, the criteria for handling that particular style were established by artists who were already extremely self-conscious about Anglo-Saxon ethnicity, as well as about professional and social stature. Thus the sculptural process often reflected the struggle to establish and enforce the standards and practices of a specific, influential group of sculptors primarily of British ancestry. These issues will be discussed in part 1.

Over a period of years, members of the NSS were able to develop a professional network that produced large, artistically significant works under what were often trying political circumstances. In part 2 we shall look into this process and its complications, through a discussion of several significant sculptural projects. While some were funded through private bequest or subscription, all were placed outdoors for everyone to see on city-owned property. Hence municipal cooperation was essential for their successful completion.

Although the list of works discussed is selective, the projects examined provide broad evidence of what was typically involved in public sculptural enterprises. They suggest which individuals and groups had greatest influence upon artistic decision making. Because of their size, visibility, and fame (or notoriety!) these works also had the greatest potential for wide popular impact. They permit us to analyze the range of artistic conventions and modes of representation considered most effective during this era. Through them, elite values and assumptions were revealed in detailed, forceful, and comprehensive fashion. These elaborate architectural sculptures and monuments thus allow us to scrutinize the ideals and ideologies prevalent among sculptors and powerful New Yorkers.

Each example covers the production and iconography of an individual project, but it also highlights certain aspects of the broader institutional structure of public art patronage, and illustrates the range of purposes public sculpture served. Each project may also be seen as a link in a chain of circumstances that explains,

from the point of view of institutions rather than exclusively of style, why academic sculptors were not able to maintain longer-lasting artistic influence.

To understand the organizational aspects of New York public sculpture from 1890 to 1930 we must also address the question of audience response. Sculptors' anticipation of an audience provided the primary rationale for the groups and organizations that sought to foster civic art. In part 3 we will consider what meanings the works were intended to convey, how these jibed, or failed to correspond, with the sculptors' means of expression, and whether and how they conveyed their messages.

The sculptors' manner of representation and the ideals they attempted to symbolize in public art were rooted in visual conventions and beliefs that, although widely disseminated, could hardly be called popular. Many people were familiar with the techniques sculptors (and other artists) used to express a coherent set of values. Periodically they also contributed money to pay for monuments or statues, especially those dedicated to ethnic heroes. Nevertheless, complex allegorical monuments and architectural sculptures, even memorials, were usually not initiated by the public at large. The artists' sophisticated academic methods and symbolic meanings cannot have reflected the ideals and aspirations of the majority of New Yorkers in any natural or obvious way, any more than advertisements were accurate expressions of the true desires and values of the masses.[12] Professional sculptors in fact met resistance in their attempts to be sole arbiters of artistic taste and communication. Ridicule and parody revealed the fragility of the mythical framework upon which the artists and their supporters relied to provide the themes for their allegorical works.

Initially those who took issue with the sculptors' myths of modernity and civic harmony subverted them through mockery. Debates about audiences, messages, and authority became more explicit as the social and political balance of power in New York City shifted out of the hands of the older generation of elites during World War I and into the 1920s. The responses to Frederick MacMonnies's *Civic Virtue* indicated that a meaningful connection between academic modes of representation and symbolic content could no longer be taken for granted. Nor could the sculptor be certain that the allegorical ideals he hoped to convey would be passively accepted, even when correspondences were made between means and ends. By 1922, the relationship of the public sculptor to his middle- and upper-middle-class audience had become strained.

The breakdown in consensus about the significance and value of large public

sculpture projects paralleled the fragmentation of the sculptors' groups during World War I. The collapse of crucial government and professional support became apparent during the unsuccessful attempts to construct a World War I memorial in Manhattan. Partly this was a consequence of the immediate events of the war; partly the controversy brought to a head tensions that had always been present. Sculptors had conceived of their works as straightforward, politically neutral expressions of national and civic unity and of modern life. Such a view was now regarded with skepticism by a broad and vocal segment of the urban public. This new public included women, whose attitudes previously had not been taken seriously. There were further signs of sculptors' loss of authority, and of diminishing enthusiasm for sustained production of large public sculpture projects as an important civic activity. By the 1920s, it was no longer possible to maintain the cultural and civic enterprise that had developed out of the network of sculptors, architects, planners, politicians, and other elites, and depended upon it.

Every historical work has its limitations. This book is not intended to be a comprehensive history of American Beaux-Arts sculpture. Some explanations for my particular focus are thus in order. First of all, why New York? As the artistic and cultural capital of the country, it was the home of the majority of successful artists, and the place where most aspiring artists hoped to be. Its broad range of social, professional, and institutional groupings covered the full spectrum of patronage. Most of the major cultural shifts of the 1920s and afterwards were generated in New York. Understanding the conditions under which public sculpture developed in that city can provide a foundation for analyzing parallel developments in other cities and on a national scale.

One might view public sculpture as just one part of a larger artistic enterprise that included the creation of works for museums and for individual collectors. Yet while sculptors personally considered these other projects to be worthwhile and important, their sense of professional stature was linked to their activities as civic artists and to the production of public art. Monuments and architectural sculpture projects offered the most effective indicator of sculptors' ability to organize and to influence the city's most powerful forces. They thus illuminate in an especially fascinating way the conditions, constraints, and artistic issues that affected sculptors and, in fact, all the other artistic professions. Sculptors' position within the institutional structure of art patronage affected what they as individ-

uals were able to accomplish through their smaller, private creations. Things did not work the other way around. To the extent that sculptors as a group were successfully integrated into the larger institutional structure that supported civic art, they also found greater support for their small bronzes and other works.[13] Sculptors' loss of influence in broader public spheres came first, but diminished authority in other realms soon followed.

Two issues remain. This study emphasizes the importance of specific local institutional factors for the rise and demise of civic sculpture in New York. Yet what occurred in New York may not seem much different from what happened in Europe and South America, where similar types of public sculpture flourished during roughly the same period.[14] Moreover, how can this discussion account for the fact that the move away from representational art toward more modern art forms was an international phenomenon?

To be sure, certain conditions (such as industrialization and urbanization) that gave rise to the civic sculpture enterprise in the United States were comparable to those existing in other countries. But the situation is more complex. By the late nineteenth century, public sculpture was already a well-established state tradition in Europe, but not in the United States. Artistic movements in America did not inevitably have to follow those of Europe. To explain the rise of public sculpture in the United States it is necessary to investigate the impact of specific national and local events as well as of broader trends.

The final question—namely, of how discussion of New York accounts for the fact that the rising acceptance of modernism occurred internationally—can also be addressed. The shift in stylistic preferences and in art theory is the most all-encompassing explanation for the decline of academic art, so far as we now know. But such an argument is inconclusive. For even if we attribute the loss of status of academic art to a change of sensibility on the part of artists and architects, we have not fully explained *how* these modern styles became so dominant. The purely stylistic explanations that have been offered for the eclipse of academic art still leave open the related question of the external causes of the shift in style and status. To understand how this devaluation occurred so widely, it is necessary to know more about the institutional structures of art in different countries worldwide. Similar investigations of other local and regional contexts, as well as comparative international studies, are needed.

Those accustomed to reading art-historical texts with stylistic descriptions and metaphor may be disappointed by my tendency not to celebrate the artists' con-

cerns and accomplishments. I have avoided taking the sculptors' assertions of success at face value. It is only from relying completely on sculptors' perspective that the break between the pre- and post-Depression years has appeared unusually arbitrary and abrupt. The notion of a sharp discontinuity in support has only served to reinforce traditional interpretations of the revolutionary force and autonomy of style. While reassessment of sculptors' artistic achievements from a contemporary perspective would heighten present-day viewers' aesthetic appreciation of these works, I have attempted to maintain a certain neutrality and critical distance. Within the context I have chosen, aesthetic success or failure, or empathy with the ideals expressed, are not the primary historical issues. More to the point are the questions: To what extent did their contemporaries view New York public sculpture as artistic accomplishments? On what grounds did they base their judgments? What aspect of the works did they choose to discuss? The reader will find lengthy consideration of these matters of aesthetic evaluation and artistic accomplishment throughout the course of the narrative that follows. Historical understanding can enhance appreciation of these works by providing a fuller picture of the values and circumstances that shaped their meaning.

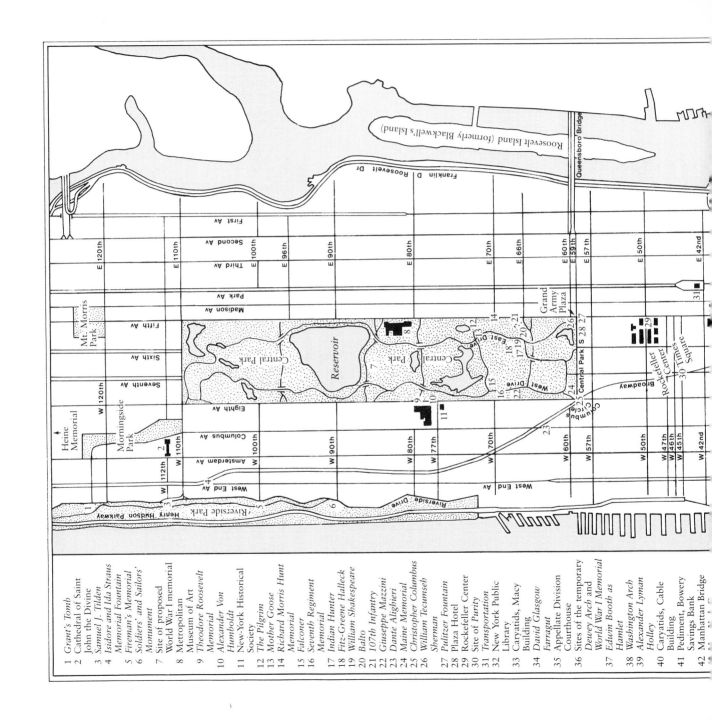

1 Grant's Tomb
2 Cathedral of Saint John the Divine
3 Samuel J. Tilden
4 Isidore and Ida Straus Memorial Fountain
5 Fireman's Memorial
6 Soldiers' and Sailors' Monument
7 Site of proposed World War I memorial
8 Metropolitan Museum of Art
9 Theodore Roosevelt Memorial
10 Alexander Von Humboldt
11 New-York Historical Society
12 The Pilgrim
13 Mother Goose
14 Richard Morris Hunt Memorial
15 Falconer
16 Seventh Regiment Memorial
17 Indian Hunter
18 Fitz-Greene Halleck
19 William Shakespeare
20 Balto
21 107th Infantry
22 Giuseppe Mazzini
23 Dante Alighieri
24 Maine Memorial
25 Christopher Columbus
26 William Tecumseh Sherman
27 Pulitzer Fountain
28 Plaza Hotel
29 Rockefeller Center
30 Site of Purity
31 Transportation
32 New York Public Library
33 Caryatids, Macy Building
34 David Glasgow Farragut
35 Appellate Division Courthouse
36 Sites of the temporary Dewey Arch and World War I Memorial
37 Edwin Booth as Hamlet
38 Washington Arch
39 Alexander Lyman Holley
40 Caryatids, Cable Building
41 Pediment, Bowery Savings Bank
42 Manhattan Bridge

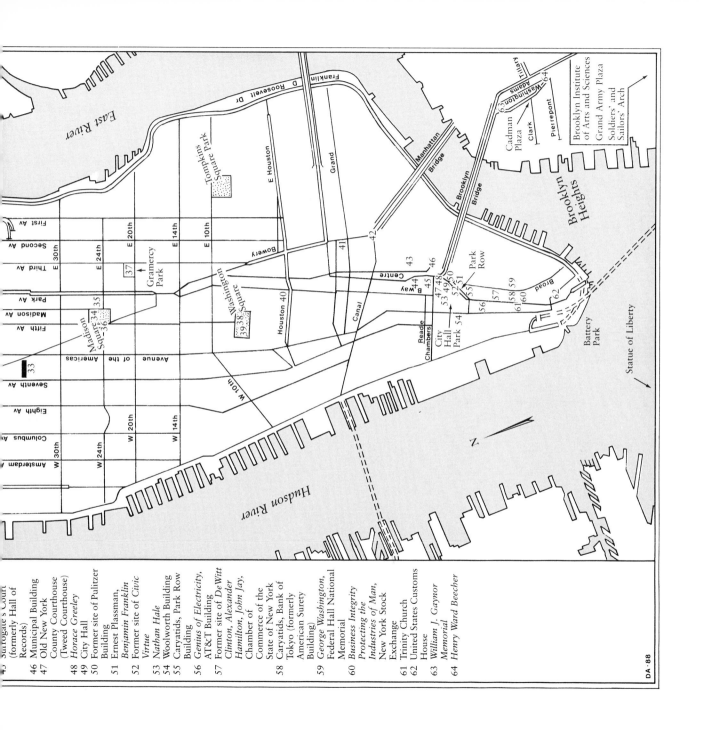

45 Surrogate's Court (formerly Hall of Records)
46 Municipal Building
47 Old New York County Courthouse (Tweed Courthouse)
48 *Horace Greeley*
49 City Hall
50 Former site of Pulitzer Building
51 *Ernest Plassman, Benjamin Franklin*
52 Former site of *Civic Virtue*
53 *Nathan Hale*
54 Woolworth Building
55 *Caryatids,* Park Row Building
56 *Genius of Electricity,* AT&T Building
57 Former site of *DeWitt Clinton, Alexander Hamilton, John Jay,* Chamber of Commerce of the State of New York
58 *Caryatids,* Bank of Tokyo (formerly American Surety Building)
59 *George Washington,* Federal Hall National Memorial
60 *Business Integrity Protecting the Industries of Man,* New York Stock Exchange
61 Trinity Church
62 United States Customs House
63 *William J. Gaynor Memorial*
64 *Henry Ward Beecher*

Brooklyn Institute of Arts and Sciences
Grand Army Plaza
Soldiers' and Sailors' Arch

I

The Formation of a Professional Network

I Sculptors and Public Sculpture before 1893

Sculpture has embellished public buildings and spaces since the dawn of civilization. Sculptors were prized royal servants in ancient Babylonia and Egypt. Their status varied throughout history, but rarely were sculptors completely free to express whatever they wanted. Sculptors conformed to their patrons' expectations, and followed well-established paths in their working procedures. They acknowledged that they operated within a larger social framework. In this sense, the circumstances sculptors faced in New York represent a specific illustration of problems traditionally associated with the creation of institutional art.

Sculptors of the past could function as they did because sculpture was assumed to be an integral part of society. From ancient Greece to nineteenth-century Europe, sculptors were commissioned to express fundamental religious, cultural, and political ideals. During the first century of the American republic, no such assumptions about the value of sculpture existed. Early sculptors were considered artisans. Nineteenth-century sculptors who aspired to be fine artists had to prove the value of sculpture in the first place, before they could impress prospective clients with the merits of their creations. Sculptors and their work thus had to experience a gradual shift in status, patronage, and purpose before public sculpture could emerge as a sustained civic enterprise in New York.

American sculpture through much of the nineteenth century was primarily oriented toward private patronage and experience. Sculptors lacked the skills, the technology, and the assistance necessary to producing public works. The absence of well-equipped, high-quality quarries and foundries and knowledgeable craftsmen made sculpture in the United States a difficult and expensive procedure. Experienced European artists received many of the early sculptural commissions in the United States. Educational opportunities for American sculptors were notably

17

deficient. Institutional support and a sense of artistic community were also absent. Merchants and gentry, who could afford to fund public sculpture, showed only occasional commitment to such work. There was no real precedent for popular patronage of outdoor public art.[1]

Midcentury sculptors had to struggle for recognition in relative isolation, and the absence of commissions and of a suitably supportive atmosphere prompted many of them to leave for Florence and Rome. Expatriates like Horatio Greenough and Hiram Powers became successful by fashioning private works, such as portrait busts and ideal parlor statues. Several of them eventually received federally sponsored commissions. Nevertheless, they encountered continual difficulties gaining official support. The situation was hardly conducive to the development of a commitment either to an American public art or to civic improvement.[2]

The difficulties faced in the production of American public sculpture were most apparent in New York City. In the mid-nineteenth-century public sculpture had a questionable status, since little of it existed. One of the few midcentury works commissioned in the city, Henry Kirke Brown's *George Washington* in Union Square (1856), was an early instance of organized involvement with public art, but one nevertheless unusual for this period.[3]

In midcentury New York, as elsewhere, there was also the question of where and how to place such statues. In Europe, sculpture had traditionally been placed in formal and informal parks, gardens, and squares, where it marked borders and axes and served as end points to vistas. New York had no comparable precedent of public landscape gardens with statuary until the creation of Central Park in the latter 1850s. The discussions about park statuary marked the beginning of a significant transition. The issue of what works to put where brought out new debate about the nature and function of parks and landscape design: should public parks be refuges for elites or playgrounds for the masses? These arguments reflected in microcosm some of the incipient tensions generated by immigration, urbanization, and industrialization. They also marked a new concern about the purpose and value of public sculpture and about the relation of a monument to its site.

Citizens groups, especially those representing European immigrants, saw gifts of statues for Central Park as an appropriate way to beautify their city and to legitimate their heritage as well as their newfound status as Americans. Donations began as early as 1860, and by 1873 more than twenty sculptures had been offered to the commissioners of Central Park. Among the works ultimately accepted were *Alexander von Humboldt* (Gustave Blaeser, 1869; 77th Street and Central

Park West); *The Falconer* (George Simonds, 1872; near West 72nd Street); and *Giuseppe Mazzini* (Giovanni Turini, 1878; West Drive and 68th Street).

The installation of such works proceeded only over the strong objections of the park's designer, Frederick Law Olmsted, who believed that sculpture conflicted with his conception of the natural landscape. In 1865 Olmsted and his business partner Calvert Vaux succeeded in preventing construction of four elaborate sculpture-adorned gateways designed by architect Richard Morris Hunt for the park's southern entrances. But they were powerless to ward off the growing numbers of different groups who after the Civil War conceived of Central Park (and later, Brooklyn's Prospect Park) as a formal garden and memorial ground.[4]

The Aftermath of the Civil War: The Search for Artistic Excellence and the Expression of National Values

The years immediately following the Civil War witnessed a marked shift in attitude toward public sculpture and in the status of American sculptors. Several factors produced this change. The war aroused public emotions on behalf of a popular national cause, which seemed to demand expression in monumental symbols. At the same time, new and better opportunities for artistic training became available in France. Third, a core group of highly talented and charismatic artists connected with influential New York elites helped to establish sculpture as an organized, respected profession.

The Civil War was the primary impetus in turning Americans toward civic sculpture. Few places had gone untouched by the pain of the conflict. Even before the war ended, there emerged an unprecedented and widespread demand for commemorative monuments. Initially, many of these were standardized, relatively inexpensive, custom-order images of soldiers on pedestals, hewn in stone or cast in bronze, zinc, or lead, and patterned after designs by two well-known neoclassical sculptors (fig. 1.1). Most clients cared little that the statues were often awkward-looking and crudely rendered. What was important was to pay proper and immediate respects to the men who had sacrificed their lives.[5]

But while small towns might be willing to make do with mass-produced soldier figures, New York's wealthy, sophisticated postwar citizenry demanded higher-quality work. In the 1860s there were still only a handful of American sculptors considered sufficiently skilled to make public monuments. In this situation, John Quincy Adams Ward (1830–1910) was the right man in the right place at the

right time. As one of America's leading "native" (as opposed to immigrant) sculptors at a time when public monuments were increasingly in demand, Ward rose to a position of power unusual in his craft. Before 1890 he enjoyed a virtual monopoly on major public commissions in New York. By 1893 he had become the "dean" of American sculptors. Ward's artistic activities reflected the emergence of a culture of professionalism that played a crucial role in development of public sculpture during the last third of the century. His reliability and his adeptness in dealing with individuals, commissions, and political factions proved advantageous both for himself and for younger sculptors later on.[6]

Ward bridged the older practices and modes of representation and the newer approaches that dominated in the last third of the century. He began modeling works for bronze at a time when most of his American peers were practicing in Italy in a neoclassical style.[7] Ward himself refrained from going to Europe. Instead he worked successfully toward perfecting his techniques and obtaining public commissions. His *Indian Hunter* (unveiled 1869), funded by twenty-three prominent artists and businessmen intent on beautifying urban areas with fine art by native sculptors, became the first work of American sculpture installed in Central Park (fig. 1.2). To Ward's contemporaries, *Indian Hunter* signalled a new level of realism and artistic excellence. As a result, he received numerous other commissions in New York and elsewhere.[8]

Ward's accomplishments boded well for a new, younger generation of American sculptors, such as Augustus Saint-Gaudens and Olin Levi Warner.[9] These artists were convinced that success and commissions would not come unless they had the quality of artistic training that could help them meet the burgeoning demand for portrait statues and monuments. Neither apprenticeships nor the courses offered in America's few art schools could provide the professional education that they believed necessary to attaining excellence. They found what they were looking for, just as American architects had earlier, in the art schools of France.

In 1863 major administrative and curricular changes at the Ecole des Beaux-Arts in Paris resulted in its becoming the foremost center for training in the fine arts. The reforms altered the school's organization and programs in a way that made it much easier for foreign students to attend. American sculptors of the post–Civil War generation admired French works for their lively, broadly modeled surface textures, great realism of features, and individuality of expression, through which, they believed, the artist's technique revealed his unique person-

ality. Now they too had the opportunity to study these techniques in French schools. By the mid-1880s most aspiring American sculptors traveled to Paris to study at the Ecole des Beaux-Arts, the Ecole Nationale Gratuite du Dessin (Petite Ecole), and other, independent ateliers. Together, these comprised the most highly organized, centralized, and professional system of training in art ever available.[10]

Without a doubt, the curriculum of the Ecole des Beaux-Arts and the other schools and ateliers notably improved the technical proficiency and professional standing of American sculptors. French artistic theories and practices represented a standard of excellence against which all other artistic solutions were measured; they soon affected even sculptors who did not go abroad. Moreover, French art schools inspired young artists with a sense of purpose, stressing both in lectures and in the atelier the significance of the harmonious relationship of sculpture to architecture and the value of using statuary to inspire, to edify, and to enhance civic beauty.

The French art experience had a major impact on the post–Civil War generation of American sculptors. According to Lorado Taft, sculptor and author of the influential *History of American Sculpture* (1903), American sculptors' switch from Italy to France for artistic training was the turning point for American sculpture, a time when they emerged with a new cosmopolitanism and sense of self-confidence.[11] Imbued with French theoretical and stylistic models and starstruck by the order and opulence of Paris, sculptors like Augustus Saint-Gaudens, Olin Warner, and Frederick MacMonnies, returning to the United States between the late 1870s and 1890s, were committed to developing the aesthetic ideals and stylistic modes that had been perfected abroad. The challenge was to adapt these foreign ideals and technical practices to an American context.

Civic sculpture had acquired new importance for many of these artists, but the quality of French craftsmanship and the resplendence of Baron Georges Haussmann's newly renovated Paris (with such displays of contemporary sculpture as those in the Luxembourg Gardens, Hôtel de Ville, the new wing of the Louvre, and the Opéra) would have reminded the Americans of one bitter fact.[12] While French artists could anticipate that assimilation of the theories, techniques, and visual syntax of harmony and order would be rewarded in the form of state commissions, American sculptors had little prospect of comparable government patronage.

The full significance of all of this for American sculptors was literally "brought home" by a highly publicized manifestation of the impact of French sculpture on

1.2
John Quincy Adams Ward, *Indian Hunter*, Central Park, 1867. (Stereograph by unidentified photographer, 1873–1874. Courtesy of the New-York Historical Society, New York City.)

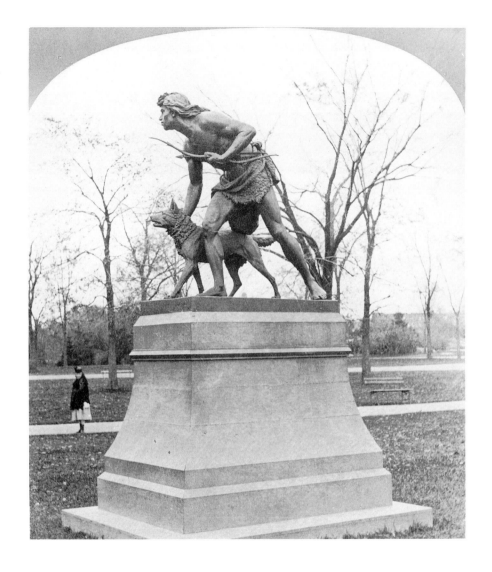

the United States—the *Statue of Liberty* (fig. 1.3). Plans for the statue were being developed during the 1870s, just when American sculptors were beginning to travel to Paris. Through his colossal *Lion of Belfort*, begun after the traumas of the Franco-Prussian war and the Commune, sculptor Frédéric Bartholdi became

identified with French resistance, reconstruction, and republicanism. The *Statue of Liberty* extended this legacy.[13] As conceived initially by its chief promoter, Edouard-René Lefebvre de Laboulaye, and as executed by Bartholdi, the statue, *Liberty Enlightening the World*, was to be, in Marvin Trachtenberg's words, a "missionary icon of France." *Liberty* would link that nation's history and destiny with republicanism, exemplified by the United States of America, and hence promote the establishment of France as a modern republican state.[14]

American sculptors rarely recorded their responses to the *Statue of Liberty*.[15] But as admirers of French culture and as members of the post–Civil War generation, many sculptors must have identified with the ideals *Liberty* symbolized. Saint-Gaudens and Warner, who had experienced firsthand the trauma of the Franco-Prussian war, joined with other artists in mounting a New York exhibition to raise money for *Liberty*'s pedestal.[16] Like the prominent citizens who comprised the American Committee, formed to garner support and funding for the statue in the United States, they saw a parallel between the situations in France and in postwar America. Thus for many American sculptors, the *Statue of Liberty* not only represented a good cause. It also offered encouragement that there existed institutional and political backing for major public sculpture projects.

The donation of *Liberty* and the subscription campaign for the pedestal in 1885 clearly publicized American sculptors' cause but at the same time lent urgency to their efforts. Here was an extraordinary testament to the power of sculptural allegory made possible through the marriage of artistic vision, new technology, and fine craftsmanship. But although *Liberty* fostered awareness of public monuments and galvanized popular support for expressing "national" ideals in sculptural form, a Frenchman, not an American, had created it.[17]

American artists could take advantage of the burst of interest by turning the popular acclaim for *Liberty* into backing for public works by Americans. To do this, they had to bring to community awareness the idea that national unity could find public expression through memorials of lasting artistic significance. In championing this goal, they could take advantage of a significant movement in which elites were deeply interested: remembrance of the Civil War.

Once the more immediate concerns of winning the battles and mourning the dead had passed, people began to try to come to terms with why the war had been fought and what its value had been. The desire to assess and understand what had happened increased during the 1880s, as the generation most directly affected by the war aged and became distanced from the conflict. The need to

1.3
Frédéric Bartholdi, *The Statue of Liberty*, 1886. (Photo, Irving Underhill, 1931. Courtesy of the New-York Historical Society, New York City.)

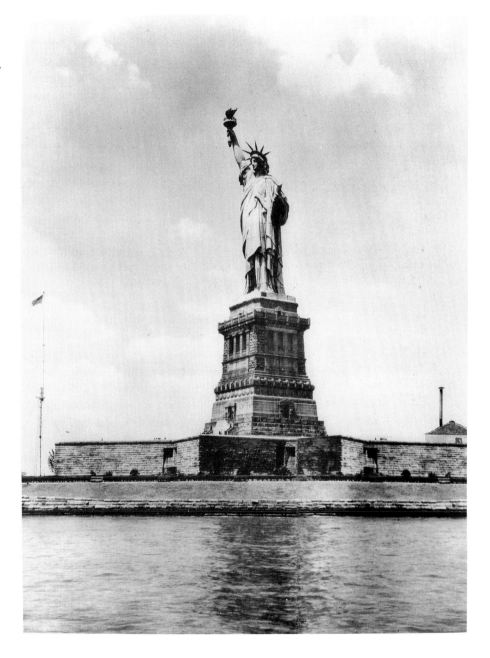

endow contemporary society with a deeper purpose was underscored by the turmoil of the postwar Reconstruction period. Immigration, urbanization, industrialization, new fortunes, and great trusts were producing enormous changes in American society. Indeed, the war had quickened the development of the mining industry, as well as the transcontinental networks of transportation and communications that produced the great "robber baron" fortunes of such men as Jay Gould, Andrew Carnegie, and John D. Rockefeller.

The affluence and corruption of the Gilded Age led many northern intellectuals to fear that the true meaning of the war was being forgotten and trivialized. In their view, the moral issues over which the war had been fought were being undermined by the worst of its economic and political effects. From the northern intellectuals' standpoint, the nation's destiny depended upon immediately recovering the moral spirit of the Civil War. They considered the memory of the war crucial to the ideal of nationality and unity, for both present and future generations. In their view, the significance of the Civil War lay in reunion: the triumph of national order and the fulfillment of the enlightened republican ideals of the Founding Fathers and the American Revolution. Such ideals offered the rationale for reestablishing the natural leadership of America's most learned and cultivated citizens—men like themselves.[18]

While neither sculptors nor their spokesmen stated their artistic aims explicitly in these political terms, their views clearly intersected with this post–Civil War intellectual trend. The artists believed that a distinctly American art would result from assimilation of the forms and spirit of the country's classical and colonial cultural heritages, suitably conveyed both through collaborative activity and through the style and iconography of individual works. In giving visual expression to the notion of American thought and civilization as a unified whole, art would represent and advance the ideals of nationality that had been achieved in the political sphere through the Civil War.[19]

Sculptors felt they could make a unique contribution to enhance the memory of the Civil War, and indeed, to enhance historical consciousness. As Lorado Taft recalled, during the years after the Civil War "the spirit of American sculpture" began "to respond in some measure to the thrill of a newly guaranteed national existence."[20] Not surprisingly, the younger, technically more adept sculptors believed that this goal could only be achieved through high-quality civic monuments. In their view, such works would have to have more lasting significance than the awkward lead and zinc soldiers that paid an immediate tribute to the

recently deceased. They began to dismiss the statues and Civil War monuments of their predecessors as crude, inartistic, and devoid of proper emotional content, and promoted themselves as best capable of expressing the memory of the entire war and the true ideals of the national Republic.[21]

In principle the sculptors' goals were consistent with those of the postwar generation of American elites, but there were few clear-cut ways to realize them in the United States. By contrast, the artist's function in Europe was well defined and supported by the state. Success depended on the sculptors' ability to acquire prestige and thus to become part of the circle of influential men like Richard Morris Hunt and Stanford White, who were involved in the new architectural and civic developments of the 1880s. Many of the significant changes originated in New York.

Developing a Network

Sculptors in the late nineteenth century gradually developed a sense of common identity and purpose that allowed them to assert their influence. Several factors converged to make this possible. These included the formation of great fortunes; the ascent of a group of influential professional architects; and the early success of several leading figures, Augustus Saint-Gaudens, Frederick MacMonnies, and Daniel Chester French.

Saint-Gaudens set public sculpture on a new track with the creation of his portrait of David Glasgow Farragut. MacMonnies extended a collaborative relationship begun with Saint-Gaudens and Stanford White that resulted in several important New York monuments. French's privileged background helped forge connections with other elite groups. These men had the greatest impact as individuals, but the immigration of German and Austrian sculptors proved significant as well. These foreign-born artists set new standards of excellence, added cultural variety, and worked actively to form and maintain a professional community and to promote the civic benefits of municipal art.

The possibilities in architectural projects changed rapidly and substantially in the late 1880s. The creation of enormous fortunes during this period fostered new civic values and institutions and resulted in substantial development of the city. Wealthy families prided themselves on conspicuous display. Envisioning themselves as modern-day Medicis, they hired a new generation of professional archi-

tects to design opulent contemporary Renaissance palaces. Their attempts to create associations with Renaissance culture and civilization extended into the public sphere. Their admiration of the great Italian city-states led them to an unprecedented concern with civic ideals, and prompted the formation of numerous clubs, libraries, museums, and other cultural institutions.

All of this helped give architecture and architects an importance they had not had earlier. The newly rich disdained luxury townhouses constructed by builders on speculation. They wanted their own magnificent dream homes built to order by architects who claimed professional status because they had trained at the Ecole des Beaux-Arts or in the new university-affiliated architecture schools in the United States. With all of this work available, architecture acquired new prestige. By the end of the century architects would be major participants in the planning of cities as well as designers of buildings.

Richard Morris Hunt (1827–1895), the first American architect to train at the Ecole des Beaux-Arts, was a major contributor to the new professional climate. As the favored architect for the Vanderbilt family, he designed numerous important apartment complexes and public buildings in New York. Beaux-Arts design emphasized elaborate ornamentation and artistic unity. As its foremost practitioner, Hunt often included architectural sculpture in his plans, including those already mentioned for the abortive gateways for Central Park. He was a firm believer in collaboration between sculptors and architects. His work with John Quincy Adams Ward, and later with Karl Bitter, set new standards of excellence for the design of public sculptures in harmonious relationship with the surrounding environment.[22]

Next to Hunt, the most influential of the new breed of professional architects were Charles Follen McKim, William Rutherford Mead, and Stanford White, who in 1879 formed the firm of McKim, Mead, and White. Their activities represented the new interconnections among social, artistic, and business interests that gave the firm a pivotal role in late-nineteenth-century architecture and in the artistic development of cities. Their family connections, high social standing, cosmopolitan orientation, and business acumen gave these architects access to urban political leaders and industrial magnates and led to a string of important commissions, including mansions, churches, and numerous public buildings. The architects' very ability to get so many of these large commissions was a reflection of their new authority and of the range of different elites for whom such buildings were now done.[23]

The firm's important social and professional position was expressed through its aesthetic ideals and practices, which were a function of the architects' background, and in turn of their wealthy patronage. McKim, Mead, and White were spokesmen for the notion of a modern American Renaissance as an expression of wealth, civic–mindedness, order, national identity, and cultural unity. As architects for the new millionaires, they were expected to draw architectural associations between their patrons and the Renaissance merchant princes.[24]

These associations were perfectly consistent with the architects' own social ideals. They considered Rome and Early Renaissance Florence to represent the apogee of civilization in general and of republicanism in particular. In this respect, their attitudes tied in closely to the broader postwar social and political concerns for the revitalization of nationhood. The destiny of the nation, the legacy of the Founding Fathers' republican ideals, was seen as inextricably linked to the republicanism of ancient Rome.[25]

But McKim, Mead, and White's ideals also grew out of more purely aesthetic and cultural concerns, for they looked upon these epochs as times of supreme artistic excellence, when unity among the arts had reached its height. Inspired by the architectural traditions of these earlier periods, the firm incorporated sculpture into their designs.

McKim, Mead, and White were receptive to the principle of using sculpture didactically and to emphasize building structure. They saw collaboration with sculptors as the best way to assure the quality of their embellishments and to incorporate the idea of national and artistic harmony into actual practice.[26] But such artistic interests extended beyond single buildings. Like their European counterparts, they regarded unity of the arts as a total aesthetic conception through which sculpture, mural painting, landscape gardening, and architecture became means to attain a total urban (and suburban) environment. Like Hunt, McKim, Mead, and especially White viewed well-designed architectural sculpture and freestanding monuments as integral components of a beautiful and orderly metropolis. The sculptor Augustus Saint-Gaudens (1848–1907) became a crucial figure in making this collaborative ideal a reality.

In the late 1870s, the young Ecole-trained Saint-Gaudens met McKim and White while he was working for the architect Henry Hobson Richardson. Saint-Gaudens was the son of a French shoemaker and an Irish mother of working-class origins, who had emigrated to the United States six months after his birth. His back-

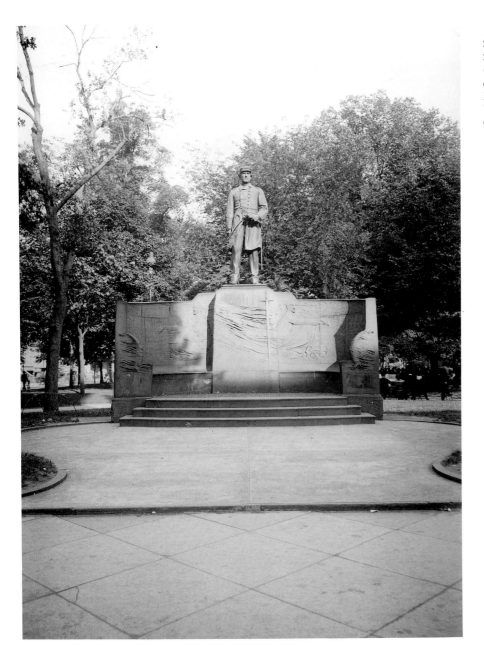

1.4
Stanford White, architect, Augustus Saint-Gaudens, sculptor, *David Glasgow Farragut*, northwest corner of Madison Square, 1881. (Photo, May 1905. Courtesy of the New-York Historical Society, New York City.)

ground might not have portended a likely relationship with men of the refined intellectual Anglo-Saxon upbringing of McKim and White. But his combination of charm, talent, and determination had already proven successful in giving him access to high social circles.[27] The sculptor's dashing irreverence and his passion for things Italian hit a responsive chord in McKim and White, and their acquaintance developed into a close friendship. The relationship extended almost immediately into the professional sphere, in the form of both private and public commissions. In 1876–1877 they worked together on the construction of Richardson's sumptuous Trinity Church in Boston; White gave Saint-Gaudens the commission for the angels (now destroyed) for New York's Saint Thomas Church.[28] In addition, around 1877, White and Saint-Gaudens joined forces on the first of several collaborative public monument projects, the statue of Admiral David Glasgow Farragut (fig. 1.4).

The *Farragut* set a new direction for public sculpture both organizationally, aesthetically, and ideologically. Organizationally, it established Saint-Gaudens's importance as a charismatic figure, who knew the importance of maneuvering. This in itself was nothing new; but in a world in which the hunt for commissions was extremely competitive, political shrewdness was essential. The Farragut commission reflected the growing necessity of negotiations not only with private individuals but also with interest groups and public officials. Saint-Gaudens mastered this talent in the early stages of his career, and it put him in a permanent position of artistic leadership.

In this particular case, the sculptor had heard, as early as 1874, of plans to erect in New York a statue of the Civil War commander of the Union fleet. Determined to win the commission, he went straight to Farragut's widow, in the hopes that if she saw his work she would recommend him for the job. Once having won her backing, Saint-Gaudens called on the eminent lawyer Edwin Stoughton (one of his early patrons) and lobbied several other members of the Farragut monument committee. Saint-Gaudens ultimately won the commission by the skin of his teeth. J. Q. A. Ward, whose support he had also requested, actually received the award, but he declined it on behalf of the younger sculptor. After enduring many frustrations in completing the *Farragut* and in securing a desirable site, Saint-Gaudens finally saw *Farragut* dedicated in May 1881.[29]

Aesthetically, *Farragut* also set a new precedent. Almost everyone agreed that in style, expression, and technical handling *Farragut* was unlike any previous American monument. Many commentators saw it as the start of a new artistic

era in sculpture in the United States, a view that has remained strong ever since.[30]

Saint-Gaudens's contemporaries in the late nineteenth century responded in part to what was, at the time, a relatively new sight: a portrait monument rendered by means of the new French techniques and conventions of representation, which the artist had absorbed as one of the first Americans to study sculpture at the Ecole. Saint-Gaudens's depiction of Farragut evoked the spontaneity of a specific moment, just slightly prolonged—a device that had a powerful emotional effect on contemporary viewers. The pedestal, designed by Saint-Gaudens and White, represented yet another example of artistic unity, as did the act of collaboration itself. Critics admired the contrast between the staunchly realistic-looking admiral and the flat, pictorial decorations. These features counterbalanced the sense of immediacy evoked by *Farragut*'s details and pose with an effect of idealization and "universality." Moreover, critics observed, the artist handled these decorative features with a respect for their medium and function, and also with proper subordination of the parts to the whole.

These creative triumphs inspired author Richard Watson Gilder to write that in creating *Farragut*, Saint-Gaudens had adhered to classical principles that revealed his underlying sympathy with Early Renaissance Florentine art. Indeed, Gilder noted, "in modeling severe, broad, yet minute in finish and modern in expression—in character alert, eager, reticent, full of dignity and reserved force," the *Farragut* could well be described as the work of a new Donatello.[31] Not only had Donatello's *Saint George* inspired the pose for the *Farragut*; in Gilder's view, the two artists endowed their subjects with a similar depth of character and timeless significance.

Gilder, a personal friend of Saint-Gaudens, knew that Donatello pose well. While visiting the sculptor in Paris, where the latter was agonizing over his model of the *Farragut*, the newly appointed editor of the *Century Magazine* lent a helping hand by posing for the admiral's legs; his tribute to the artist thus incorporated an small inside joke. But his aesthetic analogies between classical and Early Renaissance art and the *Farragut* had several quite serious broader purposes. First, and most explicitly, his comparisons underscored Saint-Gaudens's talents as an important portrait artist and assured the sculptor a place in the pantheon of great masters. Second, they confirmed that Saint-Gaudens had grasped one of the major canons of academic art theory: sculpture must not merely record appearances, it must express more fundamental, universal truths of nature in a way that the Greeks had perfected and conventionalized. In addition, Gilder's statements

implicitly paid tribute to Saint-Gaudens's (and, by extension, to his collaborator White's) acknowledgment of the primacy of the classic values of tradition, memory, authority, unity, and sacrifice—signified through the very choice of Farragut as a subject, and all linked with the search for national identity.

Indeed, *Farragut* represented far more than just a convincing likeness or a merely stylistic change from the public works of the past. As a portrait, *Farragut* typified the growing tendency toward what Charles Caffin later called "hero-worship" on the part of a nation "reawakened by a great moral question . . . chastened by the stern discipline of a tremendous struggle," and "bound up with a fuller, deeper sense of national life."[32] Saint-Gaudens depicted the admiral as a "hero of sacrifice," a man who would have willingly given his life for the cause of nationhood. Farragut became an emblem of courage, leadership, and duty. Thus Saint-Gaudens addressed in sculptural terms the fundamental moral and ideological concerns of the postwar generation. The monument firmly secured the sculptor's reputation as one of the country's most talented and highly regarded artists. From this point on, until his death in 1907, Saint-Gaudens's work set the standard of excellence for public sculpture in New York and the rest of America.

Stanford White (1853–1906), whose talents as architect and designer remained constantly in demand, worked only with those he considered to be the best. When it came to sculpture, this meant working with Saint-Gaudens. But by the late 1880s Saint-Gaudens too was in demand, and could not always take on all the new jobs that White and others were making available. White therefore extended his collaborative network to include Frederick MacMonnies (1863–1937) and, periodically, several other French-trained artists. Before leaving for France for Ecole study in 1884, the Brooklyn-born MacMonnies worked as an assistant in Saint-Gaudens's studio. There he met White. Impressed by MacMonnies's modeling skills, the architect arranged in 1888 to get him two major commissions for garden sculpture for the private estates of Edward Dean Adams (Rohallion) and ambassador Joseph H. Choate (Naumkeage). In 1890 he asked MacMonnies to do the spandrels for the new permanent *Washington Arch* in Washington Square (fig. 5.2). At about the same time Saint-Gaudens also gave MacMonnies the commission for an enormous fountain, the *Barge of State*, for the 1893 World's Columbian Exposition. This commission, along with his statue of *Nathan Hale* (dedicated 1893) for Manhattan's City Hall Park, brought MacMonnies nationwide recognition as a public sculptor. And in 1894 White provided MacMonnies

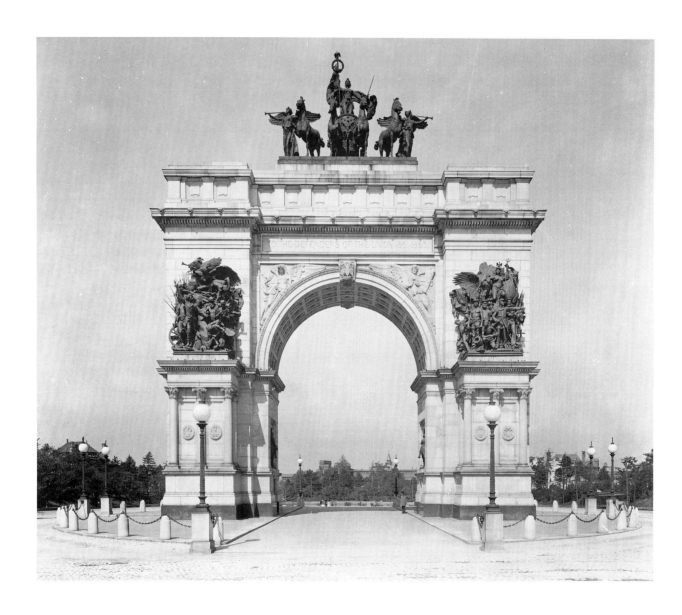

The heroic sculptures by Frederick MacMonnies included a crowning quadriga (1898), titled *The Triumphal Progress of Columbia*, and two colossal reliefs on the south pedestals (1901): *The Army*, subtitled *Genius of Patriotism Urging American Soldiers on to Victory*; and *The Navy, American Sailors Boarding a Vessel at Sea Urged On by the Genius of Patriotism*. Inside the arch are bas-reliefs: Thomas Eakins, *Abraham Lincoln* (1895); William O'Donovan, *Ulysses S. Grant* (1895).

an even more prestigious opportunity—the commission for three monumental groups for John Duncan's *Soldiers' and Sailors' Memorial Arch* (fig. 1.5) at the entrance to Brooklyn's Grand Army Plaza at Prospect Park, an area that White was in charge of redesigning.[33] MacMonnies worked on these sculptures over the next eight years.

MacMonnies's works, even more than those of Saint-Gaudens, epitomized almost in an extreme sense the virtuoso effects of the Beaux-Arts approach to modeling and to representation. They typified the exuberance that the new French techniques could bring to New York's public sculpture. MacMonnies lived much of the time in Giverny, France, and was somewhat isolated professionally from his American peers. While he had numerous supporters and commissions, circumstances did not work consistently in his favor all the time. As will be seen, he was often an extremely controversial figure. Nevertheless, MacMonnies's talent and his connections with White and with local elites in the right places helped him to make an ongoing contribution as a sculptor of New York public monuments.

Like Saint-Gaudens, the majority of those who became sculptors in the late nineteenth century came from first- or second-generation middle-class and working-class families, with fathers who (like Bernard Saint-Gaudens) were artisans, artists, schoolteachers, small businessmen, or preachers. Few artists started out as members of the social, intellectual, and economic elites, although several eventually gained access to these circles. Daniel Chester French represented one of these exceptions. Partly for this reason, the development of his career helped set the stage for the establishment of public sculpture in New York. Although he too visited Europe, French, unlike Saint-Gaudens and many others, did not attend the Ecole. His special importance for the emergence of public sculpture lay partially in his background. His genteel upbringing helped him to interact with the upper echelons of society, and this proved crucial in integrating sculptors into a larger institutional framework.

Daniel Chester French (1850–1931) was born in Exeter, Massachusetts, into a family of "old New England stock." One grandfather, Daniel French, had been attorney general of New Hampshire. His other grandfather, William Merchant Richardson, was chief justice of the same state. His father, Henry Flagg French, a lawyer, practiced in Exeter and Boston. The elder French and his wife Anne encouraged their son's early interests in modeling. In 1867, at his father's prodding, French enrolled in college at the Massachusetts Institute of Technology. In con-

trast to his brother, William (who had graduated from Harvard in 1864 and later became director of the Art Institute of Chicago), Dan was not academically inclined. He dropped out of MIT after the first year, after failing physics, chemistry, and algebra. From that point on his academic affiliations were all purely ceremonial, but he lost none of the advantages due a person of his class and upbringing.

Over the next several years French began intensive training in sculpture. After a period of study in Concord with May Alcott (daughter of transcendentalist Bronson Alcott and sister of Louisa May Alcott) in 1868–1869, he spent one month working in the now-established J. Q. A. Ward's New York studio. In 1871 the young artist had his first major artistic opportunity. The town of Concord, Massachusetts, had begun considering the best way to commemorate its central role in the American Revolution for the upcoming celebration in 1876 of the United States Centennial. A friend of the French family, also a prominent Concord citizen, recommended that French create a statue to go on the hill where the minutemen had gathered for their momentous battle. Anticipating his own good luck, French created a model for such a work even before he actually won the commission in 1873 for what became the famous *Minuteman* statue. The monument, depicting a young volunteer with his weapon, stepping away from his plow, became an important patriotic symbol of America's colonial past and an evocation of an American Cincinnatus.[34]

Family ties helped the sculptor on other occasions. The elder French, now assistant secretary of the United States Treasury, was instrumental in securing for his son a commission for sculpture groups for the United States Customs House in Saint Louis. A series of other important public commissions followed during the 1880s, including groups for the Philadelphia Courthouse (1883) and the Boston Post Office (1885). By the time of the World's Columbian Exposition, French was an accomplished sculptor and, next to Saint-Gaudens, the most acclaimed of his generation.

French could not have gotten far had he not had talent; nonetheless, he started out from an advantageous social position that few other sculptors could match. His correspondence and his wife's memoirs reveal that he circulated with ease and grace among bureaucrats, literati, academics, reformers, philanthropists, and wealthy socialites as well as among architects and sculptors. His letters—modest, polite, but never deferential—were written in a straightforward, congenial tone that reveals his adeptness as a confidant and negotiator. He was also extremely reliable.

These qualities all helped to make French a major presence in New York cultural affairs after 1900, more so than even Saint-Gaudens. In addition to his sculpture commissions, he held numerous ceremonial and consultant positions: first sculptor member of the Art Commission of the City of New York (1898–1904); delegate to the Fine Arts Federation; member of the New York City Improvement Commission, appointed by Mayor McClellan in 1904; director of the Department of Sculpture for the Metropolitan Museum of Art; and trustee of the Metropolitan beginning in 1903.[35] He also took on a ceremonial professorship of sculpture at Columbia University, which also awarded him an honorary degree. He constantly assumed the role of mentor, advising former assistants and "suggesting" their names as possible substitutes to create the many commissions he turned down for himself. From the turn of the century onward, for about the next twenty years, the career of Daniel Chester French represented the ideal of professional stature for American sculptors.

Foreign-born artists, especially Austrians and Germans, also proved to be a important force in the development of New York civic sculpture, and especially in the organization of the profession. A few German sculptors had already come to this country at midcentury and had created several statues for New York City. But these artists did not have the same cultural impact as the generation who began arriving around 1890. In contrast to many eastern European, Irish, and Italian immigrants, the Germans and Austrians tended to come with marketable skills and from comfortable middle-class backgrounds, and they assimilated relatively easily.[36]

Some of the German-speaking artists, such as Karl Bitter and Isidore Konti, came already experienced in architectural sculpture, with which few Americans were familiar. Several had studied together. Bitter had trained at the School of Applied Arts in Vienna, and both he, Konti, and Frederick G. R. Roth all studied with Edmund Von Hellmer at the Imperial Academy of Fine Art. Adolph Weinman and Albert Jaegers received their primary school education in Germany but came to the United States at a young age. They received their art training in New York schools, and apprenticed, along with others, with French and Saint-Gaudens. Their associations with these two artists helped considerably to advance their careers. In interesting contrast, the Austro-American Bitter became a fairly powerful artist, but kept a much lower profile. He rarely used personal influence on behalf of assistants as French and Saint-Gaudens did.

To be sure, the background and artistic schooling of German-born or -educated sculptors clearly differed from that of the second-generation German-American artists. Nevertheless, all shared a strong feeling of cultural identity and camaraderie. Konti, Bitter, and Roth, for example, already had common memories and artistic experiences.[37] Their correspondence with each other (and, in the years around the turn of the century, with Weinman) conveys a warm sense of *Bruderschaft*, with letters written in English often lapsing into German when the topic turned controversial or personal. This sense of ethnic identity affected both the individual careers of these artists and their impact upon the larger professional community.

Their talents, good manners, and efficient working methods would win them major commissions and consultant jobs, and most of them became involved with municipal art affairs. Bitter and Konti—through their work on public projects in Vienna—and Weinman—through his assistantship to two of the country's leading sculptors—had learned the artistic results of organization and cooperation early on. Thus, significantly, established sculptors like Bitter, who could have chosen to work independently and unaffiliated, committed themselves instead to developing an American institutional framework. The German-Americans would maintain a strong commitment to the National Sculpture Society, and would work in a variety of administrative capacities to maintain organizational cohesion. German-American involvement would have important consequences for American sculpture, both positive and negative.

Among the German-American artists, it was Karl Francis Bitter who really paved the way for other sculptors. Before his desertion from the Austrian army and his immigration to America in 1889, Bitter, son of a chemist, had worked on the elaborate decorative programs underway in the rebuilding of Vienna. He arrived in New York virtually penniless, with no knowledge of English, but he did have the name of a decorating firm in the city. On showing the manager his work, he was hired on the spot, for he had the ability to model sculptural details such as a tympanum that no other modeler had been able to undertake properly.

Bitter's talents soon earned him $48 a week (worth about $552 by 1988 standards) and quickly brought him to the attention of the architect Hunt, who often commissioned ornaments from the firm for whom Bitter worked.[38] Enormously impressed by Bitter's skills, Hunt hired him as "house sculptor" and gave him his own studio. Bitter then went on to create sculptural designs for the numerous Hunt mansions, including the Fifth Avenue home of John Jacob Astor; for Marble

House and Idle Hour, the Newport and Long Island estates of William K. Vanderbilt; and later, for the George Washington Vanderbilt estate Biltmore in Asheville, North Carolina. In 1891, undoubtedly through Hunt's intervention, he also won the competition to work with the architect on the Broadway and Wall Street entrance doors to Trinity Church.[39]

Hunt's patronage had important consequences both for Bitter and for other sculptors. Hunt's stamp of approval on Bitter's work helped to shift the artistic stature of architectural sculpture—once considered mere ornament—to the level of fine art. This broadened the market and heightened competition for architectural commissions. One of the key indicators of architectural sculpture's newfound prestige would be the inclusion of an elaborate program of sculptural adornment at the 1893 World's Columbian Exposition.

Bitter's reputation continued to mount, as a "court sculptor" for Hunt, for Hunt's former student George B. Post, and hence also for the country's most elite families. Within two years of his immigration he had forged the connections necessary to ensure his future success. Bitter's extraordinary work for Hunt's Administration Building at the World's Columbian Exposition revealed his virtuosity as a modeler, and led him to receive numerous important new commissions. But Bitter's talents were not solely sculptural. He had a vivid concept of the ideal city and the ability to impart it to others. As Director of Sculpture for three subsequent American world's fairs, and as an activist on behalf of a comprehensive program of municipal art for New York, Bitter devoted himself to urban beautification efforts until his untimely death in 1915.

By the time of his death, Bitter had attained eminence and power. Yet for all of his achievements, he rated only minor mention in three of the major early histories of American sculpture. McSpadden's *American Masters of Sculpture* examined only artists of British ancestry. Adeline Adams's *The Spirit of American Sculpture* concentrated on discussion of sculptors of "older stock" like Ward, Saint-Gaudens, and French. Lorado Taft's *History of American Sculpture* gave Bitter more coverage, but only in a chapter on decorative artists and men of foreign birth. Taft discussed Bitter's work in terms of his "decorative" instinct, thus implying that his work lacked serious content even though he had the ability to model deftly picturesque sculptural compositions that fit satisfyingly into a architectural context. Charles Caffin discussed Bitter's art in a similar fashion.[40]

This critical treatment reflected the problematic impact of what became a strong German presence in the American sculpture profession. An apparent

respect and decorum was manifested in the relationships between German-American sculptors and those of other ethnic origins, and between sculptors and other groups. But below the surface, an underlying current of distrust persisted; and, at times, outright hostility toward the Germans erupted. As will become evident, anti-German biases ultimately worked not only against certain individuals but against the German sculptors as a group. Around 1890, however, the appearance of gifted sculptors like Bitter helped increase attention to the potentials of public sculpture, and this new interest was welcomed by the emerging American sculpture community.

The concern for a revitalization of nationality; the formation of key personal and professional relationships; and the emergence of a core group of talented, diverse, and respected sculptors—all these various tendencies converged in the 1893 World's Columbian Exposition in Chicago (fig. 1.6). The exposition provided the first major opportunity for American sculptors to prove their expertise to a mass audience, and fostered valuable new social and occupational relationships.

The fair was a spectacular collaboration among leading businessmen, engineers, architects, and sculptors. As director of works, architect Daniel H. Burnham believed that these authorities would set standards of perfection that would assure the cultural respectability of the fair and, ultimately, its success. His calculations proved correct. The exposition became a prototype for subsequent world's fairs and was considered the epitome of excellence in art, architecture, and landscape design.[41] As such the fair became an important model for the City Beautiful movement that emerged over the next several years.

Open between May and October of 1893 in Chicago's Jackson Park, the White City, as the fair was dubbed, commemorated Columbus's discovery of America and celebrated the nation's coming of age. From the outset the fair was intended as a colossal commercial venture that would surpass the 1889 Universal Exposition in Paris, but the planners insisted that there was more at stake than financial profit. The greatest value of the fair, they asserted, would be as an educational experience illustrating the world's finest industrial and artistic achievements—particularly the progress of American culture.

The fair would represent a specific notion of culture, which critic Matthew Arnold had described as "the best that has been thought and known in the world." Arnold and his American followers argued that the attainment of culture would ultimately result in social equality but that such change would occur only

1.6
View of fairgrounds showing *Columbian Fountain* by Frederick MacMonnies, World's Columbian Exposition, Chicago, 1893. (Photo, C. D. Arnold. Chicago Historical Society.)

Frederick MacMonnies's exuberant *Columbian Fountain*, featuring the *Barge of State,* depicted the apotheosis of modern liberty—Columbia seated on a triumphal barge, rowed by Art, Science, Industry, Agriculture, and Commerce, guided by Time, and heralded by Fame.

gradually. In the meantime, strong sympathetic leadership by the nation's educated elite would provide guidance for the public.[42] The fair's advocates rallied behind this genteel cause, averring that the quality of both the plan and the exhibits would raise the level of American taste. In particular, the fair would demonstrate the progress of American art by showing artistic continuity from the great classical civilizations to the present American high culture.[43]

41 *Sculptors and Public Sculpture*

To ensure that the fair would demonstrate that American art embodied the classical spirit, Burnham and his advisors set formal criteria. All major buildings would be designed in a style based primarily on Beaux-Arts and Italianate sources. All would reach uniform height, and all would be painted white. Burnham hired Saint-Gaudens as director of sculpture. In so doing, Burnham initiated a set of professional hierarchies and procedures that would soon become commonplace in large projects. The architect would always have the final word, but would delegate some of his authority to a single eminent sculptor who as supervisor would dole out the commissions through a system of patronage. To this end Saint-Gaudens recommended that a number of young, mostly American-born and European-trained sculptors execute the largest program of American architectural and freestanding sculpture to date.[44]

The fair buildings were temporary constructions, fashioned mostly out of staff, a material composed of plaster and fibers, which allowed architects and sculptors to make extremely detailed, ornate works on a monumental scale in a short time for relatively little cost. This provided the sculptors with an unusual chance for displaying their talents, and throughout the fairgrounds sculpture was ubiquitous. Statues stood atop bridges, beside stairways, and beneath the entrances to buildings.

The majority of works functioned as didactic decorations. These sculptures created a play of solids and voids that dissolved building masses into vibrant patterns of summarily modeled lights and shadows. Whether as single animated twisting figures or as complex group configurations, much of the architectural sculptures stood out from the buildings. They were anything but rigidly architectonic (figs. 1.7, 1.8).[45]

Few of the sculptors designing works for the "official" portions of the fair were women. From the point of view of most of the male sculptors, this was (and should remain) the appropriate state of affairs. Although the number of American women sculptors was increasing rapidly during this period, they generally encountered the same problem as women in the sciences and social sciences: a commonly held assumption that the sexes should operate in separate professional spheres. While they were by no means locked out of the sculptors' profession, few women sculptors were touted as monument makers. In the coming years, most women sculptors would concentrate on smaller, more "domestic" pieces—animals, genre subject, fountain and garden figures—and it was for this kind of work that they received the most encouragement.[46]

1.7
Philip Martiny, *The Four Races Supporting the Horoscope*, *The Seasons*, and *Abundance*; Larken Mead, *The Triumph of Ceres* (pediment sculpture); for the Agricultural Building, McKim, Mead, and White, architects, World's Columbian Exposition, Chicago, 1893. (Charles Dudley Arnold Collection, Avery Architectural and Fine Arts Library, Columbia University.)

1.8
Administration Building, entrance,
World's Columbian Exposition,
Chicago, 1893. Karl Bitter, *Fire
Controlled* (left) and *Fire Uncon-
trolled* (right). (Charles Dudley Ar-
nold Collection, Avery Architectural
and Fine Arts Library, Columbia
University.)

Within this larger professional context, however, women did work at the fair.
Lorado Taft hired several of his female students from the Chicago Art Institute to
assist him in modeling and pointing up his designs for the Horticultural Building.
Janet Scudder, Enid Yandell, and Bessie Potter Vonnoh received commissions for
statues for the individual state buildings. And Mary Lawrence, a Saint-Gaudens
protégé, modeled a statue of Christopher Columbus at the entrance to the Elec-
tricity Building, although Saint-Gaudens received much of the credit for the de-

Daniel Chester French, *The Republic*, World's Columbian Exposition, Chicago, 1893. (Charles Dudley Arnold Collection, Avery Architectural and Fine Arts Library, Columbia University.)

sign. Women were also "compensated" by being given their own pavilion—the Women's Building—designed and decorated entirely by female artists.[47]

Women's art was set apart at the fair, but the works of both sexes revealed common assumptions about appropriate thematic focus. To display properly this progression, the scope of the Columbian Exposition sculptures was enormous, extending far beyond the simple themes of nationalism, memory, and sacrifice that had prevailed in the soldiers' and sailors' monuments and in much of the public statuary of recent years. At the same time, the ideal of republican unity was by no means overlooked. To the contrary, it formed the heart of the fair's entire thematic plan, culminating in the basin of the Court of Honor with its sixty-four-foot allegorical colossus of *The Republic* (fig. 1.9). Conceived by Saint-Gaudens, but realized in sculpture by Daniel Chester French, the hieratic *Republic* was the American answer to the *Statue of Liberty*.[48]

Allegorical themes of progress and triumph over the frontier predominated, especially in works celebrating man's triumph over primitive nature through art and industry (figs. 1.6, 1.8). These thematic programs underscored an additional ideological premise—the white race's superior cultural status—projected by the fair as a whole.[49] Such notions were, of course, not new to the visual arts or to sculpture. But the peculiar circumstances of the fair allowed sculptors to make the "great ideas" stand out both formally and iconographically, and the concept of progress took on special meaning for these artists. It confirmed their own beliefs about their professional advancement. "Look here, old fellow," Saint-Gaudens reportedly told Burnham enthusiastically, "do you realize that this is the greatest meeting of artists since the fifteenth century?"[50] Indeed the range of allegories presented implied that all of life was now within the sculptors' domain of expression. By depicting the aspects of life they deemed significant, they expressed their belief that sculpture could present tangible evidence of harmony and universal order.

The fair really was the sculptors' dream; several writers even called the fair itself the Dream City.[51] Many sculptors hoped this dream would materialize in the form of more commissions. After the exposition closed, several writers referred to its success as sufficient reason for continued support of sculptural projects and for including architectural sculpture in buildings already commissioned. The fair, they reminded readers, was the most significant display of cultural unity since the Renaissance.[52] Since its organizers had demanded technical and artistic excellence, and since so much sculpture had been included, the skill and the imagination of American sculptors were no longer in question. Furthermore, they continued, the alliance of sculpture and architecture had advanced civilization. J. H. Gest of *Engineering Magazine* spoke for many when he wrote, "The beauty of grand buildings harmoniously grouped in Jackson Park, the charm of decorative sculpture, the richness of public places and avenues abounding with statuary, create an unsuppressible longing that something of this, apparently so permanent, yet really so temporary may remain as a lasting impression upon our people."[53]

The time was right to give permanent form to the lessons of the fair and to make sculpture and the sculptor an integral part of American society.

2

The National Sculpture Society, Artistic Alliances, and the Search for a City Beautiful

The World's Columbian Exposition had been a valuable experience for sculptors. It showed that they could successfully collaborate on short-term but large-scale projects. Furthermore, since sculptors were now perceived as a cohesive group with common goals and interests, the fair demonstrated unequivocally the advantages of organization. It became clear to a number of sculptors and their supporters that the way to keep sculpture in the public eye was not simply through collaboration but through a professional society. In coming to this conclusion, sculptors joined the ranks of architects, doctors, engineers, scientists, and other groups who had already forged identities as professionals, as experts who possessed valuable knowledge as well as technical skills. These groups used their societies to set standards, to promote their interests, and to present a unified voice in their various enterprises. Sculptors believed it would be advantageous to develop a similar organizational framework.

Artistic societies were not in themselves new. The American Art Association (later called the Society of American Artists) began in 1877, and was followed by the Architectural League (founded in 1881). The young painters and sculptors who founded the Association had not done so, however, to assert their expertise or to establish a code of professional standards, but rather out of frustration with the conservative attitudes and exhibition policies of the National Academy of Design. They formed the society specifically to mount their own independent exhibitions.[1]

The National Sculpture Society (NSS) was conceived both as a counterpart to the specialized artists' clubs and societies, for whose members exhibitions were a major priority, and, in addition, as a professional society that could control qual-

47

ity, set standards of artistic expertise, "arouse" the taste of the country for more and better sculpture, and help distinguish its fine arts sculptor members from stonecutters and modelers.[2] The NSS furthermore initiated a series of activities and institutional alliances that contributed to the production of important public sculptural works in New York during this period. Yet because of its priorities, personalities, and relationships, both the formation of the society and its subsequent civic accomplishments depended heavily upon the involvement of nonsculptors. On one level, this situation reflected the broader interests of art patronage. Nonartist members helped sculptors define and attain their artistic and civic ideals over a twenty-five-year period. At the same time, however, the makeup of the society put sculptors in a position of dependency that periodically compromised their efforts and later proved debilitating.

No "official" history of the National Sculpture Society exists, but the slightly eccentric Frederick Wellington Ruckstull (né Ruckstuhl 1853–1942), the society's cofounder and first secretary, did provide some useful, if highly colored, reminiscences. According to his account, the inspiration for a sculptors' society came to him in 1887 while sitting in a Parisian cafe with fellow American art students Herbert Adams, George Bissell, Alexander Coles, Frederick MacMonnies, and Edward Clark Potter.

It was about 12:30, we had finished our lunch, lit our cigarettes, and had opened a confab about the condition of Sculpture in the United States and the way it was neglected by the American public. We all became more or less heated and also disgusted with the American public and press—because of its indifference to Sculpture, generally, throughout our beloved country.

Finally, in a moment of super-altruistic feeling I said, after pounding the table with my fist:

"Boys!—If I ever do get home, and if I ever locate in New York, and if I ever get my hooks in—I'll raise Hell!!"

"Bravo!"—said MacMonnies. "More power to you!" said Bissell, and a general laugh went up at my expense. Which amounted to saying:

"Well, what will *you* be able to do with that sprawling leviathan, called New York?" . . .

"Well, Ruck, what would you do if you ever did 'get your hooks in,' as you say?"

"Well, Mac, I'll tell you," I replied: "I have, for some time, been thinking that, if some one would organize a Sculpture Society, for the purpose of boosting Sculpture all over the country, it would become a tremendous power in the developing of our neglected art."

"That's a dream!" MacMonnies countered. "You will never be able to start, or keep

together, such a Society—in New York. They are all too damned jealous of each other and at logger-heads with one another. They would rip each other up in the back in less than no time."

"What makes you think so?" I queried.

"Well, I know the town. I was born there and raised among them, and I know them."

After talking the matter over a little more we all scattered, back to our work, and forgot all about it. But, time and chance, sometimes work wonders with a fool and circumstance![3]

These grand ideas remained students' art talk until art critic Charles De Kay (1848–1935) came to Ruckstull's aid six years later. De Kay was a literary gentleman who had attended Yale, wrote poetry, and worked as literary and art critic at the *New York Times* from 1877 to 1894. After a three-year stay abroad as American consul in Berlin, De Kay resumed writing for the New York press. De Kay also enjoyed a second career as a frequenter and founder of clubs. He started the Authors' Club in 1881, the Fencers' Club in 1888, and the National Arts Club in 1898. In 1895, while in Berlin, he set up the Berliner Fecht Club, the German counterpart to the Fencers'.[4]

In 1893 Ruckstull became involved in an altercation over the misplacement of one of his works at a Society of American Artists exhibition. He persuaded De Kay that sculpture, when shown together with painting, would never receive the kind of installation it deserved. De Kay argued that a sculpture society that could hold its own exhibitions might remedy the situation, and he pushed Ruckstull to help him organize it. But once having decided to form a sculpture society, the two men faced a situation comparable to that of many other fledgling societies. They had to try to recruit the most prominent men in the profession to endorse the new enterprise and to lend their expertise in establishing professional standards. Ordinarily this would have posed few problems, but the cofounders of the sculpture society had to overcome some major hurdles, especially the competitive individualism to which MacMonnies had referred in Paris.

In contrast to organizers of groups like the American Physiological Society or the American Institute of Architects, De Kay and Ruckstull encountered resistance to the idea of a society from such eminent sculptors as Saint-Gaudens, Ward, and Olin Levi Warner.[5] They were fearful that it sounded too commercial and nonprofessional and that it would be impossible to get sculptors to cooperate with each other in any case. These artists could afford to be relatively unconcerned about the value of organization to promote American sculpture. In the end, however, all three acquiesced (according to Ruckstull, somewhat less than

wholeheartedly) and agreed to lend their support to a society if it could actually be formed. At that point De Kay then became the primary force behind the organizational drive. Applying his experience in such matters, he sent out invitations to prospective members, inviting them to come to an organization meeting at the home of *Century Magazine* editor Richard Watson Gilder, his brother-in-law.[6]

On 30 May 1893 Ruckstull's grand idea finally became a reality as a group of eminent sculptors, critics, architects, and businessmen joined to form the Sculpture Society (renamed the National Sculpture Society in 1896). Seeking to lend prestige to the enterprise, De Kay and Ruckstull convinced Ward to become the group's first president.

Ward had nothing to lose. He was already the "grand old man" of American sculptors. He was firmly established, and he was able to use his excellent reputation and ties to some of the city's elites and politicians to advance the society's interests. In addition to being the society's first president, he served on the executive committee of the Municipal Art Society in its first year (along with Saint-Gaudens and Olin Levi Warner). He was on the Board of Directors of the MAS in 1898 and was vice president of and NSS delegate to the Fine Arts Federation during that year.[7] Ward thus became a key spokesman for NSS sculptors at the crucial point when the society was just getting started.

During its early years, NSS membership reflected the dominant culture. Most members were Anglo-Saxon males who lived in New York.[8] But the society was not ethnically exclusive, especially since the expertise of foreign-born artists often surpassed that of the native-born. Next to the old line, genteel American sculptors of British descent, German-born and second-generation German-American artists represented the largest contingent in the society—again, an indication of the degree of acceptance accorded the German population in general in the United States at the turn of the century.[9] Within the first ten years at least one Danish, Italian, Spanish, and Russian-born sculptor had also been accepted in the National Sculpture Society. In addition, the society began to admit a few accomplished women sculptors, usually former students or protégés of prominent male artists. Bessie Potter Vonnoh and Enid Yandell were members by 1898. Ten women belonged by 1910.[10] Over the years the constituency expanded to correspond to general trends of ethnic assimilation in urban areas.

The purposes of the society were to standardize procedures for competitions,

to enhance the professional status of sculptors, and to promote commissions for American sculpture in homes, public buildings, parks, and squares.[11] Although most NSS members lived in New York City, and most of its activities were centered in the metropolis, the society hoped its achievements in New York would serve as models for the rest of the country. The society's founders hoped that its presence would confirm the expertise of its sculptor members and help them to command respect within the broader institutional framework of America's cultural elites.

To succeed in carrying out its promotional function, however, the NSS, much like other professional societies, had to take a protectionist stance. In particular, it was necessary to establish a realm of purely aesthetic priorities that would differentiate sculptors and their independent artistic interests from commercial modelers and stonecarvers. Many of these men were English, Irish, Italian, or German immigrants. While the most highly skilled of them had artistic training comparable to that of sculptors, the less-specialized modelers and stonecutters did not. As we will see in the next chapter, sculptors had an ongoing yet ambivalent relationship with these artisans, especially regarding architectural sculpture.[12]

From the outset, NSS sculptors hoped to make it clear to the gentlemen with whom they associated that sculptors and journeymen modelers and carvers were not in the same league.[13] The society called for standards of artistic excellence whose criteria implicitly excluded the products of the building trades. Moreover, since admission to the society required nominations and a "yes" vote from the group, unwanted candidates could be excluded by never being brought up for vote in the first place.

The establishment of the society implied the existence of a unified group in pursuit of mutual interests. But it did not fully succeed in bringing artists together. Indeed, from the very outset the enterprise of professionalization was fraught with complications. The internal problems Saint-Gaudens and others anticipated did in fact erupt, and the peculiar nature of the group made NSS sculptors dependent upon the support of nonsculptors. These circumstances ultimately divided the organization from within, and weakened the artists' authority among outsiders.

The rivalries among NSS members were notorious. Ruckstull later commented, "Had I known, the *extent* of the ramifications of all this hatred, back-biting, and

cursing, going on among the sculptors of that time, before I embarqued on the organizing of a Sculpture Society, I certainly would have refused to lift my voice in the interest of any Sculpture Society in America." [14]

Ruckstull was not alone in his assessment. Theodore Dreiser, well acquainted with New York artists after his experience as a journalist, even commented on the situation in his novel, *The "Genius"* (1915).[15] Such differences among individual members came into the open in debates over who would control the organization and, even more, in discussing the issue of competitions for public statues (this latter question will be considered further in Chapter 3). The arguments, which weakened NSS efforts from the start, came to a head in 1904, when a small group led by William Ordway Partridge split off from the NSS to form the short-lived Society of American Sculpture. Partridge was reinstated in 1914. However, grumbling among the NSS sculptors continued, and as will be seen in Chapter 12, created serious internal difficulties in 1918.[16]

Other tensions existed beyond the personal differences among sculptors. They arose from larger questions of power and influence. For although numerous sculptors supported the society, went to meetings, and served on committees, the actual power of the group largely depended on the cooperation of a limited number of artists. Only a few sculptors like French, Saint-Gaudens, and Bitter actually attained much lasting influence outside the immediate artistic community. And, while French and Bitter did actively serve the NSS membership, Saint-Gaudens functioned more as a figurehead, whose membership helped gain respect for the organization. This authority on the part of a limited few proved frustrating for many of the other active NSS members.

The participation of nonsculptor associates also became a significant aspect of the NSS that worked both to sculptors' advantage and disadvantage. Like the members of other professional organizations, sculptors hoped that the formation of the NSS would assure them credentials as experts. But coordinated decision-making and action were not the artists' strengths. It had taken the initiative from a critic to get the society organized and going. And unlike the situation in most other groups, a combination of financial and political circumstances required that sculptors encourage outsiders to join. Sculptors lacked sufficient social and political clout to get along without this other constituency. Thus from the beginning, nonsculptors (who included architects, painters, writers, scholars, businessmen, lawyers, and other unaffiliated sculpture aficionados) were admitted as an additional class of membership and formed a key base of support. For example, in

1895 the society had 41 sculptor members and 184 lay members. With the exception of Saint-Gaudens and the English-born architectural sculptor Robert Ellin, the society's first governing body, its council, consisted almost entirely of nonsculptors. The proportions on the council shifted in the sculptors' favor by the end of the decade. Even so, the membership statistics indicate the continuing significance of this lay membership.[17]

As one who had been dealing with the sculptors for several years, Charles De Kay seemed fully convinced that they would get nowhere on their own. To attract the necessary backing, however, it was necessary to cast the situation in a positive light. The sculptors depended on outside support, De Kay pointed out in 1900. Lay participation, he argued, distinguished the society from the professional art organizations of Europe, which represented centralized authority and promoted what he considered to be an official, routine art. An American sculpture society could not be like those of Europe; it had to be in keeping with the distinctive social and political framework of a democratic republic to advance truly national forms of artistic expression.

The structure of the National Sculpture Society, with its inclusion of nonsculptor members, was the most appropriate way to accomplish this. Unlike European academies, De Kay commented with populist rhetoric, American artists' organizations were closing "the gap between art and the great body of the people, not merely the wealthy, or the well-to-do, but the anxious hard working public." Like many of his peers, De Kay sought to convince his readers that this broad public was the natural American audience for art. A society like the NSS, which included the public as members and asked them to "share with [the sculptors] the burden of keeping their society alive," better suited the "ideas, social and political, and appeals to the sentiments and habits of thoughts of our own people."[18] As such it would represent the ideal solution to one of the dilemmas American sculptors faced when traveling and studying in France. This national but private enterprise, in promoting American art, would compensate for the lack of a tradition of state patronage of the arts.

De Kay continued: sculptors not only needed backing; they also needed spokesmen, the keys to the NSS's "vigor" and "power." *Somebody* had to be able to drum up support among such eminent members as Samuel P. Avery, a connoisseur and philanthropist, and Seth Low, heir to a mercantile fortune, Republican mayor of Brooklyn, and in 1896 the president of Columbia University. Active, articulate boosters were necessary to help those who could not fully help them-

selves. Through his 1900 article, De Kay apparently assigned this central role as spokesman largely to himself. As he commented discreetly, "Few artists are there who are likely to subscribe" immediately to "such a maxim"—namely, to the fact that they could not handle their professional affairs effectively on their own. "Many I fear receive it with aversion; but," he added, "perhaps, from the very nature of their occupation, they are not in the best condition to realize what is best for themselves." Members like De Kay would help the sculptors with self-promotion. Moreover, he concluded, inclusion of lay members would unquestionably broaden support and help avoid snobbishness and insularity—"the old pitfall of professionalism."[19] For De Kay and the sculptors, however, counteracting snobbery meant cultivating the right kinds of people, those with appropriate social, political, or intellectual credentials, and who represented an ideal of cultivation and civic influence that the sculptors themselves hoped to attain.

Including nonsculptors did have the value of providing artists who could not afford or who were not accepted into such clubs as the Century an entrée into social and business networks. Indeed, true to De Kay's conjectures, the participation and advice of such nonsculptor members as lawyer and civic activist John DeWitt Warner did prove crucial in this regard. Warner (1851–1925), a graduate of Cornell University, was elected to Congress in 1890 and 1892, where he worked vociferously for tariff reform. Like De Kay, Warner founded and belonged to several clubs, including the Reform Club and the Shakespeare Club. Warner provided the members of the society with powerful connections they might not otherwise have had. Moreover, his involvement in New York City's political and cultural affairs endowed him with unique insights into how the sculptors should best promote themselves. At his suggestion, the NSS sculptors adopted elaborate protocols in their meetings and professional practices; such standards were typical of the very proper institutional structures to which they aspired and to which those involved in New York civic affairs were accustomed. The sculptors listened to him: Warner became a continual presence on the council at NSS meetings, and was a frequent spokesman on the society's behalf. He became a key figure in helping the NSS to expand its membership and in helping sculptors work effectively with government and civic groups. (In turn, work in the society gave him the chance to use his acquaintanceships and his legal and political expertise for cultural empire-building.)[20]

NSS sculptors' connections with architect members were also significant, sometimes even helping the artists to procure commissions. For example, James Brown

Lord, who became architect of the building for the New York State Supreme Court, First Appellate Division, was recommended for the job by Bruce Price, an architect who was on the NSS board of directors. By 1898 Lord became an NSS member. Not surprisingly, his design for the court building provided for a large amount of architectural adornment by NSS members, as we shall see in Chapter 4.

But the situation within the society paralleled the power hierarchies that existed outside: architects had a great deal of influence on the policies and activities of the artists, even though they had less at stake professionally by belonging to the organization. Unlike the sculptors, for example, the architect members did not have to depend on the NSS for professional advancement. They already possessed the prestige and influence that sculptors sought to acquire, and they had their own exclusive professional society. Yet like men such as De Kay and Warner, architects attained a great deal of power within the organization. This was a reflection of their greater social acceptance. It was the architects and their spokesmen who most often wrote on behalf of sculpture in the professional and even the popular press: good sculpture, after all, contributed significantly to the enhancement of architecture and to the surrounding environment. Architects usually controlled the organization and execution of many important sculptural assignments. Their pronouncements carried a weight equal to that of the sculptors themselves. Such circumstances forced the NSS sculptors to remain dependent on, and sensitive to, those other members' opinions on the role of sculpture in architecture and society.

However, the interests of the sculptors and the others sometimes differed, and the diverse membership became a mixed blessing for the artists. The inclusion of nonsculptor members helped considerably to get the society established, but in a way that encouraged dependence. NSS sculptors were thus put in a position of diminished authority, for it was hard for them fully to establish autonomous, internal standards of excellence and practice. To this extent the NSS never became a professional organization of the same order as the American Institute of Architects, which only admitted laymen as honorary members and whose ideologies, rules, and actions were governed by considerations arising directly out of professional experience. This constraint remained an ongoing difficulty for the sculptors. Nevertheless, during NSS's first twenty years, the skills and determination of its members channeled their energies into a constructive course of action that produced visible results.

Artistic Alliances and the Search for a City Beautiful

The founding of the NSS was a significant event, but the sculptors recognized that the extent of their influence in the larger social sector would ultimately depend upon connections with other professional and civic groups. They soon linked themselves with the National Society of Mural Painters and the Architectural League.[21] Informal ties quickly led to the formation of more broadly oriented organizations, especially the Municipal Art Society (MAS) and then the Fine Arts Federation (FAF), which in turn played an important role in the establishment of the Art Commission of the City of New York. All were devoted to urban beautification and municipal reform. These organizations not only broadened sculptors' base of support; they also facilitated attempts to make sculpture an integral part of the New York cityscape by giving the artists greater access to municipal decision makers. Sculptors' involvement with the Municipal Art Society, the Fine Arts Federation, the Art Commission, and the New York City Public Improvement Commission put them into a much stronger position of advocacy and of cultural leadership.

In these endeavors, artists joined businessmen, lawyers, politicians, and various economic elites in a commitment to improve New York. The activities of the NSS, MAS, and FAF thus complemented those of groups who sought to implement such wider causes as home rule, tenement reform, primary and ballot changes, separation of municipal from national government elections, and more centralized control of government. These concerns converged in the debates on urban beautification and city planning; together they formed a part of the City Beautiful movement, a branch of Progressivism that emerged between the turn of the century and World War I.[22]

The City Beautiful movement developed throughout the country in response to the explosive growth of American cities. Immigration and electric streetcars contributed both to dramatic population growth and to the expansion of urban areas and the appearance of suburbs. In cities such as Chicago, Cleveland, and San Francisco as well as New York, artists and reformers anticipated an exciting new era of urban development. At the same time, they wanted to be certain that this growth would not result in social or physical chaos. They believed that orderly planning and a comprehensive system of design were needed to produce beautiful and well-run cities.[23]

The World's Columbian Exposition, with its unified scheme of painting, sculp-

ture, architecture, and landscape, provided the model. City Beautiful advocates hoped to recreate the fair's ordered plan across the nation. Architect Daniel Hudson Burnham and such authors as Charles Mulford Robinson proposed comprehensive plans that included thoroughfares, transportation, architecture, and adornment all arranged in harmonious relation to each other. Land and water approaches and civic centers would become the major urban focal points. Congestion, noise, and such visual irritations as wires and street advertising would be eliminated.

The City Beautiful would have wide, tree-lined boulevards with uniform-corniced buildings, grand vistas, and a park system (figs. 2.1, 2.2). Monuments and architectural sculpture should form integral parts of such arrangements. "Sculpture and architecture are twins," insisted sculptor Jonathan Scott Hartley. "From the earliest times the two arts have always been intimately connected with

each other."[24] The NSS became a strong advocate of this belief, arguing that sculpture would be an important force in civilizing the public. Because it was inspired by both the poses, technical handling, and edifying subject matter of the finest European prototypes and also by contemporary national and local concerns, American public sculpture would familiarize people with the best and most fundamental values of past and present cultures. If planned on a comprehensive scale such works could convey broader and more significant lessons than could a single statue.[25]

City Beautiful plans were to be models of excellence for America, teaching both citizens and new immigrants aesthetic standards and moral values.[26] Many of those behind these efforts hoped that the higher expectations coming from good design would lead to other reforms, including elimination of congestion, poverty, prostitution, and corruption in government.

2.2
Connection between Fifth Avenue and Blackwell's Island Bridge, from *Report of the New York City Improvement Commission to the Honorable Mayor McClellan, 1907.* (U.S. History, Local History and Genealogy Division, the New York Public Library, Astor, Lenox, and Tilden Foundations.)

The sweeping improvements of City Beautiful advocates demanded a strong, centralized government led by upright men. In Washington, D.C., where such a powerful and nonrepresentative government existed, proponents of a City Beautiful could implement their ideals to at least a certain degree. Building upon Pierre L'Enfant's original 1791 plan for the District, the federally supported McMillan Plan (1902) expressed perfectly the unity, stability, and authority that early twentieth-century artists and Washington statesmen found attractive.[27] As will become evident in later chapters, such attempts met with little success in the more democratically governed New York. The people involved with these enterprises did not agree on many important matters. While they had the power to influence decision making pertaining to cultural issues, they did not band together with any absolute consistency. Nor did they always win the changes they lobbied for.[28] Nevertheless, important new sculptural projects did come about as a result of their activities.

In New York, Karl Bitter and Frederick Ruckstull were among those who made notable efforts to advance the City Beautiful cause, and in particular the role of sculpture in creating a monumental urban environment. Both were active participants in municipal affairs at the turn of the century, and continually attempted to draw the subject of public sculpture to the attention of other reformers. As NSS secretary during its first five years, Ruckstull was a vocal spokesman and lobbyist for the society. His persistence often worked, most notably in 1899, when the city approved NSS proposals to construct a temporary triumphal arch to Admiral Dewey. Bitter, raised in a middle-class Viennese environment, in which both freestanding and architectural sculptures were a part of everyday experience, was committed to public sculpture that would promote civic values. Convinced that aesthetic and social harmony could be achieved only through comprehensive city planning, he became involved with groups like the Reform Club of New York (a part of a national organization founded in 1875 to promote "honest, efficient, and economical government") and the Municipal Art Society. He presented his vision of what civic sculpture could accomplish in several articles in *Municipal Affairs*, an important but short-lived journal published by the Reform Club and devoted to topics of urban beautification and public improvement.[29]

While Ruckstull's and Bitter's activities helped sculptors considerably, it was the emergence of the Municipal Art Society, and subsequently of the Fine Arts Federation and the New York City Art Commission, that ultimately made it possible for these men to do more than simply assert that public sculpture could inspire and edify. These groups permitted artists from different fields to combine

their strengths and coordinate their efforts to press for their beautification goals in the political arena.[30]

The Municipal Art Society was founded on 22 May 1893, eight days before the NSS, but independent of it. Seeking to perpetuate the artistic momentum gained from the enthusiastic response to the World's Fair, architect Richard Morris Hunt called upon a group of his friends and acquaintances to establish an organization to beautify New York City.[31] The MAS initially devoted itself to embellishing the city with beautiful statuary and ornaments—from monuments to such useful objects as lighting fixtures, fire alarms, and signs. At first MAS members hoped to donate one work of art per year to the city.[32] In 1894, for example, they arranged a competition for privately funded mural decorations for the Criminal Court building on Centre Street. Four years later they joined with ten other groups to commission Daniel Chester French and architect Bruce Price to design a memorial to Hunt, who had died in 1895; it was installed on the edge of Central Park at Fifth Avenue and 70th Street. The exedra-shaped structure, which evoked the memory of the formal park entrances that Hunt himself had proposed, but on a much reduced scale, was a fitting tribute to the first major American practitioner of urban beautification through artistic collaboration in the formal, Beaux-Arts manner.[33]

In 1898 the MAS incorporated itself, expanded its membership, and changed several of its policies.[34] Realizing that attempts to raise private subscriptions for monuments would probably not work over the long term, MAS officials decided instead to initiate competitions for special projects, and then try to get the city rather than private citizens to finance the work. In addition, the society decided to promote a comprehensive City Beautiful plan for New York. The commitment of such influential men as Congressman Olivier Belmont, Manhattan borough president Jacob A. Cantor, financiers Andrew Carnegie, Henry Marquand, and Jacob Schiff, and lawyer Robert de Forest provided important political support for the society's new activities. Their shrewdness in politicking helped the society during the year 1898–1899 to obtain $10,000 from the municipal government to oversee the decoration of the new assembly room ceiling in Manhattan's City Hall, a project from which city officials would obviously benefit.[35]

The MAS and NSS were only two of a number of New York City–based organizations interested in artistic improvements. The Architectural League of New York, the American Water Color Society, the National Society of Mural Painters, and others also hoped to bring about such changes. By 1895, the members of

these groups felt their efforts in this regard were somewhat duplicated and fragmented; they thus joined to establish the Fine Arts Federation, to "ensure united action by the art societies and to foster and protect the artistic interest of the community."[36]

The federation itself was an embodiment of the cultural unity that its constituents sought to attain through their work and wider reforms. It soon functioned as a semiofficial lobbying and consultant group on broad issues of municipal art policy that affected all societies in question. It became the mediator between member groups and city government. For instance, it tried to get artists included in the efforts to develop a city plan.

The FAF found a major challenge awaiting it. Its members hoped to dissuade the city from its practice of accepting donations of public statuary indiscriminately and then allowing them to be installed in the limited number of prime municipal locations. In the early 1890s, for example, Park Commissioner Paul Dana had turned down two separate proposals for statues of Christopher Columbus—one from a group of Italian-Americans, one from Spanish-Americans—for the entrance to Central Park at Fifth Avenue and 59th Street. The Italian-Americans were given another prominent spot at Eighth Avenue and 59th Street (Columbus Circle), and a committee of prominent New Yorkers (including Saint Gaudens, Hunt, and White) endorsed the statue by the Italian Gaetano Russo. Nevertheless, to many less professionally active artists it must have seemed that foreign sculptors were appropriating too many of Manhattan's important public spaces.[37] This issue took on particular urgency in 1895 because of German-American attempts to give the city a new public sculpture, the *Heine Memorial*, also called the *Lorelei Fountain*. The debates engendered by the *Heine Memorial* came to a head in the years immediately preceding the establishment of Greater New York in 1898. They helped lead to the formation of an official body to maintain high aesthetic standards, the city's Art Commission.[38] The case of the *Heine Memorial* highlights tensions among sculptors, politicians, and urban groups that surfaced in a struggle to determine the disposition of public monuments. More broadly at issue was cultural control in New York City. *Heine Memorial* thus merits detailed examination.

The *Heine Memorial* controversy began in Germany in the early 1890s. A group of Heinrich Heine admirers proposed to erect a monument to the poet in his birthplace, the city of Düsseldorf, but the city council turned them down. Heine's

satirical jibes at the Prussian upper classes, his criticism of the Hohenzollern dynasty, and, as a writer for the *New York Times* described it, "his unmerciful mockery and ridicule of 'Deutschthümierei'—that is to say, of mere stolid and grim and unprogressive Germanism" had made him persona non grata in official circles; that he had been a Francophile and a Jew only made matters worse. After municipal authorities in the city of Mainz also refused to allow a Heine memorial, German literati began to despair of being able to commemorate the poet in Germany. They were thus pleased when in 1893 a German-American group, members of the Arion Society, offered to have the memorial erected in New York City. The society contracted with Ernst Herter, a prominent Berlin sculptor, to create a magnificent fountain for 100,000 marks, and they called upon their fellow German-Americans to help pay for it.[39]

The Arion Society received a tremendous response. A Heine Memorial Association held a large fund-raising fair, and succeeded in collecting subscriptions from hundreds of German-Americans. A Heine memorial offered a significant opportunity for them both to express support for the liberal values that the poet represented, and to assert that Germans played an important part in New York. Among the largest donors were the prominent newspaper publishers Joseph Pulitzer and Ostwald Ottendorfer (of the *New York World* and the *New Yorker Staats-Zeitung*, respectively); piano manufacturer William Steinway; brewer George Ehret; and the banking firm of Kuhn, Loeb, and Company.[40] In the meantime, the Arion Society began arranging to offer the fountain to the city. At this point, the organization ran into trouble.

The Arion Society and the Heine Memorial Association planned to erect the fountain at 59th Street, preferably in the plaza at the southeastern entrance to Central Park. Before approaching the city, the group decided to get the approval of the NSS, on the assumption that its support would give the city additional incentive to approve the desired site. An official of the Heine Memorial Association brought photographs of Herter's sketch models to then–NSS secretary, Frederick Ruckstull, who relayed them to NSS members. The association was confident of gaining NSS enthusiasm for the project, but they were wrong.

The German-Americans' proposal was bound to be rejected. Many NSS artists had studied in France, and many were somewhat hostile toward Germans because of the ongoing political tensions between Germany and France. Quite apart from that, the Americans were, by reason of training, not especially fond of German sculptural techniques as typified in Herter's work (fig. 2.3). Compared to French

sculpture, German statuary often had less lustrous and lively (and thus flatter and more matte) surface textures; German figures looked rounder, squatter, and heavier. Moreover, late-nineteenth-century American sculptors tended to prefer more "classical" restraint in pose and overall design. Many of them would not have responded to the sense of active, spiraling movement created by Herter's figures and pedestal, as seen, for example, in the downward counterthrust of the Lorelei's right arm, left thigh, and right leg, and as carried through in the twisting action of the reclining figures below.

Even more important, the German-Americans had selected *the* choice site, and one that NSS members had been intending to develop themselves. Together with the Architectural League, the NSS was currently trying to arrange for the erection of a city-financed soldiers' and sailors' memorial designed by NSS members. Clearly the *Heine Memorial* idea did not sit well with NSS members, and they thus sat on the matter.

Hearing nothing, the Arion Society members went ahead with their plans and made their offer to Paul Dana, commissioner of parks, who had jurisdiction over the placement of statues in park areas.[41] The commissioner, well aware of the various plans for the plaza, asked the NSS for an expert opinion on the merits of the proposed *Heine Memorial*. Architect-critic Russell Sturgis, Fine Arts Federation president and an NSS member, immediately sent an angry letter to the *New York Times* criticizing the monument on aesthetic grounds, questioning its appropriateness, and informing the public of the art societies' plans. It was preposterous in his view that a monument to a German, and not an American, should be placed in one of the most central locations in the country's major city. Some months later, moreover, the *Times* reprinted an article from the German-American paper the *Staats-Zeitung* in which Sturgis reportedly said that the *Heine Memorial* and the other statues of German poets should be placed in Tompkins Square Park (in a predominantly German area on the lower East Side, between East 7th and 10th streets, Avenue A to Avenue B) where "their sauerkraut-eating countrymen lived."[42]

In November a special NSS committee (including Saint-Gaudens, Stanford White, and Sturgis) expressed the society's disapproval in a report to the park commissioner. "If the society has any censorship," their report stated, "this is an occasion to exercise it. . . . The committee do not signalize this monument more objectionable than many that now exist in prominent places in New York, but desire to emphasize disapproval of more monuments belonging in the class which this represents."[43] In other words, it was necessary to ensure that no other works like the *Heine Memorial* would even be given consideration for placement in important sites. Some form of ongoing, systematic, and expert supervision was necessary.

Needless to say, the Heine Memorial Association and its German-American supporters were indignant. They pointed out that even with the political opposition to the monument in Germany, no one had objected to it on aesthetic grounds. They cited the praise of several eminent German sculptors and critics as proof of the merits of Herter's design. A *New York Times* art critic responded with an ethnic attack. German art was "by no means outside the pale of criticism," he commented. With a few exceptions, "the men may generally be classed as florid, academic, and unsympathetic. They lack grace, beauty, the subtle and higher artistic qualities that are more frequent attributes of the Latin races." One only had to look at the photographs of the fountain submitted to the NSS to

recognize the "intelligence" of the society's action. The German-Americans responded in turn with charges that the NSS was nativist and anti-Semitic.[44] Ruckstull denied the accusations, pointing out that out over 15 percent of the sculptors in the NSS (seven out of forty-four) were German.[45]

Park Commissioner Dana was now in an extremely awkward position. Having asked the NSS for its opinion, he felt obliged to abide by it. Even so, Dana was technically supposed to make his decision independently. Faced with mounting pressure to do so from such prominent German-Americans as Carl Schurz, he agreed to obtain a second opinion. But it also appears that the commissioner agreed with the NSS. The organization whose opinion he solicited was the Fine Arts Federation, whose president, Sturgis, categorically refused to reconsider the merits of the statue. Sturgis indicated that it made no difference how many eminent European critics had endorsed the memorial. The judgments of the NSS and FAF members were "self-sufficient unto themselves."[46] Theirs were the unassailable standards against which all artistic work would be measured.

The Heine Memorial Association protested that neither the NSS or the FAF had ever really provided any detailed reasoning behind their objections to the work. The implication was that from the artists' point of view, they, as experts, did not need to defend their standards—the only ones—by providing specific reasons for their refusals.[47] Finally, in early 1896, Ruckstull, as NSS spokesman, did provide a few of his colleagues' objections. He cited a German architect who called Herter's fountain "but a pretty porcelain design in a rococo style." He continued, "the French say that rococo means bad taste in art and architecture, and the English define it as florid, grotesque, fantastic, decayed art. The fountain lacks dignity and majesty. It is a gingerbread affair." Moreover, claimed Ruckstull, the fountain had been designed for marble. "Our severe climate would crumble the marble in a very few years."[48]

Disgusted with the NSS and especially with Sturgis's intransigence, the Arion Society withdrew its offer to donate the fountain to the city, and claimed they would seek another site.[49] Despite their threat, however, the German-Americans really had no intention of giving the statue to another city, nor of backing down on an issue that had assumed such moral and political importance for them. This became evident when two wealthy members of the Arion, George Ehret and William Steinway, started to publicize new plans to erect the *Heine Memorial* at North Beach (in Astoria, Queens), on their own property.

Allowing the memorial to be erected on private grounds after it had been of-

fered to the city would have been too embarrassing for municipal officials. The last thing New York politicians and bureaucrats wanted was to lose the support of the large and politically powerful New York German community. Thus in early 1896 a subcommittee of the Board of Aldermen stepped in. They held a hearing about the possibility of locating the fountain somewhere else in Greater New York. It was proposed that the *Heine Memorial* be placed on a site at the intersection of 167th Street and a new grand concourse, in the new borough of the Bronx.[50] In 1900, City Council President Randolph Guggenheimer unveiled the *Heine Memorial* at 161st Street and Mott Avenue, at the entrance to Grand Concourse, in a neighborhood in which many middle-class German-Americans lived.[51]

Although many NSS members did not want the *Heine Memorial* placed on city property at all, even in the Bronx, the organization had for the most part succeeded in this battle. But its members were well aware that their tough stance had not helped their public reputation. From the very outset of this controversy, they recognized—as did the MAS, FAF, and the other groups that supported the NSS—that some official agency was necessary to prevent such open conflicts in the future.

Sculptors and Municipal Government

The 1896 legislation resulting in the establishment of Greater New York provided the opportunity to create such an agency. The bill, passed into state law in January 1898, consolidated Greater New York out of old New York City (Manhattan and what is now the Bronx), Brooklyn, Staten Island, and the areas that became the borough of Queens. This action, which vested political control of the city in a single centralized municipal government, had been supported by a variety of disparate interest groups who saw consolidation as the way to implement sweeping and beneficial socioeconomic changes (such as the creation of new tax and transportation systems and a broadened and uniformly well-serviced real estate market) and to check the power of fragmented political factions.[52]

The anticipated centralization of the city government in 1898 necessitated the drafting of a new charter for New York City. Artists' and architects' connections to the groups involved with framing the charter resulted in several major artistic and political gains. For sculptors, the most significant of the charter articles was the one conceived by architect John M. Carrère, which provided for the Art Com-

mission. The FAF, engaged in the debates over the *Heine Memorial*, was deeply interested in getting such a commission established.

Referring to the example of the art commissions formed in Boston in 1890 and in Baltimore in 1895, Carrère suggested to his FAF colleagues in 1896 that New York should have a similar body. As he told the federation, New York needed "broader and fuller" supervision not only of works of art, but of all those features, including buildings, that would affect the look of the city's avenues, parks, and squares. The city needed an art commission especially because "the number of statues was increasing annually and the artistic quality of the work was maintained at a very low standard."[53] Carrère's plan, presented to the federation's September 1896 meeting, was endorsed, and a committee (consisting of Carrère, Sturgis, painter Frederick Crowninshield, and architects Walter Cook and Henry Rutgers Marshall) proposed the idea to the Greater New York City Charter Commission, then in the midst of the drafting process.

Carrère's group encountered some initial resistance, but it had the support of several prominent men, including Seth Low and Elihu Root. An MAS member, Low was a political liberal and a strong supporter of urban reform and city beautification. He would run unsuccessfully for mayor in 1897 on the ticket of the Citizens' Union (a third party devoted primarily to reform in municipal affairs), and win the mayoral election in 1901 on the Republican ticket.[54] Root was a lawyer and legal advisor both to Mayor Low and to Police Commissioner Theodore Roosevelt (in 1905 he would become Roosevelt's Secretary of State). The two men used their considerable political clout to get the designation of an art commission included in the new city charter. Architects and artists initiated the Art Commission; but the backing of these wealthy (mostly Republican) lawyers and businessmen like Low and Root was necessary to bring such a commission into being. These temporary alliances among a variety of different political and professional groups continued to be necessary conditions for the success of municipal art projects.[55]

The New York Art Commission's purposes were protective. Initially it was charged with passing judgment on any works of art to be located on city property, but in 1901 its authority was extended to include jurisdiction over public buildings costing over $1 million and later, all public buildings.[56] The commission did not have to provide any reasons for turning down a particular submission. Such a policy was grounded upon assumptions similar to those expressed earlier by Sturgis—that expert aesthetic opinion sufficed and did not have to be justified or

compromised through explanation. It also precluded any discussion of possible political bias, and thus implied commission members were not susceptible to such prejudices.

The charter stipulated that the Art Commission be composed of ten members altogether (six appointed members and four ex officio). The mayor, the president of the Metropolitan Museum of Art, the president of the Brooklyn Institute of Arts and Sciences, and the president of the New York Public Library served as ex officio members. A painter, a sculptor, an architect, and three laymen were also always included. The mayor would choose the latter members from a list (with three names for each vacancy) provided by the FAF. The charter thus designated the Fine Arts Federation as an official artists' organization—an important coup for this group. Moreover, it gave sculptors and their affiliated groups the chance to be part of municipal government.

The charter also stated that when a structure came under the jurisdiction of a particular city department, its head would become an Art Commission member during consideration of the proposed designs. This stipulation promoted "cordial relations" between the commission and municipal departments, flattering bureaucrats who ordinarily might have little interest in art matters and who might otherwise be obstructionists. The commission found such alliances extremely useful as it embarked on its task of assuring that only the best works of art—those displaying appropriate themes and technical virtuosity—would adorn municipal property. Over the next several decades, the Art Commission exercised considerable power in ensuring that New York City's art and environment stayed in keeping with the high and conservative standards of its artist members. An 1895 article in the *New York Times* indicated that many statues and monuments were being planned immediately before the formation of the Art Commission. Only a portion of them were ever actually erected on city property. Other circumstances intervened as well, but the commission also had a significant say in the outcome.[57]

The permanent inclusion of a sculptor on the Art Commission was particularly significant for the NSS, considering their relations to the other professional art groups in New York City's art institutions at this time. Sculptors held lower social and economic positions than the businessmen and lawyers—and even the architects—with whom they associated. Few sculptors had a liberal education, in contrast to architects, lawyers, and many businessmen. The same was true of many painters, but they did not have to depend nearly so much upon official collaboration with elite groups to attain their primary professional goals. Only

the most eminent sculptors (for example, Saint-Gaudens, French, Bitter, and Paul Wayland Bartlett [1865–1925]) belonged to prestigious social or literary clubs, like the Century Association, which brought artists and patrons together and were considered "the passport to high social circles."[58]

Under these circumstances, it is important that sculptors succeeded in organizing and in working with these other groups to the extent that they did. The presence of talented and cultivated artists like French proved crucial; through them the sculptors gained respectability and acceptance among other powerful New Yorkers.

French's involvement with the New York City Public Improvement Commission is a good indicator of the stature that sculptors' City Beautiful ideals had attained in the eyes of other New York groups by the first decade of the century. With the election of reform candidate Seth Low as mayor in 1901, supporters of civic improvements felt that New York's City Beautiful movement's time had come. Both Low and Manhattan borough president Jacob Cantor were MAS members and predisposed toward the City Beautiful concept. But it was only at the very end of Low's term, after artists' and citizens' groups lobbied in force, that the primarily Democratic Board of Aldermen finally passed a bill establishing a New York City Public Improvement Commission. Appointment of the new commission was thus left to the new Democratic mayor, George B. McClellan, who selected members in March 1904.[59]

Although personally a supporter of the City Beautiful movement, McClellan appointed personal friends and prominent citizens rather than strong City Beautiful advocates.[60] Significantly, in seeking a representative of the movement, he chose a sculptor, French. French was the sole appointee who had actively supported the legislation establishing the commission in the first place. He was also one of only two artists on the committee. Few other sculptors would have a comparable degree of involvement in the politics and planning of New York. However, French's appointment to this official commission gave sculptors crucial access to inside matters of planning and served to publicize their interests for the next several years.

The Improvement Commission developed two reports. The second, comprehensive report, which attempted to situate New York squarely in the heart of the City Beautiful movement, was presented to Mayor McClellan in January 1907. The plan (figs. 2.1, 2.2) proposed such surface improvements as the creation of a network of wide, radiating avenues that would integrate all the boroughs. In ad-

dition, one of the recommendations was to have more centrally located public monuments. French clearly played a important role in impressing upon his colleagues the idea that sculpture should be an important priority.[61]

If implemented, this report would have been an incredible boon for New York sculptors. As it turned out, little came of the commission's proposals. McClellan merely asked the Board of Estimate to file the report for municipal bureaucrats' future reference. The commission's recommendations remained plans on paper, but its proposals indicated nonetheless that sculpture was broadly considered a valuable (and economically viable) part of the built environment.[62]

Although the NSS, the MAS, the FAF, and the Art Commission never succeeded in getting New York to adopt a City Beautiful plan, the impact of these groups was still considerable. By 1900 these bodies constituted an organizational structure within which sculptors could work to advance their profession and to control the development of public sculpture in New York. Sculptors now had ties with other civic groups and with individuals representing a range of powerful elite social and professional interests. These connections proved sufficiently strong to assure a sculptor a place on the short-lived, but nonetheless prestigious, Improvement Commission.

All of these networks provided sculptors with a greater degree of political power and hence with greater artistic possibilities than if they had worked alone or as a single artists' group. Despite the tensions that came from their own internal divisions and from their dependence on outside support, the sculptors generally found themselves in a more advantageous position socially and professionally. The organizational stage was set. Over the next twenty years the combined efforts of the sculptors and their allies would result in the creation of numerous civic monuments and works of architectural sculpture in New York. These art forms were important contributions to the city's heritage. But more was at stake for sculptors; certain projects were more crucial than others in advancing their interests. It was not enough just to have more sculpture. The artists had to have some control over the production of sculptural work. Over the long term, satisfaction and success depended upon recognition and acceptance of this fact by architects, government officials, and other patrons. To understand why, it is necessary to examine some of the general procedural issues and practices with which sculptors contended.

II New York Civic Sculpture in Context

3 The Public Sculpture Process

The creation of the National Sculpture Society was an expression of sculptors' desires to achieve greater strength through cooperation and thus to foster the right kinds of work. They hoped to determine the aesthetic standards and practical procedures by which artists were selected, projects were carried out, and sites for art works were chosen. Since their efforts were often challenged, they repeatedly became enmeshed in governmental and professional politics.

Among the first difficulties were those that arose in the attempts to determine procedures for the creation of sculptural programs for New York's federal, state, and municipal buildings, and for statues and monuments. From the artist's standpoint, clear administrative procedures were not only crucial means for ensuring works of art of the highest quality; they were a measure of the artists' professional stature and influence. Procedures were both a means of artistic control and an expression of it. To achieve their ends, it became essential for the sculptors to convince laymen of the priority of their aesthetic standards over other, political, considerations. They achieved their goals often, yet with varying degrees of success.

Sculptors encountered different procedural problems with architectural sculpture than they did with commissions for statues. In architectural sculpture, sculptors faced a dilemma. Publicly funded architectural sculpture programs were commissioned as parts of the new kinds of municipal government that many sculptors supported. However, the artists' attempts to obtain and execute projects as they wished often forced them to circumvent the bureaucratic rules and practices that were significant features of reform government. Sculptors confronted fewer constraints when it came to the production of statues and monuments, though they often became embroiled in controversy when it came to selecting artists and sites.

Architectural Sculpture for Public Buildings

The increase in large architectural sculpture programs of the late nineteenth century was in many ways a consequence of the good-government movement. Buildings with architectural sculpture were constructed because of the expansion, centralization, and specialization of government. The Pendleton Act of 1883 extended federal activities by establishing new departments and by initiating the development of a professional bureaucracy. This expansion produced a need for new office buildings. In New York, the United States Customs House (fig. 6.4) was one of the most important of the structures built as a consequence of this growth.

Comparable developments occurred at the state and local levels. The end of the century witnessed an unprecedented boom in the construction of new state capitols and courthouses. Consolidation of Greater New York spurred construction of several city office buildings, including the new Hall of Records and the Municipal Building (figs. 7.1, 10.1). In turn, the Greater New York charter provided directly for the construction of new structures for several important private cultural institutions to be built on city property under municipal auspices: these major public edifices included the New York Public Library and the Brooklyn Institute of Arts and Sciences, as well as large new wings for the Metropolitan Museum of Art (figs. 8.1, 8.4, 8.8).

We saw in Chapter 1 that both architects and sculptors considered architectural sculpture an integral part of public buildings. Sculptural adornment could help to make the architecture an expression of the consolidating tendencies in political and cultural spheres. Through its didactic content and formal components, architectural sculpture would reinforce the ideas of unity, authority, and progress that were also embodied in government. In this sense, sculptural programs for public buildings were conceived as expressions of the spirit of political reform. But another such expression was the movement to establish stringent supervision over such areas as public construction projects, particularly in the light of such flagrant exhibitions of corruption as the old New York County Courthouse, otherwise known as the Tweed Courthouse (Chambers Street between Broadway and Centre Street), a building with a $12 million price tag in 1878.[1] While sculptors understood the purpose of the controls imposed upon general contractors and the need for strict rules about schedules and competitive bidding, they believed that the exceptional nature of their work should exempt

them from many of these procedures, and on several occasions they attempted to circumvent them. The sculptors' conceptions of artistic quality and their efforts to determine aesthetic standards and procedures came into conflict with the ideals of good government.

By the turn of the century, the selection of architects for federal buildings proceeded according to relatively straightforward rules. In 1893, Congress implemented the Tarnsey Act to improve the quality of federal buildings. Whereas previously the supervising architect of the Treasury had been responsible for all federal building design, he was now allowed to hire architects from outside firms on a competitive basis. The Treasury architect oversaw an entire operation, while the architectural firm would take charge of the details of design and construction. The process involved complex negotiations with the supervising government agency, a general contractor, and numerous subcontractors, who included artists and craftsmen members of the trade unions.[2]

After soliciting bids for construction, the architect selected a general contractor, usually the firm that bid lowest, or that seemed most likely to get the job done for the least cost. The general contractor answered to the architect. Underneath him, foremen supervised the work done in the various construction departments—steel work, masonry, concrete, and carpentry. Each department had to keep to a strict schedule. As projects became larger, general contractors began to subcontract work to specialized individuals or firms. All of these—including the commercial modelers who created the conventionalized ornament such as capitals and keystone heads—generally had to bid for their contracts. An inspection department checked the progress of all work. In addition, federal laws required that an outside inspector ensure that all work meet strict government specifications.[3]

Thanks to the Tarnsey Act, and to the close ties between major architects and leading Republican officials, architects of federal buildings were allowed certain freedoms that worked in sculptors' favor. For example, in contrast to the situation with commercial modelers and other craftsmen, the architects were usually permitted to choose directly the sculptors whom they wished to design large-scale figures or programs for their buildings. Architects like Cass Gilbert insisted upon including this provision in the building specifications, arguing that the quality of the architectural sculpture was crucial to the aesthetic merit of his design. Sculptors, except for the most eminent, would often write deferential letters to the architect to propose themselves for the job when they heard through the grapevine about the possibility of an architectural project.

Although sculptors were selected by the architect, they were still subject to certain federal rules that sometimes created obstacles for them. For one thing, despite often strenuous objections, they were required to put up large bonds to ensure completion of their work. They also had to contend with the company hired to cut stone and carve it. The selection of such a firm was generally based on the lowest contract bid. Thus there was no absolute certainty that the company selected would have in its employ the skilled experts in sculptural modeling and carving whom the sculptors needed to execute their work and on whom they tried to insist. As we shall see in the case of the United States Customs House, however, sculptors had two points in their favor. Gilbert himself demanded the highest-quality work and knew who the best firms were; also the supervising architect of the Treasury, who had the final authority, was Gilbert's former partner. The relatively good treatment of sculptors on federal projects like the Customs House reflected their good standing both among influential architects and the Progressive politicians and bureaucrats in power in Washington in the early years of the century.[4]

New York State also followed strict procedures, but they were somewhat more variable because of the peculiar relationship of the state to the City of New York. During the last third of the nineteenth century the state legislature controlled policy both for the city and the region. It was state law, passed prior to the consolidation of Greater New York, that authorized the buildings for the State Supreme Court, First Appellate Division (fig. 4.1)—the major state building erected in New York City during these years—and for the Hall of Records (fig. 7.1), a municipal building. In the case of the Appellate Courthouse, which was built on New York City property, the legislature divided responsibility and authority between state officials (the justices of the state supreme court) and a municipal body, the commissioners of the Sinking Fund, whose activities will be discussed later. Indicative of their stature within state government, the justices were given authority to select an architect without his having to compete—a privilege not usually extended to officials of lesser state agencies. Similarly, the architect was permitted to select sculptors directly, and artists attempted to convince him of their unique talents for the job. As with federal projects, the architect offered sculptors the opportunity to contract for specified groups or statues at a set cost and within a given amount of time. Construction companies, however, were selected on the basis of bids, just as they were for federal contracts.

Turn-of-the-century planning, construction, and contract procedures were not

nearly so clear-cut in Greater New York. Although some projects were carried out in the same way as those done for federal and state government, others were complicated by New York City politics and by differences of opinion about supervisory hierarchies and contract arrangements.

On the one hand, Democratic politicians loyal to Tammany Hall posed challenges that often affected the sculptors.[5] Tammany Democrats courted lower-middle-class and working-class ethnic constituencies and strongly resisted the moves to concentrate power in the hands of upper-crust professionals, their political opponents. They tended to oppose the lavishly decorated municipal projects as wastes of money, as symbols of the triumph and authority of Republican government, and as an ineffective way of distributing patronage. While Tammany politicians could do little to stop such buildings once they were underway, they did create problems for sculptors and architects, as will become apparent in such examples as the Hall of Records, the New York Public Library, and the temporary *Purity*.

On the other hand, a factor in making city sculpture projects complex was that sculptors' artistic preferences were often at odds with the standardized procedures that had been established to ensure propriety and professionalism in the arena of municipal construction. As with federal and state contracts, candidates for postconsolidation municipal commissions were required to submit bids. City officials often attempted to apply this rule to the selection of sculptors, a practice the artists opposed.

Sculptors sought to convince all the parties involved in municipal projects to abide by the standards established by professional artists, who, they contended, had special concerns. They hoped to achieve consistent procedures for government-funded commissions, but without having to bid like other subcontractors. In addition, many sculptors strongly objected to putting a general contractor directly in charge either of selecting sculptors or of supervising execution of their work. This practice was likely to occur when sculpture was included as part of the general contract for stone or stonecarving, a provision sometimes found in contracts for municipal buildings. For most artists, the ideal situation was one where an architect was given a separate lump sum contract for sculptural adornments, and could chose several sculptors directly.[6] Sculptors and their supporters believed that this process would allow individual artists to spend more time on a single work of art than could a modeler or carver hired to execute a number of such works en masse. Such an arrangement would also give more work

(and profits) to more sculptors, give them more autonomy, and strengthen the relationship between artist and architect.

From the sculptors' perspective, there were several major drawbacks to having the general contractor responsible for selection and execution of architectural sculpture. They felt that contractors were generally insensitive to their artistic goals and practices. Since contractors were ultimately responsible for all aspects of a building's construction, they were usually under tremendous financial pressure. They were anxious to get the most work done for the least cost, and thus were not necessarily discriminating about the quality of the work. Some general contractors subcontracted decorative sculptural work to journeyman stonecarvers associated with the company already hired to do the exterior stonework. In the eyes of professional sculptors, the results were all too often disastrous.

The situation was problematic for sculptors partly because of the range of specialization and skills of the modelers, stonecutters, and carvers, and partly because of the labor practices of the firms for whom they worked. The term "modeler" was used rather broadly to describe the men who worked in either unionized or nonunionized ornamental modeling shops. Such shops were equipped to execute everything from scale models of buildings to clay and plaster models of capitals, lintels, keystones, cartouches, faces, grotesques, and other standard architectural features. Within a shop those who fashioned heads and other complicated sculptural decorations often represented a specialized subgroup; in the largest firms, the work of preparing full-scale plaster models of architectural ornaments (either from sculptors' models or from drawings) was divided among three different groups of specialized artisans. Similarly, the men who carved sculptural ornament were a subgroup in the stonecarvers' and stonecutters' shops. Stonecutters "rough pointed" the large stone blocks out of which a work of architectural sculpture was to be carved. Their job, learned through apprenticeship, was to remove enough material to provide the general shape of the object. Stonecarvers roughed out the sculptural forms even further, at which point the most highly skilled carvers took over, completing the intricate details.[7]

In the sculptors' view, however, the work of the modelers and carvers hired by the contractors was extremely uneven; the output of some of the stonecarvers and stonecutters was sometimes sadly indistinguishable.[8] Furthermore, sometimes these modelers and carvers received the very jobs sculptors thought *they* should have.

The craftsmen who worked on these projects generally belonged to building

trade unions such as the Operative Plasterers' International Association of the United States and Canada and the Journeymen Stone Cutters' Association of America, both of which were affiliated with the American Federation of Labor. Unfortunately, few records survive from the turn-of-the-century period to document the interactions between sculptors and these other groups.[9] However, it is clear that from the 1890s onward there existed a certain amount of tension between sculptors and unionized craftsmen. First, there were the differences over contracting procedures. The sculptors wanted to be able to hire their own qualified carvers—to control both the designs and the execution and public expression of their artistic conception. However, the unions as well as the government contracts demanded competitive bidding. Thus sculptors often ended up working with firms whose output they considered mediocre but who bid the lowest price. Moreover, the sculptors themselves were trying to resist ongoing pressures to join the unions. And periodically they ran into jurisdictional disputes (quite common in the building trades) with the plasterers' and stonecarvers' unions.[10]

The sculptors, who tended to opt for discretion on these matters, rarely expressed explicit opinions on such politically sensitive subjects as labor. In his book *American Masters of Sculpture*, however, critic Charles Caffin conveyed the sculptors' attitudes, if obliquely. He expressed disappointment with architects who, instead of hiring real sculptors whose work would have "personal, vital significance," opted for the simplest and cheapest way out: simply to copy designs from pattern books; to give these images to draftsmen to make working drawings to be given to a contractor, who then would just dole them out to "journeymen modellers." The result would be dry and conventional "inert" copies in which "any individuality of feeling" is "suppressed," and "the divorce between design and craftsmanship is perpetuated."[11] Caffin thus linked the products of unionized contract labor to dull, unimaginative work, diametrically opposed to that of a serious artist, free to express himself.

Sculptors were reconciled to the presence of union labor and readily admitted their dependence upon and respect for the skills of commercial modelers, plaster casters, enlargers, and stonecarvers; rarely did they openly compete or conflict with members of the plasterers' and stonecarvers' unions. Still, the stated aims, procedures, and other general statements of NSS sculptors indicate clearly that they considered the notions of professionalism, talent, and freedom of expression to be at odds with the ideals and practices of the average carvers' or modelers' shop.

Underlying the sculptors' views on craftsmen and contractual arrangements was their presumption that a relatively small group of elite professionals had superior know-how. This is what rationalized their attempts to remove sculpture commissions from the strictly economic considerations implied by commercial bidding. They were at an advantage so long as they could justify their work in terms of aesthetics and evade the subject of their own self-interest.

Artists' procedures, when actually applied in the construction process, inevitably made it more complicated and expensive. Architects—the most respected of whom tended to share the sculptors' views on the matter of contracts—sometimes had to convince city officials to make certain exceptions to the rules. The award of a municipal contract to a sculptor could entail surreptitious negotiations among artists, the architect, the general contractor, and city officials—the Board of Aldermen, the mayor, and the head of the municipal department under whose jurisdiction the building in question was being carried out. The "Swallowtails" (wealthy merchants and lawyers who wore frock coats) who served as trustees of cultural institutions also became involved in the decision-making processes surrounding the sculptural decoration of their new buildings.[12]

In specific cases, the outcome of procedural and contractual negotiations usually depended on whether municipal politicians stood hard and fast to the rules of the new city charter, whose limits had not yet been tested, or whether they were receptive to the pressures and special pleading of the cultural interest groups who argued that artistic work was exceptional. When, for example, the Brooklyn park commissioner agreed to argue on behalf of architects McKim, Mead, and White that a contract for the Brooklyn Institute sculpture should be let to sculptor Daniel Chester French without bidding, for aesthetic reasons, the sculptors had won at least a temporary victory. With the help of the Brooklyn Institute's trustees and architects, sculptors now saw their work accepted on the terms for which they had been arguing. Aesthetic and economic discourse were inextricably bound together when it came to public work; but the fact that public officials would allow an aesthetic argument to supercede the various ideological and political aspects of the debate was an important signal to sculptors that they did have some influence.

In the sculptors' view, success occurred when all the various groups could agree to cooperate with one another in such a manner that the artists got their way. The following chapters describe the extent to which this happened in the construction and sculptural decoration of New York's most important publicly

funded buildings. Not only were the buildings themselves of architectural and cultural significance: the arrangements for their construction were the most varied and complex. Political machinations and labor problems sometimes made it difficult for sculptors to operate as easily as they would have liked. Still, for at least three decades they managed to achieve their goals, albeit not without tension. In retrospect, what seems significant is that the sculptors' group actually had the opportunity to be involved in these sorts of major projects; and that most prominent architects, city planners, and intellectuals were in agreement that they should be. Problems arose again when influential New York architects no longer saw the need for sculptural work to be designed and executed by professionals and when their own relationship with sculptors no longer seemed important.

Statues and Monuments

Commissions for statues and monuments presented sculptors with a different situation than did architectural sculpture. Such works were broadly considered to be individual and self-sufficient forms of artistic expression. Creation of statues and monuments gave the creators opportunities to extend their artistic reputations and to perform a valuable civic service. And commissions for freestanding works offered sculptors additional professional independence and artistic control. Although he would usually still work with an architect on designing the pedestal, the sculptor of monuments was in a less subordinate position than in adorning a building.

Public sculptures stood in the public domain and often on municipal property, but the works themselves were usually initiated and funded by private groups, and thus less subject to government rules with regard to contracts and execution. As we shall see, this allowed for a variety of ways of handling the selection, treatment, and demands of the artists. It also meant that NSS sculptors had greater potential control over artistic procedures. The looser arrangements controlling statues and monuments—the relative absence of set procedures—periodically produced internal conflicts. Some sculptors, for example, insisted upon establishing uniform procedures that would work in their favor; others did not wish to conform to preordained rules. At the point at which a work was installed on a municipal site, the process could become a broader political issue, and sculptors then had to contend with a panoply of interest groups within and outside municipal government.

Like architectural sculpture, freestanding monuments and statues were intended to express "shared" values and ideals. In addition, sculptural groups often served a commemorative and didactic purpose. "It is self-evident that our public monuments should give some adequate idea of history, both local and national," wrote sculptor Henry Kirke Bush-Brown in 1899. "Their reason for being is to inspire the beholder with high ideals and to emulation of deeds of self-sacrifice, valor, or patriotism." Great events "made definite and permanent in the mind" by an enduring "living picture" would "supplement the study of books in our schools and form a part of our educational methods."[13] Sculpture, in other words, could perform a valuable public function by visually teaching history to Americans (or new immigrants who might not have mastered English).

In the eyes of sculptors and City Beautiful advocates, statues and monuments also functioned aesthetically when installed in harmonious relation to their surroundings.[14] Those who felt sculpture should play a greater role in beautifying New York were heartened by attempts to include statuary as part of the proposals for city improvement. Comprehensive plans had not yet been adopted; while the federal, state, and local governments were the primary patrons of architectural sculpture, the creation of statues and monuments had to depend upon isolated private initiatives for the time being.[15]

The creation of New York's statues and monuments usually involved several stages: the establishment of a fund-raising and supervisory committee, the fund-raising itself, selection of an artist, creation of the work, approval of the work and site, and installation. Volunteers or appointees from specific groups or organizations (which in New York included the Arion Society, Sons of the American Revolution, and the Chamber of Commerce, among many others) would form a monument committee (such as the Heine Memorial Committee). This body would solicit donations from the rest of the organization's members, or even initiate a city- or nationwide subscription campaign. Compared with government architectural sculpture projects, the production of individual statues or monuments involved fewer participants and stages; but the organization of these commissions as a whole involved a broader range of social and professional groups.

Once the necessary amount of money was available, a sculptor could be chosen, in one of several ways. Sometimes, particularly in New York City, a committee or a panel of experts would select a sculptor directly. Sometimes a group or an individual would give a bequest to the city and ask municipal officials to make the selection. At other times a committee held a limited competition, inviting sev-

eral modestly compensated sculptors to submit sketches. Another option—roundly discouraged by the National Sculpture Society—was an open competition.

This issue was a particularly sore point for sculptors, and produced considerable tension and rivalry among NSS members. Most open competitions were held for commissions for statues or monuments, but periodically a private corporation like the American Surety Company held a similar contest for architectural decoration for its headquarters (in the latter case, the job was won by the Scottish-born architectural sculptor John Massey Rhind). Often, a group with little knowledge of sculpture or of sculptors' concerns would initiate an open competition to give themselves the broadest possible range of selection and to obtain the best design. Anyone could enter, but contestants usually received no compensation for submissions. The patrons usually had only limited funds; moreover, from their point of view, open competitions were presumably the most democratic means of selection because they gave each individual sculptor the honor and opportunity to express his own unique interpretation of the subject.

No standardized code of competition procedures existed prior to the 1890s. Some competitions were anonymous and some were not. Some called for sculptors to submit small (for example, one-half inch to the foot) sketch models; others required substantially finished figures. Moreover, no set procedures existed for jury selection, a factor that NSS sculptors found especially irksome. They felt that juries often consisted solely of laymen who "knew what they liked" but who did not know enough about sculptors' design practices to judge the merits of a small-sized sketch as a monument. According to the sculptors, moreover, in certain cases the competition jury already had someone in mind from the beginning. And some jurists were artists who had biases and who could recognize a given sculptor's sketch method. Although the sculptors were generally not supposed to incorporate any distinctive signs or identifying marks, there were always artists who cheated, either unbeknownst to the jury or through collusion between artist and jury.[16]

The NSS members resented this situation. The society argued that while young sculptors might find open competitions advantageous because juries ostensibly judged their work on the same basis as that of better-known artists, the actual practices were exploitative and debilitating. Whatever the procedures followed, competitions always cost the artist a great deal of time and expense to enter, a plight made worse by the fact that the average artist had little chance of actually winning.

The society believed one of its major priorities should be to oversee and consult on competitions. But even this was not sufficient. Members saw it as their task to formulate appropriate procedures that would assure that professionals had a significant role in determining what works were selected. In 1898 they drew up a code that called for competition programs that would have definite statements of cost, fixed procedures for assuring anonymity, prior notification as to exactly who would serve on the jury, and a promise to include "experts" on any such panel. In addition the code demanded uniform requirements for whatever drawings, models, or proposals were asked for, as well as a fixed time and place for their delivery. Finally, the NSS code requested that the nature and the amount of the award be specified clearly from the outset.[17]

In establishing this code and in expecting its members to abide by it, the NSS sought not only to protect them, but to extend the limits of its own authority. The society did receive requests to suggest proper competition rules, and its members were asked to serve as advisors and jurists. Moreover, in New York City NSS members often had connections with individuals belonging to the groups (such as the Players' Club) that were planning open or limited competitions for statues (such as that of actor Edwin Booth in Gramercy Park). The NSS's presence on the scene gave its members an opportunity to exert pressure on New York patrons in a way that could not be done elsewhere. NSS officials expressed the opinion that their efforts helped considerably to improve sculptors' working conditions. Nevertheless, rule infractions and fixed contests continued to occur, and the society's attempts to regulate the process met with only partial success.[18]

The situation was complicated by the fact that powerful artists like Saint-Gaudens and French could control their own affairs by refusing to enter competitions, arguing that they were generally unfair and time-consuming and that they lowered standards of integrity and excellence. Moreover, by not participating, they hoped to give younger artists a chance. These reasons were no doubt sincere, but they had the additional effect of confirming, even strengthening, these sculptors' own power and of weakening professional solidarity. The excellence of their oeuvre put them above having to get involved in such matters. If a monument committee truly wanted excellence or art by a name, it would have to request the honor directly from the artist himself. Moreover, although French and Saint-Gaudens themselves did not participate in competitions, their protégés did; and while neither ever intervened surreptitiously, they did wield influence by dropping subtle hints that clearly helped their former assistants.[19] Some sculptors seem to

have accepted this old-boy network as common practice, undoubtedly hoping that someday they too might benefit from a French's kind words. A few others, like Fernando Miranda and Gutzon Borglum, periodically protested.[20] For many sculptors, however, competitions still remained a necessary means of trying to get commissions.

Once a sculptor actually was chosen, he would sign a contract either with the particular group or (in cases where bequests had been donated to the city) with the head of the municipal department under whose jurisdiction the sculpture was to be placed (usually the Department of Parks). The sculptor worked up a set of designs, clay and plaster sketches, and small-scale models (as with architectural sculpture, usually one-quarter and one-half size; figs. 8.5, 8.6, 9.5).[21] These then had to be approved by the monument committee before the sculptor's enlargers and his studio assistants made them full scale, and before they were cast into bronze at a foundry or carved into stone by specialized carvers. If the work was planned for city property, the models also had to be approved (before 1898) by the park commissioner, and (after 1898) by the Art Commission of the City of New York and by the specified municipal department official.[22] At the end of the nineteenth century, this process of approval went beyond mere acceptance of the work on the basis of its aesthetic merits (also the basis of much contention). The various participants also had to agree about the matter of the site.

The selection of a municipally owned site, the point at which the city consistently became involved, often engendered as much—if not more—heated controversy as style, subject matter, or iconography alone, especially with larger monuments like the *Heine Memorial*. As Daniel Chester French commented in 1914, "The important thing is, not to find a site for a statue but to find a statue for a site."[23] Insofar as the new Art Commission could disapprove designs that its members felt would have a bad effect on a given location, its domain included not only the works themselves but also the immediate surroundings. The commission stood close guard over the city's choicest areas, but in some cases the park commissioner had his own ideas about the appropriate place for a work that the professional societies and Art Commission had already approved; sometimes other groups involved had differing opinions.

In the case of the statue of William Tecumseh Sherman (fig. 9.2), for example, Augustus Saint-Gaudens and Charles McKim initially hoped to place the equestrian monument in Riverside Drive, in front of Grant's Tomb. When the Grant family refused to allow their memorial to be upstaged, the sculptor and architect

selected a new site at the south end of the Central Park Mall. The park's current landscape architect Samuel Parsons vetoed this plan, objecting that the statue would destroy the views that radiated from this point. He proposed an alternative site at 59th Street and Fifth Avenue. In spite of Saint-Gaudens's and White's lack of enthusiasm, the Art Commission and Mayor Low's park commissioner, William R. Wilcox, accepted this location. After long delays, the statue was unveiled on 30 May 1903.[24] Dissension had also erupted over the placement of Attilio Piccirilli's and H. Van Buren Magonigle's *Firemen's Memorial* (fig. 3.1), dedicated to firemen who had died in the line of duty. The Art Commission approved the designs for the memorial and its proposed site at Union Square North in December 1909, but the project was put off for several months when a new commissioner of parks took over. He preferred to use this area for open-air meetings for "overwrought agitators." Moreover, the fire chief liked neither the Union Square site nor the memorial's design, preferring a site either at 58th Street and Fifth Avenue or on Riverside Drive. These differences annoyed the memorial committee (which included such eminent financiers as Isidore Straus and Cornelius Bliss), but they ultimately went along and proposed several new locations to the Art Commission. In June 1910, it was agreed to place the memorial at Riverside Drive and 100th Street, where it stands today.[25]

Thus placing control in elite and professional hands did not mean consensus. Not surprisingly, the aesthetic standards of the artists, the immediate pragmatic interests of politicians, and the emotional concerns of the groups commissioning the sculptures periodically continued to clash. Far from being matters of purely artistic concern, the production and placement of monuments sometimes became occasions for battles in which broader social and political issues were fought out.

In its earliest years the NSS was relatively successful in ensuring that only the kind of works of which they approved, executed according to the kinds of procedures of which they approved, were placed on municipal property. The society's influence was a function of its good standing within certain powerful cultural and political circles in New York. Sculptors had to work actively to reach that position; as we shall see, they had to struggle to maintain it. Over the years, the process of doing so produced some underlying hostility because some artists achieved greater power than others. While tensions remained beneath the surface for a number of years, by the time of World War I the conflicts could no longer be contained.

In the late 1890s, however, the need to acquire and maintain influence seemed

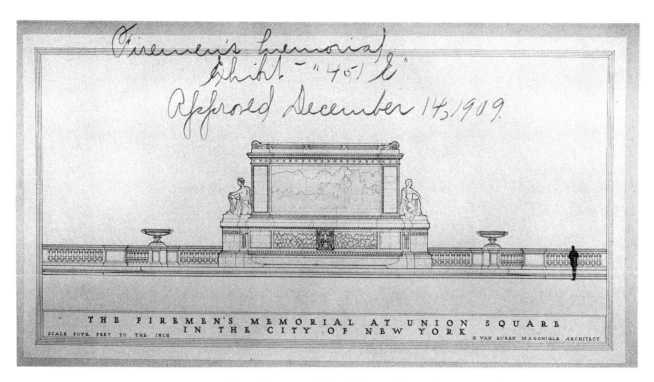

THE FIREMEN'S MEMORIAL AT UNION SQUARE
IN THE CITY OF NEW YORK

SCALE FOUR FEET TO THE INCH H VAN BUREN MAGONIGLE ARCHITECT

3.1
H. Van Buren Magonigle, drawing for *Firemen's Memorial*, proposed site at 100th Street and Riverside Drive, 1909. (From the Collection of the Art Commission of the City of New York, Exhibition file 451-H.)

a positive, surmountable challenge for sculptors. Major new public buildings were being planned, and sculptors saw to it that they were involved with those projects. During the next decade the NSS would contribute successfully to the artistic expression of a civic ideal in New York. The most significant of these public and semiprivate achievements and the contexts of their production must now be considered in more detail.

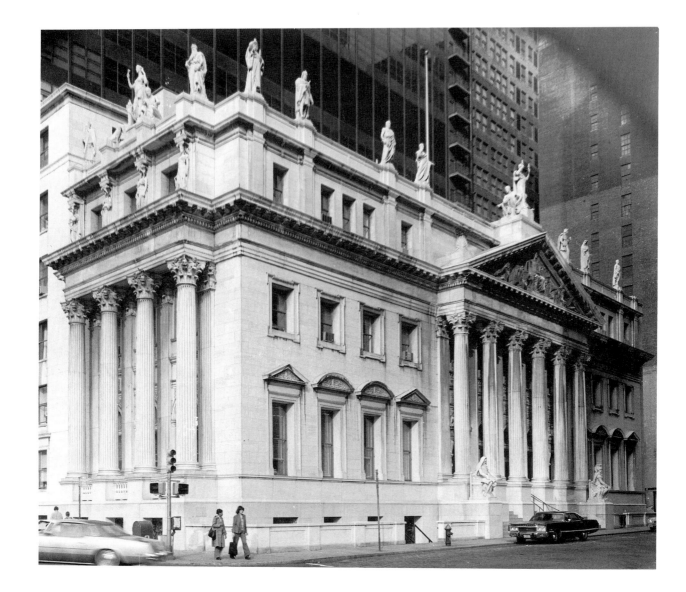

4

A Quick Start: The Appellate Courthouse

4.1
James Brown Lord, the New York
State Supreme Court, First Appel-
late Division, 1896–1900. (Photo,
Joseph C. Farber.)

4.1
James Brown Lord, the New York
State Supreme Court, First Appel-
late Division, 1896–1900. (Photo,
Joseph C. Farber.)

Madison Avenue side: Thomas
Shields Clarke, *The Seasons*; Karl
Bitter's three-figure group *Peace*,
top center, represents the conditions
and ramifications—both material
and spiritual—of peace. The ten
attic statues, based in pose and pro-
portion upon Renaissance proto-
types, are (starting from left on
Madison Avenue side) Philip Mar-
tiny, *Confucius* (Chinese Law); Wil-
liam Couper, *Moses* (Hebraic Law);
(25th Street side) Edward C. Potter,
Zoroaster (Persian Law); Jonathan
Scott Hartley, *Alfred the Great* (An-
glo-Saxon Law); George E. Bissell,
Lycurgus (Spartan Law); Herbert
Adams, *Solon* (Athenian Law). East
of Daniel Chester French's group of
Justice, Power, and Study (above
pediment) are John Donoghue,
Saint Louis (French Law); Augustus
Lukeman, *Manu* (Indian Law);
Henry Kirke Bush-Brown, *Justinian*
(Roman Law).

One of the first successful products of the NSS's labors to control artistic activity
and obtain government commissions in New York City was the sculptural deco-
ration of the First Appellate Division of the New York State Supreme Court (fig.
4.1). The justices' refined tastes, their political standing, and their support of
professional artists helped to make the Appellate Courthouse a remarkable com-
mission from the sculptors' point of view. A profusion of architectural sculpture
covered the exterior of the building; a series of elaborate mural paintings adorned
the walls within. Indeed, admirers noted approvingly that the Appellate Court-
house was one of the most richly decorated public buildings in America, realizing
the "most advanced ideas in modern mural and sculptural decoration."[1] Not only
were there a great number of sculptures, but an extraordinarily large proportion
of the total construction budget was allotted just for sculpture. Numerous NSS
sculptors worked on the project. Moreover, the program itself was the first com-
prehensive sculptural expression in New York City of the ideals of order and
progress, the motivating forces underlying the sculptors' enterprise. Hence the
Appellate Courthouse represented an unprecedented show of support for artists
and their work. For the sculptors involved, the project meant even more; for
them, the Appellate Courthouse was the ideal for how collaborative architectural
projects could and should be organized and executed. It provided sculptors a
guide for what they could achieve procedurally as well as visually. But it was a
model that became difficult to follow.

The establishment of the Appellate Division of the Supreme Court, First Judi-
cial Department, was representative of the trend toward centralization and
specialization that was taking place in other sectors of American society. Its
formation was the last step in a series of judicial reforms that began in 1846 and
that were implemented to increase judicial efficiency by relieving the state su-

preme court of some of its work load. It was a powerful body, as the result of a new code of civil procedure, which extended the right of appeals so that the intermediary appellate court could now review a trial judge's decision.[2]

Although the Appellate Division was a state body, the construction of its building involved negotiations between city and state, for it was to be built on municipal property. The 1897 statute authorizing the building stipulated that while final approval of construction was in the hands of the state judges, plans and construction were to be guided by the commissioners of the Sinking Fund of New York City. This commission, made up of the mayor and four other senior elected officials, had the power to reassign or to dispose of city property, with the proceeds of land sales credited to the Sinking Fund to pay off ("sink") city debts. The money was to be raised by a bond issue, with repayment from the Sinking Fund, and therefore did not involve a direct appropriation through taxes. This meant that the mayor and municipal officials were much less accountable to the public for how and where the money was being spent.[3]

The special status of the Appellate Courthouse project became evident early on, with the selection of the site. Rather than being situated in the downtown civic center area, near the lower courts whose cases the Appellate Division reviewed, the supreme court judges selected a choice location on Madison Square. The neighborhood to the east was more residential than downtown, and an easier walk from most of the justices' homes. A congressman who owned the property sold it for the rather high price of $370,000, but no one stood in the way of the justices getting the site that they wanted.[4]

The judges' privileges also extended to selecting the architect. They picked Princeton graduate James Brown Lord (1859–1902), a man with impeccable social and artistic credentials. His maternal grandfather, James Brown, was founder of the investment banking firm of Brown Brothers. His paternal grandfather, Daniel Lord, had been senior partner and founder of the major law firm of Lord, Day, and Brown, and his father was still one of its practicing attorneys. After gaining experience as an architect with the firm of William A. Potter, Lord had set up his own practice, receiving commissions for several Tuxedo Park mansions and for two of New York's elegant Delmonico's restaurants.[5] The justices were already acquainted with Lord's work, having earlier chosen him to remodel the old Arnold Constable Building at Broadway and 19th Street for use as a temporary courthouse.

Satisfied with the work Lord had done there, they asked him to prepare ten-

tative designs for the new building. His design called for an elegant neo-Palladian structure, lavishly decorated with stained glass and mural paintings. In addition, the scheme also called for copious amounts of architectural sculpture to be created by the city's finest artists. Lord had a good incentive to incorporate this feature into his plans. He had come highly recommended by Bruce Price, a prominent architect. Price, who also happened to be on the council of the NSS, had earlier succeeded in convincing the judges of the value of a design that included architectural sculpture.[6]

The judges, impressed both by this ornate conception and by the spacious offices Lord planned for them, presented Lord to the Sinking Fund commissioners as their choice.[7] The next step was for Lord to submit plans and cost estimates to the Sinking Fund commissioners and judges and for the city and state to agree on a general contractor who, unlike the architect, had to be selected through bids. The city's corporation counsel prepared contracts, and then advertisements soliciting sealed bids were published in two daily newspapers in accordance with municipal law. The justices picked the lowest bidder, Charles T. Wills, at $638,968.[8] The Sinking Fund commissioners, aware that the justices' liberality in decorating the courthouse did not also extend to the cost of building it, made it clear that they kept close watch over the amount of money committed and the procedures for spending it. After the scandalous construction of the "Tweed" County Courthouse, city officials knew that the justices would be keeping an eye on Sinking Fund commissioners' activities and clearly felt obliged to stay within the budget of this new structure.

It was in formulating the construction contract, particularly with regard to sculpture, that the extent of the justices' partiality toward art became clear. Approximately $160,700 out of the total construction budget—more than 25 percent—was allotted for sculpture. Not surprisingly, then, the sculptors viewed the Appellate Courthouse as a spectacular commission.

Lord had control over the work and materials stipulated in the construction contract; here, too, he emphasized the importance of the building's sculptural adornments by dividing the general contract into two separate parts: construction work and monumental and decorative work. Wills in turn broke up the monumental and decorative work into different categories, distinguishing sculptors from plasterers and other ornamental craftsmen. Firms considered directly associated with construction of the building had to bid for their jobs. Lord, on the other hand, had the authority to choose the artists directly, working through the

professional societies. The National Society of Mural Painters developed a program, directed by John La Farge, for interior murals, at a cost of $54,300. And, in consultation with the NSS, Lord chose Saint-Gaudens and French to suggest artists to design the building's sculptural features. Frederick Ruckstull and Charles Niehaus were asked to supervise the sixteen NSS members chosen. In adopting this limited, elite approach to artistic selection Lord set a precedent that the NSS hoped to see perpetuated.[9]

Lord's decision to select sculptors in this manner met strong opposition from artists who could not benefit from such procedures. Fernando Miranda protested to the press against the awarding of contracts for the Appellate Courthouse sculpture without bids or competition. According to him, sculptors on the outside had not even been informed about the possibility of such commissions; everything he knew he had learned secondhand. Especially irksome to him was the appointment of the French/Saint-Gaudens committee, which, he remarked caustically, was only to be expected. "It is against this insulting presumption that only the elect should have a chance to compete that I and other sculptors protest." While Miranda did not state outright that favoritism had been shown, he argued that the process certainly invited "suspicion."[10] Little heed was paid Miranda's objections; Lord preferred to pick his own artists, and spurned competitions. He was fully convinced that the NSS—recommended methods were the right ones. The society had cemented its relations with the architect; it had the upper hand.

Both architect and contractor succeeded in staying within their original budget and closer to their original time estimates than was usual in most government projects. Construction was completed within three years, which was one and one-half years longer than expected. Justices George C. Barrett, Charles C. Van Brunt, William Rumsey, Edward Patterson, and Morgan J. O'Brien were able to move into their new headquarters on 2 January 1900. The sculpture, however, was not finished when the courthouse opened; although the sculptors delivered their models promptly, the marble into which the statues were to be carved was not available on time. Since the sculptors' contracts included control of the carving of their work, they had to ask for an extension. Their statues were completed by 1901.[11]

The sculptural program of the Appellate Courthouse (that is, its total array of subject matter) was an extremely elaborate grouping of complex imagery, consisting of about thirty figures and statues. The scheme exemplified didactic architectural sculpture as members of the NSS envisioned it should be: a richly varied

assemblage of historical and allegorical personifications that together expressed a theme of fundamental and universal significance.

The architect and the sculptors combined a variety of conventions of representation to convey the dominant idea of world law and, implicitly, its contribution to modern civilization. Such an all-encompassing theme had special resonance at a time when massive immigration and urban poverty evoked for many middle- and upper-class New Yorkers the specter of uncontrollable crime and chaos. The architects of the sculptural program sought visually to assuage such doubts; but the program also implied that protective measures still might need to be taken to defend the law's truths. Ruckstull's seated figures of *Wisdom* and *Force*, for example, conveyed the message that reasoned judgment in making the law and in controlling order was essential. "Every law not based on Wisdom is a menace to the state," read the inscription on the one statue's plinth. At the same time, however (to restate the inscription of the second figure, *Force*), force would be necessary "if just laws are defied" (see figs. 4.1, 4.2). The works of French and Bitter signified that proper study of the law would yield justice, power, and peace. Niehaus's pediment assured onlookers that despite any apparent threat to order and stability, the law would triumph (fig. 4.3). Thomas Shields Clarke's *Seasons* emphasized this point by asserting that the law remains universal through time. Further proof of this was provided by the ten attic figures, each depicting a historical figure as a personification of the world's great legal systems. Together they represented the progress and achievements of law that culminated in the triumph of American justice.[12]

The building and its sculpture received generally positive critical response.[13] To be sure that such response would continue, NSS cofounder De Kay took the occasion of the completion of the Appellate Courthouse to draw public awareness to the importance of the NSS's enterprise. Using his leverage as both sympathetic colleague and ostensibly objective critic, he "distanced" himself from the group and then addressed the significance of the sculpture in two separate reviews. He gave serious attention to the works, both in relation to the larger architectural structure and as individual works of art. The ideology of the program was not an issue; most of De Kay's readers accepted its assumptions. Rather he judged the works using aesthetic criteria, the approach artists preferred. De Kay viewed the neo-Palladian structure as "essentially modern in its crowded and energetic architecture," alluding positively to the plays of lights, shadows, and forms created

EVERY LAW NOT BASED ON WISDOM IS A MENACE TO THE STATE

4.2
Frederick W. Ruckstull, *Wisdom*, Appellate Courthouse, 25th Street at Madison Avenue, 1900. (Photo, Joseph C. Farber.)

Wisdom and *Force* flank the pedimented and Corinthian-columned entrance portico on 25th Street. To the right of *Wisdom*, two reclining figures and medallions of the sun and of the moon and stars represent Morning and Night.

4.3
Charles Niehaus, *The Triumph of the Law*, pediment sculpture; above: Daniel Chester French, *Justice, Power, and Study*, Appellate Courthouse, 25th Street side, 1900. (Photo, Joseph C. Farber.)

In the center of the pediment a seated figure, Law, holds the tables of the law. Flanking figures are Roman soldiers with swords, a laurel-leaf crown, and shields. Also included are a ram, an owl, and a crescent moon, all associated with law. Male figures—a nude with fasces (probably Youth or Strength) on the left, and Father Time with his scythe on the right—recline in the lower corners.

by the design and sculptural elements. For the most part he was favorably impressed by the individual figures, but there he did find exceptions. He noted, for example, the ways in which the attic figures accentuated the structure as prolongations of the building, yet also intimated that they were out of proportion. Ruckstull's *Force* looked "dull" in contrast to *Wisdom*, and Martiny's *Confucius* recalled an "imaginary Chinaman, half Mongol, half Turk." Nor did he like the Niehaus pediment. The scale and "archaic, stiff style" of this work did not appeal to him; furthermore, he noted, the figures should have been in low relief and conceived more in relation to the other sculptures.[14]

But these were minor criticisms, especially coming from an insider. What was important was that such an extraordinary program had been executed. The NSS sculptors looked upon the Appellate Courthouse as a resounding success. To paraphrase the words of sculptor Jonathan Scott Hartley, it was the first public building where sculpture had been properly considered in relation to the architecture with which it was allied.[15] The architect and clients wanted enormous amounts of sculptural decoration; moreover, the percentage of building funds designated for art was nothing short of phenomenal. Best of all, the NSS had succeeded in having the selection process implemented in accord with its standards. The artists had all been chosen by their own colleagues, on the basis of reputation and previous work, not through bidding or competition. The project involved among the largest number of sculptors ever employed on a single building in the United States. Moreover, sculpture represented over a quarter—and, together with the decorative work, over 50 percent—of the final cost of the entire building ($588,768).[16] The NSS looked upon this experience as a clear mandate for its services. For members, the successful completion of the Appellate Courthouse's sculpture confirmed the value of both the society's activities and the merits of their profession. Extraordinary opportunities for expression of civic ideals were available to them if only they could continue to impress men in high places. The question remained, however, whether such experiences could be generalized when sculptors' relations with architects and government officials were not so smooth.

5 An Art of Conquest: The *Dewey Arch*

The construction of the Appellate Court building decorations gave NSS sculptors a satisfactory degree of autonomy and involvement in decision making about public art. Encouraged by these successes, the NSS hoped to capitalize on them as quickly as possible, even while the Appellate Court project was still in process. One such opportunity was offered by the *Dewey Arch* of 1899 (fig. 5.1)—part of a nationwide celebration of Admiral George Dewey's triumphant return from the Philippines in the wake of the Spanish-American War. The arch had a significant purpose. Not only did it honor Dewey's wartime feats; like the admiral's own actions, the arch was an expression of America's expansionist policies. Although the monument, made of staff, was only supposed to be temporary, the NSS hoped that a positive reception might lead to calls to make it permanent. The project gave them a chance to seize the limelight—to show what good civic sculpture could be. At the same time, however, it brought into the open conflicts between sculptors and architects over which profession should control the design and execution of public monuments.

The time seemed opportune. Apart from the urban and institutional developments that had given rise to buildings like the Supreme Court Appellate Courthouse, interest in expressing nationalist sentiment through commemorative and celebratory sculptural programs was at a peak. The 1889 centennial celebration of the inauguration of George Washington had initiated this widespread patriotic enthusiasm. Two major triumphal arches had been commissioned for that occasion—Stanford White's temporary *Washington Arch* on 8th Street (later made permanent in Washington Square, fig. 5.2[1]) and John Duncan's *Soldiers' and Sailors' Arch*, a Civil War memorial in Brooklyn's Grand Army Plaza (fig. 1.5, whose decoration, supervised by White, was still in progress in 1899). These two monuments represented important recent precedents. Both arches, in their

celebration of heritage and in their assertions of national unity, became significant formal and expressive models for the *Dewey Arch*. Both were designed to establish and command prominent sites. Both designs included a good deal of sculpture and ornament. (However, in the case of the *Washington Arch*, continuing lack of funds prevented the commissions for Washington groups on the north and south bases from being given out until 1913.)

At the same time, from the NSS point of view these works did not represent ideal circumstances. In both cases, the number of sculptors involved was kept to a minimum. White made certain that the majority of the commissions for both arches went to his favored artist MacMonnies. Earlier in the decade, before White was brought in, commissions for reliefs for the inner span of the *Soldiers' and Sailors' Arch* had gone to William O'Donovan and Thomas Eakins, neither of

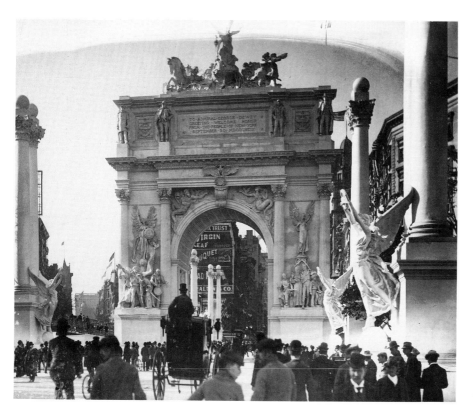

5.1
Charles Lamb, *Dewey Triumphal Arch*, Fifth Avenue and 24th Street, 1899, demolished. (Courtesy of the New-York Historical Society, New York City.)

North face, pier sculpture: left, Philip Martiny, *The Call to Arms*; right, Daniel Chester French, *Peace*. Attic figures: Thomas Shields Clarke, *Commodore McDonough*; J. J. Boyle, *Commodore Porter*; Henry K. Bush-Brown, *Commodore Hull*; H. Augustus Lukeman, *Lieutenant Cushing*. Spandrels: Roland H. Perry, *Atlantic and Pacific Oceans*. Keystone: Frederick Ruckstull, *Great Eagle*. West side of arch, alto relievo panel: Johannes Gelert, *Advancement of Civilization*. Medallions above: Ralph Goddard, *Commodore Bainbridge*; F. C. Hamann, *Commodore Preble*; F. W. Kaldenberg, *Commodore Barry and Admiral Davis*; Henry Buberl, *Captain Lawrence*; Frederick Moynihan, *Admiral Worden and Admiral Foote*. Top: John Quincy Adams Ward, *Naval Victory*.

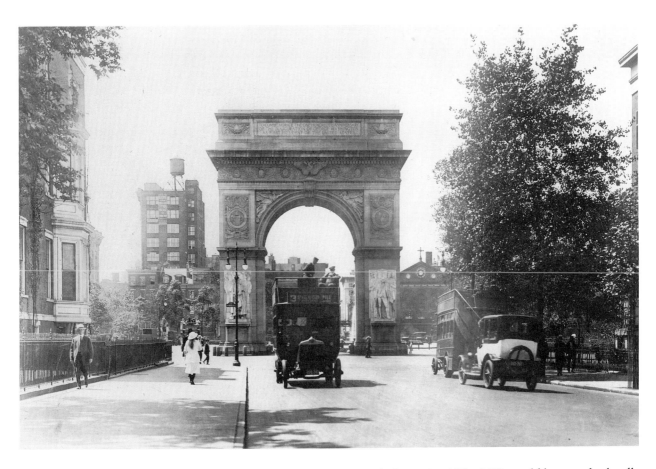

whom were closely connected with the society.[2] The NSS would have undoubtedly preferred to have had this number of commissions (MacMonnies had three large groups alone for the Brooklyn arch) more broadly distributed among a range of sculptors, preferably active NSS members. The current Appellate Court project was a major victory in this regard. The eruption of the Spanish-American War provided the society with new possibilities of professional advancement and of making another significant civic artistic statement.

In April 1898, after the sinking of the battleship *Maine* in Havana Harbor, the United States intervened militarily to free Cuba from Spanish rule. Commodore George Dewey, under orders to attack the Spanish colony of the Philippines in the

event of a declaration of war, sailed his Adriatic Squadron into Manila Bay on the night of April 30. Early the next morning he opened fire. After only a brief encounter, Dewey's ships had destroyed virtually all of the Spanish fleet, with only one reported American casualty. Dewey's capture of Manila Bay paved the way for the successful land operations in the Philippines that ultimately resulted in their annexation later that year. The stealthy swiftness of Dewey's achievement, which contributed substantially to the rapid conclusion of the war (an armistice was signed August 12), was seen as all the more extraordinary in comparison to the squalid and chaotic United States military campaign in Cuba. The United States emerged victorious from the war as a major international power.[3]

The triumph of the Spanish-American War, epitomized by Dewey's display of American naval might, represented, for the numerous supporters of American participation, the triumphant culmination of the post–Civil War struggle to achieve national identity. The very decision to enter into war was itself considered proof that the goal of national unity had been achieved: that the values of democracy, civilization, and progress for which America stood were so certain that for humanitarian reasons the country was morally obligated to bestow them upon the dark, ignorant races overseas.[4] In light of these beliefs, Dewey and his achievements took on more than military significance. He became a popular symbol of American power, freedom, nationalism, and imperialism.

By 1899 Dewey's victory appeared both more significant and more controversial as debates developed over imperialism. In spring of that year, New York City officials began to plan a late September celebration to welcome the admiral's return (Dewey had been promoted). A 1,152-member Dewey Reception Committee, selected by Mayor Robert Van Wyck, was making the arrangements that would allow New Yorkers to pay proper tribute to Dewey's "genius as a seafighter" and to the "efficiency of the entire American Navy in time of war."[5] The New York celebration was an indication of the political and business community's strong enthusiasm for him. In retrospect, it was a visible assertion of city leaders' implicit decision to ignore arguments against imperialism and to support United States foreign policy. As the nation's trading center, New York had more than merely sentimental interest in overseas expansion.

The planned three-day celebration would include an enormous pageant of war and official government ships through New York Bay, along with gigantic fireworks and electric light displays and numerous receptions. The festivities would

culminate in a parade in which Dewey and a host of military regiments would march all the way from Riverside Drive and 125th Street to Washington Square, with Dewey alighting at 24th Street and Broadway to review the troops.[6]

Within this environment, members of the NSS saw an opportunity to make a major cultural, historical, and patriotic statement. The upcoming Dewey celebration in particular struck second vice president Charles R. Lamb (1860–1942) as the perfect way to promote the work of society members. In late May 1899, Lamb suggested that the society erect a triumphal arch to Admiral Dewey to coincide with the extravaganza. In Lamb's view, an arch erected under the auspices of the National Sculpture Society would not only suit the ritual aspects of the occasion perfectly, it would also provide the perfect way, in Frederick Ruckstull's words, for the society to "cover itself with glory."[7]

At the next NSS meeting, Lamb, Ward, and Ruckstull asked sculptor members whether they would be willing to furnish small models of figures to go on the arch "free of charge—to the greater glory of Dewey, the country, and American sculpture."[8] Most members agreed to do so, and the society picked a committee consisting of Ward, Ruckstull, Bitter, Lamb, and John DeWitt Warner to approach the soon-to-be appointed Citizens' Committee. The willingness of so many NSS members to volunteer to work without pay was an indication both of the persuasive powers of the society's leaders and of the artists' commitment, which stemmed from the fact that the arch was to be conceived and controlled entirely by the NSS.

The *Dewey Arch* had the attraction of being a sculptural project not dominated by architects. With Lamb as designer, the sculptors could be assured of having an appropriate amount of input and of being treated as equals. Lamb, a respected spokesman for civic art and City Beautiful ideals, believed that sculpture should have a prominent place in any urban scheme. His attitude toward architectural sculpture as a fine art rather than as ornamentation was in part a function of his artistic background. After college, his training included study at the Art Students' League and work in the family firm of J. and R. Lamb Studios, which specialized in interior decorations, especially stained glass and mosaic. Although known as an architect, he had no formal architectural training; although he developed several important visionary schemes, only two of his designs—for his own home and the *Dewey Arch*—were actually built.[9]

In early June 1899 the NSS committee approached Mayor Van Wyck with their idea. Van Wyck appointed Ward and Warner to the Citizens' Committee

and also put Ward on the executive subcommittee charged with planning the celebration. Lamb developed several sketches for a general plan for a triumphal arch with sculpture, and submitted it to the Committee on Plan and Scope for the Dewey Celebration.[10]

At first there was some uncertainty as to whether the arch would get off the ground. Van Wyck, a Tammany mayor, generally opposed municipal expenditure for beautification projects the sculptors and other civic groups sought. He had already held up construction of the New York Public Library and in 1900 (as we shall see in Chapter 7) would cause the NSS many headaches over the Hall of Records commission. Yet when Bitter, Ward, Ruckstull and Lamb met with the mayor, Comptroller Bird S. Coler, and Lewis Nixon (a shipbuilder, chairman of the East River Bridge Commission under Van Wyck, and soon-to-be successor to Richard Croker as boss of Tammany Hall) on July 27, they convinced them to allot $26,000 for materials and labor for the *Dewey Arch* venture.[11] For Van Wyck, an arch and sculpture for this particular occasion were apparently a viable exception.

It is not difficult to ascertain why the city agreed to fund the arch. On the one hand, the sculptors were so anxious for acceptance of their offer that they had offered their professional services entirely free of charge, "a circumstance without precedent" (as J. Wilton Brooks described it) and an act of faith that would weaken the artists' position in later bargaining with the city.[12] The city thus did not have to take on much real responsibility or pay as much money.

On the other hand, city officials were to play a prominent part in the gala. The reception idea had been initiated in the Municipal Assembly, and Van Wyck had the authority to chose the planning committee. He himself was an ex officio member of the reception committee and very much involved with the arrangements. Nixon was the chairman of the Committee on Music and Fireworks, and Council President Randolph Guggenheimer was chairman of the Committee on Refreshments.[13] Such ceremonial assignments accorded well with the ritualistic aspects of the arch and its sculpture, which could help to enhance city officials' image as patriots and public servants. Although $26,000 was a considerable expenditure, particularly for a temporary work, it was not a large sum "wherewith to express the civic pride of a city the size of New York," as an author in *Public Improvements* observed (especially in a celebration where city officials would share the limelight with the admiral).[14]

Once plans received official approval, in late July, work progressed at a hectic

pace. Only six weeks remained before the celebration. The twenty-five volunteer sculptors still had to work up their models, have them enlarged in staff, and have them installed on the staff-and-timber arch. Most of the artists worked in space given over to them in the basement of the second Madison Square Garden. No sooner had they started, however, than they learned that the city planned to solicit publicly for bids for all materials and labor on the arch costing over $1,000.

Competitive bidding was of course standard procedure for municipal contracts, but it would have meant a thirty-day delay on the project. This would have left the sculptors less than two weeks to finish the arch. In panic, they sent an urgent letter to borough president Guggenheimer, warning him that if the municipal requirements for public letting were not removed, New York would "miss the opportunity of celebrating the return of Admiral Dewey in the grand manner proposed by the Plan and Scope Committee, and which now has been advertised in this country and abroad. . . . Not a day is to be lost."[15]

Agreeing with them, Guggenheimer urged the Board of Aldermen—who had the authority to make such exceptions but who had been sitting on the resolution—to authorize the contracts without public letting. This obstacle removed, the work on the arch hastily proceeded.[16] Karl Beil of Chicago was brought in to supervise the enlargement from models and, finally, the placement of the sculpture onto the architecture. His experience with the construction at the World's Columbian Exposition had no doubt prepared him for the pressures of short-term construction deadlines. Working around the clock, the artists and artisans finished the arch at the very last minute, when "debris and tardy workmen alike [were] swept from the streets by streams from the fire engines called in thus summarily to close preparations."[17]

The gleaming white *Dewey Arch* (fig. 5.1) stood strangely monumental in the midst of the street signs and congested thoroughfares surrounding Madison Square, the entertaining and hotel center of the city. Seventy feet long, thirty feet wide, and eighty-five feet high, it ran east and west across 24th Street, its archway opening onto Fifth Avenue at its junction with Broadway. As the focal point of a vista that extended from several radiating avenues, it was visible from Washington Square to Central Park on Fifth Avenue, from Herald Square to 10th Street on Broadway, and from the East River to the Hudson on 24th Street.[18]

The structure was, first and foremost, a showcase for sculpture. The NSS developed the sculptural program, focusing on themes of the United States as a great conqueror and as a maritime nation in search of peace. Such schemes pro-

vided the rationale for Dewey's activities, and crystallized the imperialist convictions that had been used to justify American presence in the Philippines in the first place.

The north and south faces of the arch offered a "continuous series personifying four great steps in patriotism." [19] To the northeast stood *The Call to Arms* (Patriotism) by Philip Martiny; at the southeast was *The Combat* (War) by Karl Bitter; at the southwest was *The Victors Returning* (Triumph) by Charles Niehaus; and at the northwest *The Warriors Resuming Their Occupations* (Peace) by Daniel Chester French (fig. 5.3). Eight heroes, chosen by the Secretary of the Navy, represented the crucial periods of America's naval history for the tops of four large Corinthian columns on the north and south fronts of the arch. In addition to designing large figures and groups, the NSS also filled the spandrels of the arch with bas-relief. In the north spandrels Roland H. Perry depicted the Atlantic and Pacific Oceans to indicate the international bounds of American responsibilities. To the south, Isidore Konti created the North and East rivers to emphasize New York's position as a commercial metropolis. Great eagles perched above the keystones, and Ward fashioned a crowning quadriga, *Naval Victory*, which depicted sea horses drawing a ship with a modified Nike of Samothrace Victory at the prow. Two high-relief panels, *Protection of Our Country* at the east (by William Couper) and the *Advancement of Civilization* at the west (by Johannes Gelert) adorned the east-west ends.

The program extended to both ends of the colonnade, which expressed the culminating forces of America's power and the delight of its "spoils:" for the south end, Ruckstull modeled a group of the army and George Bissell created a navy, complete with battleship and guns. At the north, Charles Lopez and Isidore Konti fashioned groups of "our new possessions," the East and West Indies, "dependencies" acquired as a result of the Spanish-American War.[20]

The NSS employed virtually all conceivable forms of sculptural representation in this extraordinary project. They brought together portraiture and traditional "classical" allegory as well as "modern-day" allegories signified through narrative anecdote and wearing contemporary clothing. Daniel Chester French, for example, conveyed the universal ideal of Peace by depicting generalized contemporary figures in a group that was itself inspired by a specific present-day historical event. Lest anyone doubt the effectiveness of this approach, architect Barr Ferree, an NSS member, took care to assure readers of the *American Architect and Building News* that the sculptors' efforts were an unqualified success. They had

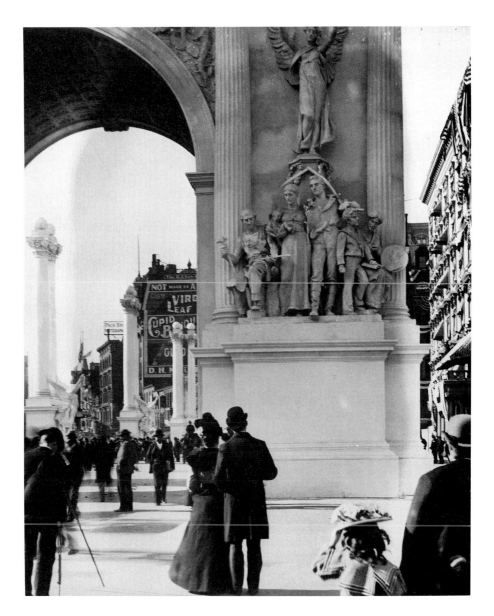

5.3
Daniel Chester French, *Peace*, northwest pier of *Dewey Arch*, 1899, demolished. (Photo, Robert Bracklow. Courtesy of the New-York Historical Society, New York City.)

summed up and illustrated "the whole history of war as interpreted by the American people," and their allegories were "at all times intelligible, penetrating, and admirable."[21]

The artists purported to express universal themes—valor, nationhood, and (curiously) peace—that they believed were signified through military ventures in general and brought into play specifically through Dewey's victory. They assumed that the public would comprehend the general themes by reading the anecdotal elements represented by the relationships among the figures in each of the groups. A century later, the "universal themes" of the *Dewey Arch* would appear to be based upon racist and imperialist premises that were then taken for granted by most white Americans—beliefs grounded upon the social Darwinist notion that it was the duty of the American "Anglo-Saxon," the "fittest" among all peoples and races, to protect those "incapable" of doing so for themselves.[22] Within this scheme of things, America was destined to guide modern civilization along its steady and inevitable course.

But after all their efforts to create a symbol of conquest to cap the ritual of the victory procession, neither the sculptors nor anybody else saw Dewey pass through the spectacular arch. The reviewing stand had been placed on the northeast side of the structure. When the land parade arrived there, Dewey disembarked from his carriage, thus leaving the procession "to pass beneath the arch that had been built for [his] special honor and distinction." This situation, Barr Ferree lamented, was truly the "misfortune of the day," for, as he quoted one bystander as saying "What was the use of building a $40,000 arch, if they did not take Dewey through it?"[23]

Despite this annoyance, the sculptors viewed the arch as a major success. It had heightened the public interest and the appreciation they had hoped for. *Municipal Affairs* reported that waves of curious onlookers came by to "inspect and admire" the arch while it was under construction. During the preceding two weeks, the article reported, there had been a "crowd day and night, weekday and Sunday alike. . . . [T]ens of thousands, filled large portions of the great square," making the area virtually impassable for trolleys and "other surface cars."[24]

The artists received much publicity and praise, even before the arch was erected. Newspapers and journals provided extensive coverage, and hailed the sculptors for their patriotism, organization, ability to cooperate (given the time constraints), and generous donation of time. Indeed, several writers excused any artistic defects as being the inevitable result of the need for haste.[25]

Sculptors had been able to advance an important didactic message—the notion that sculpture should be like a textbook in its capacity to bring an image "before the eye in some concrete form [and] fix the thought in the mind."[26] They attributed their success to their collaboration with Lamb, a sympathetic architect, who from the outset had conceived the architectural design especially for sculpture. Lamb had given them the freedom to conceive their groups virtually as freestanding monuments, less formally constrained than usual by the demands of the architectural structure. The success of the *Dewey Arch* might convince Americans of the value of sculpture produced under the direct supervision of sculptors. The situation had also provided the NSS with unprecedented artistic authority. The artists' hopes were no doubt buoyed by a *New York Times* editorial praising the sculptors and contrasting the success of the Dewey Arch production to Stanford White's *Washington Arch*. The latter, wrote the author, was conceived by "architects" who "did their duty and then dropped the matter, so that the Washington Arch is as much an anomaly and a negation of its purpose as if an equestrian monument were to be erected and the work were to stop short with the pedestal."[27]

Such lavish attention and praise for sculptors and scorn for architects did not sit well with certain members of that profession. They appreciated neither the merits of the *Dewey Arch* nor the fact that sculptors seemed to be trying to take center stage and disrupt the long-standing hierarchy that had always given priority to architects. In the editorial opinion of the *American Architect and Building News*, Lamb and the sculptors seemed to be undertaking projects for which they were not qualified; these critics roundly denounced the *Dewey Arch* for having had too little input from professional architects.[28] One editorial, criticizing the sculptors in particular, questioned the propriety of asking the city to make an exception to the law requiring public advertising for contracts exceeding $1,000. Such an action would set a bad precedent by suggesting to New York politicians, especially Tammany Hall, "a way of evading a very sensible law," and thus required "the sharpest censure."[29] Another editorial, on Lamb's first drawing for the arch design (fig. 5.4), complained that the columns were spaced so far apart "as to suggest penuriousness, to say the least, on the part of the ecstatic citizens."[30] Moreover, the columns themselves were far too stout, and worse—"tied together at the top by long strips of cloth, exactly as if the mamma arch were taking out some little pup columns for a walk, tied together with ribbons to prevent them from straying." Concluding his patronizing commentary, the anony-

mous writer stated that while it was reasonable that the NSS should have wanted a structure most suitable for the display of sculpture, a professional architect would have done a much better job and could have avoided a composition that looked "architecturally ridiculous."[31]

The *New York Evening Post* and the *New York Times* came to the defense of Lamb and the sculptors. Alluding to the tensions among painters, sculptors, and architects, the *Times* asked why the architects, "the largest and wealthiest body of men in the city who aspire to the title of artist," had not made any effort to contribute to the Dewey celebration.[32] An editor in the *American Architect and Building News* retorted that the *Times*'s "rather pathetic editorial" implied a concern that the decorations for the Dewey festivities might be "meagre and spotty" without architects' involvement. The problem, the author continued ironically, was that now that the sculptors had already used an arch, "architectural property," it would "hardly do for the architects to erect another arch—or a dozen of them, since they are so wealthy."[33] The *Architectural Annual* also took issue with the *Times*, suggesting that part of the problem stemmed from ever conceiving of the artists as being in the same league as the architects. He emphasized that the *Dewey Arch* was architecture, not architectural sculpture, as some critics like Russell Sturgis had characterized it.[34] In the opinion of the *Architectural Annual*, the *Dewey Arch* might be architecture, but unfortunately, Lamb was just an artist, not the architect he professed to be. Consequently, his architectural composition and approaches were amateurish, and demonstrated an "ignorance" of the "basic laws of creative architecture." Clearly, "a mastermind was lacking." Were the arch to be made permanent, as some sources intimated that it should be, a professional architect would have to be called in to correct Lamb's errors and to oversee the project.[35]

Indeed, soon after the Dewey celebration, when the temporary arch started to weather and vandals began to cart off pieces of it as mementoes, calls increased for the monument to be put into durable materials. A private committee attempted to raise funds to reconstruct the structure as a permanent monument. However, the question of what group would design it became moot when the admiral declared himself willing to be drafted as a presidential candidate in 1900. The project was abandoned because it seemed to have acquired a partisan political character. By 1900, the question of United States involvement in the Philippines was becoming more controversial. Anti-imperialists had stepped up their campaign against the American presence there, and this may also have diminished

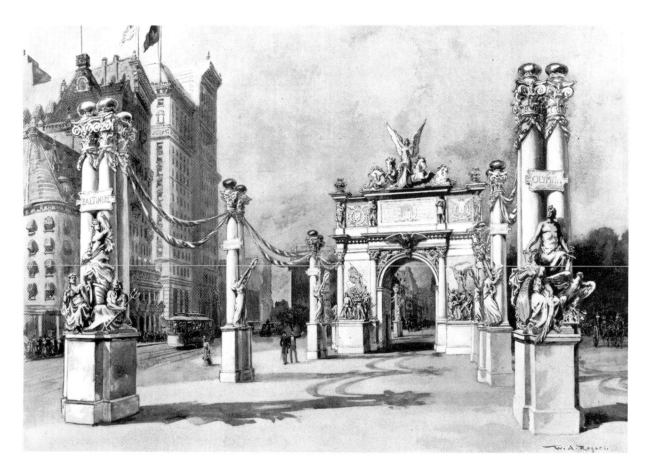

5.4
W. A. Rogers, "Honoring Admiral
Dewey—The Proposed Triumphal
Arch and Colonnade at Madison
Square, New York City," from *Harper's Weekly*, 12 August 1899, p.
787. (Columbia University
Libraries.)

public enthusiasm for such a project.[36] Even so, architects had prepared to fight and had begun to pull their weight. The following year, 1901, when the United States Naval Academy Alumni Association proposed to have a new naval arch constructed at the base of Manhattan, the architects saw to it that Ernest Flagg, a professional architect unaffiliated with the NSS, was placed fully in charge. (Flagg was the designer of the Naval Academy at Annapolis.) Although that proposal did not get off the ground either, the architects had nonetheless reclaimed their artistic dominance. From this point on, arches, and indeed virtually all large public monuments, would remain firmly under their control. The tensions between sculptors and architects abated, but never fully disappeared.

6

Professionals and the Federal Government:
The United States Customs House

During the same three-year period in which the Appellate Courthouse and *Dewey Arch* were underway, two other important building projects were being proposed. Like the previous two, sculptural adornment was a significant feature of both structures, the United States Customs House and the New York City Hall of Records; but these exhibited the contrasting operating styles of the federal and city bureaucracies. The civil service reforms of the mid-1880s led to a system of hiring and promoting based on merit, rather than party loyalty. By the 1890s, federal procedures were hierarchically organized, strictly controlled, and relatively systematic. New York elites were much less successful in their attempts at civil service reform. Municipal administration remained much more disorganized, partisan, and corrupt. As we shall see, these circumstances affected the production of federally and municipally funded architectural sculpture.

The Customs House was a larger and more complex project than the Appellate Courthouse. The sculptors who worked on the Customs House had to operate within a much more rigid organizational framework, and were in a more subordinate position than with the other two commissions. At the same time, as with the Appellate Courthouse and *Dewey Arch*, the production of the Customs House sculpture program offered artists certain important benefits and opportunities. Their special professional relation to the architect, Cass Gilbert (1859–1934), helped especially to facilitate their activities. Gilbert shared their convictions that architectural sculpture was a significant art form. He was thus willing to make the case to his superiors that sculptors required proper working procedures to achieve the best results possible, and that attainment of such conditions might necessitate a departure from standardized government construction practices.

The architect privileged the sculptors over modelers and even, to some extent, over the general contractor. In turn, Gilbert's ability to make such exceptions was a function of his own good standing among the federal officials who determined the limits of government flexibility.

The tariff had been one of the central legislative issues of the nineteenth century, ever since Jefferson and Hamilton had debated whether the United States should be a great commercial power or a decentralized agrarian nation. The Republicans, following Hamilton's Federalist tradition of strong national government, along with a firm commitment to a high, often protective tax, prevailed throughout the late nineteenth century. Before income and corporate taxes were imposed in the second and third decade of the twentieth century, the tariff revenues on imported goods were the primary source of the federal income. As the volume of trade increased, so did the authority of the Customs Service, especially that of the collector, the officer directly responsible for collecting revenues.[1] The federal bureaucracy depended on the effective operation of the Customs Service, which was indeed synonymous with the power and competency of the national government.

New York was the largest and most important port in the country. In 1890 68 percent of the annual imports to the United States passed under jurisdiction of the collector of the Port of New York. The collector was the largest source of federal jobs in the state, employing 2,000 people in 1893 and 3,200 by 1908. All procedures for shipping into the Port of New York had to receive the collector's approval. Since the port was crucial to both the New York and national economy, the collector was thus in a position to shape policies at the municipal, state, and county levels.[2] Thus it is not surprising that in the late 1880s, when many major institutions were commissioning large new buildings, the federal government also arranged for an elaborate new structure to house the United States Customs Service of the Port of New York, the most conspicuous and essential of its operations.

The New York Customs House had occupied several buildings since its establishment in 1789, but had repeatedly outgrown its quarters. As of 1863, it was housed in the former Merchants' Exchange at William and Wall streets, but by 1888 this building was considered inadequate. The government authorized construction of a new building, and in 1892 the Secretary of the Treasury approved a site at Bowling Green, where Fort Amsterdam and later the Governor's House

had once been located. Situated at the very tip of Manhattan, the new building would represent the official entrance to New York and to the nation.[3]

The Customs House was the first structure in New York City—and one of the first in the country—built under the provisions of the 1893 Tarnsey Act, mentioned in Chapter 3. The act was the outcome of intense lobbying by the American Institute of Architects. The purpose of the legislation was to establish an honest, functional set of procedures that would be insulated from petty party politics and changes in administration. Its members believed that the act would help to upgrade the quality of federal architecture. They also hoped that it would expand their influence nationally and secure them more important commissions by broadening government patronage to give outside architects a new, more central role. Nevertheless, as mentioned earlier, the supervising architect of the Treasury was still the final authority; he had to approve all aspects of construction, including the work of the architect selected.[4]

The United States Customs House seemed to epitomize many of the ideals of professionalism and architectural excellence the AIA had envisioned in pressing for the Tarnsey Act's passage. The architect was to be selected through a competition judged by professional architects. But while the act opened up and systematized the commissioning process, that process was still subject to irregularities, as becomes clear from examining briefly the history of Gilbert's selection. On one level, the appointment of a newcomer, yet unaffected by municipal politics, signalled national over local priorities. On another level, Gilbert's selection represented the triumph of Midwesterners over the Eastern establishment. It is likely that Gilbert's good fortune was not simply the result of talent and good design; his chances were helped significantly by his personal and business connections and his knowledge of how to maneuver in inner political circles.

In 1884, after working in the New York office of McKim, Mead, and White, the Ohio-born architect set up a practice with James Knox Taylor, a former MIT classmate, in Saint Paul, Minnesota. Their association lasted for eight years. Taylor went on to become supervising architect of the Treasury, and in 1896, Gilbert won a major commission for the Minnesota State Capitol. Hoping for more big opportunities, and having heard of plans for the new Customs House, Gilbert moved his practice to New York while the state capitol was still under construction.[5] Accompanied by Minnesota senator Knute Nelson, Gilbert then visited Treasury Secretary Lyman Gage in early March 1899 to inform Gage of his qual-

ifications and availability for federal commissions. Not long after, Gilbert's became one of the twenty firms invited to submit plans for the Customs House. The jury, which included Supervising Architect Taylor, quickly narrowed the choice down to two firms, Carrère and Hastings, and Cass Gilbert.

When the jury selected Gilbert's designs (firm names were visible on the submissions), few architects or politicians were surprised, and Carrère and Hastings and others objected. In the architects' view, Gilbert had only too recently moved his practice from Minnesota to New York City. They considered him a newcomer, if not an outsider. They also charged favoritism. Taylor's refusal to judge the plans of the two finalists seemed to some an admission that he had been biased toward Gilbert from the outset. Members of the state Republican machine also complained bitterly, arguing that Gilbert was not a member of any New York Republican organization and that the selection looked too much like a Midwestern scheme.[6]

But to no avail. Gage, with strong support from Congress, confirmed Gilbert as architect in early November, signalling that in the national interest the federal government remained the final authority, resistant to pressure from local politicians and from disgruntled competitors.[7] The way was now paved for Gilbert to prove that the highest professional and artistic demands could be combined successfully with government priorities and standards.

The new Beaux-Arts-style Customs House was to be a building of great public significance. Some twenty years later, the relatively unadorned facades of Washington's Internal Revenue Service building—paid for with taxpayers' money—would reflect Treasury officials' concern that Americans would consider excess ornamentation too ostentatious. By contrast, the New York Customs House—funded by foreigners' tariffs—was lavishly decorated to celebrate the presence and wealth of the national government. As approved by the supervising architect in late January 1900, Gilbert's design for the Customs House called for a neobaroque structure with monumental half-columned colonnades on the sides (fig. 6.1). Sculpture and ornamentation formed an important part of Gilbert's conception. Four massive sculptural groups atop tall plinths were to project from the lower-story base, drawing viewers' attention to the paired columns immediately above, on the second level. Circular medallion-shaped ornaments on the entablature would extend the line of sight upward to culminate in ten full-length statues on the attic level above. A massive cartouche flanked by two figures accented

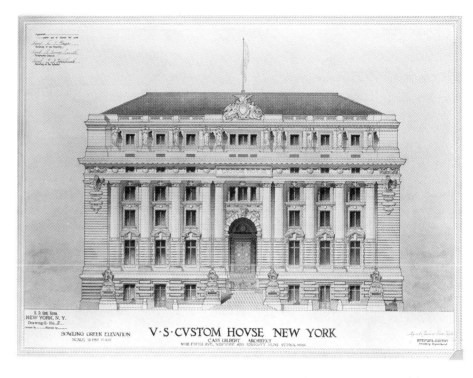

further the vertical thrust and marked the center of the building. In addition to the large-scale sculptures, extensive ornamentation, to be executed by modelers, was also planned for capitals, pilasters, lintels, keystones, spandrels, consoles, and pediments. All of this was in keeping with the Beaux-Arts concern that architectural sculpture serve as visual and spacial accent and as a means of expressing the broader purpose and significance of the activities to be housed within.[8]

With the architect and designs confirmed, construction of the building could begin, at a projected cost of about $3 million. (The final cost was actually about $5,130,000.)[9] In November 1901 John Peirce won the bid to become general contractor, and work on the foundations began early the next year. Peirce had to maintain a strict construction schedule, coordinate the work of an enormous number of people, placate both the subcontractors and the architect, and contend with strikes and labor unrest. Moreover, because the Customs House was a government project, the general contractor also had to post a large bond as guarantee of prompt completion.[10] Saddled by this enormous responsibility and financial

burden, Peirce was anxious to get the job done at the least possible expense to himself. Gilbert's high demands and professional standards conflicted with Peirce's pragmatic attitudes and practices and often produced mistrust and tension between them.

The differences in perspective between the two became evident in the production of the sculpture and ornament, especially when Peirce questioned Gilbert's assumptions about the capacities and responsibilities of the craftsmen and artists. In one instance, Peirce hired a modeler, a Mr. Beuhler, to create grotesque heads for the second-story window lintels.[11] When Gilbert decided to modify his designs to have heads "typifying various human races" instead of grotesques, Peirce reported that Beuhler had balked. According to the contractor, the modeler argued that this new kind of work was too specialized, that it was "not within the scope of his art," and that Peirce would have to hire a "sculptor," who would charge $200 extra to model each of the eight heads. Beuhler argued that ethnically distinctive human heads would have to be based on individual models observed from life by a sculptor, while a modeler would work from conventional imagery taken from pattern books or photographs. A skilled modeler could render forms such as grotesques, vegetal and classical ornament, and idealized human faces, but in Peirce's view could not handle the more complex and individualized images that Gilbert wanted. Peirce complained that part of the modeler's problem was that he had no architect's drawings of the heads to use as a guide. Moreover, Peirce told the architect, the absence of these drawings was delaying the contractor from ordering the rough-cut stone in which the heads were supposed to be carved.[12]

Gilbert responded to Peirce in tones of great irritation. He refused to pay anything extra, and insisted further that verbal instructions to the modeler would be perfectly sufficient. The modeler's skills were not in question, or even the real issue. Gilbert's own experience with Beuhler and Lauter had shown them to be perfectly capable of modeling any work needed for the Customs House (aside from the principal sculptural figures) on the basis of verbal descriptions. Moreover, Gilbert continued, his own refusal to send drawings and the contractor's delay in furnishing stone were two separate matters that had nothing to do with each other. Indeed, the architect suspected Peirce's complaints about the drawings were an attempt to circumvent procedures Gilbert had demanded and to obtain an undeserved postponement of other deadlines that Peirce was having trouble meeting.[13] Indeed, once this dispute was resolved, Beuhler and Lauter completed the heads of the races in one month's time without architect's drawings.

The disagreements over the modelers centered on their skills and the extent of the supervision they needed. From Gilbert's standpoint, these issues did not apply to sculptors of the large-scale figures for the Customs House. While he was clearly concerned about the quality of all the decoration, Gilbert was especially determined to get the finest artistic work possible for the full-length sculptures. While he farmed out supervision of many aspects of the construction to assistants and the contractor, Gilbert kept the sculpture under his personal charge. He had decided from the outset that the work would be done by professional artists, selected by him personally. Although the sculptors would be subordinate to the architect, in comparison to the other craftsmen and artisans who worked on the project they had greater independence and leeway. To give the artists enough flexibility to achieve the best works of art, Gilbert drew up the architectural specifications so that the modeling and carving of the sculpted figures and groups would be handled as an item "separate and apart" from the other ornamental modeling. In addition, each of the sculptors was to have his own contract, instead of having a single contract for all ornament, stone, or statuary. Modeling was to be done by "sculptors of known skill and ability, who shall be selected by the architect."[14] In August 1901 Gilbert asked the Treasury for enough money ($150,000) to hire "sculptors of eminence." (He was allotted $129,000.)[15]

Gilbert's relationship with Supervising Architect Taylor helped immeasurably in getting the concessions necessary for proper production of the architectural sculpture. The two shared similar attitudes toward professionalism; they considered it essential always to hire the best artists: men who could lend their expertise and talent to the expression of national values. True artists could subordinate their own personalities and concerns for the good of the whole and still produce works of excellence.[16] The two architects also believed that certain exceptions to the rules might be needed to do the job right. Thus as we shall see, when Gilbert made a special request, Taylor, although now a bureaucrat, tried, very slightly, to adjust rigid government procedures to accommodate the artists.

The sculptors found all these prospects appealing. They were pleased that Gilbert intended to keep artistic control rather than transfer all aspects of supervision of decoration to the contractor. Judging from their general statements, many of them responded well to the fact that Gilbert chose direct selection over competition or over having a modeling firm do the major sculptural work. The Customs House project thus not only promised that large-scale architectural sculpture would be aesthetically significant but also that individual

sculptors would have some autonomy and that their artistic stature would be acknowledged.

In early 1903 Gilbert began to arrange for the selection of sculptors, a process that took place in two stages. His initial effort was to try to attract two prominent sculptors to take on the four entrance groups, the largest and most significant works. He turned first to Augustus Saint-Gaudens and Daniel Chester French, the country's two most renowned and talented sculptors, and, as his correspondence intimated, probably the two whom he regarded as his social as well as artistic equals. Gilbert was so determined to get them that he drafted the pertinent sections of the specifications with their interests and expectations in mind. Writing to both in early February, he invited them each to create two seated entrance figures in grey Tennessee marble. Ten thousand dollars would be allotted for modeling and $3,500 for carving; the sculptors had the option to take responsibility for both. In giving them this choice, Gilbert signalled both his concern about quality control and his absolute confidence in the sculptors' artistic judgment.[17] As was common practice on architectural sculpture commissions, Gilbert told Saint-Gaudens and French what subjects he wanted; the Customs House groups should represent the four continents, be nine feet six inches high, and be completed within two years. The remaining artistic decisions would be up to the sculptors; the images could be depicted either as single figures or include a "child, a globe, an eagle, or some other accessory as the sculptor might find desirable in working up the subject."[18]

Gilbert could not lure Saint-Gaudens, who turned the commission down immediately, citing his time constraints. The sculptor wrote that he also did not want to have to risk having to pay the consequences for any possible delays (for which he was notorious) on another federal government project. "The United States are not pleasant people to have dealings of that kind with," he observed, and the price, while "liberal . . . is not what I receive for my work and I am not rich enough to indulge in the execution of work no matter how alluring when there is other at hand much more lucrative."[19] For Saint-Gaudens, who had done so much to champion the cause of a national art, the desire for artistic perfection and the federal bureaucracy's insistence on punctuality seemed to have become irreconcilable. In actuality, Saint-Gaudens's fears about the impact of delay may also have been prompted by medical concerns that he chose not to mention—his fatal cancer, to which he succumbed in 1907.

French, on the other hand, was happy to take on the project. After Saint-Gaudens turned down the commission, Gilbert invited French to do all four groups, now stating that this would enhance the building's stylistic unity.[20] A less volatile and more efficient worker than Saint-Gaudens, French expressed pleasure in taking on the job, but was also hesitant about finishing four huge groups within two years' time. Gilbert, clearly anxious not to end up with somebody less competent, went immediately to Taylor, who succeeded in twisting the specifications to give French a one-year extension. French then accepted the commission. Throughout the project he would receive exceptional treatment as a member of the top echelon of the professional coterie. He began work on his one-quarter-size sketches immediately and continued to work on them through that spring.

Gilbert next turned his attention to hiring sculptors to do what had now become twelve attic figures and the cartouche. Meanwhile, the artists who had already heard about these choice commissions began to follow their own common but unacknowledged procedure—using the old-boy system and informally caucusing. Prominent sculptors wrote Gilbert on behalf of favored assistants. As soon as Gilbert had been confirmed as architect, for example, MacMonnies wrote to suggest that he select Janet Scudder; Saint-Gaudens proposed François Tonetti, John Flanagan, and his own brother Louis.[21] Lesser-known sculptors without influential patrons wrote gentlemanly letters to recommend themselves.[22] The most poignant example was a letter written on his own behalf by the unlucky Fernando Miranda, the Spanish-American sculptor who had protested about favoritism in the Appellate Courthouse commissions. In his letter, dated long after the assignments were made, Miranda first complained to Gilbert that Gilbert was too inaccessible, then stated proudly that both French and Saint-Gaudens could provide references. If he were just given the chance to submit sketches for work on the Customs House, he assured the architect, Miranda would demonstrate his ability "to produce the real representation of the true Spain in every particular." "You can be sure," he continued, "no anachronisms or ignorance will mar such a work wich [sic] is to remain forever standing before the public and the people of these nations."[23]

Frederick Ruckstull was also among those who wrote, but his approach differed from the rest of the sculptors. For even here, in a situation where he had to show deference in asking a favor, Ruckstull persisted in trying to strengthen the status of his profession. Although well aware that his position and talent did not approach that of a Saint-Gaudens or a French, Ruckstull refused to be obsequi-

ous; he continually sought to remind the architect of how active a role he and other sculptors played in the larger cultural picture.

After a wrenching experience with the upcoming Saint Louis Louisiana Purchase Exposition, Ruckstull was leaving New York for Paris "indefinitely" and was looking for work. He knew that Gilbert was well aware of the cause of his distress, and hoped to take advantage of the situation. The previous December (1902), Ruckstull, then director of sculpture for the Saint Louis Exposition, had resigned after a blowup with the exposition's president Isaac Taylor, with whom Gilbert, one of the fair's architects, had also had bad dealings. First, Taylor had accused Ruckstull of allotting himself too much of the work. Then, without consulting the architects, he had forced Ruckstull to eliminate some of the sculpture planned for the fair buildings. Ruckstull's letter to Gilbert reminded him of these events. The sculptor then remarked quite candidly that he felt the right to ask for a commission because, as he put it, had he merely looked out for his own interests in Saint Louis and capitulated to Taylor, Taylor would have "mutilated" the architects' creations—including those of Cass Gilbert. Now, should Ruckstull be "punished and left out in the cold as a reward?" No, the sculptor replied rhetorically, he could not *possibly* imagine that Gilbert would allow himself to be influenced by Ruckstull's "enemies."[24]

Gilbert clearly had some sympathy for Ruckstull; in 1904 the architect would file suit against Isaac Taylor and the exposition company in United States Circuit Court. And when Gilbert selected the sculptors around June 11, Ruckstull became one of those chosen. Gilbert insisted to Ruckstull emphatically that the matter of the Saint Louis Exposition had in no way influenced his decision.[25] But although Gilbert sought to act objectively, Ruckstull reminded him in effect that the selection process was not based solely on aesthetic criteria, but involved other considerations as well. Undoubtedly to Gilbert's annoyance, Ruckstull continued to refer to the Saint Louis incident in his Customs House correspondence. One time he commended the architect, "You and the rest of the architects have all been treated like dumb driven cattle by that bloated, hydrocephalic hippopotamus in the shape of a human being."[26]

Seven other sculptors were chosen to create the eleven remaining attic figures. In addition to Ruckstull (*Phoenicia*), they were: Frank Edwin Elwell (*Greece* and *Rome*); Augustus Lukeman (*Genoa*); François Tonetti (*Venice* and *Spain*); Louis Saint-Gaudens (*Holland* and *Portugal*); Johannes Gelert (*Denmark*); Albert Jaegers (*Germany*); Charles Grafly (*England* and *France*). According to Gilbert,

their sculpted personifications would represent those nations that at one time had "influenced the progress of the world by commerce on the sea or by naval power."[27] The architect stipulated the subjects and indicated where each would stand on the building. He also suggested the basic direction each composition should take.[28]

Once having made his selections, the architect instructed Peirce to draw up contracts and arrange to furnish each sculptor with light Tennessee marble for carving the figures.[29] As was usually the case with federal projects, nothing in the sculptors' contracts was left to chance, reflecting federal government practices of spelling out procedures and responsibilities. Artists would receive no payments until all sketch and full-size models were delivered—first to the architect, then to the supervising architect—and approved by them both.[30] At the same time, the contracts covered both the modeling and carving; the sculptor was responsible for executing both, just as the artists preferred. Gilbert reasoned that this way the sculptors could have no cause for complaint either about the "progress of the work or the satisfactory quality of the carving."[31]

The preferential treatment accorded sculptors as professionals produced tensions between them and the general contractor. This led to further disagreements between Peirce and Gilbert. From Peirce's point of view, sculptors and modelers, whatever their artistic capacities, were subcontractors, and he was responsible for seeing that they got their job done. Everyone was considered a worker on this same basis. Thus to cover himself and his expenses, Peirce had inserted a bond requirement into the contracts of all subcontractors, including the sculptors. Several artists strongly objected to this method. Louis Saint-Gaudens, probably on the recommendation of his brother, even refused to take on the work under the circumstances.[32] The sculptors argued that the bond imposed a financial hardship; since they worked as individuals rather than as paid employees for a large company, they had little capital with which to pay expenses. Undoubtedly they also considered it demeaning to accept a labor practice that equated their creative work with mere craft or labor.

As a fellow professional, Gilbert sympathized with the sculptors' plight. On hearing about their problem, he suggested that Peirce retain 10 percent from the sculptors' first payment instead of forcing them to lay out a large sum of bond money all at once. The contractor responded that this was not feasible. The purpose of the bond, he said, was not to compensate the contractor for time lost if a sculptor did not complete his work punctually, but rather to "impress upon the

sculptor the necessity of having his work done on time." Moreover, he argued, the fact that the sculptors hesitated to give bond seemed to indicate doubt about their ability to get the job done promptly. If the government were so concerned about artistic quality, he stated, then it would make "concessions" to the sculptors. In fact, he suggested, the government would do well to take the matter out of Peirce's hands and negotiate directly with the artists.[33] This was not done, but the matter of bonds was apparently resolved in a manner that satisfied the artists.

New problems arose over the sculptors' payments. Peirce did not want to pay the sculptors until he knew when he himself would get paid for the sculptural work. Once again, Gilbert, now extremely annoyed with the contractor, intervened to ensure that the sculptors would be reimbursed for some of their labor and expenses. He went back to Supervising Architect Taylor and made payment requests on the sculptors' behalf. Taylor, trying to be accommodating to Gilbert, said he was open to suggestions as to how to help the sculptors in such a way that the federal government would still remain protected.[34] When Peirce tried to argue that the answer was for the government to pay him more money in advance, Gilbert warned Taylor not to accede to such a request, and Taylor informed Peirce that he would not be paid until all the sculpture had been placed on the building. Taylor argued to Peirce that the specifications had been set up to protect the federal government, not to relieve contractors of a financial burden. The government would not pay out without getting any "actual return" for its money.[35]

Gilbert sided with the sculptors in both the bond and the payment disputes. Clearly, Taylor was also sympathetic to Gilbert's belief that the sculptors should not be subject to the same kinds of restrictions—that the government could be flexible when dealing with professionals of integrity in pursuit of the highest artistic goals. Peirce thus decided that the best way to get what he wanted was to play Taylor's and Gilbert's professional game. Writing back to the architect, he justified his requests less in terms of his own economic needs than in terms of the need to reconcile the creative process and the exigencies of construction work. Peirce drew attention to the fact that the sculptors' art required preliminary studies and plaster casts to be made long before the final architectural sculpture was completed. The artists, "rich in talent but poor in the world's goods," could not afford to do this work without being paid, and therefore the general contractor had to advance them some money. The only other alternative, he threatened, was to contract with other sculptors who could afford to pay for their materials and labor. Unfortunately, however, these artists might not be those whom

the architect originally selected. The quality of the sculptural work might be compromised.[36]

This tactic worked better. Gilbert again relayed Peirce's requests to the Treasury and to the supervising architect. At first the comptroller of the Treasury resisted, turning down any modifications in Peirce's contract that would allow him to pay for sculpture work that had not been set in place and accepted. But Peirce's argument proved successful in the long run. In January 1904 the Treasury Department agreed to give him an extra sum to pay for the sculptors' models as they progressed. But Taylor continued to refuse payments for any of the carving until the statues stood in place. Since the sculptors were also responsible for getting the carving done and this expense was 50 percent of their total charges, the artists were still compelled to assume primary responsibility for completing the work on schedule.[37] They still had to incur considerable expense, but the Treasury's concessions did relieve some of them of a portion of the financial burden. Equally important, the agreement expressed respect for the sculptors' capabilities and artistic stature on the part of the architect and the government. This expression of professional kinship and confidence did not extend to the general contractor.

With the procedures finally worked out, the sculptors could move ahead with their work. In November 1903, about six months after he selected the artists, Gilbert had visited their studios to inspect their eighteen-inch maquettes, on the basis of which they would receive their first payments. From this point on, most of the sculptors spent their time perfecting their models, enlarging them from one quarter to half size, and having them cast in plaster with the help of assistants (fig. 6.2).[38]

The majority of sculptors preferred to work independently, and had little contact with the architect. Ruckstull was an exception. Although he followed the same basic technical procedures as the other sculptors, Ruckstull did not retire into the role of invisible worker. Feeling marginal, he persistently kept himself and his work in the architect's eye.

Since he lived abroad at the time, Ruckstull felt special need to remind Gilbert of his participation and interest. Thus in several long, typewritten letters, he offered Gilbert his opinions and questions on sculptural matters ranging from design and iconography to labor and installation. Where would his statue be placed, he wanted to know. Which sculptors would be making the figures next to his? Did the work *really* have to be done in New York? Could Gilbert send a sketch of the sorts of details he wanted included? Should there be laurel leaves? Should

the drapery have large or small, "classic" folds? Should it be "flowing" or straight?[39] Ruckstull continued: he himself had definite ideas about such matters; he had already made suggestions to James Brown Lord about the sculpture for the Appellate Courthouse. Now, Ruckstull intimated, he was willing to offer similar advice to Gilbert. Gilbert had made his building classic, the sculptor observed; maybe he might want the statues to be "severely" classic too.

Then, as if suddenly conscious that the presumptuous tones of his letter overstepped the bounds of appropriate professional hierarchy and protocol, he de-

6.2
François M. L. Tonetti, *Venice*, model for facade of United States Customs House, 1904. (Courtesy of the New-York Historical Society, New York City.)

ferred: perhaps Gilbert wanted severely classic statues, but then, perhaps he did not; "it remains for you to say. . . . [I]t is you who must finally decide about the mass and silhouette of all the sculpture as those factors of the building are part of your poem and I have learned how to follow as well as to lead. I am following now." [40]

Having now acknowledged his subordinate position, Ruckstull continued to write elaborate, rambling accounts of *Phoenicia* (fig. 6.3) in progress, always reminding the architect that he, the sculptor, was playing the professional game.

I have about half completed my working model. It shows a tall, powerful woman, with a slightly Semitic face—the Phenicians, you know, were a Semitic people—holding a classic boat before her, as in my sketch in your office. Only, she holds it a trifle higher and farther forward as if in the act of showing it to mankind. . . . I have copied, almost entirely, the Greco-Phenician head-dress you like so much, with the two discs at the sides. And it looks fine. As the Phenicians were at once a trading and fighting people, I have put a short cuirass on the upper torso of the woman with the two discs on the breasts that you suggest. The rest of the drapery I will make almost exactly as you suggest. . . . The pillars I shall set back behind her more than in your sketch—to suggest her passing *beyond* the Pillars of Hercules. The Pillars you suggest are not Phenician. They are Persian. Of course you know this. But I think it would be a mistake to introduce a Persian motive that was not invented until the Phenician people, as such, had practically ceased to exist. We would lay ourselves open to the needless criticism of the "art critics" who know so much and so little. . . .

Would you kindly compose, and send to me as soon as you possibly can, a pillar having the monolithic and grand characters that the words Pillars of Hercules would evoke, in men of imagination. . . . I would not suggest to you the labor of composing a pillar but for the fact that any pillar I might compose might not please you; and it is time saved for both of us to have you compose it at once—to satisfy *you*.[41]

Ruckstull's style of activity was bound up with his religious background. His experience as a former Baptist theological student had endowed him with a strong sense of mission as a sculptor for whom public art had special moral and inspirational significance. Moreover, Ruckstull was wary of sculptors becoming too complacent. Artists could not afford to fade into the background, he later wrote.[42] Organization, publicity, and active crusading were necessary to attain and maintain their goals. Ruckstull believed that only such an activist stance could assure delivery of the appropriate sculptural message (hence his ongoing discussions about iconographic detail in the letter above and in others). He believed in preaching relentlessly the value of municipal art. Only by doing so would sculptors continue to enjoy the kinds of privileges as artists that they experienced with the Appellate Courthouse and with this commission. It was these convictions,

along with his keen political instinct, that led Ruckstull to proselytize the importance of civic sculpture with the evangelical fervor that he had absorbed as a student for the ministry. As will become evident later, Ruckstull's concerns about publicity were correct.

The activities of Ruckstull's colleagues would suggest that they harbored no such obvious doubts about their position. They were occupied with the exigencies of the moment: finishing up their models according to schedule. Once again, however, just as with the Appellate Courthouse, several unforeseen difficulties delayed completion of their works.[43] Just as before, there were problems with the stone. According to Peirce, the sculptors' models turned out to be too big for the size of stone ordered; the quarries were overwhelmed with the size of the order, and as a consequence the marble was delivered late.[44] Thus while French, for example, had completed three of his half-size plaster models by November 1904, no marble arrived at the shop of the Piccirillis, his carvers, until seven months later (June 1905), and the blocks that finally did arrive there were flawed. The contractor had to place a new order, the last portion of which the Piccirillis did not even receive until June 1906—six months after the expiration of French's contract.[45] In addition, general strikes halted construction of the Customs House all during the winter of 1903–1904 and then again in 1906. All of these factors led to new disputes between the sculptors and Peirce, especially when the contractor, under tremendous pressure to finish, tried to force the artists to let him install their statues before they felt they were ready.[46]

By 1907, however, all of the sculptural work was finally in place. Although fraught with complications and delays, the complex process had nonetheless been completed successfully. In its commanding and central location, the new Customs House and its sculptures became the focus of much favorable public attention.[47] Indeed, the lavish decorative program was hailed as a particularly appropriate expression of American commercial glory, as a conspicuous display of the forces that had made the United States a great nation.

In keeping with this theme, the twelve attic figures (fig. 6.4) represented elaborate emblematic personifications of historically significant seafaring nations at the foundation of American commercial progress. Elwell had depicted Greece as Pallas Athena and Rome as a soldier of Caesar's time; Ruckstull completed *Phoenicia* as he had described her in his 1904 letter to Gilbert; Lukeman had modeled *Genoa* as a Christopher Columbus; Tonetti had shown Spain as Queen Isabella displaying on a globe "the new continent she has given to the world" and *Venice*

as a doge in robes of state (fig. 6.2); Louis Saint Gaudens represented Holland as Admiral Van Trumo (a Dutch adventurer from the Knickerbocker period); his *Portugal*, a knight in armor, was Prince Henry the Navigator; Gelert created a Viking woman as *Denmark*; Jaegers's *Germany* (before it was altered to represent Belgium in 1918) was a woman leaning on an antique shield inscribed "Kiel" (the insignia of Kaiser Wilhelm); Charles Grafly depicted France as a female figure holding a small statue symbolizing the fine arts, England as Queen Victoria with the wand of Hermes. And, between the balustrades above, Bitter's two winged

6.4
Cass Gilbert, architect, United States Customs House, looking south to Bowling Green from Broadway, 1900–1907. (Photo ca. 1912. Courtesy of the New-York Historical Society, New York City.)

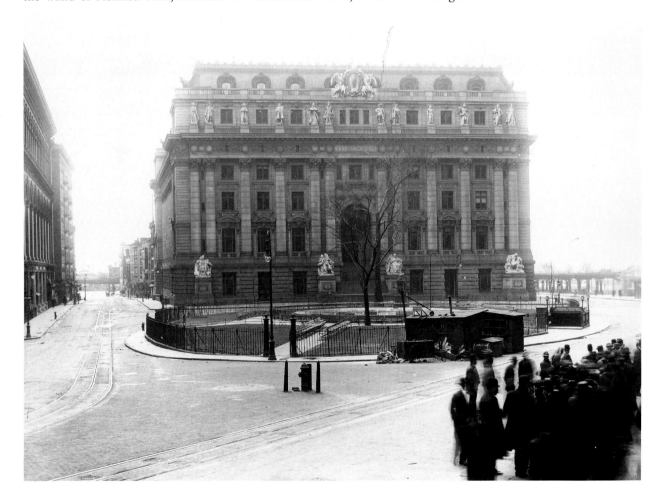

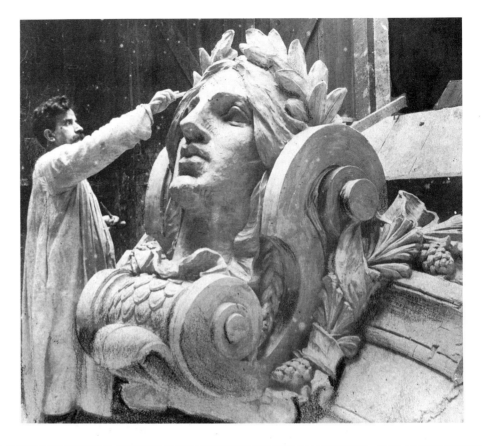

women—one with a sheathed sword portraying the nation at peace, one with fasces symbolizing force and strength—supports an ornamental shield of America. Together these figures represented the common perception that the history of America, a major international power, now incorporated the history of the world.[48]

The decorative ornament created by the modelers was also blatantly nationalistic. In addition to heads depicting the races of man, the keystone head over the central arch represented Mercury, god of commerce. Another depicted "Columbia" (fig. 6.5). The lions' heads in the panel above were cougars, "American lions." The arms of New York City (with windmill and beaver) were depicted in a panel over the vestibule door. All of the carved ornaments were American flora

and fauna: longleaf pine, oak and laurel, sea plants and shells. The snail, Gilbert noted at a later date, was suggested as a humorous though "of course" unjust reference to the "progress of government business: Red tape was omitted for obvious reasons," he continued jokingly, "though a little of it is suggested in the fillets around one or two of the minor heads."[49]

Not unexpectedly, however, it was French's elaborate *Four Continents* groups that received the greatest amount of publicity and praise.[50] In addition to symbolizing the individual continents, the artist extended the significations of his groups through a system of hierarchical contrasts. These encompassed the realms of both commerce and culture. They contrasted such concepts as primitive/civilized, East/West, past/progress, other races/Caucasian. The chauvinistic beliefs French expressed, although considered repugnant today, were quite pervasive (among whites) at the time.

In 1916 Gilbert provided a detailed "reading" of the symbolism of the *Continents* in which these widely assumed stereotypes were made clear. Whereas, in Gilbert's words, "calm" and "impassive" *Asia* (fig. 6.6) has to her left a group of "toiling prostrate figures representing the masses of humanity borne down by superstition, tyranny and oppression," the "whole aspect" of *Europe* (fig. 6.7), shown as "an Imperial figure of the highest intelligence, . . . is one of high civilization, great luxury, intellectuality and power." *America* (fig. 6.8), holding a "torch of Progress," is a "beautiful, alert, young female figure, rising to meet new conditions of civilization, eager for advancement in all that makes for peace and happiness." Rising "to meet the future," she crushes a "forgotten fragment of Aztec Sculpture, symbol of prehistoric civilization." By contrast, *Africa* (fig. 6.9) is shown asleep, with her left arm resting "upon the head of the sleeping lion, some day perhaps to awake with all the power of brute force. . . . Behind her is a heavily draped and cowled figure, mystical, veiled, contemplative and impenetrable."[51]

The United States Customs House, linked with the symbols and activities of the federal government and with the supposed beliefs and values of the country as a whole, was congruent with the professional and nationalist aims of the sculptors. The same federal control and protection that made possible the imposition of the tariff had also helped to ensure their work's successful completion.[52] Just as important for the sculptors, the Customs House project had worked well both because many artists were involved and because they were accorded a reasonable

6.6
Daniel Chester French, *Asia*, half-size model for the United States Customs House 1904. (Photo, A. B. Bogart, ca. 1906. Courtesy of the New-York Historical Society, New York City.)

Cass Gilbert described *Asia* as "calm and serene in itself . . . surrounded by symbols illustrative of the Sculptor's conception of the ancient civilization of the Continent; the costume obviously oriental, the face impassive, the throne resting upon the skulls of dead humanity. . . . To the right the tiger, beast of the jungle significant of the power of evil, seeking its prey by night, furtive yet powerful, freer than humanity itself, but subordinated also to the calm cynical intellectual power of the central figure, looks questioningly up into the face of 'Asia.' In the lap of the central figure is the idol, symbol of false worship, while above the right shoulder of the figure is seen the rising luminous cross of Christianity, symbol of hope, which found its birth place on the continent of Asia." Gilbert to Grant M. Overton, 24 August 1916, United States Customs House Papers, Cass Gilbert Papers, the New-York Historical Society.

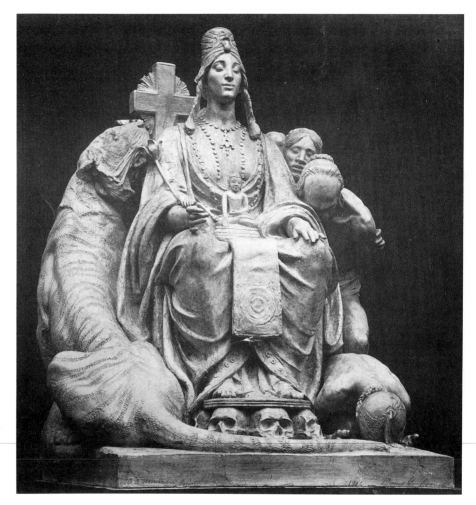

amount of autonomy and professional respect. This experience confirmed to many sculptors yet again that when given the chance and proper treatment, they could meet the challenge of creating work that expressed national ideals and embellished New York City.

The adornment of government structures hinged upon sculptors' ability to work with architects, politicians, and bureaucrats who shared their convictions about the prestige and educational significance of architectural sculpture created

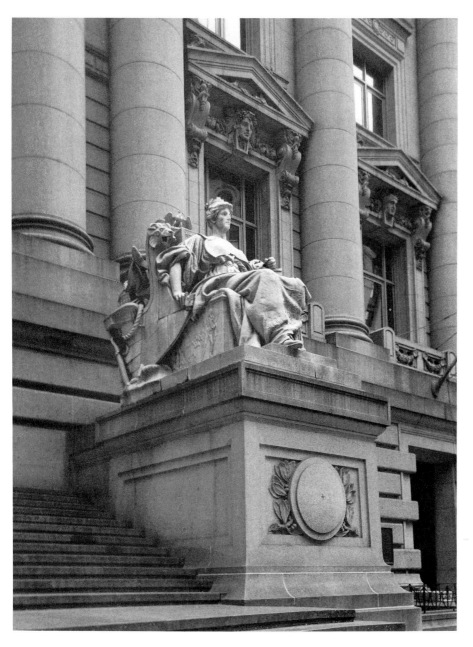

6.7
Daniel Chester French, *Europe*,
United States Customs House,
1907. (Photo, Michele H. Bogart.)

Europe, according to Cass Gilbert, "is enthroned upon a seat of classic design, the sides of which bear sculptured figures from the frieze of the Parthenon. She rests her right arm upon a bound volume of laws supported by the globe, over which her modern system of law and civilization has spread. At her right are the prows of the ships of the adventurous Norse discoverers. Rising behind the figure is the Roman Eagle, symbol of empire. Upon the border of her robe are embroidered arms armorial (symbols of sovereignty), of the great dominating nations of the old world." Gilbert to Grant M. Overton, 24 August 1916, United States Customs House Papers, Cass Gilbert Papers, the New-York Historical Society.

6.8
Daniel Chester French, *America*,
United States Customs House,
1907. (Photo, Michele H. Bogart.)

"America is represented as a beauti-
ful, alert, young female figure . . .
eager for advancement in all that
makes for peace and happiness."
Her left hand "throws back the
robe as though eager to cast aside
whatever might impede her upward
and forward movement. . . . At her
left side is a kneeling male figure,
setting in motion the winged wheel
of commerce; while in the back-
ground, seen over her right shoul-
der, is the figure of an American
Indian. The bundle of fagots in her
lap may perhaps represent the bind-
ing together of the races or of the
states that individually would be
weak but collectively are strong.
America is young, vital, forceful and
beautiful. The future is her own."
Gilbert to Grant M. Overton, 24
August 1916, United States Cus-
toms House Papers, Cass Gilbert
Papers, the New-York Historical
Society.

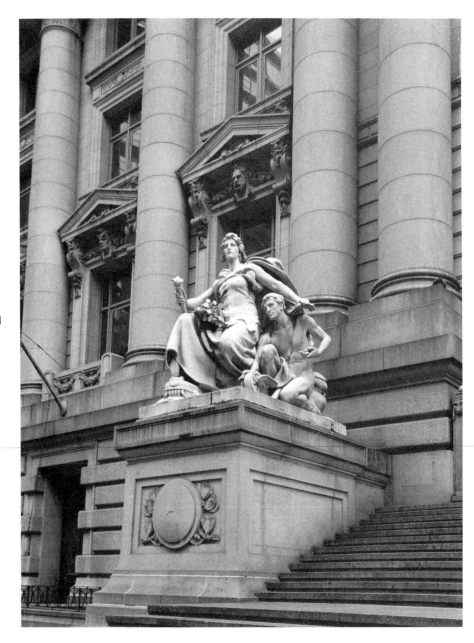

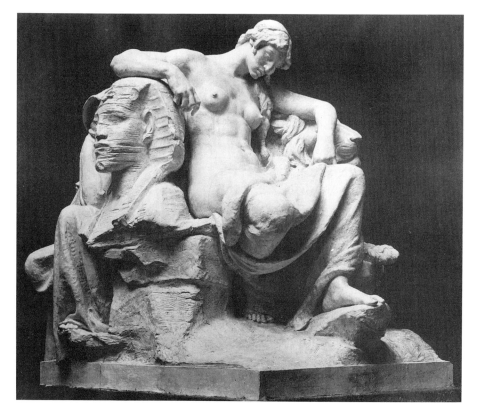

6.9
Daniel Chester French, *Africa*, half-size model for the United States Customs House, 1904. (Photo, A. B. Bogart, ca. 1906. Courtesy of the New-York Historical Society, New York City.)

For Cass Gilbert, Africa is "somnolent in every line of her figure. Her right arm rests upon the head of the silent sphinx, remnant of the art of by-gone time." Gilbert to Grant M. Overton, 24 August 1916, United States Customs House Papers, Cass Gilbert Papers, the New-York Historical Society.

by expert hands. From many artists' standpoint, official willingness to bend the rules was necessary to assure professional control and hence aesthetic quality. As the next chapter will indicate, such cooperation was not a foregone conclusion, especially when it came to municipal projects executed during Tammany-controlled administrations.

7

Sculptors and Tammany Hall:
The New York City Hall of Records

The federal bureaucratic approach shown with the United States Customs House commission contrasted sharply with the New York City Hall of Records and its sordid background of municipal politics. The building of the Customs House, despite delays and complications, followed the basic requirements and organizational procedures specified by the federal government. One architect controlled the project. The designs included an impressive sculptural program; and the architect, responsive to the artists' concerns, sought to ensure that the creative process would proceed without hindrance and result in works of excellence.

The Hall of Records (fig. 7.1), one of Greater New York's first major building projects, began with similarly high hopes. It was to be erected as a repository for the city's real estate records and other important documents. Its very existence was to be a sign of good, honest government. As planned by the architect, the building would express this ideal in architectural and sculptural terms. Indeed, City Beautiful advocates and reformers viewed the designs, created by John R. Thomas, as an appropriate beginning to what they envisioned as a revitalized, reconstructed civic center.

But such would not be the case. Much of New York's artistic community considered the Hall of Records project an unmitigated disaster, especially after the triumphs of the Appellate Courthouse and *Dewey Arch*. An aura of absurdity surrounded the construction process, which was plagued by political corruption and bureaucratic chaos. Both sculptors and reformers considered the Hall of Records a project that did not work, and an expression of the worst artistic politics. Sculptors were pitted against themselves, urban elites, and municipal politicians in an unsuccessful power struggle. The case reveals the many obstacles sculptors

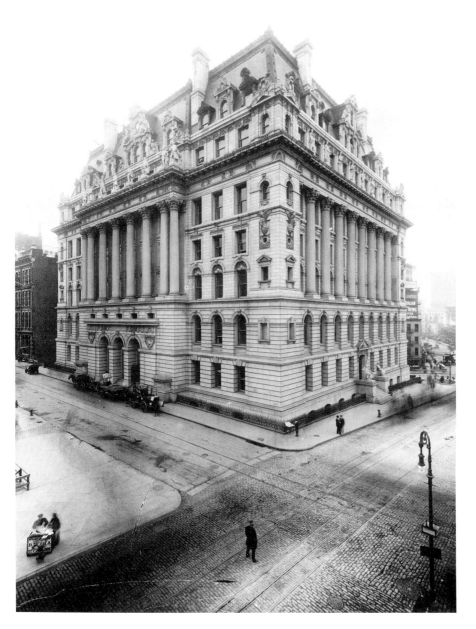

7.1
John Thomas, and Horgan and Slattery, New York City Hall of Records, view from Chambers and Centre Streets, 1899–1911. (Photo before 1907. Courtesy of the New-York Historical Society, New York City.)

Chambers Street (south) facade, sixth story dormer windows: Henry Kirke Bush-Brown, *Maternity* (left), *Heritage* (right), *Poetry*, *Philosophy*. Caryatids: Albert Weinert, *Spring*, *Summer*, *Autumn*, *Winter*. Centre Street (east): Philip Martiny, (entrance) *Equity*, *Justice*; (north to south) *Architecture*, *Music*, *Industrial Art*, *Navigation*, *Commerce*, *Industry*, *Medicine*, *Chemistry*; central dormer: Henry Kirke Bush-Brown, *Recorder*, *Keeper of the Rolls*. Reade Street (north) side: Philip Martiny, *Justice*, *Electricity*, *Printing*, *Force*, *Tradition*, *The Iron Age*, *Painting*, and *Sculpture*.

faced and could not overcome when the architect and the authorities in control were not sympathetic to elite professional priorities. It also indicates how municipal government could either facilitate or obstruct the implementation of civic architectural sculpture even at a time when, because of the recent consolidation of Greater New York, the limits of its powers were uncertain.

Although no architect was hired for the Hall of Records until 1897, interest in such a building began as far back as 1871. A grand jury condemned its predecessor, built before the Revolution as a debtors' prison, on the grounds that it was not sufficiently fireproof and hence "valuable documents were in danger."[1] The intimation was that the Tweed administration had found it "convenient" to store government records where they might, at some future date, be easily destroyed. In fact, many documents had decayed over the years. Lawyers began to agitate for a new building that would better preserve titles to $4 billion in city real estate, along with other municipal documents.[2] In November 1896 a three-thousand-member Hall of Records Association was formed to lobby the city for a new building. As a result of its efforts the state legislature authorized the city to build a new structure on the Chambers Street site then occupied by the old jail.[3]

The process of securing an architect did not begin auspiciously. The first problem arose in May 1897 when Mayor Josiah Strong and the commissioners of the Sinking Fund appointed John R. Thomas as architect without holding a competition. Thomas (1848–1901) already had a good reputation among New York politicians. As early as 1874 he had been summoned by the governor of New York State to construct a state penitentiary in Elmira, and his efficiency and integrity saved the state about $1 million. His work in New York City included designs for the Squadron A Armory (Madison Avenue between 94th and 95th streets) and the expansion of the New York Stock Exchange.[4] Thomas had won an 1893 competition for a new city hall, but this project had been abandoned. In the wake of the Lexow investigations, which had uncovered widespread municipal corruption, Strong (who had been elected on a reform platform) decided it would be prudent to save time, trouble, and money, and to compensate Thomas, by giving him the Hall of Records commission instead.[5] The architect would simply adapt the designs the city had already paid for.

On learning of Thomas's selection, the New York Chapter of the American Institute of Architects passed a resolution calling upon city officials to hold an architectural competition and to consult with architects of the "highest reputa-

tion" in doing so. As the *New York Times* put it, good results could not be assured "where direct appointment of the architect is made by officials representative of the people."[6] Although the AIA architects had no objections to Thomas as a designer, they were upset about the way the city was handling the procedures. The commissioners ignored the architects' recommendation. In the meantime, Thomas selected John Peirce as contractor, and in December Peirce signed a contract with the commissioner of public works.[7]

Thomas outlined designs for an ornate nine-story French Renaissance structure with a steep mansard roof. The building was to have a two-story-high triple-arched entrance with a line of Corinthian columns extending from the third to the sixth stories, and colonnades extending around all three sides. He also planned an extensive three-tiered sculptural scheme for the new building: works on the lowest story would be "historical," meaning they would offer "types of mankind," and show the "various races and nations composing the inhabitants of Manhattan at different epochs."[8] The second level would consist of portraits of distinguished men in the city's history, and the statues on the uppermost level, above the eaves, would be "symbolical"—ideal figures representing city activities.[9]

Not long after his selection as architect, Thomas gave the contract for the sixteen sculptures on the roof story to Henry Kirke Bush-Brown (1857–1935).[10] These works—along with materials for the foundations, basement, and walls—were included in the contractor's general estimate of $1,997,000 for exterior construction. According to the *Times*, "somebody" (probably a representative of the Municipal Art Society or the NSS) told the architect that it was neither good artistic nor political policy to give out commissions for this amount of sculpture to just one person. Moreover, the sculptors tried to warn him, the inclusion of sculpture in the general construction estimate was very likely to cause problems, since expense rather than artistic quality was likely to be the primary concern.[11] A few of the caryatids were subsequently contracted or subcontracted out to a decorative sculptor, Albert Weinert. But as far as the sculptors were concerned, the word came too late.

Sensitive to the fact that the method of his own selection had already alienated the architects, Thomas set out to mend fences with the city's other professional art groups. He tried especially to cooperate with the sculptors. The *New York Times* reported that Thomas expressed regret about his "oversight" in not having consulted them from the outset. He asked an NSS committee to advise him, and

he planned to delegate the society to oversee a competition to produce the rest of the sculpture. The result, he predicted, would be a building with "decoration in marble and bronze second to no structure in the land."[12]

But other problems began to arise in 1898, when a Tammany administration, headed by Mayor Robert Van Wyck, came into office. Like their predecessors in the Tweed era, turn-of-the-century Tammany officials had little liking for a municipal department that would preserve and make available the records of their activities. Van Wyck also did not wish to facilitate the efforts of artists, businessmen, and Republican politicians attempting to transform the City Hall area into a costly monumental plaza in the "classical" European manner. Moreover, he disliked the idea of having such a large contract executed during his administration, yet not under his control: not even the architect and contractor were his choices. The Hall of Records project offered too many opportunities for Tammany to exercise its own patronage. Thus "questions" soon arose as to whether the city could borrow the money to pay for the building so soon after the consolidation of Greater New York.[13]

Once assured that the money was indeed available, Van Wyck sought to change the architect's designs, and to get his own men onto the project.[14] After several unsuccessful attempts, Van Wyck enlisted a Tammany firm, Horgan and Slattery, to study Thomas's drawings to determine whether the project (estimated to cost more than a lofty $4 million) really had to be so expensive.[15] This firm had a reputation in professional circles for dragging out projects in order to collect large fees. A disparaging comment in the *Times* was that "if a scow of the Street Cleaning Department needed repairing Horgan and Slattery would supervise the work and get the usual fees."[16] Horgan and Slattery reported that Thomas could easily cut the $2.5 million estimated cost of the building's interior to $1.5 million. Van Wyck ordered the architect to change his designs to save money, and Thomas had no alternative but to comply. Throughout 1900, the mayor persisted unsuccessfully in his attempts to get control of the construction contracts.[17]

But in August 1901 Thomas died, leaving behind a complete set of drawings that the contractor easily could have used to finish the building expeditiously.[18] Instead, Mayor Van Wyck pushed through a resolution, over the vigorous opposition of Borough President Guggenheimer and Comptroller Coler, appointing Horgan and Slattery to oversee the completion of the Hall of Records. The 550-day time limit originally set for completion was abolished, and the firm now estimated that the building would cost $6 million, about $2,101,000 more than

Thomas and Peirce initially anticipated.[19] The Thomas family promptly sued the city on the grounds that the "reputation of the architect might be affected by the methods of the new contractors," whom they claimed "might add spires or columns or other features" Thomas had not planned, even "though his name would be listed on the cornerstone as the architect."[20]

A reform administration, headed by Seth Low, won the November 1901 mayoral election. Although he tried to oust all Tammany appointees from municipal offices, Low did not believe that he could remove Horgan and Slattery from the Hall of Records job, for—as he explained—they had signed valid contracts with the city, and that settled the matter.[21] But the mayor did call the new architects into his office and, according to the *Tribune*, insisted that they produce nothing but the "highest grade" of decoration. "Mr. Horgan," the *Tribune* reported with an irony that would soon be expressed by all sides, "is understood to have assured the Mayor that his firm would do its utmost to complete the building along artistic lines."[22]

The sculpture question had still not been resolved. Contracts originally signed between Thomas and Henry Kirke Bush-Brown and Albert Weinert remained intact, so they continued through late 1901 to prepare the figures and decorative caryatids for the roof sections of the building. As already mentioned, Thomas had intended to hold competitions for the rest of the sculpture and to hire several sculptors to do the work, in accord with NSS recommendations. Horgan and Slattery, however, had no intention of following the suggestions of the professional artists' groups. These had, after all, opposed the firm's appointment. Moreover, their stance epitomized the broader attempts of an intellectual elite to control the look and the culture of New York City. Instead of cooperating with the NSS and the Municipal Art Society, Horgan and Slattery rewrote the specifications. They now stated that the architects would choose the sculptors and carvers and would also direct the latter to finish the sculptures in whatever manner they saw fit. The contractors would pay the sculptor a total of $85,000 for the modeling, and would also pay for the carving (the amount was left unspecified).[23] Horgan and Slattery then hired one single sculptor, Philip Martiny (1858–1927), to model the entire rest of the Hall of Records statuary, a substantial amount of work.[24]

The city's art and cultural groups, especially the NSS, were appalled that Horgan and Slattery had given this enormous commission to just one person and had changed the specifications to boot. Although Martiny was a member of the NSS,

he was not considered a major talent. Had the NSS picked a single sculptor to do all of this work, Martiny would have not been their choice. The Alsatian-born sculptor was well known for his facility in making decorative allegorical figures, having made a name for himself at the World's Columbian Exposition by modeling numerous caryatids, cherubs, and other ideal creatures for several of the fair buildings at an extremely fast clip. Karl Bitter had diplomatically characterized Martiny's methods as unique: "He works with incredible rapidity and apparently with little reflection, but always with such an instinct for the right thing, decoratively speaking, that he rarely fails in his results."[25]

On the sculptors' behalf, the *New York Times* protested Horgan and Slattery's newest actions by contrasting the aesthetic spirit to manual craft, much as the artists often did. Bush-Brown remained well-regarded by his peers despite his earlier willingness to take on the earlier Hall of Records sculptural work. Reminding readers that he had already been put in the position of having to churn out figures, the *Times* commented:

The methods used to produce Mr. Bush-Brown's sculpture are those which obtain in ordinary office buildings whose owners are ambitious for decorations not too costly, not the work of sculptors of the first rank, not sculpture which has the touch of the individual, but a "good enough" article more or less reminiscent of things to be seen in Europe. . . . Sculpture is a fine art, and should be precious; the methods employed on this public building are such as to foster commercial machine-made art, groups and figures turned into granite by journeymen stone cutters, and for that reason bound to lose the finest quality of work by masters. It is a mistake. If in the sculptures by Bush-Brown we get good statuary, it is a matter for congratulations, but it does not warrant our permitting the city to be caught again in the same mistake.[26]

For a time it seemed that the art organizations might be too weak to check the architects. But there remained one form of protection: the Art Commission. By law, the commission had to approve all of the statuary for the Hall of Records, since they were works of art belonging to the city. Although the commission could not tell the architects or sculptors what to do, it could, through its power to disapprove, say what could not be done. At the expense of Bush-Brown and Martiny, the Hall of Records became a test of the Art Commission's authority and, consequently, that of the NSS and the cultural elite.

Bush-Brown, who had been working on his various models, began to submit photographs of them to the Art Commission in June 1902. First, the commission approved several groups for the dormers of the building. But tensions began to

mount two months later, when the commission suddenly began disapproving many of Bush-Brown's submissions, to drive home the point, as the *Times* later put it, "not that the sculptors selected are inferior, but that sculpture ordered wholesale cannot, in the nature of things, be the best that a good sculptor can supply."[27] Commission vice president and painter Frederick Dielman sniffed that Bush-Brown's *Industry* was "commonplace—very," and complained further that none of the figures looked as though they had even been designed specifically for this building—a major defect in architectural sculpture.[28]

The commissioners seemed to be looking for problems, and in fact the *Tribune* reported that some of them favored "open warfare" against Horgan and Slattery.[29] The Art Commission subcommittee assigned to this project turned down Bush-Brown's models of *Maternity*, *Philosophy*, *Poetry*, *Industry*, and *Commerce*, and rejected three separate models of *Heritage*, a nude male instructing a young child from a chart. The committee had disapproved his first submission

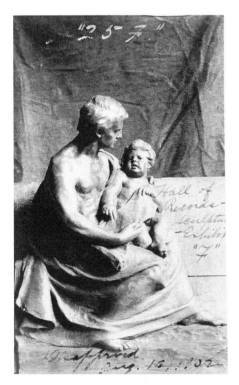 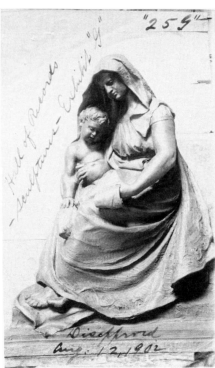

7.2
Henry Kirke Bush-Brown, models for *Heritage* (left) and *Maternity*, for New York City Hall of Records, 12 August 1902. (From the Collection of the Art Commission of the City of New York, Exhibition files 25-F and G.)

(fig. 7.2) in August 1902. In November they turned down a revised version (fig. 7.3) in which Bush-Brown generalized and downplayed the folds of drapery of the male figure, especially to his right, and shifted the position of the baby's head from its initial thrust-back pose of squirming childlike obstinacy to a softened lounging position. The male figure now sported a cap (possibly meant to be an antique helmet). But the commission also rejected this revised group, arguing that the hat now looked too "modern," and did not harmonize with the building.[30]

Such criticisms were consistent with the Art Commission members' general preference for "classical" simplicity and their distaste for ornate detail. While no one denied the primacy of the relationship between the sculptural silhouette and the architecture, some observers felt the commission's objections seemed overly strenuous. Not only was the figure to be positioned high on a dormer window in the roof above the sixth floor; it would stand against the background of the building rather than against the sky, meaning that its silhouette would not be as no-

7.3
Henry Kirke Bush-Brown, model for *Heritage*, for New York City Hall of Records, 11 November 1902. (From the Collection of the Art Commission of the City of New York, Exhibition file 25-N.)

ticeable. Since the commission's word was binding, Bush-Brown tried a more noticeably antique winged helmet, a solution the commission also rejected.[31]

Bush-Brown certainly thought the commission was being inordinately harsh. Although he probably had not wanted to publicize his opinions (it was not considered "good form" to complain), word began to "leak" from the sculptor's "friends" to the press that Bush-Brown felt that the commission was deliberately giving him a hard time.[32] Then, the next day, a new incident compounded Bush-Brown's frustration and embarrassment. The *Tribune* "reported" that Horgan and Slattery, tired of contending with the injustices rendered by the Art Commission, who "either consciously or unconsciously . . . are injecting politics into the situation with the intention of 'pounding' this firm," had sprung a "neat trap" on them. According to the *Tribune*'s account, Victor Slattery claimed that he had suggested that Bush-Brown "'try something by Michelangelo on them.' This he did by turning in some designs for gargoyles [purportedly from Saint Peter's in Rome], which the Art Commission duly 'disapproved,' as they did many other worthy productions from Mr. Bush-Brown."[33]

Slattery's reported actions were just a hoax. The Art Commission files show no record of any such "gargoyle" submission.[34] The Art Commission, the *Tribune* stated drolly, was "maintaining a dignified attitude."[35] The commission's president John DeWitt Warner denied the story of conflict in the next day's paper. He stated that nothing but the most "cordial" relations existed between the commission and Horgan and Slattery. In turn, Horgan and Slattery wrote to the commission to deny that anyone had met with reporters or "made any such statements as have been published" to the effect that the commission had delayed the Hall of Records work or that there had been friction.[36]

Bush-Brown, undoubtedly quite frustrated by this time, wrote to the commission in an ironically prim tone.

In view of late publications, I trust you will pardon my request for the facts as to my designs—submitted by Horgan and Slattery—for the new Hall of Records, and your action thereon. I need not say that the Michelangelo, Praxiteles, Da Vinci, etc. story . . . is wholly imaginary, so far as concerns anything I know or believe, and that these late publications were the first intimation I have had of any other than the most cordial relations between myself and the Art Commission or reason therefor.[37]

By 1905 the commission had approved all of Bush-Brown's models. The commission's disdain for the firm had, however, become obvious, and their communications with the architects just barely civil. When, for example, Horgan and

Slattery intimated that the commission was sitting on the approval requests for the designs of various sculptural decorations on the Centre Street elevation, Milo Maltbie, assistant secretary to the Art commission, replied icily that the Commission had to have some "design" before it, before "it may approve or disapprove." In other words, the architects' office did not even have the competence to enclose the materials to which their letter specifically referred. This manner of correspondence persisted throughout.[38]

The city's arts groups decided they ought to take action to prevent the complete mishandling of the Hall of Records decorations. The Fine Arts Federation exerted pressure on Horgan and Slattery by passing resolutions for the Art Commission that called for an elaborate, "consistent" (and expensive) program of exterior and interior decorations. They proposed a series of corridor murals costing in the neighborhood of $200,000. For the $6 million price tag the architects were now estimating, the city deserved a "lasting monument with an original scheme of sculpture and mural painting in keeping with its purpose and worthy of comparison with any building of equal importance in the world."[39]

The federation wanted to see Daniel Chester French involved in the plans for the exterior sculptural program. As chairman of a special committee on sculpture within the federation, French submitted a report with recommendations for the exterior sculpture. His proposals differed even from Thomas's original conception. Thomas had planned for most of the exterior sculpture to be carved in granite, with the Chambers Street groups in marble. French suggested that all groups below the sixth floor be bronze.[40]

French also proposed new ideas for the subject matter. In accord with Thomas's recommendation that the second level of sculpture consist of historical figures, French proposed that the twenty-four statues over the cornice above the sixth floor represent "historic personages"—maybe one from each decade, to represent the age of the city. Two groups at the Chambers Street entrance would represent the earliest settlers and inhabitants, the Indians and the "Hollanders." The two groups at Reade Street would show later settlers, the French and the English. He also recommended that twelve portrait reliefs and two six-foot-high figures be made for the building's interior.[41] Presumably French believed this strong emphasis on history to be appropriate for a building whose purpose was to protect records and documents. But there may have been an additional motive underlying French's proposals for such a sculptural scheme—one going beyond that of securing images in keeping with the building's purpose. Statues of "his-

torical personages," with their inherent need for accurate likenesses and detail, would require time and an outlay of money that few individual sculptors could afford if commissioned to do all of them. Ideally, at least several artists would be needed to execute the program successfully. French and the federation undoubtedly hoped that such a program, if accepted, would discourage the architects from persisting in giving all of the work to Martiny, whose forte was not historical figures. Finally, French stipulated that sculptors—not the architect or contractor—should supervise the execution of the work, no matter what the final medium. Sculptors had this authority in the production of the Appellate Courthouse and Customs House sculptures, and the results were successful. French hoped that Horgan and Slattery would follow this precedent.[42]

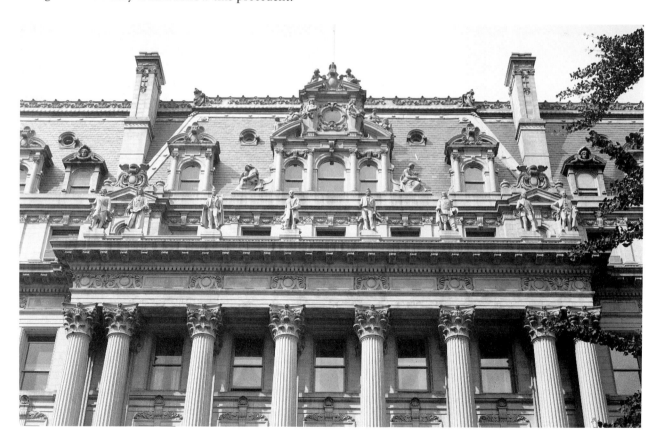

7.4
John Thomas, and Horgan and Slattery, architects, Philip Martiny and Henry Kirke Bush-Brown, sculptors, New York City Hall of Records, south facade, Chambers Street, 1899–1907. (Photo, Michele H. Bogart.)

The architects took little notice of these suggestions. They had been willing to retain the good-government emphasis of Thomas's original program, but they were not willing to capitulate further to the demands of the artistic opposition. They overruled French's recommendations that the works on the Reade Street side be cast in bronze, not carved in granite. They reduced the suggested twenty-four historic figures on the sixth-story level to eight statues depicting New York mayors and leaders. They decided that the rest of the figures, in addition to those above the eaves (which Thomas had outlined in his plan) would be "symbolical." And they maintained their contract with Martiny, who began to model both the historical portraits and the remaining allegorical statues.

The historical portraits were (from east to west) James Duane, Cadwallader Colden, Peter Stuyvesant, Phillip Hone, Abram Hewitt, DeWitt Clinton, Caleb Heathcote, and David DeVries (fig. 7.4). It is not known who selected these particular people. The portraits, examined in conjunction with the descriptions (that the architects or the sculptor himself probably wrote) accompanying the submissions to the Art Commission, took on emblematic significance as expressions of reason, scientific knowledge, honesty, shrewdness, culture, charity, improvement, cosmopolitanism, and negotiating talent. Together they represented the turn-of-the-century genteel conception of New York City's history and government, with the concern for the values and activities and achievements that paved the way for the city's progress. The submission forms in particular emphasized the contributions of these men to the expansion of the city, to technological and commercial advancement, to a well-defined government, and, especially, to the growth and development of civic institutions.[43]

Colonial and federal leaders represented the majority of those selected, a tendency in keeping with the prevailing view of American history as bound up exclusively with the Anglo-Dutch Protestant cultural heritage.[44] The fact that most of the men memorialized were early leaders seemed to indicate a desire to avoid any overt allusions to present politics. Hewitt, a former mayor who had associated with Tammany Democrats, Democratic reformers, Republicans, businessmen, and laborers, was the one recent city leader who had pleased everyone (fig. 7.5). Moreover, he had just died, in 1903, while Martiny was working on his models. Hewitt's image on the building became his memorial.[45]

Martiny's remaining figures over the entablature were to personify various city activities. These personifications—which included Sculpture, Chemistry, and Electricity—were basically the same figure with a few variations in pose and at-

7.5
Philip Martiny, full scale model for *Abram Hewitt*, for New York City Hall of Records, south facade, 2 June 1904. (From the Collection of the Art Commission of the City of New York, Exhibition file 25-BE.)

tributes (figs. 7.6, 7.7). (An exception was *Force*, depicted as a Herculean male.) In addition Martiny was to model two figures for Centre Street: *Equity* and, on the opposite side, *Justice* (fig. 7.1).[46]

While Irish-Americans like Horgan and Slattery would probably not have questioned the authenticity of the heritage immortalized in the Hall of Records sculptural program, they were probably conscious that its underlying ideology did not entirely represent their own interests or those of many New Yorkers, especially supporters of Tammany Hall. Nevertheless, the architects did not care to get engaged in disagreements about iconography. Thus, the exterior architectural sculpture as finally worked out was just as elaborate as Thomas originally planned it.[47] The basic thematic program varied in emphasis from that proposed by Thomas and French, but superficially at least, it was maintained.

Yet the program and the arrangements for carrying it out had important implications. In choosing to include more "ideal" allegorical personifications (which could connote present as well as past activities and events) and to reduce the number of historical portraits, Horgan and Slattery downplayed the symbolism and sense of threat that political groups like Tammany associated with the Hall of Records' intrinsic purpose: to protect city documents and to discourage cheating and corruption.

The architects further shunned NSS and genteel reform priorities and procedures by hiring just a single sculptor, and in particular by hiring Martiny, known for his ability to turn out virtually identical figures rapidly. The FAF and NSS had argued that several sculptors were necessary to achieve good results. Horgan and Slattery ignored these demands. By extension, they also rejected the elite ideology of professionalism expressed by the notion of "good" artistic techniques and results.

Martiny was to pay dearly for accepting this commission. In November 1903 he began to submit photographs of his models of the eight mayors and personifications to the Art Commission. There they met much the same fate as Bush-Brown's figures: the commission turned down all but three of his first twelve submissions. He encountered the most problems with his effigies of the civic leaders and mayors, particularly Mayor Hewitt's (fig. 7.5), which was rejected four times. Then the Hewitt family, who had initially approved the clay model, objected to "some small points about the hands and feet" in the plaster.[48] To make matters worse, the *American Architect and Building News* began to poke fun at the as yet

7.6
Philip Martiny, model for caryatid, *Chemistry*, for New York City Hall of Records, east facade, 2 June 1904. (From the Collection of the Art Commission of the City of New York, Exhibition file 25-DI.)

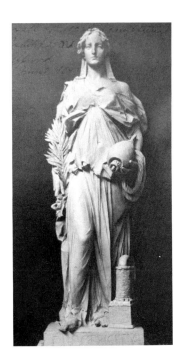

7.7
Philip Martiny, model for caryatid, *Electricity*, for New York City Hall of Records, north facade, 2 June 1904. (From the Collection of the Art Commission of the City of New York, Exhibition file 25-DU.)

unapproved statues, carping that the sculptor had given to the feet and legs of his portrait figures "an air of levity hardly in keeping with the character of the building." Were one to imagine a "theater-drop to have descended in front of the eight statues," the author noted, it would appear that six out of the eight pairs of legs were "busily engaged in doing a double shuffle or some other 'step.'"[49] In other words, the figures seemed too animated and thus insufficiently dignified. They were not subordinate to the general lines of the architecture.

Martiny fared better with the personifications; the commission approved most of them after some revisions of the first groups. But it held up approval of the *Equity* and *Justice* figures all through 1905. This meant that the general contractor, responsible for seeing the sculptures carved and placed, was falling increasingly behind in completing the work. This exacerbated tensions between him and the architects. Disgusted with the whole situation, Peirce, whom Horgan and Slattery had not wanted to keep on after Thomas's death in any case, refused to pay the sculptor the $13,800 owed him until the sculptor delivered *all* of his work. Martiny could not do that because the commission had still not passed the *Hewitt* and several of the other figures. When Horgan and Slattery pressured Peirce to pay Martiny, he responded that he could just not set up all but one of the statues. If the delay was the doing of the Art Commission, he wrote, Horgan and Slattery should bring the matter to its attention, "as the procedure thus far has been extremely unbusinesslike and unsatisfactory."[50]

The worst was yet to come. Martiny still had his two large groups for Chambers Street to complete. The subjects of these works accorded with Thomas's and the Fine Arts Federation's original recommendations that the groups refer to the function of the Hall of Records as the repository of the city's history. As with the eight civic leaders, these two groups—*Manhattan in Revolutionary Times* and *Manhattan in Dutch Times*—gave priority to New York's colonial heritage and the peaceful progression from primitive state to civilized entrepreneurial empire.[51]

The Art Commission was in no mood to accept Martiny's sketches for these groups. It was clear that they disliked the cluttered-looking work that the sculptor was doing. Their general frustrations with the handling of this entire commission only prejudiced them further.[52] Once again, committee members took their time in giving their decision, and then they responded unfavorably. The financially strapped Martiny submitted two more sets of revised and simplified sketches (fig. 7.8), only to have them also turned down by new committees.[53] While not legally

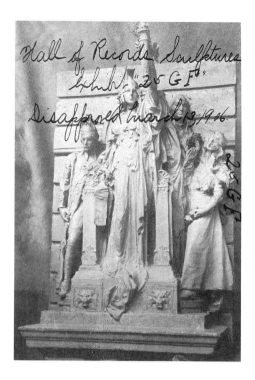
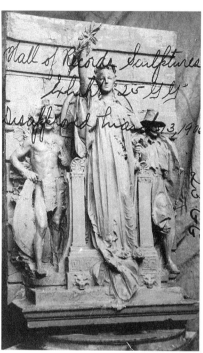

7.8
Philip Martiny, sketch models for
New York in Revolutionary Times
and *New York in Dutch Times*, for
New York City Hall of Records,
south entrance, 13 March 1906.
(From the Collection of the Art
Commission of the City of New
York, Exhibition files 25-GK
and GG.)

obliged to provide reasons for their decisions, the committee who judged Martiny's work in March 1906 explained some of their actions, arguing first that "the extended arms in the air" did not "sufficiently express the majesty and dignity of the Law;" second, that the subject matter demanded more "repose and quiet;" and finally, that the sculptor had to convey this sense of calm and harmony more effectively by using fewer "upright lines" and distracting symbols and attributes.[54]

Martiny ended up modifying and simplifying his two groups all through the rest of the year. In the final version of *New York in Dutch Times* (fig. 7.9), he eliminated much of the background detail, reduced the amount of folded drapery in the central figure, and lowered her arms to establish more symmetry. He altered and then hid the arms of the throne, and he shifted the stance of the Indian's torso slightly back. In addition, he added the sweeping arc of the klysmos chair, the ends of which extended toward the two lateral figures and linked them visually with the central figure. This unified the composition considerably by endowing

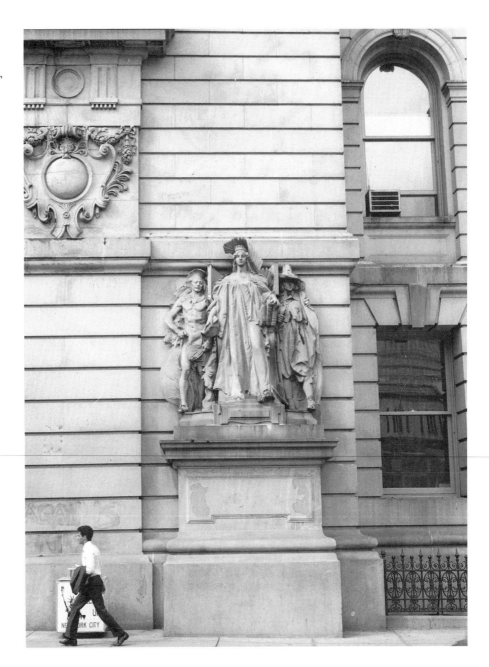

7.9
Philip Martiny, *New York in Dutch Times*, New York City Hall of Records, south entrance, 1907. (Photo, Michele H. Bogart.)

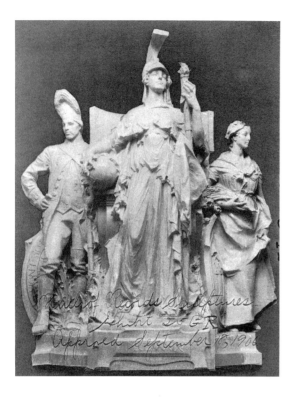

7.10
Philip Martiny, full scale model for
New York in Revolutionary Times,
for New York City Hall of Records,
south entrance, 18 September 1906.
(From the Collection of the Art
Commission of the City of New
York, Exhibition file 25-GR.)

the whole with a greater degree of simplicity and visual stability. The commission finally approved both groups that September, but still another year passed before workmen began to place the sculptures on the building, in September 1907 (figs. 7.9, 7.10).[55]

In 1897 at the outset of the project, the construction of the Hall of Records seemed to artists and urban reformers a sign of the municipal government's apparent commitment to art and to centralized, efficient, and honest government. The elaborate plans for the sculptural adornment of this building represented a manifestation of this faith. The sculptors hoped that they would have the opportunity to participate as a group in this important artistic and civic event by collaborating on the creation of elegant sculptures that would set forth the lessons of the city's history and the values that would guide its future.

But the realities of New York City's politics quickly compromised this vision. The Hall of Records commission, which was supposed to discourage the possibility of corruption, represented the politics of art production at its worse. Van Wyck's efforts to replace Thomas and Peirce, Horgan and Slattery's gargoyle hoax, the commissioners' treatment of Bush-Brown and Martiny, and everyone's insistence that relations among the artists, architects, contractor, and Art Commission were perfectly cordial—all of these machinations seemed a far cry from the cooperative spirit of the *Dewey Arch*, Appellate Courthouse, and Customs House. A project that was intended to signify honesty degenerated into an interchange of false and sarcastic statements disguised by gentlemanly posturing. No one—not the architects, politicians, art commissioners, not even the sculptors—was exempt.

The Hall of Records also provided an early indication that the Art Commission was not the detached, objective body that it claimed to be. While commission members sought to remain aloof from petty politics and to assess submissions on their merits, their opinions were inevitably colored by the particulars of the case and their concern about its broader impact. The aesthetic problems with the Hall of Records sculptures could not simply be blamed on the artists' lack of skill; from their perspective the aesthetic deficiencies were the inevitable result of the political context of the project.

If anything, the organization of the project tested the Art Commission's power, still uncertain at the time that the Hall of Records construction was beginning. The commission sought to act quickly and assertively to avoid losing control and to prevent Tammany's architects from circumventing its authority. While its members sincerely disapproved of both Martiny's and Bush-Brown's submissions on aesthetic grounds, it is clear they also had some additional political reasons for doing so. Unable to initiate civic projects, the commission sought to use its veto power to shape municipal artistic practices in the ways it deemed most appropriate. Its members' judgments were politically motivated, just like those of everybody else.

In the case of the Hall of Records, delay and disapproval of the sculptors' designs became the commission's means of driving home to Tammany Hall a point about the necessity of excellence, defined according to their terms. These actions had an immediate impact, strengthening the position of the commission in the municipal power structure, and in fact improving the quality of the artistic work. These events occurred at considerable psychological and financial expense

to the two sculptors involved. They also took an indirect toll on the entire profession. The incident forced the sculptors to confront the extent of their powerlessness in the larger sphere of municipal politics, and as such it represented a tremendous setback to their larger cultural enterprise. As we shall see, semiprivate projects also presented sculptors with complex organizational and political challenges.

8

Cultural Institutions and the Art of Negotiation:
The Metropolitan Museum of Art,
the Brooklyn Institute of Arts and Sciences,
and the New York Public Library

Government enterprises played an important role in public sculptural production. Semipublic endeavors, however, provided alternative channels and procedures that were as crucial—if not more so—to civic artistic activity as those of government. These ventures included cultural institutions such as the Metropolitan Museum of Art, the Brooklyn Institute of Arts and Sciences, and the New York Public Library, formed and supported by wealthy New Yorkers who envisioned themselves as the guardians of American culture and civilization. Beginning in the 1890s, the trustees of many cultural institutions commissioned enormous new buildings, most of which had at least some sculptural adornment.

The municipal government funded construction and maintenance of these structures, and thus was still an active presence, but the boards of trustees were dominant in the commissioning process. Yet despite the common educational and civic aspirations of many trustees, their ideals were not translated in the same ways into sculptural form. Not all trustees were fully committed to having elaborate programs of architectural sculpture. Even those who were determined to have such enrichments had to invest a great deal of energy to realize their goals.

New York's major cultural institutions assumed their distinctive forms during the late nineteenth century. A range of smaller endeavors—amateur art and historical societies, concert and opera groups, and libraries—had existed earlier in the century. The businessmen, lawyers, and other eminent citizens who founded New York's museums and libraries in the late 1860s and 1870s conceived of cul-

ture as the "highest and most valued of human activities," associated especially with the fine arts. Culture could be the antidote to America's moral and spiritual problems. Their new institutions would be civilizing forces and vehicles of moral uplift, as well as recreational attractions.[1] The years that followed the war saw the foundation of the Metropolitan Museum of Art, the Brooklyn Institute of Arts and Sciences, the American Museum of Natural History, the Metropolitan Opera, Carnegie Hall, and the New York Public Library. The establishment of new cultural organizations represented in part the response of civic leaders to the industrialization, immigration, and corruption of the post–Civil War decades. The postwar conditions that made such institutions desirable also contributed to their structure and growth. By the 1890s, the postbellum crop of millionaires was ready to provide substantial funding to legitimize their wealth through investment in the riches of nature and art. The new generation of wealthy trustees managed their cultural interests along the same systematic organizational lines as their highly successful businesses. By 1900, many cultural institutions in New York had developed into large semipublic corporations.

By the turn of the century the governing ideals had moved increasingly away from the community interests and didactic concerns of the earlier period. Instead, those involved with cultural bodies emphasized more generalized notions of cultivation and public betterment purveyed through large, specialized organizations with highly selective policies of acquisition, performance, and display.[2] They saw these institutions as yet another manifestation of the spirit of national unity, to be attained by bringing together the most prominent people of the country's foremost city in the service of common civic and cultural goals.

Significantly, the municipal government was involved with the largest institutions from the late 1860s.[3] The Metropolitan Museum and American Museum of Natural History were built on municipal property, and the city funded the construction and provided annual appropriations for maintenance. The mayor and other officials served as ex officio trustees. The city continued to have a major stake in these enterprises. Thus the state (which incorporated the institutions) and city governments became important parties in the negotiations when museums and libraries, like everyone else, began to construct their own buildings as they expanded in the 1880s and 1890s.[4] Thanks to the efforts of men like Low and Root, the 1898 city charter demonstrated even further government commitment to cultural activity, with its stipulations that the city construct and maintain new buildings for the American Museum of Natural History, the Metropolitan Mu-

seum of Art, the Brooklyn Institute of Arts and Sciences, and the New York Public Library.[5]

Sculptors obviously welcomed the construction of the new buildings and the support of the municipal officials, which considerably improved the chances of stimulating public awareness of art and of their own work in particular. The Romanesque design for the new wing of the American Museum of Natural History (1892–1898; Cady, Berg, and See, architects) precluded any prospects of architectural sculpture commissions for that institution in the near future. However, possibilities were opened up by the provisions for new museum and library buildings passed after the World's Columbian Exposition, at the point when "classical" and Renaissance styles became more fashionable.[6] Sculptural work for these structures, if properly executed, would allow artists to express civic values in yet another significant public context. The election of John Quincy Adams Ward (and later Daniel Chester French) to the Board of Trustees of the Metropolitan Museum also helped sculptors as a group. Over the years the two functioned as liaisons between the artists' community and powerful patrons. They also helped to keep their colleagues abreast of collecting trends and of institutional politics within the broader municipal context.

The cultural commitment of the trustees made the artists' hopes for some kind of involvement with the decoration of the new buildings seem more tangible. Because of their wealth and social standing, trustees had the political clout that the artists lacked, as they had learned in the Hall of Records project. The trustees of the Metropolitan, the Brooklyn Institute, and the New York Public Library were in positions to dictate what should be done in ways not possible with other municipal art projects. Having made their decisions to build in the first place, they had sufficient influence to obtain government support and funding for construction. Trustees chose the architect, and had final approval of both his designs and of any artists who were to be involved.

Cultural power in the hands of lawyers, intellectuals, and businessmen thus produced a situation very different from that of the Hall of Records, even though city officials oversaw the construction in both instances. In the case of the Hall of Records, the mayor, the Board of Aldermen, and other politicians had a vested interest in controlling bids and construction. As a municipal government building, it offered a good opportunity to distribute patronage without the need to answer to the upright artistic groups who sought to become involved. In the large cultural projects discussed in this chapter, the power of city officials was diluted.

The presence of trustees helped to put a check upon municipal bureaucrats, who were inclined to cut corners when it came to spending the city's money on civic art, and who might otherwise have had a much freer hand. Trustees insisted upon having the artists whom they believed best, and sought to allow them to work in a manner that would produce the finest results. Thus sculptors once again had opportunities to make positive civic contributions.

Still, the influence wielded by trustees produced neither the artistic freedom, the systematic procedures, nor the amounts of sculpture sculptors hoped for. The outcome of these decorative projects was affected by problems that arose from the immediate demands of design and construction and those that emerged because of the larger social and political contexts in which the cultural institutions as semipublic enterprises operated. In spite of the trustees' power, certain aspects of the construction process remained contingent on such variables as the fluctuating relationships among trustees and municipal officials. The park commissioners of Manhattan and Brooklyn, for example, had to approve expenditures on buildings to be erected on park land in the respective boroughs. Each park commissioner in turn had to receive approval from the Board of Estimate and Apportionment, whose decisions were based upon larger political considerations. Good architectural sculpture required a great deal of energy, improvisation, and politicking. In the case of the Metropolitan Museum of Art, the trustees ultimately decided that maneuvering on behalf of architectural sculpture would not be worth the bother. The Brooklyn Institute and the New York Public Library trustees won more or less what they wanted from the city, but not always in the way that the trustees wanted or as quickly as they would have liked.

The Sculpture for the Metropolitan Museum of Art

The Metropolitan Museum (fig. 8.1) was the one building that might be expected to provide the fullest demonstration of the potential of American architectural sculpture. It actually was completed with practically no large-scale sculptural decoration, though much was planned. The trustees' failure to have the architectural sculpture decorations completed reflected their general lack of concern for contemporary American sculpture—civic monument or museum or parlor *objet d'art*—in comparison to other art forms. American sculptors may have hoped to be identified with the rarified, cosmopolitan, genteel tradition typified by this group of trustees—but in fact it excluded them. The case of the Metropolitan was

thus a telling sign that the professional influence of American sculptors and the scope of their contributions to civic art were more limited than they had anticipated.

The Metropolitan incorporated in 1870 to encourage and develop the study of fine art, to apply the arts to manufacture, to advance "the general knowledge of kindred subjects," and "to furnish popular instruction and recreation." The museum counted among its twenty-one elected trustees some of the most eminent and powerful financiers, businessmen, and lawyers of the time. Although the

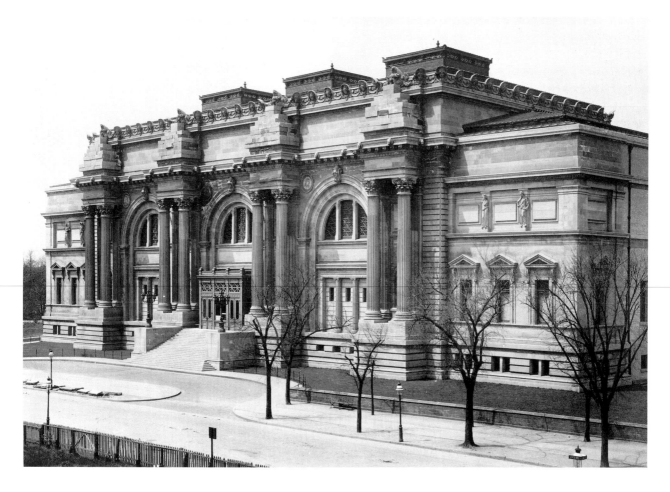

trustees did not want the city to become too much involved in their affairs, they sought the city's support to acquire a municipal site and to finance construction. The museum's six ex officio trustees included the mayor, the governor, and the head of the Department of Parks.[7] The new Metropolitan Museum building, designed by Calvert Vaux and Jacob Wrey Mould in the high Victorian Gothic style, was completed by 1880 on the west side of Fifth Avenue between 80th and 84th streets, in Central Park. The institution grew rapidly, with artistic gifts and tremendous fiscal support from its wealthy trustees and members.[8] The city again agreed to construct additions, and a new Gothic southern wing was opened in 1888. A similarly styled north wing (begun by Arthur Tuckerman and completed by Joseph Wolf) was finished in 1894.

Even before the north wing opened the trustees had decided that more space would be necessary.[9] In 1894 the president of the Metropolitan, Henry G. Marquand, asked Richard Morris Hunt to develop preliminary plans for yet another extension. Hunt's designs represented a marked stylistic departure from those of his predecessors. Where they used the Ruskinian Gothic to connote the high moral purpose of the museum, Hunt employed a Beaux-Arts classical style with ample amounts of sculpture to signify the Metropolitan's civic authority as a great temple of culture (fig. 8.2). His drawings included four caryatids (two to the immediate left of the entrance and two to the immediate right); six medallions, one for each of the spandrels of the three massive entryway arches; large heads for the keystones and for the acroteria; four figures for the niches between the massive Corinthian columns; and four sculptural groups, one each to surmount the massive entryway piers. The New York State Legislature passed a law allowing New York City to raise $1 million to pay for the new extension, and Hunt proceeded to submit his designs for approval to the Building Committee, the Executive Committee, and finally to the Board of Trustees.[10]

Hunt's sudden death in July of 1895, at the age of sixty-five, left the future of his designs uncertain. Marquand and museum director General Louis Palmi di Cesnola were anxious about the changing municipal political climate—especially the impact of the city's impending consolidation—and did not wish to delay the new extension. They convinced the trustees to move expeditiously and approve Hunt's designs. Under pressure from Hunt's widow Catherine (to whom Hunt had bequeathed all of the plans), the trustees hesitatingly appointed Hunt's lesser-known son Richard Howland Hunt to replace his father as architect.[11] Determined to carry out the original designs faithfully, the younger Hunt acted to

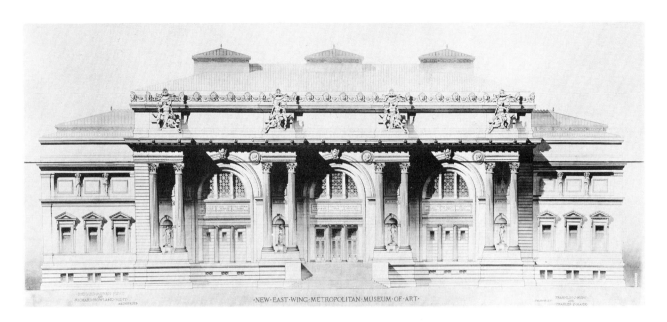

·NEW·EAST·WING·METROPOLITAN·MUSEUM·OF·ART·

8.2
Richard Morris Hunt, elevation drawing of the Fifth Avenue entrance facade of the Metropolitan Museum of Art, 1895. (Courtesy of the Metropolitan Museum of Art.)

Hunt's designs provided for a commanding Beaux-Arts facade, with three grand arches flanked by projecting bases, and giant paired Corinthian columns supporting a large, broken entablature.

secure Karl Bitter, who had worked for Richard Morris Hunt many times, to execute the sculpture.[12]

In order to conform to municipal laws that required architects and general contractors to advertise for workers through an open competition and to make a selection on the basis of the lowest estimate, Hunt appears to have suggested to Bitter that he submit a "bid" for the commission. Although an otherwise unknown group called the American Sculpture Society (represented by Fernando Miranda) pleaded in a letter to Marquand to consider lesser-known sculptors for the commissions, there is no record that any sculptors other than Bitter actually bid. This, along with Hunt's written recommendation of Bitter, suggests that Hunt was able to award the contract outright.[13]

But now, with the elder Hunt not there to insist upon the proper realization of his designs, the trustees began to show their resistance to the idea of spending money on the proposed architectural sculptures.[14] They preferred to give priority to the interior rather than to the adornment of the architecture, and felt that the primary focus of the institution should be on its collections. Some of them may well have also believed that, from the standpoint of symbolic expression, architectural sculpture was somewhat less important for museums than for other civic

buildings. The general public would in all likelihood be more inclined to enter a museum than a court house. Appropriate lessons about art and the social order could thus be transmitted through the very presence and disposition of the treasures within the building, as well as through the general style of the architecture itself. It was not quite as crucial to convey important cultural messages on the outside through sculpture, especially given the trouble they might have to go through in order to hire a sculptor rather than a stonecutter to do the work. The trustees never stated their attitudes explicitly, but expressed their lack of enthusiasm in terms of concern about cost. In retrospect, the trustees' assessment of the situation represented an indication of the problems that not only would prevent this particular project from coming to fruition, but that posed challenges to sculptors' long-term efforts in the public sphere as well.

The trustees delayed Bitter's approval for seven months. Someone evidently proposed the cheaper alternative of having a stonecutter, already working as part of the general construction contract, carve out decorations. The younger Hunt first had to convince them that the work was too difficult for an ordinary stonecutter to perform and that such artistic work could not be covered under the general contract; rather, it had to be assigned to a sculptor who could work independently. In July 1898, the trustees finally agreed to give Bitter the contract (at a fairly low total cost of $6,300) for the four caryatids representing the four branches of art, and a second contract ($4,000) for six spandrel medallions of the celebrated old masters Bramante, Dürer, Michelangelo, Raphael, Velasquez, and Rembrandt.[15]

Bitter completed the models for these works by 1900.[16] But a major part of the sculptural adornment of the building—the four groups for the niches between the columns, and the four large groups on the piers—still remained to be done. These groups were clearly not a high priority, since it was only in 1900 that Hunt wrote to the chairman of the Building Committee, Salem H. Wales, to outline his plans both for appropriate subjects and the selection of artists. To express the "character of the building" he recommended that the four large groups represent the "four great periods of Art, using the Egyptian for ancient art, the second group, Greek for classic art, the third group renaissance and the fourth group modern art." Hunt went on to recommend for "each niche, directly under the principal group . . . [a] reproduction of the best examples of art expressed in the group above." But this time he decided that it would be "unadvisable and unpracticable" to award the four groups to any one sculptor. Instead he proposed what,

from the sculptors' point of view, would have been a much more appropriate course of action: that the National Sculpture Society be asked to select four sculptors by vote.[17]

Still, Hunt had to assure the trustees that the cost of doing all of this artistic work would not be exorbitant. He noted that if necessary the first three of the niche statues could be done relatively inexpensively simply by having stonecutters use "casts already owned by the Museum of the examples chosen" and reproduced by a system of pointing. Yet another way of saving money would be to have the sculptors submit designs for the large groups only at one-quarter or one-half full size; these models could then be enlarged by the stonecutters.[18]

The architect's plans for this sculpture provoked skepticism among some of the trustees, especially from the sculptor John Quincy Adams Ward. Over the next several months, he and members of the museum's building committee voiced their concern about Hunt's ideas. The question arose of whether further decoration was important or necessary at all. The situation put John Quincy Adams Ward in an awkward position. As president of the National Sculpture Society when these decisions were being made, he was responsible for protecting the interests of his colleagues. But he had to reconcile his role as sculptor with his duties as a Metropolitan trustee when he became the primary spokesman on the decoration issue. Ward expressed his worry that the cost of completing the rest of the sculpture (which would be borne by the city) might be prohibitive. He may have anticipated the complications involved in hiring the right sculptors—the kinds of challenges that arose with the Brooklyn Institute and the New York Public Library. What was peculiar about Ward's ostensible objection was that up to this point the trustees had little problem in convincing the municipal government to pay thousands of dollars for construction.

But beyond the matter of expense, the matter of the sculpture brought up for Ward a more fundamental question about representation and meaning. Hunt had proposed that the sculptural program depict the four great periods of art and civilization. Ward considered the depiction of ancient, Greek, and Renaissance art unproblematic. Hunt's suggestion of using casts of masterworks to express these periods seemed a perfectly acceptable solution for this purpose. In Ward's opinion, however, the representation of modern art was another matter altogether. "If the term 'Modern Art' means to include any art later than the 'renaissance'" he wrote, "you would be getting into a sea of difficulties where there would be danger of disaster—Modern Art . . . is too undefined, too chaotic to

be clearly represented in a group, or by any one great example—universally accepted." [19]

Ward's inability to conceive of a single or well-defined personification of modern art was revealing. Undoubtedly his ambivalence stemmed from awareness of the numerous stylistic changes in art since the end of the eighteenth century. But in addition, his uneasiness with the concept unwittingly suggested a broader uncertainty about the contemporary conventions of representation and hence about the future of art. Lack of consensus posed a threat. A debate on the subject might compromise the image of certainty, unity, and artistic authority that many of Ward's sculptor colleagues were trying to project. Moreover, recognition of these artistic differences might then force the sculptors to acknowledge how tenuous were the systems of representation that underlay their own conceptions of artistic creation, innovation, and progress (an issue we will address in Chapter 10).

Ward's ambivalence on this matter was taken quite seriously. But insofar as he still advocated completion of the sculpture, the rest of the trustees decided they wanted a second opinion, and queried architect Thomas Hastings. Hastings responded that he considered the sculptures an essential part of the design, and proposed that if there were not enough money the committee could at least execute just two of the groups. On the question of representation, however, he was evasive; he suggested that a sculptor could easily make a group representing modern art without having to commit himself "to describing what modern art is." [20] While he claimed to see no difficulty in depicting modern art, he offered no concrete solution as to how one might represent it. The trustee's building committee did not take Hastings's advice. They chose to leave all four groups and niche sculptures incomplete for the time being. Significantly, no concerted attempt was ever made either to persuade the city to put up more money or to arrange for the rest of the architectural sculpture for the nation's foremost art institution. Neither Hunt's facade, nor McKim, Mead, and White's more modest new side wings (completed 1906) received any additional sculptural adornment. In the long run, the trustees preferred to put their efforts into getting more space and building the collection.

The ideal of artistic excellence promoted by the Metropolitan did not encompass the public art of contemporary American sculptors. Through their inaction, the Metropolitan's trustees made a social and artistic statement that represented a subtle alternative to the expression embodied in civic decoration through public works. Because of the trustees' institutional policies, true art came increasingly to

be seen by artists, critics, and the general public as an autonomous object of rarified appreciation, detached from any obligation to express common social values. Art, as associated with a museum, came to be divorced from civic concerns. But those concerns were what gave public sculpture, and even many of the artists themselves, fundamental identity and significance. Moral uplift and civic improvement formed the original professed ideological foundation for the Metropolitan's enterprise. Although the trustees' decisions on the decoration of the building had no immediate impact, they reflected the kinds of priorities that would serve to diminish the importance of Beaux-Arts civic sculpture in the future.

The Brooklyn Institute of Arts and Sciences

The trustees of the Metropolitan Museum, who were among the country's wealthiest and most powerful men, could afford a building with minimal sculptural decoration. They already set the definitive standards of American connoisseurship and good taste, and their building expressed their aesthetic priorities clearly. More was at stake for the trustees of the Brooklyn Institute of Arts and Sciences. In contrast to the trustees of the Metropolitan, the men who supported the Brooklyn Institute were local politicians, lawyers, and businessmen. Their efforts on behalf of their new building represented part of a larger effort to build up the cultural, political, and economic prestige of the city (and later borough) of Brooklyn.

John Duncan's monumental *Soldiers' and Sailors' Memorial Arch* (fig. 1.5) had been an important move in this direction. It was funded largely through donations, and its construction began under city supervision at the same time that a new museum building was in the early planning phases. The heroic triumphal arch was a highly self-conscious statement of Brooklyn pride as well as of cosmopolitanism and national spirit.[21] The trustees' decision to erect an enormous building for the Brooklyn Institute of Arts and Sciences reflected similar aspirations.

The trustees selected the prestigious architects McKim, Mead, and White as an indication of the seriousness of their intentions. The firm was renowned for its demanding standards. Moreover, they were already redesigning the surrounding areas of Prospect Park and Grand Army Plaza. With the trustees' wholehearted approval, McKim, Mead, and White incorporated sculpture into the architectural "package" from the beginning. They were persistent in their demands that the

works be executed in accord with their conception of the building. They requested, and received, municipal funding for a separate contract for the sculpture. They also lobbied actively and successfully to bypass city bidding procedures to select the sculptor whom they wanted. In keeping with their quest for the best, the trustees insisted upon hiring Daniel Chester French as primary sculptor. He controlled the Brooklyn Institute's entire sculptural program, and lent prestige to the enterprise.

The museum's director and trustees aimed high in their hopes of attaining cultural parity with Manhattan. And indeed, the Brooklyn Institute of Arts and Sciences became one of the country's foremost cultural institutions, with a majestic and architecturally important structure befitting its significance. The building, if completed, would have included an extraordinarily large and expensive amount of architectural sculpture. But the city of New York was unwilling and unable to sustain the cost of both construction and maintenance. Thus the hopes of the trustees, architects, and sculptors for their building were never fully realized.

The Brooklyn Institute had been incorporated in 1843 for purposes of popular education in the arts and sciences. It offered lectures and a library and also acquired a diverse collection of natural specimens and works of art. In the late 1880s, the institute's new director, Franklin W. Hooper, trained as a zoologist under Harvard's Louis Agassiz, undertook to make the institute a major museum devoted to the ideal of unity in learning. In 1890 the institute, renamed the Brooklyn Institute of Arts and Sciences, was reorganized into several departments manned by professionals charged with assembling a broad and significant collection.[22]

In the late 1880s Hooper asked the state legislature to allocate funds for a larger building. In 1890 the legislators passed a resolution allowing the institute to incorporate, and authorizing the city of Brooklyn to construct a new museum structure on municipal property. Two years later the institution received a site on Eastern Parkway and Washington Avenue, next to Prospect Park, near Grand Army Plaza. With the site obtained, the institute arranged to secure an architect. Although selection was through a two-stage competition, the institute's Department of Architecture worked actively to ensure the participation of the firm of McKim, Mead, and White.[23]

The design consisted of a huge building with sides of equal length and four corner pavilions (fig. 8.3). Each wing connected to a central rotunda, and each was topped by a Renaissance dome and drum. The first section of the museum

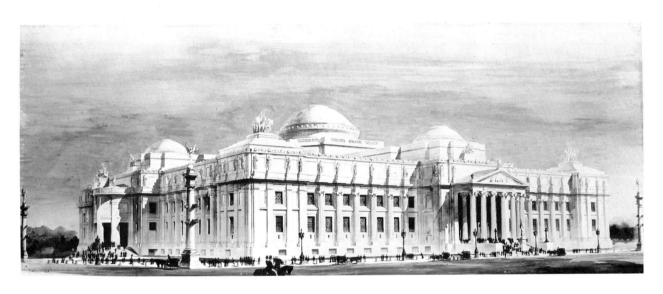

8.3
Francis L. V. Hoppin, 1867–1941, design for the Brooklyn Institute of Arts and Sciences, 1893, watercolor and pen and ink, 66.3 x 170.7 (26 1/8 x 67 3/4). (The Brooklyn Museum, x737.)

was completed by 1897. By 1900 the construction of the north and east fronts of the building was underway. By this time Brooklyn had become part of Greater New York, and as described earlier, the Brooklyn park commissioner became the municipal official in charge of construction, because the institute was being constructed at the edge of Prospect Park.[24]

The architects' designs for the east front called for carvings on the massive entrance pediment and for thirty statues above the frieze. Both the architects and trustees clearly knew which sculptor they wanted from the outset. As early as 1902, undoubtedly based on the architects' suggestion, the Institute's Board of Trustees asserted that they wished the best work possible, which for them meant sculpture by Daniel Chester French. French was by this time the most powerful and artistically active sculptor in the city, if not the entire nation.[25] However, the city, which was paying for the project, had yet to approve the necessary money. The Metropolitan Museum's trustees, fearing that city officials would turn down additional funding for sculpture, had not troubled to ask for it. Brooklyn Institute trustees moved ahead. Estimating that thirty sculptures would cost about $65,000 and the pediment about $12,000, the trustees asked the Brooklyn park commissioner to request that the city borrow $110,000. The Board of Estimate approved the Brooklyn commissioner's recommendation to include sculpture in a new contract for the construction of the east-wing extension. [26]

In making his request for municipal financing of this construction, the Brooklyn park commissioner assumed that the sculptors would have to bid competitively for the sculptural work, just as with other contracts for the city as stipulated by the charter. The institute's trustees and McKim, Mead, and White had no intention of letting this happen.[27] Indeed, they knew that French would refuse to participate on any such basis. The institute's trustees, who aspired to the same high level of cultural excellence as their Manhattan counterparts, supported the architects' demands to select a sculptor directly, just as had been done in the Appellate Courthouse and the United States Customs House. They agreed with McKim, Mead, and White that French should receive a contract for all of the sculptural designs. Once in charge, he could parcel out the commissions for most of the statues to other sculptors. As subcontractors, they would ostensibly "model" French's conception. This approach departed from those of the Appellate Courthouse and Customs House, where the architect controlled sculptors' activities directly, and where each sculptor was hired to execute his own creation rather than someone else's. In fact, however, French would allow the artists creative autonomy. He would merely coordinate the others' work and function as a general supervisor responsible for "quality control."

French himself had been aware for some time that he was the choice for the Brooklyn Institute commission. He was simply waiting for an official go-ahead to start work. When, to his dismay and irritation, the matter of competitions arose, he not only refused to have any involvement with such a procedure, but acted as if indifferent to whether or not he received the commission. He already had plenty to do; in addition to his current work on the New York City Public Improvement Commission he was in the midst of his Customs House project. French thus went even further and told the trustees that to have the work done by "reputable sculptors," as he would insist upon doing, would cost over $100,000 ($5,000–6,000 per statue)—more than the sum they had allotted.[28] He expressed his unwillingness to participate in any municipal competition, and questioned the trustees' determination really to secure the best sculpture possible.

French's refusal to yield to trustees or city bureaucrats became a crucial matter. Because the architects and trustees insisted on having him, they were willing to try to get the city to agree to his demands. Their negotiations made it fully evident that hard-and-fast rules with regard to the organization and legality of municipal art projects had not yet been established. It was still possible to obtain the kinds of procedural arrangements sculptors like French preferred, but each project in-

volved new discussions through different channels and produced slightly different outcomes. In this particular case French had an advantage in that the park commissioner was the principal municipal authority rather than the mayor (as in the case of the Hall of Records), and this commissioner was accommodating.

In May 1905, the trustees met with Brooklyn park commissioner Michael J. Kennedy to discuss the sculpture. Kennedy was sympathetic to the project and to French, but he at first resisted the plan to hire French and to subcontract sculptors separately. His stated assumption was that because the architects had included the sculpture as part of their original plans, they should provide designs for it as part of their contract with the city.[29] Hooper informed the commissioner that this arrangement would not work. The sculpture had to be done by an artist of the "highest rank," and moreover, the architect's office was not equipped with a working sculptor. Besides, they already had French in mind. Kennedy responded that perhaps the architects could hire a sculptor to design the thirty statues and furnish the plaster models. Then the carving would have to be let by public advertising to stonecutters.[30]

French agreed to undertake the contract on the condition that he be able to subcontract to artists of his choice the work he could not do in his own studio, but refused to "have anything to do with the matter" unless he had control over who did the carving.[31] He insisted further that he be permitted to form an advisory committee of three sculptors to select the others and to inspect their sketches and models.[32] He also refused to pay $60,000 "security" or bond that the proposed contract called for, indicating that the project was not so important to him that it was worth this additional bother. As he told McKim, Mead, and White, his apparent willingness to undertake the project was based "largely on account of the flattering wish expressed by yourselves and the Institute that I should do so." While he was interested in "pecuniary returns," they could not compensate for the labor and trouble involved; he certainly would not take on all of this work plus pay a bond.[33] After consulting with the architects, the trustees agreed that the architects would have to petition the park commissioner to request the Board of Aldermen to give French the entire commission.[34]

To make their case, McKim, Mead, and White spelled out the limits of their professional territory. They "naturally" had responsibility for the "general direction of the work." They also had artistic control, and it was their job to assure that the "spirit of the sculpture, its scale, and degree of elaboration" would "harmonize" with the architecture. They also acknowledged that accordance with

municipal law required that public work had to be advertised. But, they argued, aesthetic considerations made commissions for artists a special matter where the usual procedures could not be followed. Artists' work could not be judged or selected on the basis of price. "If the city were to purchase a portrait of one of its citizens," the architects wrote, "it would not throw the work open to public competition so that any person who considered himself qualified could secure the contract if his price were low enough, and the present case is, in our judgement, an exact parallel." The sculpture for the Brooklyn Institute, moreover, could not be considered mere craft or architectural detail. It represented the "ideals of the museum." As such it demanded a "master hand" to express such a vision effectively in sculptural form.[35]

Continuing to argue in aesthetic terms, the architects proceeded to explain why French (whom they did not name) alone should get the entire contract. Just as it was essential to have one architect design all of the various parts of a single facade to assure the unity of the design, so too one person had to do all of the sculpture. But, they asserted (undoubtedly with the Hall of Records in mind), the Brooklyn Institute commission was "such a great and important one" that no one man could do it alone without devoting many years to the project—a situation that was not economically feasible. They proposed to award the entire contract to one sculptor who with the assistance of subcontractors would design and model the work, and have it carved into stone by the men of his choice. No sculptor "of first class reputation" would do the work otherwise. For while there were many carvers capable of rendering architectural detail, only a few in the vicinity were qualified to execute sculptural work. Furthermore, "in order to avoid division of responsibility" the architects recommended that the delivery and setting of these statues be included in the contract of the sculptor in charge, with permission for him to sublet this work also to any "approved person." If the commissioner agreed to these recommendations, the architects would be glad to meet with him to consider the selection of just such an appropriate sculptor (whom, of course they already had chosen).[36]

This argument succeeded. Kennedy asked the Board of Aldermen to make an exception, and its members consented.[37] The architect and trustees managed to get the city to appropriate separate funds for sculpture and to allow distribution of the commissions on the architects' terms. Their preferred arrangement vested authority hierarchically with French at the top. Unlike Martiny's experience with the Hall of Records, French would have help from other sculptors, as well as total

control. Most of the sculptors seem to have accepted this state of affairs, recognizing that it could work to their advantage, especially compared to any efforts they might make on their own. In January 1907 French signed a $116,190 contract with the park commissioner, which provided him with an immediate 10 percent payment. By the end of March he had drawn up his list of sculptors to do the cornice figures he could not do personally, subject to the architects' approval.[38] One month later he invited eleven sculptors, including Karl Bitter, Augustus Lukeman, and Carl Heber, to undertake the various works. Their contracts called for nine-inch sketches, three-foot plaster models, and half-size, six-foot-high plaster models that would be delivered to Piccirilli Brothers, French's favorite carvers. He would pay the sculptors $1,500 per statue; the final cost of each work, including carving, could be not more $3,000—less than what he hoped for initially.[39]

From this point on, the sculptors proceeded with few major problems or interruptions, and completed their work within the two-and-one-half-year time limit stipulated in their contracts. The Art Commission approved their three- and six-foot models in 1908; by that October, eleven statues were almost finished in stone. The Piccirillis were ready to start placing them in June 1909.[40]

In the meantime, French and his assistant Adolph Alexander Weinman worked on the eastern pediment. French's original contract gave him nine hundred days, but because he had been preoccupied with coordinating the completion of the thirty cornice statues and other projects during this time, he requested and was granted two three-hundred-day extensions (one in April 1909 and another in 1912) to complete his pediment.[41] The Piccirillis finished carving the cornice by August 1913.

The final sequence of the cornice figures, described as "symbolic portrait statues," can be seen in figure 8.4 (see also figs. 8.5, 8.6).[42] A group of leading (but unidentified) scholars of classical and oriental culture assisted Hooper, French, and the trustees in deciding upon the subjects and names.[43] Like all of the civic architectural sculptural programs discussed thus far, the subjects of the Brooklyn Institute works were conceived as a progressive, developmental sequence according to their degree of influence as "contributions to Western civilization." As a 1910 article on the sculptures in the museum's publication *Museum News* explained, "The Museum, through its collections, is an embodiment of modern civilization and culture, and this in turn is based upon the civilization of earlier days."[44] In

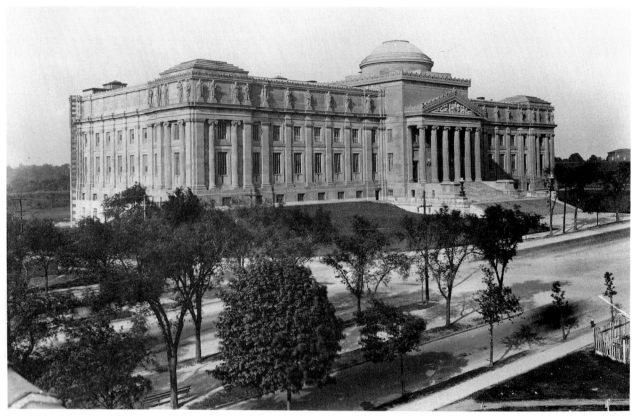

8.4

McKim, Mead, and White, Brooklyn Institute of Arts and Sciences, 1895–1915. (Photo, ca. 1915. Courtesy of the New-York Historical Society, New York City.)

The final sequence of the cornice figures ran as listed below (the names in parentheses are those the sculptors associated with the personification in question). East side: Edmund T. Quinn, *Persian Philosophy* (Zoroaster); Edward Clark Potter, *Indian Philosophy* (Sankara); Attilio Piccirilli, *Indian Literature* (Kalidasa) and *Indian Law Giver* (Manu); Edward Clark Potter, *Indian Religion* (Buddha). North side: Karl Bitter, *Chinese Philosophy* (Confucius), *Chinese Religion* (Lao-Tse), *Chinese Art*, and *Chinese Law*; Janet Scudder, *Japanese Art*; Augustus Lukeman, *Hebrew Law Giver* (Moses), *Hebrew Psalmist* (David), *Hebrew Prophet* (Isaiah), and *Hebrew Apostle* (Saint Paul); Charles Keck, *Genius of Islam* (Mohammed); Daniel Chester French, *Greek Epic* (Homer) and *Greek Lyric Poetry* (Pindar); George T. Brewster, *Greek Drama* (Aeschylus) and *Greek State* (Pericles); Kenyon Cox, *Greek Science* (Archimedes); Daniel Chester French, *Greek Religion* (Minerva); Herbert Adams, *Greek Philosophy* (Plato), *Greek Architecture* (Phidias), *Greek Sculpture* (Praxiteles), and *Greek Letters* (Demosthenes). West side: Johannes Gelert, *Roman Law Giver* (Justinian), *Roman Statesman* (Julius Caesar), *Roman Emperor* (Augustus Caesar), and *Roman Orator* (Cicero); Carl Heber, *Epic Poetry* (Virgil).

addition, inscribed tablets below the figures proclaimed the names of famous artists, authors, statesmen, philosophers, and founders of religions. "As the civilization and culture of various periods is naturally associated with the names of men who have played a prominent part in bringing them about, so inscribed on the museum walls are names of the noteworthy in their day as representative of the factors that made the times in which they lived famous." According to *Museum News*, the sculptural personifications bore no direct relation to the names below them.[45]

2372 n.5 Ficarilli and St John Divine protest

375 n.19 The NY County Court House [pp. 298-299]
375 n.20 AMNH

6 n.26 Rhind caryatids
n.26 Bowery S.B. 130 Bowery modeled by MacMonnies

n.41 all Rockefeller Ctr. art

Kent biog by Hudson R. Muse

The exact ordering of the hierarchical arrangement was the subject of debate. The discussions merit brief attention, for they provide an indication of the relative importance ascribed to particular cultures and activities by early twentieth-century elites. Hooper, for example, felt that Egyptian subjects should figure prominently along with personifications of aspects of Greek civilization, but the group of scholar consultants convinced him otherwise. The committee determined that the Greek, Hebrew, and Latin civilizations had been the three greatest influences on Western culture, especially for modern Europe and America. Ancient Egypt had its impact in the eastern Mediterranean, but its effect on America had been entirely through Greek and Roman culture. And Japan "only recently" had come to have an influence on the west; thus only one slot would be devoted to it: Japanese Art.[46] The scholars cautiously decided against including a representation of Jesus Christ on the justification that the subjects of the statues were supposed to be idealized and not portraits.[47] Hebrew religion, on the other hand, had to be depicted since Hebrew scriptures had provided the "foundations of the religion of our [meaning Anglo-Saxon] people."[48] In the end, the theme committee concluded that oriental subjects should stand in the northeast quadrant of the building, and that classical figures should occupy the northwest quadrant. The committee also planned to have medieval and Renaissance images stand at the southwest, and modern subjects to the southeast. The proposed arrangement would take into consideration both the "historical sequence and the relation between various people whose genius is to be illustrated by the sculpture."[49]

As with other allegorical representations during this period, the Brooklyn Institute statues were supposed to convey several levels of meaning: in addition to expressing the contributions of civilizations in relation to Western culture, each statue related to a historical personality or type who was associated with a specific cultural achievement. Finally, it signified the activity itself. For example, first among the Greek subjects was "the dawn of Greek life and literature," *Epic Poetry*, epitomized by the *Iliad* and thus by Homer. Greek letters and rhetoric, personified by Demosthenes, came last. This representational approach was used throughout, with the exceptions of several images such as *Japanese Art*.[50]

The trustees decided that the eastern pediment should represent the Union of Science and Art (fig. 8.7). Beyond that stipulation, French and his assistant Weinman were free to work out whatever conception seemed most appropriate. Their eight-figure grouping depicted seated embodiments of Science and Art in the center, along with the shield of the Brooklyn Institute.[51]

8.7
Daniel Chester French and Adolph
Weinman, *Science and Art*, pedi-
ment, Brooklyn Institute of Arts and
Sciences, 1914. (Photo, Michele H.
Bogart.)

To the right, three figures represent
Painting, Sculpture, and Architec-
ture. On the left stand Geology, As-
tronomy, and Biology, the three
basic sciences of the earth, sky and
nature. A sphinx on the extreme left
symbolizes Knowledge. A peacock
at the right is an "emblem of beauty
in the appearance of things," as as-
sociated with art. Daniel Chester
French to Charles H. Dorr, 26 April
1913, reel 15, FFP.

Both the McKim, Mead, and White spokesman William Kendall and the trustees, through Franklin Hooper, expressed great satisfaction with the rendering of all of the statues. Each did so in a manner that reflected his respective involvement with the project. Thus for Kendall, the statues illustrated the importance of sculpture to the "final expression" of the building. Hooper, echoing the responses of his colleagues, conveyed his pleasure with the way that the sculpture, especially the pediment, expressed the ideals of the Brooklyn Institute and the museum.[52]

From the sculptors' standpoint, the project represented a procedural as well as an aesthetic success comparable to that of the Appellate Court and United States Customs buildings. In both cases, the commission gave opportunities to a range of sculptors, whose working procedures were arranged to produce the best artistic results. For the sculptors on the project, the situation was even somewhat preferable to the Customs House; instead of reporting to the architect, they answered to a sculptor, who understood their work and could devote even more personal attention than could Gilbert. Presumably some artists were upset because French did not distribute the commissions as widely as he could have; in fact, certain sculptors received several commissions, and one was even given to a painter, Kenyon Cox. Moreover, several of the artists French selected were also working on the Customs House. But the Brooklyn Institute project was still an advance over the situation that prevailed with the Hall of Records. Indeed, of all the municipally funded architectural sculpture executed during the first decade of the century, the Brooklyn Institute came the closest to the ideal, both with regard to its procedures and its outcome.

Yet even this project had setbacks. The original architectural and sculptural vision of the Brooklyn Institute never completely materialized. The designs planned were so ambitious that construction extended into the 1920s. Only about one-sixth of the projected designs had been completed by 1927, when construction was ultimately suspended for lack of funds.[53] The planned sculptural cycle, which encompassed civilization from the ancients to Renaissance and modern contributions, would have cost several times the amount provided for the initial thirty sculptures. Only the ancient oriental and classical sections were actually finished. The sculptors ended up with less work than they had initially hoped for. The fiscal difficulties that prevented the full realization of this project ultimately appeared symptomatic of the larger problems the borough faced in trying to become the economic, political, and cultural counterpart of Manhattan.[54]

The New York Public Library

Until the mid-1890s, libraries were supported primarily through private philanthropies, and remained relatively inaccessible to the general public. In 1895, however, the privately endowed Astor and Lenox libraries of New York merged with the Tilden Trust to form a new corporation, the New York Public Library, one of several free public library systems established in America in the late nineteenth century.[55] The library's distinguished collections and sizable endowments assured its status as a major research facility from its very inception. This fact helped its first president, John Bigelow, in his efforts to obtain a central location for a new building on municipal property: the site of the Croton reservoir, 40th to 42nd streets between Fifth and Sixth avenues. Such was the anticipated significance of the library that provisions for its construction were incorporated into the new City Charter along with those of the city's other major cultural institutions.[56]

Dr. John Shaw Billings, the library's new director, sought a functional as well as an attractive structure, and personally developed basic designs for the new building.[57] Billings arranged for a series of competitions to select architects to develop comprehensive plans. The jury selected Carrère and Hastings, one of the six invited firms.[58] At the time when the architects signed their contract in early December 1897, Billings anticipated that the entire project would take about three years to complete. As in the case of the Brooklyn Institute, however, construction dragged on. Tammany mayor Robert Van Wyck, who took office just after the provisions for the library building had been signed, opposed the library as another elite encroachment on Manhattan. So did a majority of the Board of Aldermen, several of whom held grudges against the library trustees. Together, they did what they could to hold up construction, which did not start until 1902. Afterwards, prolonged bidding, strikes, and political infighting delayed completion of the building until 1911.[59]

The plans for the exterior facade, essentially complete by 1900, incorporated architectural sculpture as accents. An entablature supporting statuary projected above the three entrance arches, visually strengthening the sense of vertical support for the attic and emphasizing the symbolic effect of the grand entrance.[60] The architects also planned sculpture for two deep niches on both sides of the entrance and for small pediments that capped the northeast and southeast ends of the wings. Two large, reclining lions would flank the entrance plaza (fig. 8.8).

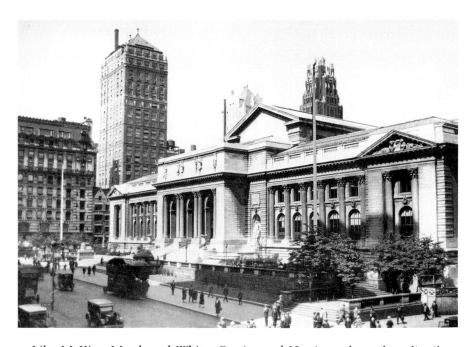

8.8
Carrère and Hastings, the New
York Public Library, 1897–1911.
(Miriam and Ira D. Wallach Divi-
sion of Art, Prints and Photographs,
the New York Public Library, Astor,
Lenox, and Tilden Foundations.)

Three large arches separated by en-
gaged columns spanned the Fifth
Avenue facade to show the staircase
hall inside. The large pediment ar-
ticulated the main reading rooms;
the attic story above the main cor-
nice represented the picture galler-
ies; and the simple side elevations
visually reiterated the administrative
offices.

Like McKim, Mead, and White, Carrère and Hastings planned to distribute
the sculptural work among several sculptors, and they already knew whom they
wanted to hire. However, from the point of view of the NSS, the sculptors they
selected may not have been the ideal choices. At the Brooklyn Institute, those
commissioned represented a cross-section of the NSS roster. For the library, the
Ecole-trained Carrère and Hastings chose George Grey Barnard, Paul Wayland
Bartlett, Frederick MacMonnies, and Edward Clark Potter. Several of these artists
were detached from the mainstream activities of American art organizations like
the NSS, and also had the reputation of being somewhat difficult.[61] The selection
of these eminent sculptors might have been considered a generally positive devel-
opment, but it did not represent much of a political gain for the New York sculp-
tors who envisioned organizational involvement as a crucial means to advance
their profession.

Although Hastings had made his decisions about sculptors quite early in the
project, he, like McKim, Mead, and White, ran into difficulties with municipal
requirements when it came to the actual hiring.[62] Initially, the architects had
planned to include sculpture in the contract covering the general construction of

the building (contract 3). But apart from this general contract, they had also hoped to get an additional $180,000 just for the sculpture work.[63] This would have underscored the importance of the sculpture to the scheme as a whole, but the architects encountered problems with this approach because the city refused to appropriate any extra money. Just as with the Metropolitan Museum and Brooklyn Institute, the New York Public Library contractors were technically obligated to advertise for workers, including sculptors, through an open competition. Carrère and Hastings thus faced the same obstacle as McKim, Mead, and White and French. They could not hire the artists they wanted directly.

Like McKim, Mead, and White, Carrère and Hastings sought to circumvent municipal procedures through contractual maneuvering. First they held out in the hopes that a new and more sympathetic Republican administration would defer to their wishes later. Republican Seth Low's administration was in power between 1901 and 1903, and indeed, construction then started to inch forward. But another Tammany-supported slate (that of George B. McClellan) won the election of 1903. Carrère thereupon "decided" that the sculpture work was "unnecessary to the success of his design," and thus, unlike McKim, Mead, and White, no longer tried to include it in general construction or to get additional funds.[64] Instead the architects deferred sculpture to a later contract, which covered construction of all the approaches to the building (such as sidewalks), and which also included a special allowance for preparation of the models. In 1908 the construction firm of Norcross Brothers won this contract, which was advertised according to standard procedures. Thus Hastings arranged for the sculpture he wanted, but only by taking a different tack from McKim, Mead, and White in the end; instead of continuing to seek exceptions, he operated within the restrictions of municipal law.

The Park Department and the Board of Estimate approved this approaches contract and in 1908 Hastings finally was able to offer his sculptors contracts. The deal as negotiated had Norcross Brothers subcontracting Bartlett, MacMonnies, and Barnard as "modelers," which allowed them to circumvent an open competition. The city paid out no extra money, and the artists simply had to work within the budget limitations of the approaches contract. By postponing the sculpture Carrère insured that the sculptors would neither have to bid nor be subjected to time constraints that would have forced them to complete their models before the stone for the rest of the building had been cut and set.

The author of a history of the New York Public Library described the works

as "labors of love." For although the Public Library sculptors received about as much per statue as those who worked on the Customs House, the latter had only to submit half-size models. The New York Public Library sculptors had to deliver theirs full size, and thus had greater responsibilities and expenses.[65] On 23 May 1911 the New York Public Library opened, some ten years late and still minus most of its sculpture. The sculptors, especially Bartlett, experienced further delays in completing their works, partly because of other work commitments, partly because of Art Commission disapprovals of some of the models, and partly be-

8.9
Carrère and Hastings, New York Public Library, Fifth Avenue Entrance, 1897–1916. (Photo, Michele H. Bogart)

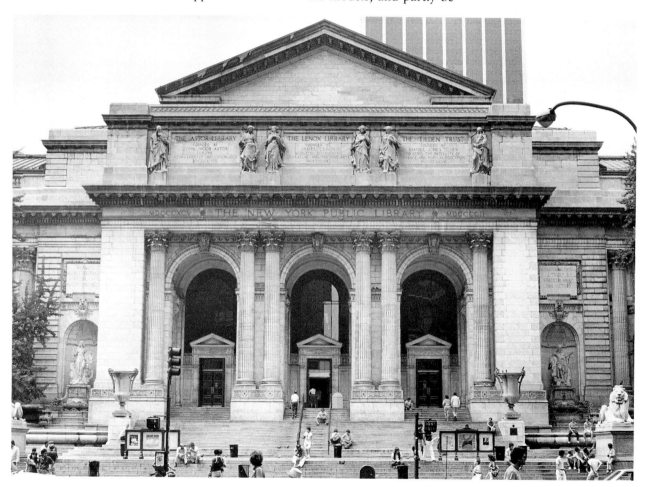

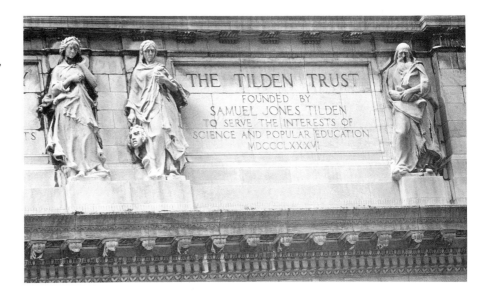

8.10
Paul Wayland Bartlett, *Poetry*, *Drama*, and *History*, New York Public Library, 1909–1916. (Photo, Michele H. Bogart.)

cause of difficulties with execution and placement.[66] The last of the sculptures, Bartlett's *History*, was hoisted into place in January 1916 (figs. 8.9, 8.10). Because the sculptures were installed intermittently and after the official opening of the library, they received minimal critical attention, although what there was was positive.[67]

Despite these various constraints, however, all the sculptures initially planned for the New York Public Library were completed (fig. 8.8). In contrast to Manhattan, Brooklyn did not even get a building for a major research library for almost another thirty years. Brooklyn officials and residents had tried since 1905 to get a main building for its own public library (which was administered separately), but a dispute had broken out almost immediately over the question of location.[68] The Brooklyn Public Library eventually became part of a general City Beautiful scheme for a civic center at Grand Army Plaza, developed in 1908 by Brooklyn architect Raymond F. Almiral at the request of the New York City Improvement Commission. In keeping with the commission's general recommendations, Almiral planned his new Beaux-Arts-style library building to be replete with architectural sculpture (fig. 8.11). The project barely got started. Not until the teens did officials make a concerted effort to develop comprehensive designs of the kind

conceived for Manhattan twenty years earlier. But the crucial momentum had been lost, and little was done to implement any of the plans. Although some work was begun on a central library building, construction had to be postponed in the 1920s for lack of funds. Building did not start up again until 1941, by which time Almiral's designs had been dropped in favor of a more streamlined conception developed by new architects, Githens and Keally, whose designs included incised relief images by Carl Jennewein rather than the ornate surfaces and Beaux-Arts groups Almiral had planned.[69]

8.11
Raymond F. Almiral, proposed building for the central branch of the Brooklyn Public Library, distant view from the Grand Army Plaza, from *Architectural Record* 23, no. 2 (February 1908): 101. (Avery Architectural and Fine Arts Library, Columbia University.)

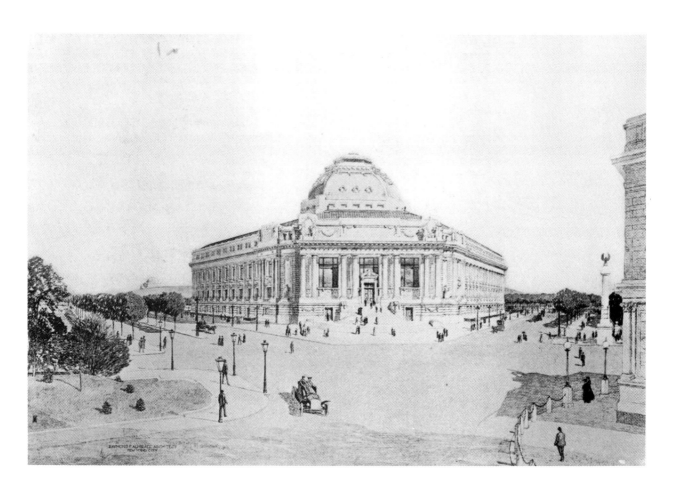

Some of the most elaborate sculptural programs on municipally constructed buildings were those done for semiprivate cultural institutions, where trustees rather than politicians had primary control. Sculptural decoration was consonant with the purposes of these institutions, and an appropriate expression of their sponsors' interests. The amount of sculpture on these buildings, as well as the purposes for which the programs were carried out, reflected the aspirations and priorities of the wealthy business and professional men who served as trustees. Circumstances on the whole worked in sculptors' favor, since a number of trustees already had some personal ties with sculptors. They generally had more interest in art and, when necessary, would often assert themselves to get the sculpture they wanted. Trustees were crucial in determining how a given project would go.

As with other municipal buildings, forward motion depended upon the willingness of city government to make exceptions to its established rules and procedures. While there existed precedents for hiring sculptors directly, the process of obtaining this privilege was never systematized. As we have seen, each project involved new negotiations among sculptors, architects, trustees, and municipal officials. The Metropolitan Museum and the Brooklyn Institute of Arts and Sciences illustrate the effect that the controlling hand of an influential sculptor could have on a project's development. In the case of the Metropolitan Museum, the dearth of sculpture was due to the trustees' lack of commitment, the absence of the original architect, and the apparent ambivalence of the trustees' sculptor member. In contrast, the Brooklyn Institute trustees were fully determined to secure the cooperation and support of municipal officials. They saw a broader significance in what they were doing. This strengthened their resolve to obtain the best and most influential architects and sculptors, whose experience had equipped them to negotiate with businessmen and bureaucrats. Organizationally, control over execution of the Brooklyn Institute program was limited, despite the many commissions. As a result, Brooklyn obtained one of its first major City Beautiful projects—one of the most elaborate sculptural programs in the entire city. Like the Brooklyn Institute, the arrangements for the sculpture for the New York Public Library were worked out primarily by architects Carrère and Hastings with the support of trustees. However, no single sculptor was involved in their negotiations with the city. Although it took the architects several years to hire the men whom they wanted, they eventually did get their way. The abortive Beaux-Arts Brooklyn public library, initiated as part of Brooklyn's cultural campaign, appears to have been a fiscal casualty of the Brooklyn Institute's success.

From the sculptors' perspective, all of these municipally funded cultural projects (except the Brooklyn public library) were a significant improvement over the Hall of Records; more sculptors than ever were involved and in control. But as we have seen, attaining these opportunities was complicated, time-consuming, and expensive. By the 1920s, moreover, the priorities and ideals of the various groups shifted. There was a breakdown of the cooperation among old elites, architects, sculptors, and municipal officials that had made possible the Brooklyn Institute and similarly complex architectural projects. The very conditions that made these projects organizational as well as artistic achievements also made it difficult to find budgetary support for major architectural sculpture as time went on.

9

Maine Memorial and *Pulitzer Fountain*: Site, Patronage, and Process

A Contrast in Styles

For major public buildings like the Customs House, Hall of Records, and Brooklyn Institute, the site was generally determined before the design process began, and therefore questions about the relationship between the style of a sculpture and its surrounding environment rarely arose. As we have seen, however, such concerns were important with freestanding monuments designated for municipal property, such as the *Heine Memorial*, the *William Tecumseh Sherman*, the *Firemen's Memorial*, and the Brooklyn *Soldiers' and Sailors' Arch*.

Most of these, unlike the publicly funded sculpture for cultural institutions, were paid for by popular subscriptions or by private interest groups. The municipal government—usually the Art Commission and the park commissioner but sometimes even the mayor—had final authority to approve or disapprove proposals about where a given work could be installed. Interactions among public officials and private groups concerning such questions often involved politicking and disagreement.

Most of the difficulties occurred in Manhattan, where space and choice locations were at a premium. But controversy arose in Brooklyn as well. Prospect Park's original landscape architect Frederick Law Olmsted objected to the Parks Department's hiring McKim, Mead, and White to bring the artistic appearance of the park and the surrounding area into accord with City Beautiful standards. The construction of John Duncan's *Soldiers' and Sailors' Arch* (fig. 1.5) in Calvert Vaux's picturesque oval plaza was initially a matter of contention.[1] While the specific contexts of each New York statue and monument differed, the general problems that arose with regard to their sites were fairly similar. The most signifi-

cant and representative issues, as well as some unusual circumstances, can be traced in two case histories that show the relation of site to the production of sculptural monuments: the *Maine Memorial* and the *Pulitzer Fountain*. Although closely related in time, location, and patronage, together the two works exemplify major differences in the ways in which large freestanding monuments were created.

The two southern corners of Central Park—59th Street at Eighth and at Fifth avenues—were, as we have seen, among the most coveted spots in Manhattan. Since the early 1890s, attempts to put monuments in these places brought power struggles among ethnic organizations, artists' groups like the NSS and the Fine Arts Federation, entrenched architects and sculptors like Charles McKim and Augustus Saint-Gaudens, the mayor, and park department officials. The debates surrounding the use of these sites thus encompassed the entire range of participants in the organizational structure of public art. The publishers William Randolph Hearst and Joseph Pulitzer introduced a significant additional element, that of the powerful businessman. Independently, these two men played crucial roles in determining the artistic development of the 59th Street area. Their concerns with public sculpture evolved not only out of their relationship with each other but as the result of their participation in events that changed the course of American history.

The *Maine Memorial* and the *Pulitzer Fountain* were both erected early in the second decade of the twentieth century, and both were modeled on academic conventions of representation, but they differ noticeably in design and in the ways that they relate to their respective sites. The simplified, schematized facial features of Karl Bitter's elegant female figure *Pomona* atop the *Pulitzer Fountain* convey an aura of calm removed from the surrounding bustle of everyday life. The placid, inwardly spiraling movement of the figure's pose accentuates this sense of introspection. The statue surmounts a fountain that itself is part of a larger, unified scheme encompassing two symmetrical plaza areas west of Fifth Avenue between 58th and 60th streets and bisected by 59th Street. The fountain, which stands between 58th and 59th streets, is the southern end point of the design (fig. 9.1). The vista extends north from this point to 60th Street and Fifth Avenue, where Saint-Gaudens's *William Tecumseh Sherman* marks the northern end of the scheme (fig. 9.2).

By contrast, *Maine Memorial* is complex and animated (fig. 9.3). A forty-foot-

Thomas Hastings, architect, Karl
Bitter, sculptor,
Pulitzer Fountain, Grand Army
Plaza, New York, 1916. (Photo,
Michele H. Bogart.)

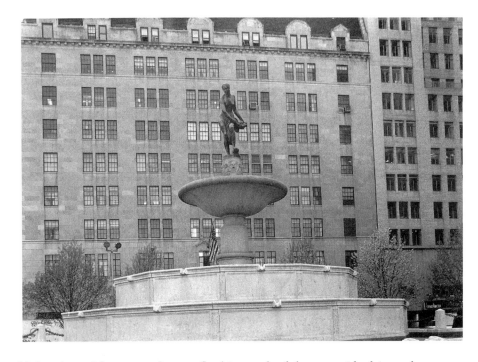

high pylon with two gatehouses flanking each of the two wide drives, the monument forms the southwestern entrance to Central Park. Carved sculpture and relief ornament decorate the sides of the pylon, which is also crowned by a bronze allegorical group of a striding female figure and horses. Huge river-god figures recline on raised pedestals on the sides of the pylon, and elaborate allegorical groups adorn the northeastern park side as well as the front. On the front side, facing southwest, a youth kneels on the prow of a Roman galley that thrusts out aggressively from the main body of the shaft and over a low fountain basin. Steps descending from the basin send the monument sprawling outward toward Columbus Circle.

Maine Memorial lacks the harmonious integration with its surroundings of its East Side counterpart. The problem has been aggravated by the constant change and development that have beset Columbus Circle since the monument was built, but even at the time observers noted a distinct lack of harmony between the monument and the larger site. Unlike the *Pulitzer Fountain* and *Sherman Memorial*, which are conceived as totalities in space, *Maine Memorial* does not com-

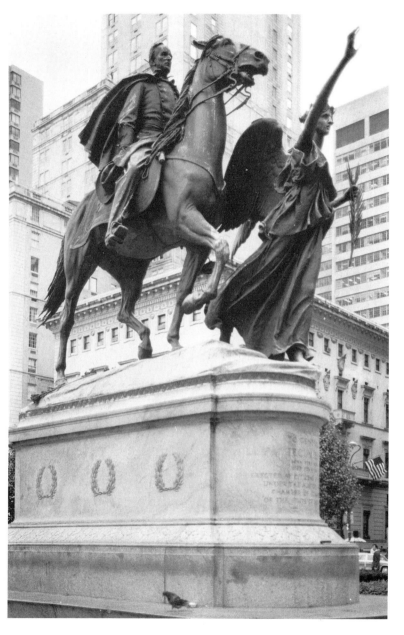

9.2
McKim, Mead, and White, architects, Augustus Saint-Gaudens, sculptor, *William Tecumseh Sherman*, Grand Army Plaza, New York, 1903. (Photo, Michele H. Bogart.)

9.3

H. Van Buren Magonigle, architect, Attilio Piccirilli, sculptor, *Maine Memorial*, Columbus Circle, 1913. (Photo, Michele H. Bogart.)

In *Antebellum State of Mind: Courage Awaiting the Flight of Peace and Fortitude Supporting the Feeble*, *Peace*, a female figure, stands protectively over *Courage*, a muscular seated nude male (modeled after Michelangelo's *Night* for the Medici Chapel), and *Fortitude*, a seated female comforting a weeping child.

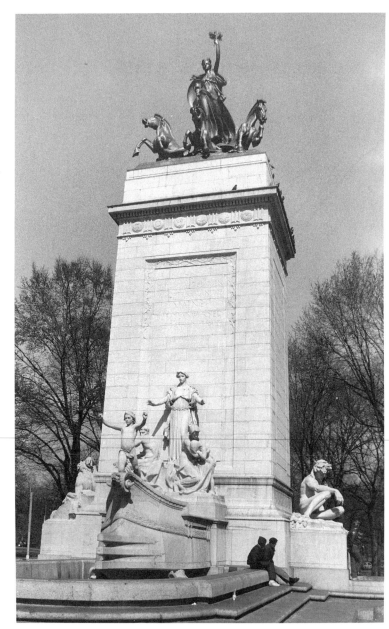

mand a single unified vista; Gaetano Russo's *Christopher Columbus* to the southwest tends to divert one's gaze (fig. 9.4). The two juxtaposed monuments compete visually and spatially with each other. One artist of the day said, "Judged in its relation to the landscape beyond, it fits about as well as an enlarged wedding cake model would—in fact, the pink tinted stone does suggest ice cream, only—and unfortunately—unlike our national desert, it will not melt in the sun."[2]

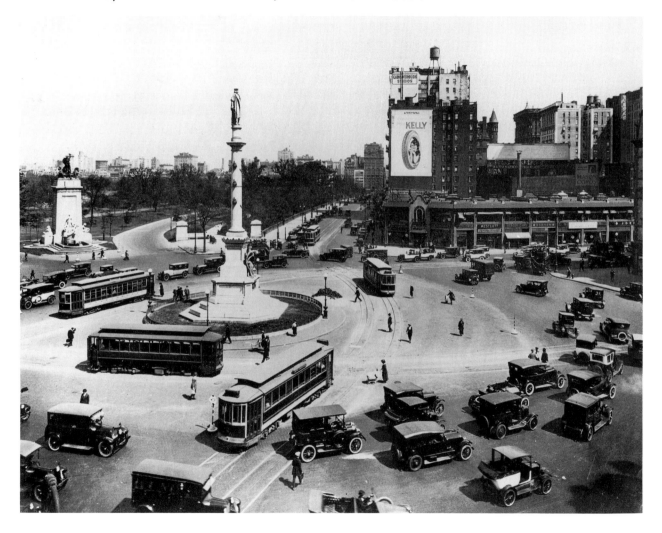

These observations about the formal differences between *Pulitzer Fountain* and *Maine Memorial*, in addition to their common elements—centrality and geographic and temporal proximity to one another—take on added significance when one considers that two of New York's most influential newspaper publishers were the driving forces behind the monuments. The one commission resulted from a bequest by the Hungarian-born Joseph Pulitzer (1847–1911), the other from a subscription campaign organized by William Randolph Hearst (1863–1951). The disparities between the two monuments, at least on one level, reflect the interactions and differences between their major sponsors. The histories of the *Maine Memorial* and the *Pulitzer Fountain* are inseparable from the ongoing and notorious rivalry between Pulitzer and Hearst, major powers not only in newspaper publishing but also in shaping the look of the city. Their monuments, contrasting case studies, reveal the absence of consistent, clear-cut policies for commissioning public sculpture in New York during these years. The two works are thus in some measure a function both of their patronage and of the process by which they were commissioned. They reflect certain fundamental differences in attitude toward the nature and purpose of civic sculpture and public art policy in a modern republican democracy. The individuals responsible for these particular monuments did not explicitly address the question of whether public sculpture should express the heartfelt, but possibly "philistine," sentiments of the many, or instead convey the more tasteful, "universal" ideals of a well-informed few. Nonetheless, the genesis of *Maine Memorial* and *Pulitzer Fountain* represented two divergent responses to this debate.

In many ways, *Maine Memorial* was the more "public" monument. It originated from a political controversy; it was funded, at least in part, by popular subscription. Its designs, executed by relatively unknown artists, were selected through an open competition. Difficulties arose in finding a site, and delays and problems persisted even after a site was obtained. The finished monument, lively and flamboyant, imposed itself upon the surrounding environment and competed with another work for viewers' attention. As a consequence, many people felt it lacked unity with its site.

In contrast, *Pulitzer Fountain* was initiated by artists as a City Beautiful project. Most of the decision making went on behind the scenes; the competitions held were limited and included only eminent artists; and indeed, in the end the choice of artists was essentially predetermined. The site posed few problems—the new *Sherman* statue was actually relocated to accommodate architect Thomas

Hastings's plans for the area. It thus comes as no surprise that *Pulitzer Fountain*, placid and self-possessed, fit comfortably into its environment. By examining these works in their historical contexts we can see how intricately construction processes, personalities, artistic politics, national politics, and aesthetics all intertwined.

New York City's newspaper industry had developed in pace with the rapid growth of the metropolis after the Civil War. By the 1890s, a host of different papers, including the *New York Times*, the *Evening Post*, the *World*, and the *Journal*, represented and shaped the specialized interests of the city's diverse ethnic, political, and economic constituencies. Papers like the *Times* and the *Evening Post* remained the stalwart voices of the city's wealthier business and conservative elites. The rhetorical and editorial policies of these newspapers were carefully crafted to express appropriately the genteel good taste of their readers. It was in this spirit that *New York Times* publisher Arthur S. Ochs coined a phrase that became one of the paper's slogans. "It does not soil the breakfast cloth," he assured his reading audience. The *Times* would "give the news, all the news, in concise and attractive form, in language that is parliamentary in good society; . . . [and] give the news impartially."[3]

Ochs's comments expressed, in his own restrained way, his disdain for the exploitative journalistic tactics used by his rivals Pulitzer and Hearst. Pulitzer and then Hearst had taken the novel step of bringing their papers, the *New York World* and the *New York Journal*, to a mass audience. They gave bylines to their journalists, and incorporated new graphic features such as gigantic headlines, illustrations, and cartoons. Their dramatic, crusading, sometimes unscrupulous articles about romance, corruption, and vice thrilled their readers just as the *Post*, the *Star*, and the *Enquirer* still do today. These new sensational methods came to be known as "yellow journalism" and revolutionized the trade. In 1885, even before Hearst came onto the scene, Pulitzer had perfected yellow-journalism tactics through his strongly populist *Statue of Liberty* campaign. In this he had used bold headlines, heartrending testimonials, and donation statistics to raise the rest of the funds for the statue's pedestal (and indirectly, to bolster circulation of the *World*). The extraordinary success of his crusade catapulted Pulitzer and his newspaper into the limelight. By 1886 he was widely regarded as a patriot, and was welcomed in many elite social and political circles.[4]

By the mid-1890s, Pulitzer and Hearst had cultivated a broad new clientele

among middle- and lower-middle-class New Yorkers who had not bought newspapers previously. The circulations of their papers soared to unprecedented numbers. But while Pulitzer and Hearst shared a commitment to journalistic innovation, they were in many ways dissimilar individuals. Pulitzer, older than Hearst, was considered the more intellectual, moderate, and serious of the two. Not the opportunist that Hearst was, Pulitzer generally subscribed to higher newspaper standards. He appeared more genuinely concerned about the well-being of his reading public, to whom he felt an obligation to enlighten.[5] He had less explicitly political motives; as a German Jewish immigrant, he also exercised caution and restraint for obvious pragmatic reasons. Handicapped by poor eyesight and general ill health throughout his youth, Pulitzer found the pressure of his work so physically debilitating that he actually retired from the day-to-day management of his properties in 1887 at the age of forty. However, he never relinquished absolute control over the editorial policies of his New York papers, and sent in detailed suggestions, comments, and criticisms daily. Pulitzer retained enormous power but, unlike Hearst, managed his operations from behind the scenes.

Hearst's own spectacular publishing achievements and record-breaking circulations did not satisfy him. He was determined to surpass Pulitzer, his competitor since Hearst purchased the *Journal* in 1895. In 1896 he reduced the price of his newspaper to one cent and lured several of Pulitzer's prized writers, artists, and associates away from the *World*. By the beginning of 1897 the two publishers had become embroiled in an increasingly vicious circulation war.

Heir to a San Francisco mining fortune, Hearst was used to getting his own way. The ambitious young man developed a reputation as a self-aggrandizing troublemaker. He had been expelled twice from Harvard—the first time for a rowdy celebration after Grover Cleveland's election, the second time after a little prank of sending chamber pots to his professors. After being thrown out of college, he cajoled his father into letting him take over the *San Francisco Examiner*. He ingeniously succeeded in building its readership and his own reputation. After purchasing the *Journal* Hearst came to New York, where he proceeded to use the power of his sensationalist press to advance his own political ambitions. The same flamboyant approach became one of the hallmarks of the creation of *Maine Memorial*. To understand this monument in context, it is necessary to examine Hearst's involvement with the Spanish-American War.

Maine Memorial

When the Cubans rebelled against Spanish domination in 1895, Spain responded with military force. Cuban refugees began to spread tales, some greatly exaggerated, of Spanish atrocities. William Randolph Hearst became one of the major purveyors of this news. Although he was sincerely devoted to the Cuban cause, he was not above exploiting the unrest to draw attention to his paper and to boost circulation.[6] Distorted accounts of Spanish "atrocities" were printed daily in the *New York Journal* as evidence of heinous foreign "aggression" against a defenseless country. Not to be outdone by the *Journal*, the *World* also began printing sensational articles. Each paper sought to outshine the other in heartrending accounts of Spain's outrageous acts, calls for Cuban independence, and pleas for American intervention. In the long run it was Hearst's personal involvement that contributed most to increased popular demand for United States action on Cuba's behalf. The bellicose rhetoric of his articles and editorials fueled public hatred of Spain even as the Spanish government attempted to avoid conflict with the United States by making conciliatory gestures.

President McKinley opposed any kind of American intervention, but as he sought a diplomatic solution, the tensions between Cuba, Spain, and the United States continued to mount. After learning of a supposed anti-American plot looming in Cuba, the United States sent the battleship *Maine* into Havana Harbor to protect American interests in Cuba. After three weeks it became clear to Navy secretary John D. Long that there was no plot, and no reason for the *Maine* to stay there. In the meantime, Hearst continued to turn a series of minor misadventures into politically inflammatory articles that strained diplomatic tensions further. On 15 February 1898, however, the "opportunity" for war presented itself when an explosion ripped through the *Maine*, killing 260 of the 350 men aboard. While no one knows for sure who or what caused it, an official inquiry not long after the tragedy absolved Spain of any responsibility, a fact that one would not easily glean from reading the *Journal*.[7]

Public outrage at the *Maine* incident, fueled by the *Journal*'s coverage, forced McKinley to capitulate in April to the calls for war, and Congress authorized the president to use force to liberate Cuba. Hence began the Spanish-American War, described by Secretary of State John Hay as the "splendid little war" and by some less charitable critics as "Hearst's war."[8]

While Hearst's role in the war has been widely debated, no one disputes that

he was the most outspoken of all of the publishers actively involved. He personally represented a "journalism that acts."[9] In a sense, Hearst's press coverage of the destruction of the *Maine* and of the war itself was the turn-of-the-century counterpart of today's orchestrated "media event." He transformed minor or irrelevant incidents into opportunities for major headlines. Once the war started, Hearst sent out his own press boat, traveled to the scene to "discover" hostilities firsthand, and even played a role in capturing an enemy vessel.[10]

The campaign for a commemorative monument offered similar opportunities for visibility and self-advertisement. Two days after the blast, the *Journal* offered $50,000 for "the detection of the *Maine* perpetrator." Four days afterwards Hearst began calling for a memorial to the dead seamen. On the front page of the *Evening Journal* bold letters announced: "HONOR THE MEN WHO DIED FOR THEIR COUNTRY ON THE BATTLE SHIP MAINE. The Journal Will Contribute $1000 Toward the Erection of a Shaft in the Heroes' Memory at the Gateway to the New World."

A monument, standing at the mouth of the Narrows, looking out over the ocean, would form a memorial worthy of the brave fellows who died while on duty for their country.

The *Journal*, as the servant of the people, will take charge of the preliminary work necessary to secure the erection of such a monument. It will start the subscription list with $1000, and will give its aid to the committee appointed to take permanent charge of the patriotic undertaking. It will receive subscriptions, pending the appointment of a permanent treasurer. It will acknowledge from day to day all moneys received. Start the Fund. Send a dime, a dollar, a hundred or a thousand or five thousand dollars. Send your tribute, no matter how small, to the memory of the 250 men who typified all that is most admirable in American Manhood.[11]

Hearst then established the Maine Monument Committee, along with General James Grant Wilson and newspaperman John W. Keller. They proceeded to solicit such notables as former president Grover Cleveland, Senator Chauncy Depew, General Miles Levi, and Oliver Hazard Perry Belmont to endorse the project and donate money. Cleveland, who had successfully avoided intervention in Cuba during his own presidency, categorically refused to cooperate, declining "to allow my sorrow for those who died on the *Maine* to be perverted to an advertising scheme for the New York *Journal*." But others were less skeptical. Day after day, alongside melodramatic coverage of the events leading up to the war, bold headlines reminded readers that the *Journal*'s heroic campaign continued.[12] Cleveland may have been uninterested, but the *Journal*'s appeals clearly touched the public's

heart, just as similar patriotic appeals in Pulitzer's *World* had done thirteen years earlier. By July of 1898 Hearst had collected over $100,000 from school children and other individuals and organizations, and he continued to mount various publicity schemes to generate more funds and attention.[13]

The Maine Monument Committee then launched a competition for designs for the monument. This "democratic" approach—as opposed to a limited competition or a direct appointment—was consistent with Hearst's publicity for the monument as a popular memorial. About forty sculptors and architects submitted sketches in the first round of the two-round competition. A committee of judges chose designs by Austin Hays and Donn Barber, George Julian Zolnay and Joseph Henry Freedlander, and Attilio Piccirilli and H. Van Buren Magonigle. While not unknowns, none of these artists was considered especially eminent. No list of competitors remains, but it is quite likely that other, better-known sculptors and architects refused to participate, and there was apparently also some controversy about the handling of this particular contest. The procedures evidently con-

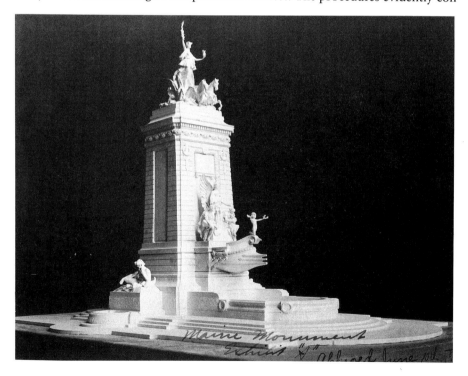

9.5
H. Van Buren Magonigle, architect, Attilio Piccirilli, sculptor, sketch model for *Maine Memorial*, 1902. (From the Collection of the Art Commission of the City of New York, Exhibition file 21-A.)

flicted with the code set by the National Sculpture Society. This alone would have deterred some artists from entering the competition.[14] The final award went to Piccirilli (1868–1945), who up to this point was known mostly for his very competent work as a carver for Daniel Chester French, and to Magonigle (1867–1935), a young architect who had recently left the office of McKim, Mead, and White to become head designer and draftsman for Schickel and Ditmars. Magonigle's and Piccirilli's design for the monument consisted of a tall shaft decorated with sculpture and centered between two sets of small, paired gatehouses, the same shape as the central monument (figs. 9.5, 9.6). Wrought-iron grille gates (later eliminated from the design) separated each pair of gatehouses.

The monument is a panoply of allegories. As it now exists, it is surmounted by a sculptural group, *Columbia Triumphant*, said to be cast from metals recovered from the guns on the *Maine* and represented by an allegory of victory and three arched-neck, prancing horses. In the center of the pylon facing southwest to Columbus Circle is an allegorical group entitled *The Antebellum State of Mind: Courage Awaiting the Flight of Peace and Fortitude Supporting the Feeble*. Following the progression, the youth kneeling on the prow of an ancient war galley represents the "new era inaugurated in Cuba through the Spanish War" (fig. 9.3). On the northwestern and southeastern sides of the monument, reclining "river god" figures of the Atlantic and Pacific oceans suggest the "national scope of the

197 Maine Memorial *and* Pulitzer Fountain

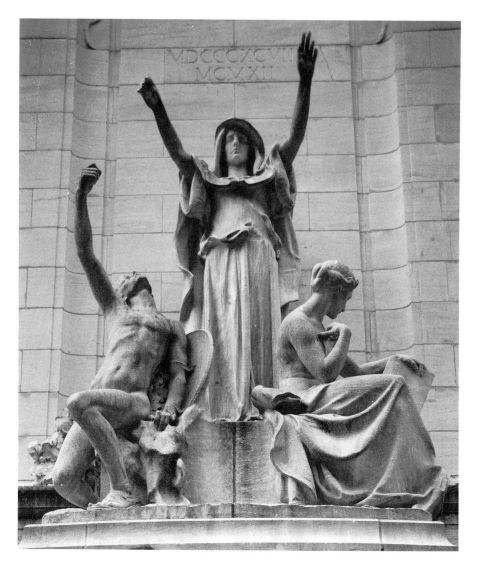

9.7
Attilio Piccirilli, *The Post Bellum
Idea: Justice Receiving Back the
Sword Entrusted to War*, Maine
Memorial, northeastern facade,
1913. (Photo, Michele H. Bogart.)

War, a seated nude youth with
shield, twists halfway off his seat to-
ward *Justice*, and thrusts up his
right arm with sword in a frenzied
gesture of victory. *History*, a seated
female figure, passively meditates
upon a tablet, the text of the past. A
hooded female *Justice* suspends her
arms high above *War* and *History*.

monument."[15] *The Post Bellum Idea*, depicting *Justice Receiving Back the Sword Entrusted to War* adorns the Central Park facade (fig. 9.7). Magonigle injected an unexpected bit of whimsy by substituting marine forms for some of the de rigueur classical ornament. The triglyphs at the top of the shaft became tridents. The discs in the moldings now included low-relief images of sea horses, nautili, fish, and sea turtles. A band of low-relief dolphins surrounds the base of the pylon.

Magonigle completed the basic plans by 1902, but since the work was to be installed on city property, the New York City Art Commission had to approve the designs and site. On 10 June 1902, the commission authorized installation of the monument at the junction of Broadway and Seventh Avenue at 47th Street, Longacre Square (fig. 9.8). But a bizarre series of events occurred. Piccirilli finished his designs (which were supposed to be completed by 1903) sometime before 1906. Around this time, however, he and Magonigle suddenly learned not only that a clerk at the Art Commission had "erroneously" failed to record the original site approved in 1902, but that a subsequent commission had unwittingly

9.8
Longacre Square (now Times Square), showing proposed site of *Maine Memorial*, 1902. (From the Collection of the Art Commission of the City of New York, Exhibition file 21-C.)

agreed to reassign the site. *Maine Memorial*, funded by popular subscription to heal the emotional wounds of the Spanish-American War, had now been displaced by another form of public "relief": a comfort station, which was already constructed before the artists and the committee learned about it.[16]

Given Hearst's notoriety, it is doubtful that this curious clerical oversight was accidental. The Art Commission was not generally so careless; and while partisan, its members had nothing against those involved with *Maine Memorial*. Indeed, one of the members of the commission committee that passed the design, painter Frederick Dielman, had been one of the judges in the *Maine Memorial* competition.

The mishap apparently offered a convenient opportunity for certain people to give Hearst and his monument a setback. In his 1944 biography of Attilio Piccirilli, Josef Vincent Lombardo, who did not mention the comfort-station incident, attributed the subsequent problems in completing the monument to the prevailing "political strife" between William Randolph Hearst and Tammany Hall. Throughout these years Hearst was alternately striking political deals and then fighting bitterly with Tammany boss Charles Murphy. In 1906 Hearst ran for mayor as an independent against Murphy's handpicked candidate, George McClellan. Tammany branded Hearst an anarchist and sent hecklers to his rallies. When one of them demanded to know what had become of the money collected by the *Journal* for the *Maine Memorial* fund, Hearst retorted that "if your money was as safe as the *Maine* monument fund you would be on easy street." A *Journal* cartoonist caricatured Murphy as a crook in prison stripes; Murphy had his men secretly manipulate the election ballots and completely sabotaged Hearst's campaign.[17]

With a Tammany mayor in office after 1903, it is entirely possible that these notorious animosities produced similar underhanded dealings in the Art Commission chambers. The commission told Piccirilli that as long as Hearst continued his *Journal* attacks on Murphy, McClellan, and Tammany Hall, *Maine Memorial* would probably just sit in the sculptor's studio. McClellan and other city officials would refuse a site for *Maine Memorial* just to deprive Hearst of the honor of seeing it erected. Indeed, after the comfort-station incident, the artists and the memorial committee encountered great difficulties in securing another location. An embarrassed Art Commission attributed the problem to a dearth of suitable sites, but it is no mere coincidence that city officials finally approved the proposed

Central Park site only after Judge William Gaynor was elected as mayor in 1909 and endorsed certain aspects of an anti-Tammany platform.[18]

In the meantime, the choice of location continued to be delayed. Only in 1908 did a reconstituted Art Commission vote on the possibility of another proposed site. This one, at the entrance to Central Park where West Drive and Central Park West conjoined at Columbus Circle, was convenient as far as Hearst was concerned (fig. 9.6). He now owned a good deal of the real estate in the surrounding area, and the presence of such a monument would raise his property values. (The Hearst Magazine Building [originally the International Magazine Building], completed in 1928, still stands at 959 Eighth Avenue, between 57th and 58th streets.) Anticipating positive developments, Magonigle modified the original design. He altered the angles of the pylon, lowered the prow of the boat, and lengthened the basin of the fountain in the front to account for the changes in scale between Longacre Square and Columbus Circle. But the Art Commission proceeded to turn down the design and site on aesthetic grounds, arguing that Russo's 1892 *Christopher Columbus* monument was and should remain the central feature of the circle. The commission feared that the proposed sixty-four-foot *Maine Memorial* would dwarf *Christopher Columbus* and detract from the beauty of both works. Moreover, the monument was too big for the proposed space; it would project into the roadway of Columbus Circle and obstruct traffic.[19]

Undoubtedly hoping that the 1909 mayoral election would bring him better fortune, Magonigle went before the Art Commission in May 1910 and proposed the same site again. This time he argued that there were no other entrances to Central Park that provided an appropriate transition between the rigid "architectural character" of the street and the "free treatment of the park." *Maine Memorial* would not encroach upon the park, but would heighten its features as a naturalized landscape. Views into Central Park would not be obscured, he wrote, but rather, given more interest and scale. The monument had sufficient mass to "carry the sense of the circle entirely around it, complete the circle and fill in the gap otherwise existing at this point." Given the trend, even then, toward constructing taller buildings, few places remained where such a monument would not be dwarfed and hence "diminished in importance."[20]

This time Magonigle (and Hearst) got their way. The Commission approved the site in July 1910, and they approved the monument itself (not including the sculpture) in March 1911, on the condition that the iron gates between the gate-

houses be eliminated. Piccirilli won approval for his allegorical figures on 11 March 1911.[21] The political obstacles had apparently been overcome. The building of the monument could finally start.

But controversies erupted again. In 1911, when several large trees in the park were cut down for the monument site, the *New York Times* stepped in with a series of editorials and letters denouncing the *Maine Memorial* as a "cheap disfigurement." The *Times* condemned the intrusion of the monument into the park, the destruction of trees, and in particular the removal of a small circular rest house (fig. 9.9). The editors blasted Park Commissioner Charles Stover, a staunch supporter of the *Maine* project, for committing an "aesthetic blunder" and for dismissing his landscape architect, Samuel Parsons, Jr., because he too had objected to the removal of trees. Parsons was a former park commissioner himself, and an outspoken opponent of any plan to include sculpture in the park. The *Times* chastised the Art Commission and the artists for proceeding "unguided by expert counsel," and for being so insensitive to the site. In 1913, as the memorial neared completion, the *Times* attacked the sculpture and the monument itself as an as an "unsightly object, . . . a monstrous combination of monumental masonry and plastic craftsmanship" with horses like "poor gored beasts of the Spanish bull rings vainly trying to regain their footing."[22]

Various artists also objected to the design of the monument and to its desecration of the site. Thirteen days before the unveiling, one group of them even told the *New York Evening Post* that they were going to ask the Fine Arts Federation to petition the Art Commission to demand alterations. Specifically, they wanted to change or remove Piccirilli's victory group at the top. One especially outspoken artist, Leon Dabo, said that the figures on the monument had no relation to each other and that the "little stone benches on either side of the drive will be a rendezvous for the young loafers who can in comfort amuse themselves with their remarks and comments on passing women."[23] Initiated after the fact and on such short notice, the artists' protests changed nothing.

Amid great fanfare, Hearst and a series of dignitaries dedicated *Maine Memorial* on Memorial Day 1913. In the presence of the Maine Monument Committee, Admiral Sigsbee (commander of the *Maine*), and Mayor Gaynor, and with ex-president Taft presiding, Hearst's little son George pulled the cord to undrape the monument while a group of warships on the Hudson blasted a twenty-one-gun salute.[24]

The *New York Times*'s criticisms of the monument, which had started much

earlier, represented a more serious challenge than the short-lived outcries of a few disenchanted artists. But the editors of that newspaper had their own motives for commenting about the *Maine*'s encroachment on the park. To be sure, the *Times* expressed the concerns of a portion of its readership, for whom the relationship of the "natural" landscape park to the city had always been an important issue. That *Maine Memorial* was a Hearst project was also a major factor in explaining why the *Times* took the spirited stand that it did. In 1911, with a certain amount

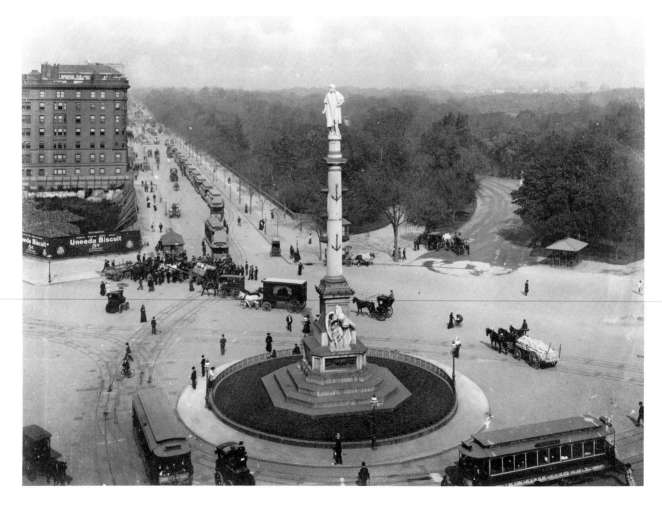

of smugness, the *Times* reported the chaotic and "unfortunate" circumstances by which the Maine Monument Committee had lost its original Longacre Square site to a public comfort station. The *Times* had its offices nearby, after all, and had *Maine Memorial* been erected there it would have been a constant reminder of Hearst. Worse, it would have represented the success of Hearst's sensational publicity and circulation-building methods—tactics that included not just monument drives but war making as well. Compared with the *Journal* and with Pulitzer's *World*, the *Times* had been uninvolved in the ballyhoo leading up to the Spanish-American War. It made little effort to dispatch its own correspondents to the front or to form a syndicate with other papers in order to do so. Indeed, the *Times*, as well as the other more conservative newspapers, the *Tribune* and the *Evening Post*, had railed against the tactics of yellow journalism during the war. In the following years, the paper only mentioned Hearst when his political activities simply could not be overlooked.

Of course, the editors of the *Times* would never have admitted that these factors affected their judgment. It was necessary to "ignore" such self-interested motives in favor of debates about more "appropriate" matters of principle like park layouts and their importance for the urban community.[25] Instead of opposing *Maine Memorial* as a demagogue's memorial to an unnecessary war and a circulation battle, the *Times* questioned the propriety of the aesthetic decisions. Formal design concerns about the relation of art to nature in the man-made park landscape still brought up important humanitarian and civic problems, though these were less noticeably mired in sordid politics. Whether consciously or not, the *Times*'s rhetoric revealed its own editorial/ideological position of genteel restraint. As the spokesman for people with "good taste," the *Times* avoided sensationalist *ad hominem* attacks on the man behind *Maine Memorial* and the provocation of the Spanish-American War. The war was long past, and attacks would only have served to bring Hearst more publicity at a time when he was seeking public office. It is true too that *Maine Memorial* commemorated a genuine tragedy: the loss of 260 American lives. Skepticism about the propriety of the monument itself (as opposed to the site) would have been construed as a completely inappropriate response. Unlike much of New York's public sculpture, the *Maine Memorial* really did represent a broad and genuine outpouring of public sentiment. The ties between the design of the monument and its popular significance were too close for a critic to launch any prolonged attacks on the work itself.

The *Pulitzer Fountain*

The *Pulitzer Fountain* also engendered debate, but it was neither as bitter nor as protracted as the controversies that afflicted the *Maine Memorial* committee and the artists. The fountain's location had been determined from the outset and was not an issue. As a private bequest to the city from a man who throughout his life had presented himself as the spokesman for the masses, it carried little of the widespread emotional charge that had sparked the subscription drive for *Maine Memorial*. Although the city was an active participant, there was little need to answer to the public politically or financially as in the case of the other monument. In contrast to Hearst's use of the *Journal* to mount a very public subscription campaign, much of the negotiation surrounding the *Pulitzer Fountain* took place behind the scenes. Once backed by the "right" constituencies, the Pulitzer project immediately won full support from the city's press and its elites. Certainly when compared with *Maine Memorial*, the construction of the *Pulitzer Fountain* progressed smoothly and peacefully.

The area east of the Plaza Hotel and north of the mansion of Cornelius Vanderbilt II had been the subject of discussion as early as 1897 (fig. 9.10). At that time the National Sculpture Society and, in particular, Karl Bitter, began to discuss the importance of developing a comprehensive plan for the site that would include the artistically not-yet-developed area of Fifth Avenue and 59th Street. It was a unique space and location: it was enclosed on three sides, led directly to the park, and was situated in one of the city's wealthiest neighborhoods. As we saw in Chapter 2, the NSS blocked the attempts to build the *Heine Memorial* in this area, then on the grounds that it should be treated as an artistic whole, and that the right kind of sculpture should be installed there. It argued that the area was much better suited for a $250,000 Civil War memorial, for which funding had been appropriated by the state legislature in 1893. Mayor Strong gave the approval for a war memorial in this location in 1897, and asked architect Bruce Price to solicit plans from seven architects and sculptors in a limited competition. The winners were Arthur A. and Charles W. Stoughton and Frederick MacMonnies, who proposed a column topped with a monumental figure of Peace. But while the NSS liked the Stoughtons' design, they did not feel it suited the Fifth Avenue entrance to the park for which it was intended. Other groups contended that the memorial should be closer to the river. The NSS lobbied hard and successfully to prevent the erection of the column in the Fifth Avenue location.[26]

It was Karl Bitter's vision, determination, and experience that would ultimately bring the Plaza project to fruition. In an 1898 article in *Municipal Affairs*, he outlined his ideas for revamping the layout of New York City streets, parks, and intersections. Bitter singled out the Plaza as one of several places that needed sculpture, but objected to a tall column like the proposed soldiers' and sailors' monument. A column would not work in a place that controlled no vista, he

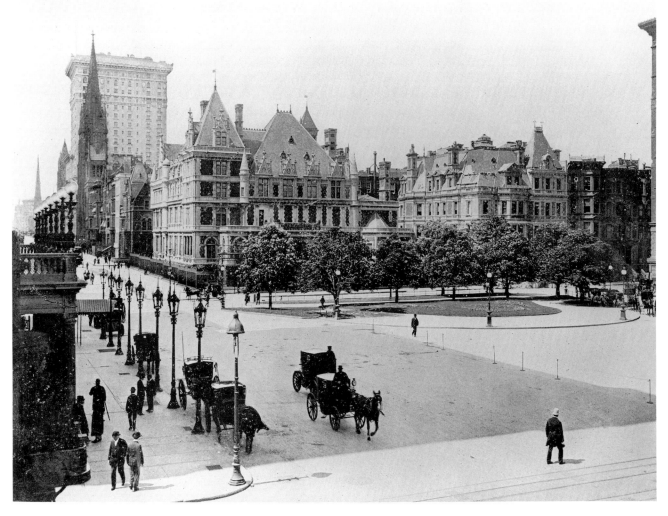

wrote. Nor could a monument simply be set down without regard for its surroundings; the site had to be developed as an aesthetic totality. Bitter then offered some suggestions for a design that would "embrace the Plaza" and lead to and culminate in the park entrance. He proposed "a symmetrical arrangement of statues or groups connected by balustrades or arcades surmounted by decorative lanterns, vases, or single figures laid out in such a manner that they accentuate and emphasize the existing and needed thoroughfares and passageways." [27]

Bitter went on to note that small fountains would be an especially effective adornment for the corners of the Plaza. Indeed, he observed, fountains in general would prove a great asset to the people of the city. And, he queried, "are there not many citizens prepared to give the means required for such a purpose? If only a few right minded and feeling persons would make the start and finally show how such a thing can be correctly and successfully made, others would follow and the city as such would shortly be beautified by a number of small yet ideal fountains possessing in addition to practical utility the merit of decorative beauty and ornamental effect." This means of funding would work well for smaller projects. But for "greater and more extended undertakings in municipal sculpture such as a modification of the Plaza until it shall compare favorably with the Place de la Concorde in Paris we shall have to look to the city." Large expenditures would be necessary to make the area "architecturally and sculpturally worthy of the wealthiest city in the world. Such labors will demand intelligence and energetic collaboration or the highest order of men." [28]

Bitter's comparison of the proposed Plaza undertaking with the Place de la Concorde was not arbitrary. At an 1898 NSS symposium, published in *Municipal Affairs* the next year, he presented a more specific plan for the Plaza in which two symmetrical horizontal bands or islands, bisected by 59th Street and open at the 59th Street ends, would be cordoned off by balustrades capped by pedestals with sculpted groups (fig. 9.11). Bitter's drawing pictured fountains with nude figures and aquatic animals at extreme ends, but perhaps anticipating that the Saint-Gaudens statue of William Tecumseh Sherman would eventually be erected on the site, he added that he saw no reason why equestrian statues could not be substituted. The islands he proposed would be shaped much like those at the Place de la Concorde. [29]

Despite Bitter's optimistic plans for the Plaza, the climate for expansive civic sculptural and architectural schemes was not especially good in 1899, with Tammany-backed Mayor Van Wyck in office. Van Wyck was in the process of thwart-

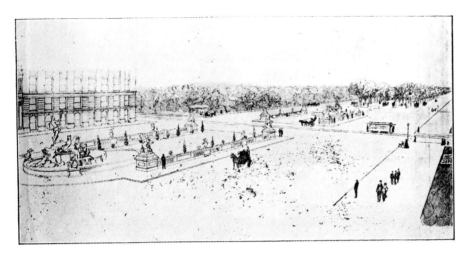

9.11
Karl Bitter, design for Fifth Avenue Plaza, from National Sculpture Society, "From Battery to Harlem," *Municipal Affairs* 3, no. 4 (December 1899): 635. (Economics and Public Affairs Division, the New York Public Library, Astor, Lenox, and Tilden Foundations.)

The islands would together define a sweeping open vista from 58th to 60th streets—a line that would be extended by a double row of trees between the west side of Fifth Avenue and the park. Running north and south, parallel to Fifth Avenue there would also be a "corso, a wide, possibly straight boulevard" for promenaders, and horse and bicycle riders.

ing the NSS sculptors' plans for the decoration of the new municipal Hall of Records. The society's Plaza idea also languished. In light of this situation, Bitter's suggestion that "a few right minded and feeling persons" could initiate smaller fountain projects and that the city (along with the collaboration of the "highest order of men") should take the initiative with larger projects, like the Plaza, seems to have been wishful thinking. The society's minutes of these years give no intimation of any progress.

Or so it seemed until the death in 1911 of Joseph Pulitzer. Pulitzer had throughout his life retained a strong sense of obligation toward his reading public and a concern about the techniques that he knew could shape values and opinions. He took these matters to heart when preparing his will. In addition to endowing a new school of journalism at Columbia University, he left a bequest for two sculptural monuments for the people of New York City: $25,000 for a statue of Thomas Jefferson and $50,000 "for the erection of a fountain at some suitable place in Central Park, preferably at or near the Plaza entrance at 59th street, and to be, as far as practicable, like those of the Place de la Concorde, Paris."[30]

The Pulitzer estate executors Ralph Pulitzer (son of Joseph) and George L. Rives (lawyer and president of the Board of Trustees at Columbia University) received immediate permission from Manhattan park commissioner Charles B. Stover to put up the fountain at the requested site in the southern half of the

Plaza. Aware of and sensitive to the NSS's long-standing interests in the area, the executors provided the society an opportunity to suggest appropriate procedures for commissioning a Pulitzer memorial fountain. NSS president Hermon MacNeil chose a special advisory committee to develop a tentative program for a limited competition. On the recommendation of this committee, NSS members adopted a proposal that the society choose ten artists by plurality vote. The five receiving the largest number would compete for the Plaza fountain commission. Not surprisingly, Bitter received the greatest number of ballots.[31] The society clearly viewed the Pulitzer fountain as Bitter's pet project.

Strong support of Bitter went beyond the simple explanation that his peers admired him and his work and that he had previously expressed an interest in the site. Rather it appears that at some point Bitter or someone close to him approached Pulitzer with the sculptor's ideas for the Plaza, and that Pulitzer conceived his bequest with Bitter in mind. It can be no mere coincidence that Pulitzer specifically requested a fountain like those of the Place de la Concorde—just as Bitter had described and conceived them in his original drawing and plans. Pulitzer knew Bitter's work. He probably knew the artist personally, for in 1890 the young sculptor had modeled four winged torchbearers for the Pulitzer building, designed by Bitter's primary patron, George B. Post. Furthermore, given his own Austro-Hungarian-American background, Pulitzer may well have also kept up with Bitter and his work through mutual acquaintances. What seems clear is that between 1899 and Pulitzer's death Bitter had greater say in the development of the Plaza area than either the records or his biographers have indicated.[32]

By 1912 he was in a good position to determine what should happen to the Plaza. The NSS had already given him a clear vote of confidence as the best person to receive the commission, even before any competition had been held. And in January of that year the mayor appointed him to the Art Commission. This post gave him power to veto any plan he could not control or disliked, and he acted swiftly when Ralph Pulitzer requested the commission to approve the Plaza as the site for a fountain. Writing to new NSS president Herbert Adams, Bitter insisted that he would not approve any plan that was not "comprehensive." Furthermore such a scheme would inevitably cost more than the $50,000 provided in Pulitzer's will. He then told Ralph Pulitzer that a special Art Commission subcommittee (Bitter, Francis Jones, and I. N. Phelps Stokes) had decided after scrutinizing the site that the proposed layout would not be "appropriate for a fountain of the character described in [his] father's will," particularly in light of the modest be-

quest. The commission would do everything in its capacity to carry out the wishes of the deceased, he promised, but its official duties only permitted it to "confer action on a particular design for a specific location." "Unofficially" however, Bitter added, he and his committee would be glad to offer suggestions.[33] As we have seen, commission members rarely offered this sort of unofficial "advice" under ordinary circumstances.

In October 1912, Ralph Pulitzer, Rives, and the commission subcommittee met together at the Plaza. This face-to-face encounter on the site gave Bitter yet another opportunity to demonstrate to Ralph Pulitzer the beauty of the scheme he had in mind. Pulitzer's report to Stover confirmed Bitter's position. The Plaza should not be developed haphazardly with the placement of just one small fountain. The "whole situation" would have to be studied carefully. Indeed, as the Art Commission committee suggested, hiring of a sculptor alone would not suffice. A competition would need to be initiated for an architect rather than for a sculptor, for the general character of the design was more of an architectural than a sculptural problem.[34]

Pending the park commissioner's approval, the Pulitzer executors planned a competition for five invited architectural firms to submit designs "worthy of the principal entrance to Central Park." As Pulitzer described them, the plans would provide "as one feature" the fountain erected at the expense of the Pulitzer estate. The other features of the Plaza would have to rest with the city—just as Bitter had indicated in 1898—although approval of the plan would not necessarily obligate the city to carry it out. Pulitzer concluded that it was his hope that a plan worked out in this fashion and involving the "best talent" of the city would appeal to public authorities and public opinion. In other words, he hoped that the city would come forth with the rest of the money.[35]

Park Commissioner Stover, the butt of *New York Times* criticism for cutting down trees to accommodate *Maine Memorial*, clearly favored the kinds of expansive City Beautiful schemes that Bitter and now Pulitzer proposed for the east side of 59th Street. Both Stover and the Art Commission quickly agreed to the terms set forth in Pulitzer's letter, and by late December 1912 the *World* announced a limited competition among five major architectural firms: Carrère and Hastings; H. Van Buren Magonigle; McKim, Mead, and White; John Russell Pope; and Arnold Brunner.[36] While the commission was, ostensibly, concerned only with a fountain, the competition provided for the broader treatment of the entire area.

The *World* expressed the hope that more comprehensive and inspiring schemes

would "stimulate public interest and result in the adoption by the city of plans for a more beautiful and expressive entrance to the great playground of the people." The general expanded plan would include "the rearrangement of the streets, curbs, park spaces and planting within the area including the location of the fountain; the relocation, if thought desirable, of the Sherman statue; the design and location of a new shelter, or shelters, to take the place of the existing iron structure used for this purpose; a comfort station for men and women, . . . seats and mounting blocks for equestrians, electroliers for general lighting, and the design of subway entrances and exits."[37] A five-member jury selected the firm of Carrère and Hastings by unanimous vote.

Hastings's winning design bore a striking resemblance to Bitter's 1899 proposal (fig. 9.11). Indeed, it appears that the competition outcome was for all intents and purposes prearranged. Hastings's fountain, like Bitter's, consisted of a series of basins, "three lower basins and five upper basins of stone and surmounted by an allegorical female figure . . . in the Renaissance style" (figs. 9.12, 9.13). As the *World* described it, the fountain would have a balustrade "suggestive" of that of the Place de la Concorde running at intervals around both islands and "across the upper end of the plaza at the entrance to the park." Hastings's design also included the same two symmetrical islands with rounded ends and separated by the axis of 59th Street. Although Hastings's design called only for the one fountain, his plan shifted the Sherman statue to the west to bring it "into line with the fountain"—a change not out of line with Bitter's earlier proposal that equestrian figures could be substituted for fountain figures.[38]

Bitter's control of the project was assured by his connections. Post, his former employer and architect of the Pulitzer building, had been the jurist representing the executors.[39] Moreover, as director of sculpture for the 1901 Pan-American Exposition, Bitter had worked closely with Hastings's partner Carrère, then chairman of the Board of Architects for the exposition. Finally, of course, Hastings chose Bitter as sculptor for *Pulitzer Fountain*.

The Art Commission approved the designs in May 1913, and the project continued without problems until Bitter's untimely death in 1915. His assistant Karl Gruppe, and then Isidore Konti, enlarged the two-foot-high plaster model left in Bitter's studio and saw the project to completion. The fountain, made of limestone with a figure in bronze, was dedicated in May 1916 (fig. 9.14).[40]

Modeled both upon archaic Greek art and the elegant mannerist statues of Nicolo Tribolo and Giambologna, Bitter's *Pomona*, or *Abundance* (fig. 9.1), pre-

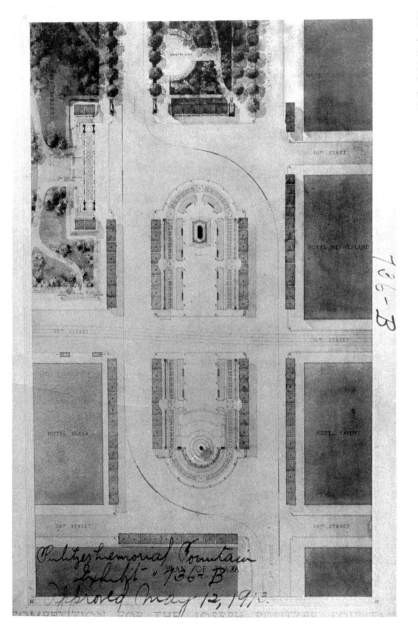

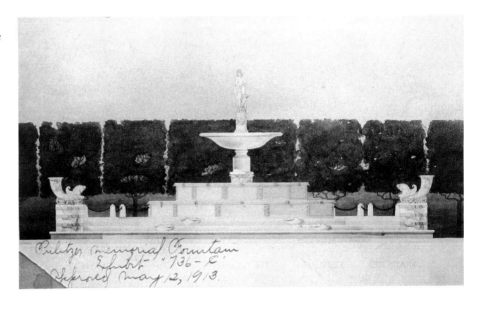

sents a pleasing profile from all points of view. The statue's formal and icono-graphic features, like all other aspects of the project, had been deliberately calculated. The title *Abundance* signified the wealth of the city; on another level, it paid tribute to the generosity and beneficence of the donor, legitimized the values of the newspaperman-entrepreneur, and absolved him of whatever indis-cretions he might have committed in acquiring his wealth and reputation. While it is uncertain whether Pulitzer had a hand in deciding the subject of the fountain statue, his desire for a single fountain, devoid of obvious didactic or personal association, is nonetheless telling. Whether or not this was intended by the patron and artists, the neutrality of the fountain signified the invisibility of commercial forces and the power of the publisher in controlling the look of the city and its cultural machinery. The discrete, behind-the-scenes negotiations by which the Plaza evolved reinforced this meaning. The anonymity and apparent transparency of the *Pulitzer Fountain* imagery evoked neither blatant ideological content nor associations with the self-promotional methods of its chief supporter, as *Maine Memorial* did with Hearst.

But no public work can be neutral. This becomes apparent when one questions not only why Joseph Pulitzer had wanted a fountain of the kind he did, but also why he chose this particular location.[41] Leaving aside the matter of Karl Bitter's

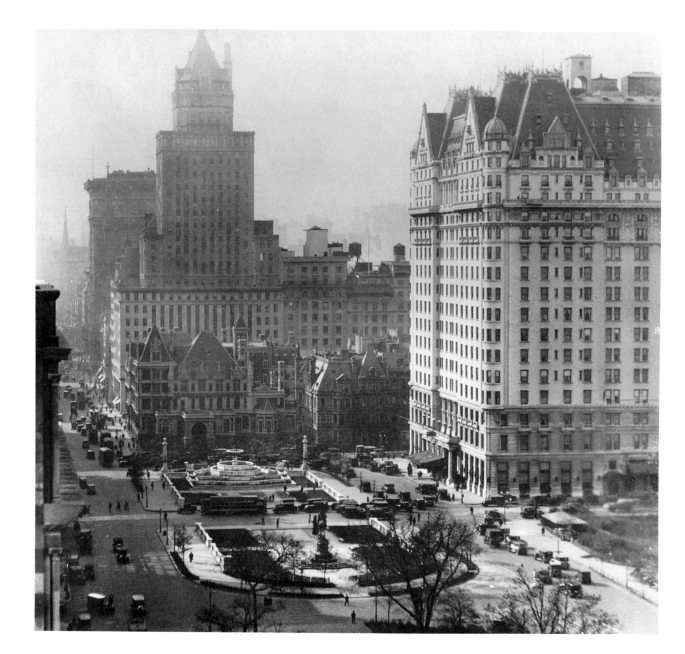

9.14
Fifth Avenue Plaza (now Grand
Army Plaza), looking south, after
1916. (Museum of the City of New
York.)

involvement with Pulitzer's decision to choose this site, it is clear that the fountain and its designated locale carried additional significance for the publisher that went beyond the personal satisfaction received through philanthropy. In choosing this particular site, Pulitzer sought, on the one hand, to vindicate the German-American cause and, on the other, once more to meet his archcompetitor Hearst on equal ground.

A major contributor to the *Heine Memorial* subscription campaign, Pulitzer must have been as chagrined and embarrassed as the other German-American patrons when the NSS—on the basis of their French-oriented stylistic preferences—challenged the artistic merit of Ernst Herter's fountain and insisted that the Plaza was no place for the German's $35,000 monument. In specifying that he wanted both the Plaza location and a design reminiscent of the Place de la Concorde, Pulitzer seemed to be trying to reconcile the differences between the German-Americans and the NSS. But the terms of the bequest also functioned implicitly to make the point that German-Americans were perfectly capable of doing things with refinement and good taste. He expressed this statement in terms to which he knew the NSS and their elite supporters could relate, thus in a sense underscoring these groups' aesthetic prejudices. The irony was compounded by the fact that a German-American had conceived of these tasteful French designs in the first place and then received the commission. In the *Heine Memorial* controversy, Bitter was one of the German members to whom the NSS pointed in defending themselves against charges of nativism. Pulitzer could provide such a commentary, moreover, without being identified specifically with a German-American cause. As the primary crusader for the *Statue of Liberty*, and as a major sponsor for Bartholdi's statue of Lafayette and Washington, Pulitzer had no need to prove his support for the French and their art.

But in and of itself this issue would not have been sufficient reason for Pulitzer to select the specific location and type of design that he did. To gain further insight it is necessary to return to the matter of his relations with his competitors, especially William Randolph Hearst. In 1888, in the midst of a circulation battle with James Gordon Bennett, Pulitzer went to great lengths to buy up Park Row property directly across from Bennett's *New York Herald* building. There Pulitzer intended to erect his own tall structure and thereby to dwarf the *New York Herald*. According to his biographer W. A. Swanberg, Pulitzer envisioned such a feat as a personal victory over the one New York publisher who still posed a challenge and as a "stroke of architectural publicity impressive to everyone."[42] When this

property turned out to be unavailable, Pulitzer paid cash to buy land three blocks north and was comforted by the disturbance the din of construction caused to *Sun* publisher Richard Dana, with whom Pulitzer was also engaged in a bitter feud. Having resorted to such schemes in the past, there is reason to assume that he again, at the end of his life, found a way to deflate his rival Hearst.

Hearst's campaign for *Maine Memorial* took place in 1898, at the height of his circulation war with Pulitzer, and at a time when Bitter and the NSS were formulating their plans for the Plaza. The attempts to place *Maine Memorial* in Columbus Circle had begun in 1908; Pulitzer had completed his will by May 1910, around the time the Art Commission completed its decision on the *Maine Memorial* site.[43] It seems no mere coincidence that in a city the size of New York two major sculptural memorials, both on 59th Street and forming architectural transitions into Central Park, were initiated one after the other by archrival newspaper publishers known for their extreme promotional methods.

Pulitzer Fountain offered the benefactor a "discreet" way to counter the promotional tactics Hearst manifested in the *Maine Memorial* headlines. While Pulitzer used many of the same techniques, he considered himself a responsible journalist. The *World* became known for the quality of its journalistic writing and, in particular, for its carefully crafted editorials.[44] Pulitzer's choice of a fountain—as opposed to a portrait statue or an elaborate allegorical monument—had to be equally deliberate. Like the discourse of the editorial itself, the "neutrality," "simplicity," and "restraint" of the commissioning process as well as of the sculptural product—especially in comparison with *Maine Memorial*—became part of the Pulitzer statement.

At the time there were no universally accepted procedures for commissioning public sculpture. Since different approaches to the "creative process" were used in these two cases, it is valid to ask whether there were potential advantages or disadvantages to either one. Many professional artists and critics believed the orderly procedures of *Pulitzer Fountain* obtained better aesthetic results. This might argue in favor of having public sculpture planned and created by an enlightened elite who would chart the course of events from behind the scenes. Those involved with the *Pulitzer Fountain* saw it as part of a larger plan that would make New York a better place for everyone to live over the long run.

Maine Memorial, judged from the standpoint of Hearst's motives, served blatantly political purposes. It was intended to draw attention to the *Journal* and to

placate the immediate, but transient, emotional needs of a variety of constituencies. It also legitimated the United States' imperialist policies. But one can view the situation from another angle. Confused as its development might have been, the *Maine Memorial* was presented as a popular monument. Voluntary donations from people all over the country (sometimes only a dime or a nickel) funded a good portion of the project. *Maine Memorial*, therefore, had more than just local significance. It was backed by widespread support matched by only a few large publicly funded monuments in the city.

Yet the simple fact of mass endorsement cannot explain satisfactorily what it meant for a monument to be accepted. These differences in process, site, and appearance that resulted from broad versus limited patronage give rise to an additional question that has yet to be addressed. What was the *nature* of popular support for public monuments? While American sculptors did not express much concern about popular approval, their efforts were predicated on an assumption that a wide audience would respond aesthetically and intellectually to their work. In the long run, the success of their public art enterprise was at least partially contingent upon middle-class comprehension of and belief in the meanings and values expressed by their architectural sculpture and monuments. Their art presupposed an unproblematic relationship that brought together the sculptors' means of expression, the works' signification, or meanings, the broader social structure, and specific events. Part 3 examines why none of these factors were easily reconciled.

III Ideologies, Interpretations, and Responses

10 The Myths of Civic Sculpture

By the beginning of the First World War, numerous statues, monuments, and architectural sculptures had been constructed in Manhattan and Brooklyn. Their thematic programs celebrated heroism, progress, nationalism, and the dominance of Americans of old stock ancestry in commerce, law, war, and culture. The sculptors put a great deal of effort into developing complex and elaborate images in a manner that would link traditional and modern ideals.

In retrospect, these works appear to have been conceived deliberately and sincerely to be conventional, obvious in meaning, and relevant for everyone: they were supposed to convey American ideals of republican democracy. They also presupposed the existence of social, sexual, and racial hierarchies. To understand the implications of these differences, we must go beyond the sculptors' and architects' own descriptions and interpretations of New York's public sculpture as we have described them thus far. We need to address what was the broader significance of the sculptural messages; how, if in any way, they represented the peculiar circumstances of late-nineteenth-century urban America; and how these social, stylistic, and iconographic factors might have affected public response to the works.

The issues discussed here relate to public sculpture in New York. But they take on broader significance in the context of a more comprehensive inquiry into the mid-twentieth-century rejection of allegory and illusionistic art.[1]

Academically trained American sculptors assumed that the success of their work depended on their ability to transmit their messages meaningfully and in an aesthetically pleasing manner. They believed that their statues had to hark back to a long-standing tradition of representation inspired by classical and Renaissance art; at the same time, the works had to affirm the essential truths of modern

American life. Their public monuments had to be sufficiently unobtrusive to blend harmoniously into the urban landscape without causing a commotion. Clearly the artists wished their works to generate positive response, but at the very least, they needed an unspoken public acceptance in order to sustain their complex enterprise.

On the face of it, the matter of popular acceptance did not appear to be much of an issue. Once erected, New York's public sculptures seemed remarkably uncontroversial and unremarkable. Iconographically, the images often resembled those found throughout Europe. The works looked and functioned just as the sculptors and their supporters thought they should. But to the extent that the sculptural programs seemed natural or convincing, it was because the sculptors took tremendous pains to make them appear that way.[2] Like all artists, sculptors at the turn of the century sought to represent universal truths "naturally" through artifice.

Reconsidered today, New York's civic sculpture represents in three dimensions what critic Roland Barthes defined as "myth:" "depoliticized speech . . . [that] has the task of giving an historical intention a natural justification and making contingency seem eternal."[3] Rather than a false idea, myth is a process in which meaning (its meaning and all other meanings) may be presented and accepted blindly at one moment and exposed to consciousness as "something else" virtually at the same time. Myths are often perpetuated, but they always have the potential to self-destruct. One might imagine a situation in which a given set of ideological assumptions might appear as fixed or closed—either to individual consciousness or to a particular social "group." From this interpretative standpoint, however, the possibility of total closure will never be achieved.

What makes public sculpture myth? To be specific: it might seem that both the formal components and the historical positioning of a public sculpture convey purposeful messages. Ideas may permeate the structure of thought of an entire society, while still representing the interests of a limited social group.[4] But the production of a public mythology is never so simple, nor so complete. It is always possible to take a "step back" and see "things" differently.[5] When examined from this perspective, the most obvious, unremarkable features of New York's civic sculpture are recognized to be the most ideologically crucial: the cultivated blandness of these works was necessary for them to succeed.

Two elements, both of which pertain to representation, could transform the "meanings" of New York's civic sculpture into myth. The first was the very cir-

cumstantiality of the objects and the meanings they were meant to convey: their connotations (such as "nationality," "New York in Revolutionary times," or "the triumph of the United States as a naval power") were generated as responses to issues in a particular time and place. The second element was the conventionality of the sculpture as a visual art perpetuating an aesthetic canon by means of its form, technique, and content.[6]

There is no reason to assume that these two aspects of sculptural representation—its historical setting (in this case, as American sculpture, made for New York City around 1900) and its general function as a mode of conveying meanings—simply coexisted without problems. When considering the ideological aspects of the content in these works, we must question the nature of the representation and the myth of modern life that the artists assumed they were conveying. Examination of these problems of meaning will help us later to understand the significance of the production of sculptural works that themselves functioned as critiques of representation and of New York establishment culture.

Creating the Myths of Modern Life

In making its case, the NSS and its supporters had argued that civic sculpture, inspired by noble European prototypes, would familiarize the public with the best aspects of past and present culture. In their view, a core of educated citizens and trained artists was needed to teach the moral lessons that the people ("the great unwashed in art" as described by the architect Barr Ferree) could not learn on their own.[7]

In stating that sculpture could be an important force in civilizing the public, the artists were echoing the rhetoric of other middle-class advocates of progressive reform.[8] Moreover, art theory in America had traditionally had a strong moralistic thrust, linking the lessons of a given work to style—design, composition, and other aspects of technique—as well as to subject matter.

Sculptors' training and professional associations would have also predisposed them to think in such terms, for the didactic concerns also had their roots in European aesthetic theories.[9] In his influential treatise *Grammaire des Arts du Dessin*, Charles Blanc, whose theories any academically trained artist of the day would have been acquainted with at least secondhand, discussed at great length the distinctive properties of sculpture and its special potential both for expressing universal ideals and for advancing public education. Moreover, he and other crit-

ics called increasingly for the sculptor to infuse his work with a spirit of modern life as well as with the principles of classical art.[10] These recommendations were more than just "pure" theories of representation. They were also ideologically charged responses to social and political conditions that ultimately affected the language of American sculptural expression. Implicit in the critics' statements was the idea that artists now had to reach out to the modern middle-class man. By the third quarter of the nineteenth century, European sculptors' solution to the problem of incorporating a modern spirit was to base the facial features and body types of their figures increasingly on live models rather than to imitate classical sculpture. They made the figures look more particularized and "realistic." In so doing, they sought to express the humanistic myth of the primacy of the individual and of personal freedom.[11] Late-nineteenth-century American sculptors adopted a similar formal vocabulary. Many of them had trained in France, and most shared a comparable outlook about the value of the individual.

Like their European and South American counterparts, American sculptors represented realism and contemporaneity in several conventional ways. Sometimes they used poses that seemed accidental and spontaneous rather than timeless and universal, such as in Daniel Chester French's monumental slumped-over sleeping continent *Africa* (fig. 6.9). At the same time, the sculptors were always careful to choose a "heightened" moment that would produce a pleasing composition and, whenever possible, to allude to a pose found in a classical or Renaissance prototype.[12] More often, the artists enlivened the facial features of their statues and in so doing further enhanced their mythical illusionist presence; the formerly blank stares of neoclassical statues became more directed glances. As mentioned, sculptors also based their work on actual people, so long as they conformed to the then-fashionable "ideal" image of contemporary beauty: in the case of women, this meant long-necked, oval-faced, high-cheekboned, wide-eyed beauties. They can be seen, for example in Philip Martiny's allegorical figures of New York for the Chambers Street side of the Hall of Records, or in Saint-Gaudens's striding Victory for the Sherman statue (figs. 7.6, 7.7, 9.2). Both artists suppressed enough physical detail to give the faces a generalized, "idealized" appearance, but the facial shapes and features were clearly based on those of live models rather than on the antique.

To a great extent, however, it was surface handling that governed the degree of likeness represented in the works and their continuing existence as mythology. Surfaces offered the sculptor a range of creative alternatives for reconciling the

"real" with the "ideal" in whatever measure and according to whatever definition he deemed most appropriate. It was for this reason that the choice of carver was considered so important. The degree of texture could be controlled so as to render a great deal of realistic-looking detail, like the corn kernels depicted in French's image of America for the Customs House (fig. 10.1). Or detail could merely be suggested in a generalized way, as in the hair of French's *Continents* or of the figures in Piccirilli's *Maine Memorial*.[13] Some sculptors, like French, kept the surfaces smooth to the touch but subtly manipulated the degree of indentation, linear incisions of chasing or carving, plays of light, surface "color," and articulation of

10.1
Daniel Chester French, *America*, detail of corn, United States Customs House, 1907. (Photo, Michele H. Bogart.)

detail to make surfaces resemble life. Others, such as MacMonnies and Saint-Gaudens, modeled their surfaces coloristically in the clay to create strong "sketch-like" contrasts of light and shadow that would suggest a purely visual play of fabrics or textures when translated into bronze.[14]

In addition to using conventional techniques and representational schema, academic sculptors concentrated on temporally localized and circumstantial themes as a third path toward the evocation of the myth of modern life. The American sculptors felt that the lessons they taught had to have contemporary and national relevance, and had developed a range of important themes with which to educate the public. These "great ideas" signified the moral, political, and cultural forces and activities that sculptors and their patrons believed to mark the progressive evolutionary path toward a more civilized society.[15] Whatever aspects of life contributed to that progress became suitable subjects for allegorical depiction. Thus commerce and art joined law, government, armed forces, and heroism as subjects. The new lessons also celebrated technological advancement and, in particular, such man-produced phenomena as steam and electricity. French, for example, sought in his Customs House groups to convey such ideals as "the inventive genius of modern America and her industrial enterprise," a muscular young man with a winged wheel shielded by the continent *America*.[16] Other works of public sculpture in New York celebrated imperialist destiny, municipal departments, and federal government red tape.

The sculptors had several compositional means of expressing these messages. They could start with a single-figure, either a specific portrait or a more generalized allegorical personification. The simplest method was the portrait statue, a rendering of a specific eminent individual who, because of his contributions to culture or society, was emblematic of the heroic ideal or genius in addition to his interest as a historical figure.[17] In a second approach, single figure renderings of important historical subjects (whose physiognomic characteristics were not always known) were used to represent the profession, activity, or country with which that person was traditionally associated. As we saw with the Appellate Courthouse and United States Customs House, these personifications acquired an additional level of meaning—an ideological charge as part of a larger sequence or program.

Not all allegory could be represented by means of images with such "readily recognizable" associations as portraiture. Thus a third connotative method em-

ployed personifications with emblematic attributes to embody new ideas. When the idea to be represented was an aspect of modern technology, some sculptors simply incorporated a contemporary attribute or invention that suggested its own causal relationship to the phenomenon being represented. For example, Martiny used an electric motor or generator in his *Electricity* on the Hall of Records (fig. 7.7). For the most part, however, artists borrowed emblems formerly used to signify an idea in one context and used them to signify another, newer concept.[18] This approach was as it should be, wrote critic William Walton. "With but few exceptions no new symbols are allowed" the contemporary sculptor:

only the slightest and freest suggestions of modern costumes are to be tolerated on an architectural facade, the conventional scroll represents the newspaper or the "blue print;" the scythe or the sickle, the reaping machine; the spade, the steam excavator. . . . For this, of course, there is good reason—there are certain things in art which may be said to have been settled, once for all; it is but fit that there should be something permanent, well established by good tradition, not liable to temporary and arbitrary aberrations, in the ever present artistic problem of personifying impersonal things.[19]

Evelyn Longman and Adolph Weinman followed Walton's call to rely upon tradition. In contrast to Martiny, Longman depicted her *Genius of Electricity* (fig. 14.6) with cables and a conventional lightning bolt. Weinman used a similar strategy in his panels for the Municipal Building (figs. 10.2, 10.3; Chambers at Centre Street) in order to represent departments of city governments. Thus the Department of Building Inspection was represented as a low-relief female figure draped in classical garb, one foot positioned on the base of a column, with a Corinthian column and flat wall behind her, and holding a scrolled plan of a building. Weinman's other representations of the municipal bureaucracy used classical figures and attributes in a similar fashion.

The artists hoped or assumed that the lessons conveyed through works such as these would be understood and accepted without doubts by middle- and lower-class Americans. As far as they were concerned, the sculptures simply glorified the values to which all citizens could or should relate. In reality not everyone necessarily shared sculptors' outlook or beliefs. Recognizing this, we have to ask in what sense the allegorical programs of public sculpture were truly intended for the general public, and to what extent, if any, average people responded to them. We need to examine how and why the reception of the civic sculpture could become a problematic issue.

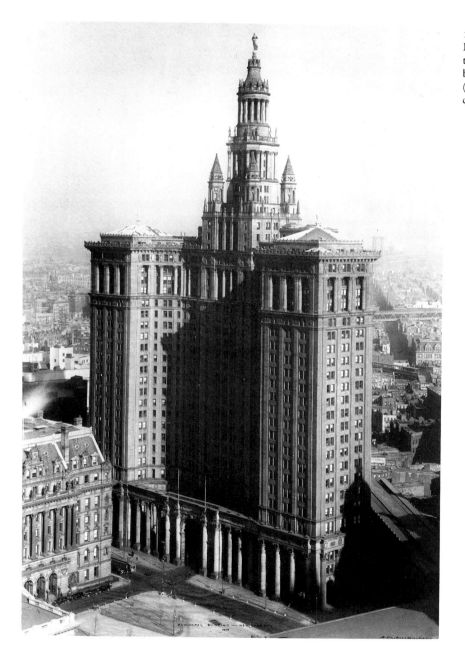

10.2
McKim, Mead, and White, archi-
tects, Municipal Building, Cham-
bers and Centre streets, 1907–14.
(Courtesy of the New-York Histori-
cal Society, New York City.)

10.3
Adolph Weinman, *Building Inspection*, relief for the Municipal Building, 1914. (From the Collection of the Art Commission of the City of New York, Exhibition file 353-AB.)

Sculptors' concern for teaching lessons through art was part of a broader endeavor to restore order in what was perceived as an uncertain cultural and political condition. Middle-class stability appeared to break down after the Civil War. In the face of social changes accelerated by industrialization, depressions, and a new wave of eastern European immigration, upper-middle-class white Americans increasingly sensed a need for better public education and for the dissemination of what they considered culture. Organization and instruction—through institutions, professions, and art—were seen as the primary vehicles of restoring proper authority as well as of promoting education.[20] This demand was felt especially in New York, the home of the greatest concentration of the powerful and affluent, and the place where the presence of immigrants was most noticeable. The city's upper middle classes were alarmed. They must have had the distinct sensation that the liberal emphasis on uplifting humanity was being carried to extremes. The acquisition of wealth by commercial and industrial magnates like the Rockefellers, Whitneys, Pulitzers, and Hearsts reverberated at the upper end of the spectrum. The phenomenon had started in the immediate postwar period, but only in the late 1880s and 1890s did this "class" of the newly rich legitimate its wealth through philanthropy and establish a new social stratum by assuming the role that the European aristocracy had traditionally played. Artists and intellectuals typically stemmed from less affluent origins. By forging relationships with prominent businessmen and lawyers they could move to establish "culture." Their ideology allowed them to preserve and enhance their own interests, while it coincided with their genuine wishes for civic improvement. At this very point, when the American elites became conscious that their upper-middle-class values were being threatened, they began their active attempts to represent order, unity, and progress through the lessons of civic sculpture.

The Limits of Myth

To understand these works, it helped to know the gods of the mythological tradition or be acquainted with such sources as Ripa's *Iconologie*. One had to be able to make the conceptual jump from the papyrus scroll to the contemporary functions of municipal government. The artists readily accepted this fact. Meaning had to be filtered through a tradition, and could be conveyed only when stated in terms of recognizable conventions. But by the turn of the century, the eclectic intermixture of attributes offered no guarantee that meanings would be immedi-

ately apparent. A viewer would not necessarily recognize the meaning beyond the simple referent (say, a man in a chair, or a nude man with a wheel) or the most obvious of connotations: Horace Greeley the eminent publisher, Plato the philosopher, or the spirit of commerce. Despite the supposed relevance of the images, the average viewer might well have to learn how to be taught, from others more "knowledgeable." This put those with less culture or education in an socially and politically dependent position in relation to the artist and the educated individuals who had delegated to themselves the task of articulating values. The production of civic sculpture presupposed that the sculptors were authorized to speak for all others; yet the very specificity of their works implicitly set limits upon what and whose values could be expressed, and how.

It is difficult to determine with certainty the broad impact, if any, of these civic sculptures as social communications. There is little written record of popular, especially working-class, reaction. Other forms of evidence (postcards and photographs for example) are statistically unreliable measures of mass interest that provide only partial insights into the complex nature of beholder response.[21] It is hard to distinguish those who ignored the works altogether out of disinterest from those who seemed oblivious because they passively accepted the overt allegorical messages at face value. To the extent that the general public understood the various meanings of the works and embraced them unhesitatingly, the sculptors succeeded in achieving important professional and artistic goals. The broader public may have identified with or empathized with some, or even all, the meanings the sculptors hoped to express. But in fact these works rarely were constructed as spontaneous or grassroot expressions of local popular sentiments. The producers of New York's public monuments sincerely wished conventionally to convey shared ideals. However, they worked very self-consciously within an elite classical ideological and artistic tradition whose representations and meanings had become complex and multifaceted, but at the same time too exclusive to be fully effective.[22]

There is no reason to assume that Americans actively and accurately constructed meanings out of civic sculpture or that an essential structure of belief in such works existed in some stable, universal, and invisible fashion. There are indications that some people doubted the sincerity of the professional sculptors' enterprise. They may even have undermined it, at the very moment when the artists and their supporters thought they were making headway. What is certain is that the pluralism of New York society and culture put strains on the sculptors'

efforts. In some cases, other groups employed similar types of sculptural images, especially allegorical figures, to mock elite culture and its representations. These reactions were not necessarily motivated by intentionally subversive concerns. The cases we are about to discuss in Chapter 11 should be regarded as isolated symptoms, not be interpreted as being directly or causally connected to the sculptors' activities. Nevertheless, their very occurrence served to expose the limitations of the mythical framework on which the artists depended to make their allegorical sculpture.

We can consider the examples of *Purity* and of Coney Island as "countercultural" alternatives on a number of levels. This was evident not only in their ostensible subject matter (which was often parodic), but also in their underlying themes and ideologies and even their manner of depiction. Analyzed together, these cases may suggest another way of thinking about the popular impact of the "official" civic works. Along with changing stylistic fashions and the institutional tensions discussed earlier, they provide a more textured historical explanation of the decline in enthusiasm for the myths of academic civic sculpture.

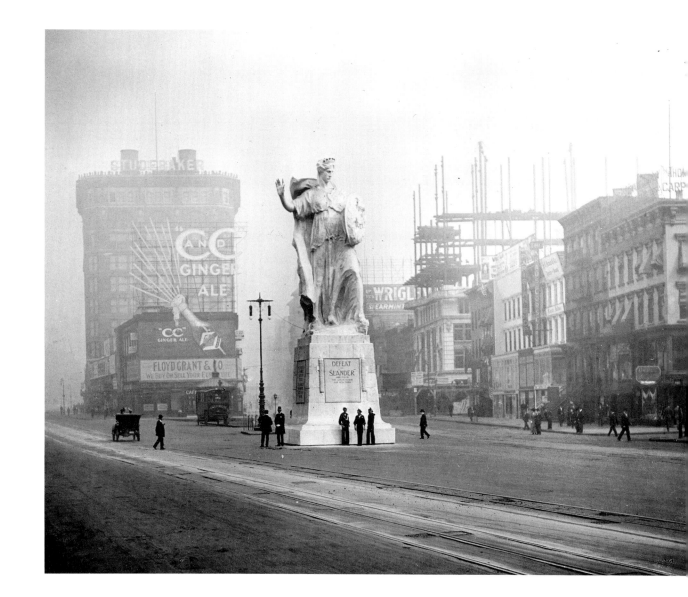

I I

Monumental Challenges to the Civic Ideal

The Importance of Believing in Purity

In the fall of 1909, a giant canvas-covered tower of scaffolding appeared in Times Square.[1] On 7 October, workmen unveiled a colossal twenty-foot-high plaster statue on a twenty-seven-foot pedestal (figs. 11.1, 11.2). A stern female figure stood "poised in an attitude of defence, her right arm thrown back, her left arm bearing a shield upraised." On the shield were inscribed the words "OVR CITY" surrounded by a laurel leaf. Several dark, mudlike splotches covered the surface of this plaster escutcheon. A tiara of incandescent lights crowned her head.[2] The plaques on all four sides of the pedestal bore the inscriptions "Defeat of Slander" (downtown side); "Dedicated to New York/The Greatest and Best of Cities/Our Home" (uptown side); "The Objects of the Association for New York are to contest for the principle of the governing of New York by New Yorkers for New York; to challenge indiscriminate and unjust criticism, and to show to the world the superior advantages of New York as a point of production and distribution for the manufacturer, as a mart for the merchant, and as a place of residence for the citizen" (east side); "That man who defames an individual injures but one. That man who defames New York injures four and a half million people" (west side).[3]

The statue immediately became a curiosity. The daily papers began to comment on this new and very public intrusion upon the urban landscape. Their descriptions and reviews were written in a manner quite unlike their usual respectful—if not always complimentary—discussions of monumental statuary. For example, the *New York Herald* noted,

Under, or rather over, the curious and none too respectful gaze of thousands of busy persons the statue of "Purity," alias "Our City," alias "The Defence of New York," alias "The

11.1
Leo Lentelli, *Purity*, (*Defeat of Slander*), Longacre Square, 1909, demolished. (Photo, Robert Bracklow. Courtesy of the New-York Historical Society, New York City.)

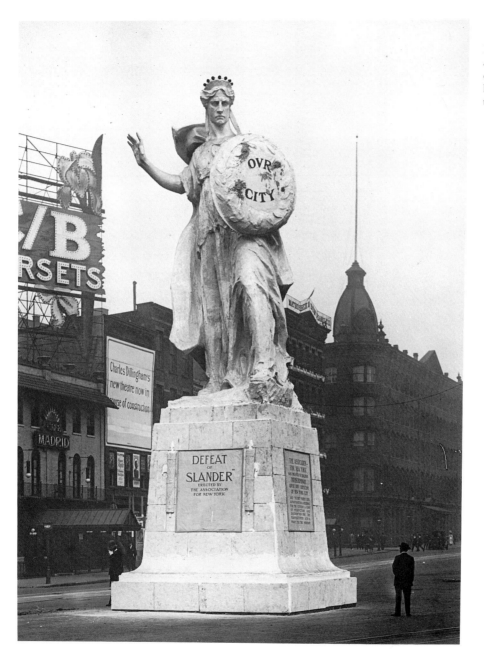

11.2
Leo Lentelli, *Purity*, (*Defeat of Slander*), Longacre Square, 1909, demolished. (Photo, Robert Bracklow. Courtesy of the New-York Historical Society, New York City.)

Defeat of Slander," . . . stood revealed for the first time in all her eight tons and fifty feet of chaste loveliness. With averted eyes, the lady stood exposed to the view of the throngs that swept by last evening. But they didn't sweep by before they had indulged in a prolonged stare.

The unveiling was a delightfully simple and informal proceeding. Three or four carpenters knocked loose a few boards and a piece of canvas was lifted from the brow. That was all. But it was an impressive occasion none the less. Possibly because they were awe stricken, the spectators did not fill the glad air with hallelujahs. Some were so affected they silently wept.

While there are four names by which the statue is mentioned none of them can authoritatively be stated to be the correct one. Not to beat around the bush, there is some uncertainty about the lady's name. She hasn't been christened yet. It may be "Our City," for those words appear upon the mud spattered shield she bears, and there is nothing to indicate her identity.[4]

Other writers echoed the confusion about the purpose and symbolism of the figure. A reporter for the *Sun* speculated whether the statue was an advertisement for "breakfast food." The article continued,

"Pardon me, but what does that misspelled way of writing 'over' signify?" was what one man asked a young individual who seemed to be acquainted with the plaster of paris person. [He] explained that the lettering on the shield which the lady brandishes is designed to be artistic, that hence when it reads "OVR CITY" it really means simply Our City.

This was about all the information that he was willing to scatter broadcast. When they asked him why the statue had been put up, who had done it, how long it was going to stay, whether it was supposed to be Mrs. Henry Hudson [a reference to the upcoming Hudson-Fulton celebration] or the personification of steam or whether Tammany or the Republicans were behind it or what corset the lady was going to advertise he merely shook his head sadly and turned his attention to the removal of spikes.[5]

On further inquiry, reporters learned that a young Italian, Leo Lentelli (1879–1961), had created the statue. A recent immigrant, Lentelli was in all likelihood innocent about the political nuances of his statue. He had probably envisioned this work as a way of breaking spectacularly into the sculptor's profession in America. When the press began to comment on his new creation, he had reason to regret his decision.[6]

A group called the Association for New York claimed responsibility for financing and erecting the figure. The association, incorporated just in July, had received a permit from the Bureau of Incumbrances, on approval from the Board of Aldermen and the mayor, to put the work up at no cost to the citizenry. As a temporary

structure (it remained in place until early December) it did not have to receive approval from the Art Commission.[7] The association reported that it had been founded to "challenge indiscriminate abuse and criticism of New York City, to set forth her advantages as a place of residence for the citizen, as a point of production and distribution for the manufacturer, and as a mart for the merchant."[8] *Purity* was to be the "concrete object lesson" of its campaign. According to the association president, one William Harman Black, the statue was also an "emblem of the city's purity and beauty, defending herself against the mud throwers and slanderers that so often assail her." These denunciations, which included, among other things, the "frequent assertions that the city has reached its debt limit and has poor credit," had led the public to question "unjustly" the integrity of municipal authorities. Nonetheless, Black assured reporters, *Purity* was not intended as a political statement.[9]

Much of the daily press assumed otherwise. The mayoral election was but one month away. And, the papers reminded readers, Mr. Black had served as the city's commissioner of accounts in 1903–1904, during the first term of Mayor George B. McClellan.[10] These facts were significant to anyone acquainted with New York politics of the day. As already noted, McClellan, during his first term (1903–1904) had received active support from the bosses of Tammany Hall. At this time New York City had no such thing as a real budget: the Board of Estimate frequently appropriated money without knowing whether there was or would be enough to cover expenditures. When the city lacked funds, the board just issued revenue bonds. The commissioner of accounts, a position created as a fiscal reform by legislative action in 1873 (after the Tweed Ring ouster), was supposed to act as a check on the activities of the comptroller and city chamberlain. More recently, however, the commissioners had been lax about uncovering violations, and the office had come to be known as a "white-washing agency" for Tammany-controlled municipal departments.

In 1904, the year that Commissioner Black left office, Mayor McClellan began attempts to straighten out the city's finances. These efforts led him to break with Tammany and later prevented him from obtaining other public offices. In 1907, the private Bureau of Municipal Research had also begun to scrutinize the financial activities of city agencies. The bureau—founded that year by young reformers William H. Allen, Henry Bruère, and Frederick A. Cleveland—studied the operations of municipal departments in the hopes of achieving more economical fiscal policies and more efficient city government. Allen, Bruère, and Cleveland

sifted through city contract specifications and other available documents, and their 1907 report, revealing misappropriation of funds and other corruption, resulted in a high-level shakeup. Tammany Hall soon nicknamed the organization the "Bureau of Municipal Besmirch," and Tammany boss Charles Murphy decided to find a mayoral candidate who would lend an aura of virtue to both the mayor's office and to Tammany Hall.[11]

Given these events and the fact that the plaster statue represented an attempt to thwart "mudslingers" who sought to "besmirch" the city by criticizing the handling of its credit, the newspapers soon began to link *Purity* (or "Virtue," as it was also called) to Tammany Hall—with no little irony (figs. 11.3, 11.4). The *Herald* ran a cartoon entitled "The Lady or the Tiger?" with *Purity* depicted as a rampant tiger whose upraised shield bore the inscription "The Lid"—a reference to the phrase "the lid is off," meaning that graft and vice had been let loose. Other local papers made similar connections.

—"Oh, well, you are here to serve a powerful political organization?" it was suggested to the White Lady. "You must serve, mustn't you?"—"I have heard on good authority," she answered, "that I am supposed to be doing noble work for Tammany. Some of the men interested in the Order of Acorns are also interested in the Association for New York. I hear around me, and it is assumed on all sides that I am a Tammany figure. I suppose these spots that were put on my buckler were meant to represent some of the anti-Tammany arguments of Tammany's political enemies."[12]

For several days the statue became the butt of mudslinging in the papers. Their comments are worth quoting in detail, for the very style of the prose itself has broader political and aesthetic implications that will be addressed later. Most commentaries focused on the ambiguity of the statue's gestures, its attributes (the shield and tiara), and the figure's ultimate purpose and meaning. A reporter for the *World* asked tongue in cheek whether the lady was signalling for a taxicab or whether the uplifted right arm meant she was "firmly waving something aside and saying, 'No sir, not another single drink tonight'?"[13] One of several letters to the editor of the *Times* offered another opinion:

Certain carping critics mention what they call a shield, carried by the lady statue now glittering white in Times Square, as looking more like an umbrella or the bottom of a washtub than a shield. No doubt it does, as far as they know. Shield, indeed! It is not a shield. It is the lady's hat, as any one with half an eye for millinery of the prevailing modes will satisfactorily testify. . . . It may be ungallant to comment upon a lady's face, except in open adulation, but say, "doesn't she look like she's been through a hard Winter?" We

draw the line at discussing the lady's age. Still, it is no more than right to say that if Virtue, or Purity, or both, is as old as that in New York, and so little doing in her line, it's about time she was hieing to a nunnery somewhere outside the city limits. On the other hand, if she be really young and her struggles with vice have pushed that hard and wrinkled look into her face, it's time the police or the preachers were handing out some first aid to the injured.[14]

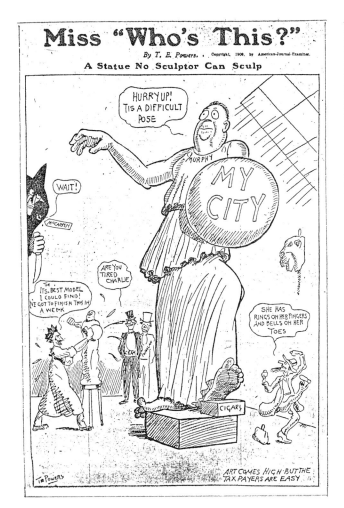

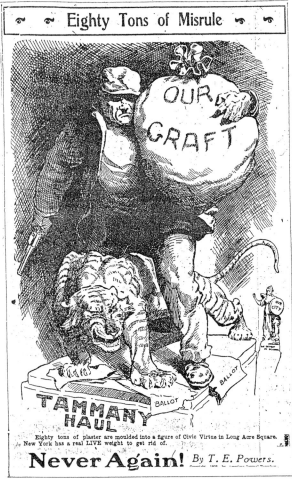

The *Times* also abandoned restraint and blasted the form, the iconography, the peculiar phraseology of sculpture criticism, and Tammany Hall, all in a single editorial.

> The Lady with the Dishpan has been the occasion of varied conjecture. . . . She is said to be Mr. Murphy's protest against calumny and the legend her pedestal bears sustains that view. Others insist that she typifies some occult, but doubtless noble, aspiration of the clan of Sullivan [a group of Tammany bosses who controlled districts on the Lower East Side]. May she not, in that center of theatres, have something to do with the stage, histrionic uplift, ambition, and that sort of thing, the right hand pointing to the upper realms of artistic endeavor, while the left holds the Dishpan, *ut quocunque parata*, as a prudent shield against possible projectiles from an unappreciative audience? . . . With that imposing mien and that appealing gesture the Lady with the Dishpan might, it seems to us, confound Vice, as Father Tom was wont to catapomphericate the heretics, "in two shakes." In that relation the meaning of the uplifted arm would be clear enough: but what in the name of salvation the Dishpan would signify we leave to the experts of the University Settlement to determine.

11.3
T. E. Powers, "Miss Who's This?" cartoon, *New York Evening Journal*, 7 October 1909, p. 22. (General Research Division, the New York Public Library, Astor, Lenox, and Tilden Foundations.)

11.4
T. E. Powers, "Eighty Tons of Misrule (Our Graft)," *New York Evening Journal*, 6 October 1909, p. 20. (General Research Division, the New York Public Library, Astor, Lenox, and Tilden Foundations.)

Although the name of the sculptor had already been made public, the editorial went on to discuss the "question" of attribution.

> We know, though, who made the statue. It is the work of Rodin, and in his best manner. Whoever has beheld his Balzac, has felt the majesty of the mind and the greatness of the soul that dwell within that figure, has really yielded himself up to the spiritual beauty and the unearthly charm and grace of that ultimate triumph of plastic art, would, at the very first careless glance, pronounce the Lady with the Dishpan a Rodin. Compare the raised hand with the outstretched puissant paw of Rodin's Victor Hugo, as it was pictured in *The Times* of Sunday last. Note the superb modeling and the attachments of the joints, all frankly revealed under the plaster clothes. It is too bad that she has no right leg, but anyone can see that the other members have been sharpened like stakes and driven into her body at the appropriate corners. That is what a sculptor with a good grounding in anatomy ought to do. He should let the admirers of his work see just how the figure is put together. Rodin did that when he combined the plaster Lady with the Dishpan, and we like him and her all the better for that engaging frankness. Mr. Murphy, if the statue is really of Tammany provenance, is to be congratulated upon the choice of a sculptor. Rodin's well-known deference and respect for his public shines forth in every fold of the Lady's garments, and, notably, from the Dishpan. This is easily his masterpiece, we should say.[15]

On one level these comments were intended to underscore the absurdity of current debates in New York City politics; the statue was merely incidental to these other matters. Yet precisely *because* of the sarcasm in these newspaper articles, *Purity* eventually had serious consequences for American sculptors and the future reputation of their public work.

For over a decade New York sculptors had consciously sought to create an impression that they were responsible, apolitical professionals. The National Sculpture Society, through its alliances with other artistic and civic groups, had been involved in the efforts to develop a New York plan for city beautification and urban reform.

The sculptors' vision of a more livable New York, with elegant parks, romantic squares, and sweeping vistas down broad, tree-lined boulevards, had been inspired by such great cities as Paris, Rome, and Vienna. New York's streets were to be woven together in orderly grids and radiating patterns and enhanced by edifying works of sculpture. These statues, created by American artists, would extol the value of modern urban life while simultaneously heightening public awareness of America's (Anglo-Saxon) heritage and destiny. We have seen that during these years it was often temporary works, like the *Dewey Arch*, that served as the models of what American sculptors thought civic work could and should be. The recent world's fairs had all included a broad array of temporary, free-standing, allegorical statuary, which the sculptors hoped could someday be recreated in more durable materials. On several other occasions, the artists resorted to making transient works in staff in an attempt to promote their work and to inspire demand for more permanent monuments.

This generation of American artists considered allegory and personification as an inherent part of their expressive vocabulary. It was a form they used in several New York projects without prompting much comment about the meaning of such allegorical statues or about their ability to convey either their literal or symbolic messages.[16] Rarely did anyone openly question the integrity of the artists' ideological intentions, or ask whether representation of allegory in sculpture could translate into practical ideas and values. *Purity* was an early exception. It would be extreme to say that the *Purity* incident specifically *caused* a breakdown in the belief system necessary for allegorical statuary to retain even the possibility of symbolic signification on a popular level. Nevertheless, the actions of the Association for New York did contribute to this effect, as can be inferred from the fact that the association did indeed have ties to Tammany Hall.

Although Tammany periodically contributed to public subscription campaigns for certain monuments, they believed the efforts of the beautifiers were intended only to benefit the wealthy. After all, Tammany men were rarely asked to serve as trustees of major cultural institutions. We have seen how Tammany had been

instrumental in delaying construction of the New York Public Library, and how a Tammany-supported architectural firm had been engaged in the power struggles over the construction and decoration of the Hall of Records.

In the election year of 1909, the newly established Association for New York was fighting fire with fire, using their adversaries' techniques to point to the reformers' shortcomings. This intention lay behind the monumental *Purity*, whose message was signified through gesture, facial expression, attributes, and written inscription. All of these features ostensibly conveyed what the statue was about, and *Purity* thus seemed to be a typical allegorical sculpture. The professional standing of its sculptor lent further legitimacy to the enterprise. Lentelli was a member of the NSS, and admission to the society connoted artistic potential, technical expertise, and adherence to a certain set of standards for what constituted "appropriate" subjects. In making *Purity* Lentelli employed the same kinds of conventions that his City Beautiful peers would have used to express civic ideals. He had used the same means but, as it turned out, to a different end. Lentelli had unwittingly created an object for parody.

As if in response to the City Beautiful demands that statuary adorn streets, traffic circles, and public squares, the association positioned *Purity* so that she accented a major intersection along an important thoroughfare. But Tammany had no intention of implementing the reforms and ideals recommended by sculptors and civic activists. The siting was a joke: *Purity* loomed above the bustling Times Square theater district, with its billboards and honky-tonk lights.

The statue was a public relations scheme, but not just another promotion in that year's mayoralty campaign. *Purity* signified rebuttal to the City Beautiful reformers, and as such it became the object of numerous parodies—parodies that the association may well have hoped for. The parody was obvious at the time: those critics complaining about the spending policies of the Tammany machine should look again at those reformers and City Beautiful advocates who claim that spending money on art is the path to a better society. What proof do they have that all those statuary schemes will improve the minds and lives of both the well-to-do and the masses? Do such expensive projects measure up in human or economic terms to what Tammany Hall has provided through jobs and other services? As the papers were quick to observe with reference to *Purity*, art is costly. The plaster *Purity* was said to have cost $5,000. And admittedly, *Purity* was a perfect example of civic art's ineffectiveness. Thus responses of the press to this

work proved how good intentions, expressed though artistic statements, would ultimately be worthless if they were misunderstood.

Purity, as a symbol of what Tammany Hall did not support, was a setback for academic sculptors. It was deliberately conceived as a monstrosity and given several names and connotations. In contrast to the ideal of allegorical statuary that most American sculptors envisioned, *Purity*'s meaning and purpose seemed not simply multileveled but misleading and unclear. It was this factor that provoked the *Times* to call the statue a Rodin, for in comparing *Purity* with Rodin's *Balzac* and *Hugo*, the *Times* editorial did more than just ridicule. Certain critics had already dismissed the distortions in Rodin's sculptures—their exaggerated modeling, bad anatomy, hulking masses, and ambiguous relation between form and content—as a bad joke. The correlation of *Purity* with Rodin thus conjured up similar charges of surreptitiousness and artistic insincerity. Indeed, the overt connotation of *Purity*—the value of art in attaining civic ideals—became merely a translucent veiling for a malicious covert message that signified just the opposite. In its paradoxical extremes *Purity* cast aspersions upon the very sincerity of American sculptors' professed ideological enterprise: to instill a love of the beautiful, teach civic values, and contribute to cultural progress through representations of "truth."

By this time the press could exploit its power to fan the fires of outrage among a broad middle-class constituency. Newspaper parodies of *Purity* brought to public consciousness the dialectical relations among artistic form, content, intention, and ideology. Once aware that it was possible to interpret art in different and even contradictory ways, a viewer could no longer assume that an allegorical statue signified a single basic concept. Nor could one assume that the work's apparent ideological premise coincided with the meaning and purpose of its artist and patron, whose intentions might not even be honest.[17] Although seemingly minor, the *Purity* incident set a precedent that had lasting effects. It undoubtedly lessened public trust in the neutrality of the sculptor and in the integrity of traditional allegorical representation. Furthermore, it fostered suspicion about the relation of personification to allegorical content among people who had generally not previously questioned such matters. As the decades of the twentieth century progressed, American sculptors found it increasingly difficult to create allegorical civic sculpture in the face of such skepticism. They could no longer rest assured that either the press or the reading public would maintain the faith that was necessary if such artistic statements were to be made convincingly.

Coney Island

Purity was a temporary and limited instance. Coney Island (fig. 11.5), the largest and most famous of the many new amusement complexes built in America at the turn of the century, represented a more elaborate, permanent, and influential popular commentary upon City Beautiful art and ideals. Coney Island developed out of the context of the World's Columbian Exposition and its designs, but it was neither controlled by the same social groups nor intended to accomplish the same purposes. Entrepreneurs rather than architects, museum curators, and genteel businessmen masterminded the Coney Island "parks," and these parks attracted crowds of immigrants and out-of-towners as well as the city's own middle and working classes. Indeed, Coney Island was most successful among the very groups that artists and City Beautifiers targeted for socialization and edification through civic art. The ideals Coney Island overtly expressed were at the opposite pole from the heroic visions of order and stability of City Beautiful programs. Instead, Coney Island's lavish architectural and sculptural arrangements were designed to contribute to a riotous, carnival atmosphere. Along the way they helped to nurture indifference and even resistance to the elite values that official civic sculpture sought to transmit.

Coney Island was a legacy of the midways of the turn-of-the-century worlds' fairs. The progenitor of these was the Midway Plaisance at the World's Columbian Exposition, an amusement strip set off from the main exhibition buildings of the Fair (the "White City"). It was packed with games, restaurants, theaters, colossi, and native villages with "educational" displays of exotic ethnic types. Colorful, chaotic, and blatantly commercial, the Midway was everything the White City and the City Beautiful were not, and thus provided visitors with alternative possibilities for spending their leisure time. The Midway Plaisance proved to be much more crowded and popular than the civilized boulevards of the White City itself; Frederick Law Olmsted even urged Daniel Burnham to incorporate some midway-type features into the White City, since according to him, visitors there all looked so miserable.[18]

Coney Island was a sort of permanent midway, with all of its amusements, but few of its didactic pretensions. In contrast to the midways, which were adjacent to the fairs and associated with their serious purposes, Coney Island was physically cut off from the rest of New York City. This isolation appropriately expressed the gap between its owners' purposes and the ideals of city beautifiers.

The gulf between Coney Island and the rest of the city was manifest organizationally as well; for whereas the wealthy and the professionals who became involved with the City Beautiful efforts had maintained some interest and control over the midways at the fairs, these people had nothing to do with Coney Island.

Coney Island had been a beach resort since the early nineteenth century, but the construction of the New York and Manhattan Beach Railroad in 1876–1877 helped to make it more accessible and popular. Beginning in 1895 promoters built large amusement parks modeled on the midway conception. George Tilyou opened Steeplechase Park in 1897; Frederic Thompson and Elmer "Skip" Dundy established Luna Park in 1903; and then in 1904 William H. Reynolds's Dreamland opened for business. Coney Island visitors streamed along a cacophonous main promenade called the Bowery, where they were bombarded by the cries of beer, ice-cream, and hot-dog concessionaires, circuslike freak shows, and such exotic offerings as "The Streets of Cairo" and an "original Turkish Harem."[19] Each of the individual parks had its own special rides, pranks, and amusements, many of which were inspired by and brought from world's fair midways.

Architecture and sculpture were an important part of Coney Island's significance as a cultural statement, just as they were at the World's Columbian Exposition and within the larger context of the City Beautiful. Undoubtedly most people who visited Coney Island went for the beach and the amusements inside the buildings. But inasmuch as the decorations functioned as advertisements for the entertainment attractions and contributed to the general atmosphere of hilarity, they played a crucial role in the amusement park experience and were the subject of careful planning. While the designs of Coney Island shared a few features in common with the official portions of the expositions, Coney Island was a parodic commentary upon the classic plans of the world's fairs and the developing City Beautiful ideals. Consequently, the sculpture at Coney Island, particularly at Luna Park and at Dreamland, functioned quite differently than that in more sober settings.

Luna Park (fig. 11.5) was the inspiration of Frederic Thompson and Skip Dundy. These two concessionaires had worked together previously on several enormously popular exhibits. The best known was their fantasy cyclorama "A Trip to the Moon," constructed at the 1901 Pan-American Exposition in Buffalo. George Tilyou hired them to recreate it at Steeplechase Park. In 1902 they left to establish Luna Park, an extraordinary amusement and architectural extrava-

"Whirl of the Whirl," Luna Park,
Coney Island, 1905. (Photo, Detroit
Publishing Co., Library of
Congress.)

ganza. There, visitors could enjoy such rides and spectacles as "Dragon's Gorge," "Streets of Delhi," "The Fall of Pompeii," "Fire and Flames," and "Shoot the Chutes."[20]

Luna Park's lavish architecture and sculptural confections contributed substantially to its fascination and success. Thompson (1872–1919), a trained architect, had as a young man worked as a draftsman in the Nashville architectural firm of his uncle George Thompson. He was sufficiently well-versed in "American Renaissance" and City Beautiful aesthetic ideals to have won $3,000 for his neo-Renaissance designs for the Negro Building for the 1897 Tennessee Centennial Exposition. Thompson had managed many of the midway concessions at both the Tennessee fair and the Trans-Mississippi and International Exposition of 1898 in Omaha, Nebraska. Settling in New York, he enrolled in art classes with the eminent academic painters Kenyon Cox, Robert Blum, and Frederick Bridgman at the Art Student's League.[21]

Thompson's artistic background shaped his attitudes toward architecture as a form of entertainment and a means of crowd control. His work grew out of the City Beautiful ideal, and was a response to it. His previous experiences in professional artistic and architectural spheres had clearly not agreed with him. In several articles written in 1908 and 1909, Thompson criticized the official portions of the world's fairs both as amusements and as entrepreneurial devices. Luna Park, he argued, offered more fun for its visitors and greater profits for its promoters than any world's fair ever would. Like the World's Columbian Exposition and the City Beautiful designs, Luna was developed on the basis of a highly controlled system. But unlike the expositions, Luna Park, even while morally irreproachable, would make no attempt to teach.

Instead, Thompson viewed laughter, emotional release, and commercial success as the desired effects of his architecture.[22] He admitted his commercial intentions quite forthrightly. "Theatrically speaking," he wrote,

architecture is nothing more than scenery. . . . Everyone, I take it, knows that a "bally-hoo" is a device calculated to attract the attention of people and to guide them into a show—a brass band, an automaton, a lightning calculator, a dancing dervish; anything which can collect a crowd and hold it until the "barker" can get in his fine work. All showmen use them, but I think I am one of the very few who have ventured to make architecture shout my wares. I have tried hard to make it as much a part of the carnival spirit as the band, flags, rides, and lights. I have tried to keep it active, mobile, free, graceful, and attractive, and I have always preferred the remarks "What is that?" or "Why is that?" to "Isn't that a beautiful building?"[23]

Thompson provided some additional explanations of his design techniques, whose effects show an interesting parallel to the shock aspects today associated with modernist art. According to Thompson, the architecture, although thoroughly composed, should not appear to be so. "I am duly acquainted with the importance of an adherence to the mathematical details of set rules, which is infinitely better than the independent meanderings of the untrained man who builds monstrosities," Thompson wrote. An architect must "understand that no structure which jars on its neighbors realizes completely its mission."[24] The amusement park and its architecture should present a bizarre theatrical context that would shock viewers by temporarily situating them in a fantastic, disorienting environment—one quite alien to the aesthetic ideals envisioned by City Beautiful advocates.

At Luna, Thompson used the "conventional" to create the "unconventional." The architect "must dare to decorate a minaret with Renaissance detail or to jumble Romanesque with l'art nouveau."[25] Thompson accepted his own dare, designing Luna's buildings by combining elements of classical, Renaissance, and oriental architectural styles in an eclectic, apparently nonsensical manner. Like other contemporary architects Thompson consciously incorporated tradition, but he did so with the express purpose of turning tradition on its head.

At Luna Park, confusion replaced the clarity, certainty, and unity of the White City. Juxtaposition and change supplanted the repetition of classical elements that contributed to the sense of wholeness and order in "typical" traditional architecture. Novelty replaced invention, the aesthetic principle of variation or imitation—theoretical principles that inspired Thompson's architect contemporaries. Thompson's models for style were the fantastic and the bizarre rather than the ideal. As a result Luna Park resounded with loud, raucous humor, not the genteel seriousness which public architecture properly evoked. Defiance and subversion of the mundane ruled the day, not acquiescence. At least for the time that people were there, Luna Park signalled the triumph of popular culture over elitism.[26]

At Luna, sculpture related to architecture in seemingly incongruous yet nonetheless effective ways. Sculptures served as ornaments and architectural accents. In the case of some of the exhibitions, sculptures were indexes of what could be found inside. Many of the images were presented as if simply "literal," pure denotations. Thus at the entrance to the "Dragon's Gorge" two gigantic griffins stood like Chinese guardian monsters, grimacing at incoming visitors. People had come to expect symbolism or some didactic allusion in sculptural imagery. Works

with meanings so apparently obvious seemed strangely ludicrous, especially when positioned architecturally in a manner traditionally associated with cultural edification. At Luna, for example, cartoonlike duck heads sprouted out from the prows that supported flags and the span of semicircular arches on the balustrade of the elevated promenade (fig. 11.6). Prows, but not ducks, had been used in

11.7
Johannes Gelert, rostral columns,
World's Columbian Exposition,
1893. (Charles Dudley Arnold Col-
lection, Avery Architectural and
Fine Arts Library, Columbia
University.)

conjunction with rostral columns at the World's Columbian Exposition (fig.
11.7). At Luna Park the prow and figurehead forms were transferred to a differ-
ent, unorthodox use that inverted old rules of decorum and produced a comedic
effect. Ducks signified ducks as water animals, and had little iconographic signifi-
cance beyond that. When ships were used for ducks' bodies, these ducks became

funny-looking figureheads, associated with the highbrow architectural vocabulary of the world's fairs and the classical tradition in general, yet instead overturning all traditional meaning.

The oddly shaped *Electric Tower* at the center of Luna Park represented yet another manifestation of its "countercultural" impulse (fig. 11.8). Decorated with circles of fleurettes outlined with colored electric bulbs that lit up at night, the tower garishly parodied monumental structures like Karl Bitter's *Column of Progress* (fig. 11.9) for the Louisiana Purchase Exposition of 1904. Luna's *Electric Tower* sported a battered shaft with hearts and bulbous scrolled brackets that supported a ornamental turret shaped like an inverted ice cream cone. For a few seasons its base supported grotesque dolphin fonts with electric lights accenting their fins. Water cascaded down a set of steps leading from the dolphin's mouths to a moat. At each of the four bases water spewed from the mouths of elephants with trunks upraised toward the sky.

Anyone who considered Luna Park too vulgar could visit its competitor, Dreamland (fig. 11.10). Financed by a group of politicians led by William H. Reynolds, a theater manager and former New York state senator, Dreamland's amusements were equally popular and entertaining.[27] But in contrast to Luna Park, the architecture of Dreamland's main area was deliberately more conventional and seemingly closer to the City Beautiful vision. The architectural firm of Kirkby, Petit, and Green grouped a series of white colonnaded buildings and globe-topped rostral columns around a small central "lagoon," in a setting that clearly recalled that of the World's Columbian Exposition and other Beaux-Arts axial arrangements. The architects also designed Dreamland's 375-foot central tower using recognizable and appropriately modified historical sources as models: the highly decorative Giralda, the twelfth century minaret that was incorporated as part of the Cathedral of Seville; and Stanford White's Madison Square Garden. With its straight lines, its swags, and other classical ornament, the tower looked much more refined than the *Electric Tower* at Luna. It too had "exotic" associations because its models were Moorish and Spanish; but unlike Luna Park, where Thompson had combined a few recognizable stylistic elements into totally fantastic forms, the Dreamland tower's stylistic exoticism was perfectly in keeping with the Spanish Renaissance and baroque architecture then in fashion.

But Dreamland's apparent artistic compatibility with City Beautiful ideals was only superficial. The park itself housed the usual compendium of wild rides and bizarre amusements. And sculpture functioned in just as peculiar a manner as it

did at Luna Park. Just as at Luna Park, much of Dreamland's sculpture lost levels of connotation and meaning. On Dreamland's tower (fig. 11.11), for example, nude-to-the-waist female figures with upraised arms bearing torches served as decorative beacons, vertical accents to the arched entranceway lavishly ornamented with daisylike flowers. Allegorical signification, however, appeared to be

absent. Similarly, depictions of firemen became funny when placed as architectural sculpture on a building housing the exhibit "Fighting Flames" (fig. 11.12). The firemen indicated the spectacles inside; in this context they signified little other than "firemen," that is, themselves. At world's fairs or on urban architecture, caryatids or sculptured figures on facades were often allegorical personi-

fications, which carried didactic associations if only through allusion to the classical or Renaissance traditions. What made the firemen incongruous was their presence as totally mundane images in an architectural context where, under ordinary circumstances, a loftier and more complex signification could be expected (although it would not necessarily be understood).

The nudity of the ostensibly allegorical female figures (with the concomitant

11.11
"Outdoor Vaudeville" (showing Dreamland tower), Dreamland, Coney Island, 1905. (Photo, Detroit Publishing Co., Library of Congress.)

11.12
"Fighting the Flames," Dreamland, Coney Island, 1905. (Photo, Detroit Publishing Co., Library of Congress.)

allusions to classicism) served as a helpful lure to Dreamland's other attractions. The most notable image of this kind was the gigantic winged woman at the entrance to the "Creation" show (fig. 11.13), a spectacle that recreated the events described in the Book of Genesis. Visitors would climb into little boats to travel back through the centuries to the center of the amphitheater where, with the "chaos of the unmade world" facing them, they watched and listened to the bib-

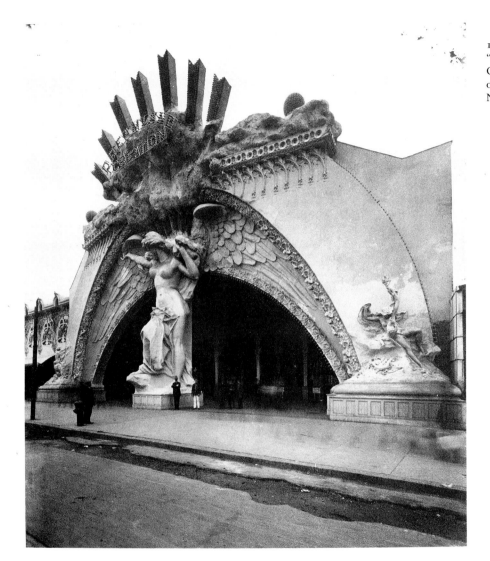

11.13
"Creation," entrance to Dreamland,
Coney Island, ca. 1905. (Courtesy
of the New-York Historical Society,
New York City.)

lical story of creation unfold before them.[28] According to the guidebook, the buxom young nude represented Eve. Advancing one leg strategically to support a rumpled mass of drapery, the figure extended an arm in a gesture suggesting both invitation and Michelangelo's figures in the *Creation of Adam* fresco from the Sistine Chapel. This lent the identity of the figure an aura of ambiguity; for the wings implied she might also be an angel of creation. To be sure, as an "idealized" nude (connoted most conveniently by the addition of wings) the towering figure could at least be purported to have a didactic function, which would excuse its nudity.[29] The appropriate associations were present, since the exhibit was a religious story, albeit sensationalized.

But it would have been the "charms" of the gigantic nude—not the religious connotations of Eve, an angel, or of the "Creation" sign above the figure's head—that lured visitors into the cavernous entrance of the exhibit. The colossus was most intentionally and unavoidably a titillating nude first and only secondly and superficially an ostensibly religious or allegorical figure. In this context the sculpture was presented as Creation but the deliberate ambiguity enhanced its signification as something else, devoid of didactic meaning.[30]

This absence of didactic meaning was the most significant attribute of Coney Island sculpture and helps explain its success. The figures modeled by anonymous sculptors working for Thompson and for Kirkby, Petit, and Green represented the simplest of possible connotations, of a kind to which a majority of visitors could relate. "Creation" might be an angel or Eve, and thereby contribute to the uplifting message of the Genesis exhibit. But then again, she might also be merely a huge naked lady; under the circumstances, it was perfectly reasonable to wink, snicker, and see her that way.

Professional sculptors hoped that people would respond to civic sculpture at a much higher level of sophistication. But there is no evidence that the majority of onlookers actually perceived the precise meanings that the sculptors hoped they would experience in the adornment of public buildings and in their elaborate monuments. That few people had such expectations at Coney Island, however, helps to explain why the place was so popular. Visitors were free to see and interpret sculptural images, which were similar to civic sculptures, as little or nothing more than what they appeared to be. This aspect of Coney Island's sculptures situated them outside the grasp of the myths of serious civic statuary. Like *Purity*, these works critiqued the capacity of "representational" sculpture to represent the more complicated ideals and concepts that their creators intended.

Monumental Challenges to the Civic Ideal

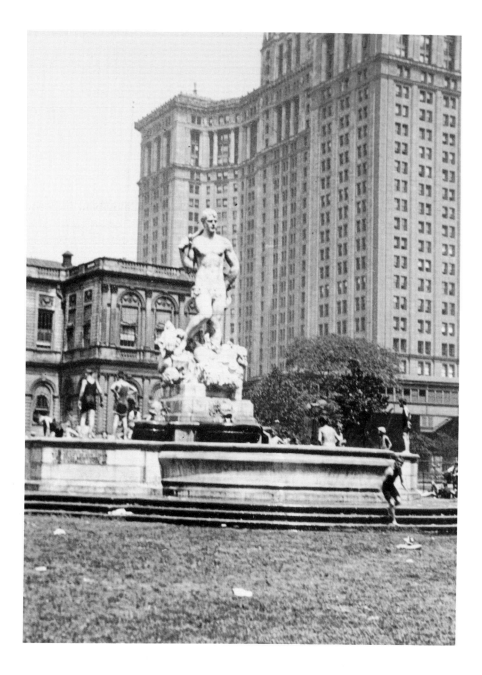

12.1
Frederick MacMonnies, *Civic Virtue*, City Hall Park, 1922. (U.S. History, Local History and Genealogy Division, the New York Public Library, Astor, Lenox, and Tilden Foundations.)

I 2 The Rise and Demise of *Civic Virtue*

The achievements of American sculptors at the World's Columbian Exposition had held out bright hopes that there were to be no limits to their expressive reach. Events of the first fifteen years of the century reinforced these convictions. Despite the political and organizational conflicts surrounding various sculptural projects, and despite some frustrating setbacks to their civic beautification efforts, sculptors steadily obtained commissions for important public works. Official receptiveness to public sculpture was at a peak around 1910. Artists and civic reformers, optimistic that Progressive and City Beautiful principles would prevail, continued to plan sculptures and monuments to celebrate their imminent triumph.

The most notorious sculptural assertion of Progressive values was *Civic Virtue*, a monumental public fountain by Frederick MacMonnies (fig. 12.1). First conceived in 1891, it was commissioned for the grounds of Manhattan's City Hall in 1909, but not erected until 1922. This project typified not only the underlying message of New York civic sculpture but also its fate. For while the fountain was ultimately completed, its numerous problems reflected the breakdown of Progressive ideals. Their weakened influence was manifested in the responses to MacMonnies's allegorical imagery.

An atmosphere of distrust toward public statuary had surfaced after World War I. In the case of *Civic Virtue*, suspicion turned into downright hostility. In the earlier case of *Purity*, a small number of outsiders created a situation that encouraged negative and ambiguous interpretations. With *Civic Virtue*, the schism between artistic intention and the public's interpretation extended to a wider segment of the middle class. This worsened sculptors' ongoing problems of exerting influence and of acquiring institutional support. The outcries against it were symptomatic of the disintegration of what had once been, among middle-

class Americans, an unchallenged belief in the meaningful correspondence of sculptural representation and allegorical content. In responding to *Civic Virtue*, much of the viewing public passed over the interpretation that the sculptor hoped they would "receive." In short, they missed the abstract concept, and read the image literally. Taken this way it was a scandalous depiction of a male trampling two females who, to make matters worse, were supposed to represent Vice. This in turn generated a different, more topical, set of meanings—the battle between the sexes and the oppression of women. Much of the contemporary viewing audience was more sensitive to this sexually charged reading than to the interpretation MacMonnies ascribed to the work. Many people questioned not only the politics of this imagery but the representation itself.

The sculptor had difficulty comprehending that the relationship between the allegorical image and its (signified) content was no longer necessarily meaningful and, moreover, that there could now be no assurance that the public would ever permit it to become so. To MacMonnies, the vociferous negative reaction seemed the unfortunate consequence of an overly literal reading of the image and a misreading of its allegorical significance. Many New Yorkers, particularly those supporting women's suffrage, did tend to stress the literal aspects of MacMonnies's rendering. But the group seemed offensive to them because its imagery carried an emotional charge whether it was read "figuratively" (as Civic Virtue) or "literally" (as a man trampling a woman). It elicited complex responses that were not the ones that the artist himself had consciously intended to convey.

For suffragists, *Civic Virtue* and its "language" of representation embodied a male-constructed vision of the world and of sexual differences no longer grounded in fact. By 1922, the intent of allegorical personifications could no longer necessarily be taken as self-evident.

The history of *Civic Virtue* spanned almost the entire period of New York civic sculpture. In her will of 1891, Mrs. Angelina Crane, a widow, had bequeathed about $52,000 to the City of New York to erect a drinking fountain in her memory.[1] The inception of the work thus represented part of the first wave of enthusiasm for urban beautification. But the delays that followed both on the part of the sculptor and of the city also typified what frequently occurred with public sculpture commissions. The executor handed the funds over to the municipality in 1901, but the city took no measures to spend the money until 1908; the sculptor did not finish the model until 1914. As already mentioned, the statue

was not installed until 1922.[2] It epitomized the frustrations encountered both by art organizations and sculptors in trying to exert influence and to maintain consistent official recognition. City officials snubbed the artistic experts by assigning a site for the new fountain without consulting the Art Commission first. Although the NSS had expressed interest in being involved with the commission, Mayor George B. McClellan took matters into his own hands and selected the eminent sculptor Frederick MacMonnies, who had been living in Giverny, France, for some years. While MacMonnies certainly kept up with what was going on in New York, he had participated little in the NSS's municipal improvement activities. Thus his selection could not have represented much of an acknowledgment of that organization's importance.[3]

McClellan had not anticipated that it would take MacMonnies nearly six years just to complete his designs. The city, which advanced the sculptor $10,000 when he signed his contract in 1909, began to get impatient, and in early 1914 the park commissioner began to insist that MacMonnies finish his work.[4] Citing commitments to other projects as the reason for his delay, MacMonnies promised to have his work completed by November. Actually, he submitted a completed design scheme in early October.[5] The plans called for the fountain to replace an old, "outdated" fountain in the southeast corner of City Hall Park near municipal offices. MacMonnies's finished scheme called for a twenty-eight-foot-wide, fifty-seven-foot-high sculptural fountain and a series of basins with decorative jets and overflows (fig. 12.2). The main portion of the fountain would depict civic virtue. According to MacMonnies, it would consist of allegorical groups, "the principle one" of which would be supported by "American mountain lions." A young man with a sword representing civic virtue, justice, order, and peace would be rendered "as having caught the siren vice in her own nets."[6]

While MacMonnies thought he had finished his plans successfully, he soon encountered difficulties. First, between 1914 and 1919, the Art Commission repeatedly disapproved his designs. The 1914 Art Commission subcommittee assigned to judge this project (Karl Bitter; John A. Mitchell, an editor of *Life Magazine*; and manufacturer Frank L. Babbott) had no objection to the subject matter or to MacMonnies's proposed imagery. But they found the fountain's bulk, the shape of its basins, the size of its figure, and even its "general style" all problematic. In their view the work did not relate properly to its surroundings or to City Hall. Bitter wrote informally to MacMonnies, urging him either to submit a completely new design or, if not, to take his chances with a new Art Commission

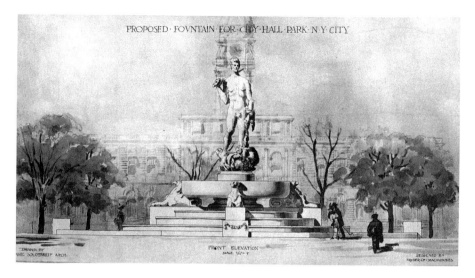

PROPOSED · FOUNTAIN · FOR · CITY · HALL · PARK · N · Y · CITY

DRAWN BY
MARC SOLOTAREFF ARCH.

FRONT ELEVATION
SCALE ½"=1'

DESIGNED BY
FREDERICH · MACMONNIES

12.2
Marc Solotareff, proposed fountain (*Civic Virtue*, designed by Frederick MacMonnies) for City Hall Park, front elevation, 1914. (From the Collection of the Art Commission of the City of New York, Exhibition file 822-F.)

the next year. However, pressured by the Park Department to finish, MacMonnies ignored Bitter's advice. He went ahead and submitted his design to the current Art Commission, which promptly disapproved it (fig. 12.3).[7]

Having lost this first official round, MacMonnies asked architect Thomas Hastings—for whose New York Public Library he had just finished modeling sculptures of *Beauty* and *Truth*—for help in developing a new plan. A year later Hastings submitted new designs, which the new Art Commission subcommittee (sculptor Hermon MacNeil, art historian I. N. Phelps Stokes, and architects Henry Bacon and Jules Guérin) approved. However, it took MacMonnies another four years to revise his models for the sculpture.[8]

In 1919 yet another Art Commission approved the general design, but now the subcommittee (sculptor Edmond T. Quinn, architect Henry Bacon, author Luke Vincent Lockwood, and painter Henry Watrous) objected to the statue's gigantic size. MacMonnies argued that only a huge statue could harmonize in scale with the growing numbers of "colossal" buildings in the City Hall area. Unconvinced, the commission took the unprecedented step of having a full-size silhouette of the sculpture, central pedestal and basin erected *in situ* in early October so that they could inspect the work in context (fig. 12.4).[9] After examining the silhouette the subcommittee still insisted that MacMonnies and Hastings reduce the height of the entire structure. The commission and Department of Parks approved the final

Ideologies, Interpretations, and Responses 262

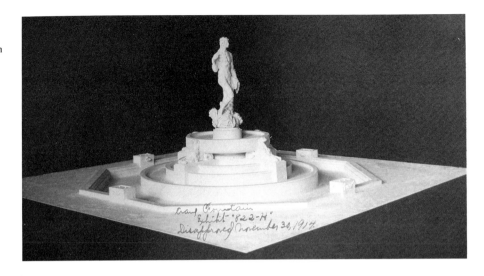

12.3
Frederick MacMonnies, sketch
model for *Civic Virtue*, 1914. (From
the Collection of the Art Commis-
sion of the City of New York, Exhi-
bition file 822-H.)

12.4
Silhouette of *Civic Virtue*, City Hall
Park, New York, 1914. (From the
Collection of the Art Commission
of the City of New York, Exhibition
file 822.)

designs in October 1919, but it took the firm of Piccirilli Brothers until 1922 to finish carving the huge group in marble and to have the work installed.[10]

The finished *Civic Virtue* consisted of a stern-looking male Virtue with a sword resting on his shoulder, standing astride two female figures representing vice and lying amidst sea creatures at Virtue's feet. Far from being a simple memorial drinking fountain, as Mrs. Crane had stipulated in her bequest, the sculpture was a monumental mythification of the pursuit of good city government. The emphasis on virtue and its representation were by no means new. But as conceived at this particular time, the notion of civic virtue had acquired a special importance for municipal reform crusaders.

MacMonnies's own discussions of *Civic Virtue* indicate that he was very much in touch with these sorts of concerns. Discussing his search for a motif that would be especially appropriate for the City Hall site, the sculptor determined that whatever he depicted would have to suggest that the men governing the city were honest and had the strength to uphold the city's laws and its dignity even in the face of constant lures to stray from these "straight" paths into "devious ways."[11] His moralizing rhetoric echoed that of Progressive reformers like Theodore Roosevelt, who in such books as *The Strenuous Life* described existence as a continuing struggle for "righteousness," strength, and courage—a "ceaseless contest with the forces of evil."[12] Like Roosevelt, MacMonnies drew clear-cut distinctions between virtue and vice.

"What concrete image could best suggest these reflections?" he had asked. His solution: "youth with its transparent simplicity, directness, idealism, expressed in figure and attitude; the unspent strength of a young man; [and] the sword, original authority back of all law . . . purposefully shortened to suggest that it has become the symbol of law rather than the active instrument of justice it once was in the brutal days." The youth would hold the sword not just "as any one would hold a weapon of war, but rather as one would wear an insignia of office." In a "secondary action," the youth would be freeing "himself almost unconsciously from the snares thrown around him." They would drop "away from him without much effort on his part." Hence Virtue

looks out into the distance so concentrated on his great ideal that he does not even see the temptation. To suggest this temptation, its dual nature which dazzles while it ensnares, its charm and insinuating danger, one thinks of the beauty and laughter of women; the treachery of the serpent coils of a sea creature wrapped around its prey. These lovely sea women coil themselves about their victim. Their scaly, sinuous tails entwine him. With one hand,

each one draws about him the net disguised in tangled seaweed; with a smile on her lips one holds, half hidden, a skull, sinister suggestion of disillusionment and death. The other hides her face as we hide all dark designs. They entirely surround him, but he steps out triumphantly and places his foot on a firm rock. Below him lies the wreck of a ship which had sped gaily, its proud figurehead of victory overturned—torn shreds of hope.[13]

Like Roosevelt, MacMonnies conceived of civic virtue in totally masculine terms. To be virtuous was a sign of strength and virility. The "goodness" that in Roosevelt's words was "whatever is fine, straightforward, clean, brave, and manly" was conceived by the sculptor as (male) "youth with its transparent simplicity, directness, [and] idealism." The resemblance between the muscular, youthful figure and Michelangelo's *David* also seemed appropriate; indeed the likeness was deliberate, for *Civic Virtue* was to represent the "modern idea formerly expressed in the figures of Saint Michael, Saint George and the Bragon [*sic*] and also David and Goliath."[14] *David*, which stood in front of the Palazzo Vecchio, had become a powerful symbol of the city of Florence. Inspired by the great *David*, *Civic Virtue* seemed a model of civic and sculptural propriety. There was also particular significance in the conception of vice as female, as a "temptation" that "dazzles while it ensnares" and that virtue must ignore at all costs. The image appeared in the immediate aftermath of antiprostitution and antivice campaigns. New York's Committee of Fifteen, established in 1900, had been the country's first vice commission, and was at the forefront of the movement. Later, with the support and funding of John D. Rockefeller, Jr., groups like the Bureau of Social Hygiene (founded 1911) conducted all-out battles to control prostitution. They presented themselves as being constantly on guard to ferret out the dens of sin and to protect poor women and young men from the evils of temptation.[15] Indeed, MacMonnies's conception of what was high-minded seemed unexceptional in 1914. He could hardly have been prepared for the political strife that would surround *Civic Virtue* eight years later.

During the war, women's groups had struggled hard, and ultimately successfully, for passage of the Nineteenth Amendment. By 1920 they had the vote and a new degree of political power, and were especially sensitive to what appeared to them to be the survival of obsolete attitudes about the status of women.

In late February 1922, before the fountain's imminent installation in City Hall Park, newspapers published several articles with illustrations of the statue. With titles such as "Civic Virtue, a Youth with a Club Soon to Menace Sirens in City Hall Park," the articles were bound to make politically conscious women take

notice. Even before its official unveiling in April 1922, the statue began to pro-
voke indignant outcries from several women's groups, who argued that MacMon-
nies had degraded women by representing the youth with his foot at the head
of a "prostrate temptress."[16] Mary Garrett Hay, head of the National League of
Women Voters, led the ranks of those objecting to MacMonnies's depiction of
Civic Virtue as male, and Vice as female. "In this age," she argued, "woman
should be placed not below man but side by side with him in any representation
of Civic Virtue."[17] Indeed, while it was unlikely that MacMonnies was aware of
the dispute over *Purity*, those who recalled it must have noted a certain irony in
the use of the female form to represent both Virtue (with irony) and Vice.

New York politicians, newly conscious but uncertain about women as a po-
litical force, suddenly became concerned about the imagery of *Civic Virtue*.
Tammany-supported mayor John Hylan had already fueled the fires of discontent
by making snide comments about the statue as early as late February. As protests
by supporters of women's suffrage and other groups mounted, Hylan acted
quickly to identify himself with the popular side of this heated issue. In mid-
March, he demanded threateningly to know whether any of his appointees to the
Art Commission had been involved with the approval of the statue.[18] The mayor
then called for a Board of Estimate hearing, over which he would preside, to
determine whether the Art Commission, in approving the statue for the site, had
"overreached its artful eye."[19]

Responding to the mayor, Deputy Controller Henry Smith (who as park com-
missioner under the earlier McClellan administration had approved the choice of
MacMonnies as sculptor) strongly objected on the grounds that the Board of
Estimate had no jurisdiction over this matter. But Hylan, anxious to appear to be
the defender and protector of the rights of (newly enfranchised) women, insisted
that as the representative of the people the Board of Estimate did have jurisdiction
and that the meetings would be held.[20]

At the hearings, opinions were expressed by the members of women's organi-
zations and by individual supporters of the statue. These included a public school
teacher, NSS members, several municipal officials who had held office in Mc-
Clellan's administration, and other women, such as National Women's Party
member Elizabeth King Black. The atmosphere was described as less than digni-
fied. Some felt that the work looked stylistically incongruous. A "Florentine"
statue looked wrong in conjunction with a "colonial style" City Hall and, more-

over, blocked the view of it. But most of the negative argument centered on MacMonnies's depiction of Civic Virtue and Vice. Many of the statue's critics viewed this choice as wholly inappropriate not only because in the nineteenth century Virtue had usually been depicted as female but also because it was totally out of line to show women "just sprawling and crawling beneath the feet of man." Saint Catherine's Welfare Association president Sarah McPike pointed out her fear that "many people would interpret literally the statue of a man thrusting his toes on a woman's neck."[21]

Indeed, in spite of his careful allusions to earlier images of civic virtue, MacMonnies had broken away from recent iconographic traditions in choosing to personify the concept of Virtue as a male. His motivations for doing so and his manner of representation were deliberate and politically conservative. The problem was that many viewers felt that his methods were antiquated to the point of being offensive. MacMonnies's sculptural group provoked the extremes of anger that it did because its allegorical personifications had taken on new connotations within a period of a few short years. When interpreted in the contemporary sociopolitical context, the sexual differences signified by MacMonnies's traditional representations now seemed too loaded with meaning.[22]

The sculptor, although at first amused by the situation, began to lose his sense of humor.[23] But his comments in his own defense did not help matters. He simply dug himself into a deeper hole. In explaining his choice of imagery to a reporter, MacMonnies described his concerns in the anachronistic rhetoric of a turn-of-the-century genteel professional. He observed that it was the artist, as expert, who had to set the standards for the representation of artistic truth. At the same time, his disdain for his audience and his emphasis on the inviolability of the artistic creation was decidedly contemporary. MacMonnies admitted proudly that he created quite consciously for an elite, and purposefully had not taken into consideration the "narrow prejudices" of the rest of the people.[24] In time, the people would come to respond, even if they did not like at first what they were given. "They will accept a poor thing if they are not given anything better," MacMonnies observed, "but they will always choose the best that is offered them."

The most beautiful form known was that of woman, he insisted. "When we wish to symbolize anything tempting we use the woman's form. It has always been so. Justice, devotion, inspiration and other beautiful, noble or graceful things are symbolized by it. But the man—his form is rugged and suggests strength and we

use it to symbolize strength. . . . I did not invent this scheme of things," he continued. "God Almighty made the forms of man and women and for a long, long time we have used the two forms to represent two different things. . . . The attainment of suffrage by women . . . and the entry of the fair sex into public prominence, has not yet taken from them their grace and beauty of form."[25]

Although twenty years earlier many people would have accepted these views as a matter of course, these convictions no longer met with uniform enthusiasm. Even MacMonnies himself now seemed aware that his opinions and his dandified womanizing persona were hopelessly outdated. Ironically mocking his own statements in another newspaper interview, he commented that temptation was usually made feminine because "only the feminine really attracts and tempts," and that no one would object if it were the other way around.[26] Other MacMonnies supporters also took this stand. Park Commissioner Gallatin noted that "sirens, as is known, are not women. Coming down town to-day I saw a devil on a billboard. He was represented as a man, but should man object to being so portrayed?"[27]

Two important questions lay underneath this argument: What should be the relation between representation and symbolism? Under what circumstances should one draw distinctions between the two? MacMonnies maintained that his women were not mere women, but sea creatures, sirens—which were commonly depicted as symbols of evil and temptation in fin-de-siècle imagery. Yet he continually emphasized "feminine" traits in drawing his connections between the representational forms and their allegorical referents. This only fueled the skepticism of many women about the artist's real motives in attempting to distinguish between the allegorical and the literal.[28] Concurring with one of his critics, MacMonnies contended that the root of the entire problem was the growing tendency of the public to "read" sculpture too literally. "Where," he asked, "would the fine arts be if such limitations were placed upon them, if an allegory were always to be taken literally? The thing is ridiculous," he scoffed. "Such literalmindedness carried to its logical conclusion would be a blow at all the fine arts. . . . These things have to be treated allegorically," he stated emphatically. "This limitation of art by a literal mind is ridiculous. . . . If we harness our art so that it can be understood by babies is there any hope for us?"[29]

Other artists echoed MacMonnies's concerns. The *New York Times*, for example, quoted NSS president Robert Aitken and painter William de Leftwich Dodge. At the hearings they expressed their indignation that in this generation it

should even be "necessary to defend a symbolic work of art against attacks by those who saw in it nothing but a strong boy standing on a woman's neck."[30]

Notwithstanding the outcry and the Board of Estimate meetings, political and economic issues took priority over concerns about interpretation, representation, and signification. During one of the first hearings Park Commissioner Gallatin had apparently provided (from municipal officials' point of view) a very compelling argument for keeping the statue. He reminded those present that since the statue had been a bequest to the city and since MacMonnies had already been paid the rest of his $60,000 on acceptance of his work, the city, bound by the terms of the contract, would have to bear the $60,000 cost of a substitute if *Civic Virtue* were removed. Gallatin therefore suggested erecting the fountain and then letting the "people decide" what its fate should be. This solution of course overlooked the fact that it would be much more difficult to take the work down once it was up.[31]

The mayor had already reaped the political benefits of catering to his female constituency. As the *Times* noted, "It was a happy day for the Mayor, who heard many pleasant things about himself." Now he also agreed that perhaps the fountain should in fact go up. "We can pull it down fast enough," he was quoted as saying.[32] Thus the statue, nicknamed derisively "strong boy," "fat boy," and "rough guy," was erected in front of City Hall in late April 1922.[33] It remained in this location until February 1941, when Park Commissioner Robert Moses had the entire *Civic Virtue* fountain hauled away to its present location at Queens Boulevard at Union Turnpike, next to Queens Borough Hall, and out of his jurisdiction. The final irony was that Moses, himself a former crusader for good government, no longer had to have anything to do with this statue which he—along with others who had outgrown Progressive idealism—now rejected and detested.[34]

The response to *Civic Virtue*, the "literalmindedness" that MacMonnies saw as threatening, exemplified diminished public receptivity to civic sculpture. To be sure, the waning acceptance of such allegorical monuments resulted partly from the new fashionable aesthetics of modernism. Advocates of modernism emphasized the immediate, "literal" experience of pictorial or sculptural elements rather than the comprehension of conventional, differentiated allegorical images.[35] They believed that it was futile and unnecessary to try to represent specific complex ideas by means of a traditional academic style. But as we saw earlier in the examples of *Purity* and Coney Island, an additional set of interpretative problems

arose out of the interplay between representations and the broader social context. In the case of *Civic Virtue*, the controversy had nothing to do with issues of modernist aesthetics.

The mass audience had once been the beneficiary of the artist's Progressive object lessons. Now it posed a potentially hostile threat even to the academic sculptor. By 1922, MacMonnies's benign didactic "intentions" were stripped from his work, leaving an empty ideological message that was felt to represent an anachronistic tradition of representation, a bankrupt set of meanings, and a futile struggle for cultural authority on the part of the artist. Civic Virtue as a concept was further mocked by the realities of New York's contemporary political scene, especially by Mayor Hylan's manipulation of the issue for political purposes. *Civic Virtue* was opposed not just by women's groups but also by ardent supporters of the mayor, who during his tenure had dismantled many of the organized Progressive efforts at zoning and on behalf of the languishing City Beautiful plan.[36] Like many Tammany politicians, Hylan sought to depict himself as protector of the downtrodden, and presented formidable political opposition to the older elite civic groups' organizations whose interests were represented by MacMonnies and the Art Commission.

The interpretation of *Civic Virtue* as antifemale, structured in political as much as in cultural terms, misread MacMonnies's expressed intentions, foiled his desire for neutrality, and ultimately favored Tammany's anti–City Beautiful contingent. Once a broader segment of the public had been exposed to questions of representation, they began themselves to question the imagery, site, and purpose of such monuments. It thus became increasingly difficult to plan for future sculptural monuments on any grand scale. This problem had already become apparent to many NSS sculptors who had witnessed MacMonnies's dilemmas. They were now forced to contend with city officials over the issue of a World War I memorial.

I3 A Loss of Memory: The New York City World War I Memorial

Up to this point, academic sculptors had encountered few problems in creating a public art that was by its very nature political. Indeed, the success of their works was contingent upon their being political, yet noncontroversial, as in the case of *Maine Memorial*. The events surrounding World War I changed the situation rapidly. As we saw with *Civic Virtue*, the postwar shift in social and political conditions created a climate in which people could no longer read the artist's statement in the manner that he expected. But whereas *Civic Virtue* was one man's experience, the World War I memorial disrupted the entire National Sculpture Society. It thus represented an even broader challenge to sculptors' civic enterprise.

American public sculpture had long been intimately connected with military events. We have seen how the Civil War contributed to the organization and rise of the professional sculptors' community, and prompted the first outpouring of interest in commemorative monuments.[1] The Spanish-American War produced the *Dewey Arch* and the *Maine Memorial* (figs. 5.1, 9.3). Thus one might have expected World War I to provide similar opportunities for sculptural expression in New York. However, the Great War produced no major public monument. Instead the war brought disillusionment and social fragmentation that contributed to the decline of the artists' organization and influence.

There had been a time lag before Americans came sufficiently to terms with the Civil War to commission large commemorative monuments. These memorials embodied a memory of war that was emotionally distanced from the grief and passions aroused at the time of battle itself. The Spanish-American War presented a contrasting situation. Compared to the Civil War, the Spanish-American War

was short, small-scale, and of minor significance. Thanks to William Randolph Hearst, the collective urge to express a sense of triumphant heroism in monument form emerged almost immediately. The catastrophe of the Great War presented a completely different situation from both of these conflicts.

Responding to this long and brutal war—so unlike any other in history—American sculptors felt impelled to start making monuments immediately. But for many of them the circumstances posed value conflicts. The artists quite sincerely believed that monuments and memorials served an important social function. They felt obliged to inform the public about the immediate value of war memorials as cathartic symbols of personal and communal grief. And they thought that they had a mission to instruct the American people regarding what sorts of designs, and which artists, could best give expression to these feelings. This mission seemed especially important at a time of extreme collective emotional stress, when there was a likelihood that quality standards would be relaxed. At the same time, sculptors were conscious that they had professional and personal stakes in whatever happened. While naturally hoping to benefit from the upturn in the market for commemorative monuments, they were anxious that the public not think that their interest in the matter was "purely mercenary."[2]

Conflicts between the sense of moral obligation and professional self-interest generated by the war brought into the open divisions within the sculptors' community, especially between those of old stock and German ancestry. The debates among sculptors reflected broader differences of opinion about the meaning of the war. These disagreements came to a focus with the attempts to create World War I memorials in Manhattan.

Planning a War Memorial

Although at first insulated from the war, which began in August 1914, Americans disagreed about the role that the United States should play. The country remained neutral, but New York elites generally supported the Allies, and their hatred of Germany produced suspicion of German-Americans as well. NSS president Paul Wayland Bartlett, Frederick MacMonnies, and architect Thomas Hastings shared these feelings. All three had lived in France and were vehemently pro-Ally and anti-German.

These sentiments created great hostility within the NSS. The society had depended upon an alliance, however tenuous, between German-American artists

and those of Anglo-Saxon and other origins. Now the German-Americans were regarded with suspicion. Sculptors like Karl Bitter, whose loyalties were torn between their identity as Americans and their Germanic roots, experienced great anguish. Like several of the German-Americans in the NSS, the Austrian-born Bitter supported Germany. In 1915, the year of his death, he wrote to Daniel Chester French that the conflict of emotions was too much for him. "I am made sick at heart by the pleadings of the warring nations for their cause," he said. "I cannot get myself to believe that any possible justification can be found for the blight which has befallen the best on earth."[3]

During the period of German submarine attacks in May 1915, reprisals against Germans in the United States became so common that Frederick Ruckstuhl decided to change the spelling of his name from the Alsatian Ruckstuhl to Ruckstull. "I never liked my name," he later wrote, "because it always stamped me as an outsider, as far as true Americanism was concerned." When Germans torpedoed the *Lusitania*, Ruckstull recalled, "I resolved the time had arrived to Americanize my name." He recommended that every immigrant should do the same to "shield him against that ineradicable prejudice, which exists in every people, against any foreigner who, by keeping his foreign jargon name, implies that he is nothing but a stranger who came here to exploit the country."[4]

With American entry into war in April 1917, antagonism mounted, and German immigrants and German-Americans were frequently the victims of threats, vigilantism, and other forms of hostility.[5] The increased intolerance affected German sculptors as well. In *Loiterer in New York* (1917, with an introduction by Paul W. Bartlett), for example, Helen Henderson lamented the sorry state of civic sculpture, especially portrait statues that accompanied what she described as the "Teutonic invasion of the field, an influence now dominant with us. . . . How the case stands may be appreciated by a glance at the membership list of the National Sculpture Society, which shows that body to be largely composed of foreign-born artists."[6] And in 1918, anti-Germanism swelled to the point where the Secretary of the Treasury pressured Cass Gilbert to make (German-born) Albert Jaegers either remove his figure of *Germania* for the United States Customs House or change it into an image of Belgium.[7] This anti-German sentiment put German-American members of the NSS in a difficult position, but it also affected the society as a whole. Concern about NSS membership became crucial because the society hoped to move to the center of the war effort through involvement with a war memorial.

The World War I memorial project began as a recruiting method rather than as a commemorative work. In February 1918, NSS president Paul Wayland Bartlett announced at a meeting of the society's council that an officer in the Navy Recruiting Office had proposed that NSS members design a patriotic monument to help spur enlistment. Noting that the same idea had also been brought up to the Mayor's Committee on National Defense, he expressed his reservations about obtaining funding for such a recruitment venture. NSS council members appointed a committee that moved to ensure NSS involvement.[8] By May they had enlisted architect Henry Bacon (designer of the *Lincoln Memorial*) to create designs and had taken their plans and $100,000 cost estimate to the Manhattan borough president.[9]

One month later, when Bacon finished his patriotic monument scheme, which took the form of a grandstand, various sculptor members of the society acted to move in and assert more control. Contending that Bacon's design was too much of a peace monument and thus inappropriate, they recommended consideration of other patriotic monument designs, made specifically by sculptors, and not by architects.[10] Several sculptors then tried their hands at some sketch proposals. The NSS Monument Committee concluded that none of these designs were adequate, and told each of the sculptors to consult with an architect.[11]

In the meantime, Bartlett, although NSS president, was doing his own negotiating on the side. At the same June 1918 meeting in which the various other sculptors presented their plans, he informed NSS members that Tammany mayor Hylan had just appointed him to the Mayor's Committee on National Defense, which Bartlett described as "about to become very much more active in matters needing artists' work."[12]

NSS members were pleased with this turn of events, considering it beneficial to have the president of the society cooperating with high-level municipal officials. But in July Bartlett suddenly reported that the matter of the monument had taken on a "slightly different aspect." The Mayor's Committee on National Defense was now considering getting involved in a patriotic monument project. The city had held a loyalty parade on that Fourth of July, and members of the Mayor's Committee had decided that they wanted to erect an arch to commemorate it.[13] Bartlett told the NSS that he had dissuaded the Mayor's Committee from building an arch, which signified victory, and appeared inappropriate while the war was still going on. He also told them that the Mayor's Committee might wish to work out a scheme that could incorporate some of the various NSS patriotic monument

designs presented one month ago. The sculptors assumed this meant that the NSS and Mayor's Committee would cooperate with each other on the city's monument, but that sculptors would still create another, completely separate work.

With the signing of the armistice on November 11, the outlook for the project changed considerably. A victory monument would evidently be necessary, and the celebrations would now acquire a much greater significance. Recognizing this, the NSS held a special planning meeting on November 12, the day after the signing of the armistice. At that meeting Bartlett told the sculptors that during the summer he had asked his friend and frequent collaborator Thomas Hastings (1860–1929) to develop a scheme for the Mayor's Committee that would combine their June 1918 designs for a patriotic monument. The plan was to include an arch and a court of honor. Now that the war was over, the monument formerly intended to promote enlistment would become a municipal victory memorial and would form part of a planned welcome-home celebration for American troops. The project was reminiscent of the *Dewey Arch*; although the designs were for a temporary structure, it was generally assumed that a permanent memorial would be commissioned afterward.[14]

Up to this point most of the sculptors appeared to have no objection to Bartlett's dual involvement with both the society and the Mayor's Committee, or to his decision to have Hastings work out a scheme with an arch. But most NSS members had also continued to assume that they were operating independently of the city—even while cooperating with the Mayor's Committee on behalf of a municipal monument. They still envisioned the patriotic monument as one encompassing basically two projects, one of which would be theirs alone.

But the lines of distinction began to blur when the issue of fundraising came up. Some wary sculptors began to wonder whether Bartlett had something else in mind of which they had not been apprised. They suddenly sensed that he had very different ideas about who was going to control and participate in the temporary and permanent projects. They also became uncertain about how many different monuments there were to be. When the sculptor Augustus Lukeman told NSS members that two newspapers had offered to help raise the money for the NSS patriotic monument, Bartlett temporized. He informed the sculptors that since the NSS monument was to be part of Hastings's scheme for celebrations run by the Mayor's Committee, the society would have to wait and consult with this official body before it started to raise any money on its own.[15] Indeed, Bartlett noted, the NSS might not even have to worry about doing any fund-raising; the

Mayor's Committee itself would probably take care of it. This was the signal that he had alternative plans as to who was to be in charge of the commission. Yet when one of the sculptors expressed fears that the NSS design conception might be losing its "identity," Bartlett reassured him otherwise.[16]

But one day later, Mayor Hylan appointed businessman Rodman Wanamaker to be chairman of a new committee on a permanent war memorial. This committee supplanted the former Mayor's Committee on National Defense, now no longer needed. Just as in the case of the *Dewey Arch*, the city officials were determined to erect a monument immediately, before the war spirit waned. Wanamaker quickly organized a new art subcommittee, and made Bartlett its chairman. Bartlett was now charged with overseeing the erection of two monuments: a temporary arch to commemorate the war dead and to welcome home the demobilized forces; and a permanent war memorial for New York City. He and Wanamaker reconfirmed Hastings as the architect of a temporary victory arch. And in early 1919, Bartlett and Hastings divided up the sculptural work among several volunteers, including Daniel Chester French, Andrew O'Connor, John Flanagan, and Gertrude Vanderbilt Whitney. Isidore Konti and Carl Heber were the only two artists of German descent who worked on the *Victory Arch*.[17] Most of the volunteers were NSS members, but they had not been involved with negotiations over the monument.

The NSS's plans for a patriotic monument were in limbo. Its members had not completed a temporary recruiting monument, and they had been shut out of the official plans for the temporary victory memorial. With Bartlett in charge, moreover, it was now uncertain whether the society would have any involvement with designs for a permanent memorial. Although most NSS members did not become aware of it until November 1919, Bartlett had felt alienated from the group for some time. In late 1918 he expressed irritation with the sculptors' seeming inability to get moving with their designs for the memorial or to take appropriate action when they had the opportunity. He was also infuriated by the fact that a number of the NSS sculptors had initially supported Germany before the United States entered the war. Once in control of the mayor's project he was determined to get back at them. "Some of these pro-Germans have had the *gall* to offer to do work on the arch," he had confided to Cass Gilbert in early 1919. "Of course you can imagine what *I* did! but I am in for a row!"[18] What he did was to make sure that only those of whose politics he approved would work on the temporary arch.

His actions made it clear that neither the temporary nor the permanent memorials would be considered official NSS projects. When faced with choosing his allegiances, Bartlett, even as NSS president, turned to the city. Politicians with connections and power could do more for him than any group of sculptors. Municipal support and control offered a greater likelihood that the permanent monument would actually go up.

In accord with the populist outlook and a practice common during Tammany administrations, Hylan's Mayor's Committee decided that the monuments should be funded by "spontaneous free will offering by the people of the city." The collection period could last only one week. To ensure that donations would be generous and readily forthcoming, Hylan sent out twenty thousand members of the city police and police reserves to collect the money.[19] With fund-raising done, work on the temporary arch proceeded rapidly. The construction was completed in time for the celebration, which welcomed home the troops of New York's Twenty-seventh Division, on 25 March 1919 (fig. 13.1).

Like the *Dewey Arch* of twenty years earlier, Hastings's 125-foot-long, 40-foot-wide, 100-foot-high *Victory Arch* (modeled on the *Arch of Constantine* in Rome) stood at the intersection of 24th Street, Broadway, and Fifth Avenue. Allegorical figures represented Peace, Justice, Power, and Wisdom. Relief panels honored war service organizations and institutions like the Red Cross, the YMCA, the Knights of Columbus, and the Salvation Army. In addition, one relief was devoted to the shipbuilders, one to munitions makers, and one to the airplane industry. Historical relief panels commemorated major battle sites, including the Battle of Ypres (for England); the Battle of the Marne (France); Chateau Thierry, (America); and La Piave (Italy). Bartlett's massive group, *The Triumph of Democracy*, crowned the top.[20]

The arch was one part of a tripartite scheme Hastings developed for the victory and welcome-home celebration. Farther north he created a symbolic altar out of his own New York Public Library, which was decorated to "recall those who made the last sacrifice on the battlefields of France." At Fifth Avenue and 60th Street, twelve dozen searchlights lit up an Arch of Jewels, comprised of about thirty-two pieces of colored prismatic crystals, to express "a spirit of thankfulness and joy."[21] The *New York Times* praised the "deftness" of the monument's design, and unprecedented numbers of people turned out for the parades and other spectacles of the day's events.[22]

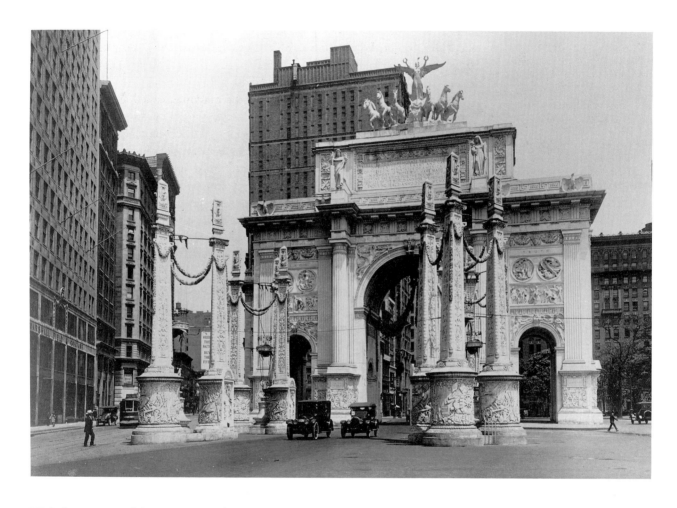

With the victory celebrations over, the Mayor's Committee and the NSS now took up the matter of the permanent war memorial. The temporary arch, an expression of the triumph of the moment, was the work of volunteers. With the permanent arch, the issue of who would participate became much more important, for it involved not only the matter of status and money, but also the question of meaning: how were the purpose and significance of the war to be conveyed? As early as summer 1919 the Mayor's Committee had recommended that the permanent memorial use a version of Hastings's arch design, but decided it would be prudent

13.1

Thomas Hastings, *World War I Victory Arch*, Fifth Avenue and 24th Street, 1919, demolished. (Museum of the City of New York.)

Above the main columns: Herbert Adams, *Peace* and *Justice*. Other side: Daniel Chester French, *Power* and *Wisdom*. Spandrel figures: Andrew O'Connor and Isidore Konti. Spandrel reliefs, side arches: Charles Heber, François Tonetti, Ulysses Ricci, and Philip Martiny. Historical relief panels: Gertrude Vanderbilt Whitney, Henry Shrady, John Flanagan, Roland Perry, Chester Beach, Henry Crenier, and Charles Keck.

to let others have their say. The committee thus authorized a public hearing for mid-November 1919 to allow both the general public and the various art and patriotic societies to present their designs or suggestions "in an open competition of ideas."[23]

The NSS, which had a major stake in the outcome, called a special meeting two days before the hearing. A bitter and lengthy debate ensued over the matter of the permanent memorial arch. At issue was whether Hastings's *Victory Arch* design should be used again in the permanent memorial, and whether the NSS would be involved in the plans and execution. The sculptors had also heard rumors that when the committee had earlier requested appropriations for the temporary arch, it had claimed that, to save money, the sculpture for the latter could be used again as models for the permanent memorial.[24] The artists vehemently disagreed with this idea. Hastings's original description of the temporary arch had indicated that it had no necessary relation to the design of the permanent memorial "either as to its site, the character of its design, or the selection of its authors." The subsequent course of events had led many of the sculptors to think otherwise.[25]

Present at the meeting was Bartlett, now no longer NSS president, but still the chairman of the art committee of the Mayor's Committee. Bartlett denied all reports about the recycling of sculpture for the permanent arch, but was not forthcoming on any issues beyond that. Despite his assurances, many NSS members no longer believed him. They felt certain that Bartlett's committee was passing them by. The NSS resolved to make itself heard, and to protest the design and the Mayor's Committee's handling of the matter. A series of resolutions were presented to the meeting by sculptor Alexander Stirling Calder (1870–1945), who months earlier had written an angry letter to the *New York Times* calling for new and more original designs for the permanent memorial.[26] His resolutions demanded that Mayor Hylan hold open design competitions, and opposed the design of the temporary *Victory Arch* as "unworthy of permanent erection."[27]

Calder's resolutions argued that Hastings's design was not appropriate. It failed to "express the distinctive character in structure of the period in which the World War was waged, and the ideals of Democracy and Justice which made Victory inevitable." Secondly, they asserted, the arch, modeled so closely after the *Arch of Constantine*, was merely "a copy, and as such merely decorative, whereas the dignity of the occasion demands an original design which shall express in its structure, and by its sculpture all these ideals, the triumphs of which, resulting in

Victory is the sole cause for the creation of this memorial." Moreover, they argued, the arch "seeks to confine within the narrow limits of obsolete formalism the growing aspirations of the live art of Sculpture."[28]

A fourth resolution stated that Hastings's design turned its back "on the facts of this present war and its consequent intellectual growth throughout the world, by adopting a type of monument foreign to present day purposes—thus giving offense to the thoughtful who know that we have an Art of our own, that could stamp a fresh record of the tremendous events of our recent History." And finally, and undoubtedly one of the primary reasons for the sculptors' protest in the first place, the resolutions objected that if Hastings's design were used again, other architects and sculptors would not have been properly consulted or allowed an equal opportunity to compete for the commission. Such a practice would not only be undemocratic; it would negate the very principles that should govern the awarding of a major public commission.[29]

On the face of it, Calder's resolutions critiqued Hastings's plans on aesthetic and procedural grounds. In stating that the arch "seeks to confine within the narrow limits of obsolete formalism the growing aspirations of the live art of Sculpture," Calder meant that Hastings had made the sculpture too subordinate to the architecture. In practice this presumably meant that the sculptural pieces would not project sufficiently or assume much interest as autonomous works of art. The formalism of the arch was "obsolete" because the architectural structure was that of a third-century Roman Imperial arch. (The NSS sculptors had not considered this form obsolete twenty years earlier when they worked on the *Dewey Arch*.) In the sculptors' opinion, American sculpture had progressed to the point where it was increasingly capable of carrying its own expressive content. It did not have to be subjugated to architecture to express meaning aesthetically.

Calder's resolutions were extremely controversial. As many sculptors recognized, they had political undertones that extended far beyond the limited circumstances and style of the war memorial. To be sure, there were questions as to who should have charge over form and procedure—all extremely important matters in themselves. But another crucial element emerged specifically because the decisions about the permanent memorial were made in such close temporal proximity to the events of the Great War. Indeed, Calder's highly charged rhetoric about the specific form of the monument reflected broader liberal internationalist attitudes, espoused in particular by President Woodrow Wilson. These were currently the subject of heated debates about what the war and the victory meant.

In attacking the arch for failing to express adequately the "ideals of Democracy and Justice" for which the war had been fought, the resolutions evoked the high-minded justifications of America's entry into the war as necessary struggle against the evils of Prussian militarism. Calder made this point explicitly in a letter to the *New York Times*, in which he condemned Hastings's "mutilated Roman Arch of imperial triumph doing duty as our monument celebrating the victory of a free democracy over an imperial power."[30] This struggle was also echoed in the moralistic tone of the fourth resolution. It called for an opportunity to prove that "we have an Art of our own," to create an original design suitable to the occasion that "could stamp a fresh record of the tremendous events of our recent History." These were not merely the assertions of American nationality. They represented the common assessment that America's contribution to the war effort had been both special and crucial.[31] Criticism of the "obsolete formalism" of the arch constituted more than an attack on the unoriginal art of what Calder had described earlier as "brains paralyzed by precedent."[32] From Calder's liberal standpoint, the arch was outdated because, as a symbol of victory, it blatantly celebrated Germany's defeat and implied the humiliation of a conquered people. From the liberal Wilsonian point of view, what was needed was a new democratic expression of peace formulated in a spirit of international reconciliation, not of retribution.[33]

The Anti-German Backlash

The NSS passed the resolutions by twenty votes to six. However, of the thirty-four members present at the meeting, eight did not vote. Had they done so, the margin of difference might have varied considerably.[34] Calder's resolutions back-fired, however, and the NSS became the victim of anti-German sentiment. This was still pervasive in the United States, as evidenced in the attacks on Wilsonian peacemaking policies, particularly the proposed League of Nations. The NSS resolutions, with their liberal and internationalist rhetoric, became a prime target for criticism from the political opposition.[35] The anti-Wilsonian *New York Herald* got wind of the resolutions, and two days after the NSS meeting, an article appeared with the title "Sculptors Oppose Permanent Arch as 'Rough on Germany.'" It attacked the NSS resolutions and cast aspersions on members of the society, insinuating that then–NSS president Frederick George Richard Roth was a German sympathizer because—although born in Brooklyn—he had received his education in Bremen and his art training in Vienna and Berlin. The article

misspelled the name of the British-born Augustus Lukeman as Luheman, with the intimation that he too was German. And furthermore, the *Herald* observed, quoting some of Lukeman's comments at the 15 November meeting, "he is one of those in the Society opposed to anything like an arch, as it would indicate that New York was anxious to emphasize the fact that the enemy had been defeated."[36]

The next day the *Herald* published an editorial ("Wanted: A Society of American Sculptors"), again attacking the sculptors. Most people, it stated, assumed that the temporary arch had been intended as a symbol of victory over the Germans and as an honor to the army and navy men who died in the Great War. "But now it appears such a conclusion would be absurd," and that it was equally questionable whether the United States had even won the war or whether it was still at war with Germany.

The editorial blasted a comment made by Lukeman at the 15 November meeting to the effect that Hastings's Roman arch was inappropriate since it conveyed the idea of "the humiliation of a conquered people." The paper mocked his Wilsonian vision that since Germany would someday be a member of the League of Nations the United States should not be "rough" with it.[37] Mentioning Roth's German associations, the editorial asserted that it would be hard to find a "true citizen of this country" so deluded as to think that the permanent monument should commemorate "to any extent German gallantry, German good faith, German respect for the weak, German reverence for religion, or German anything else." A last jab played upon the supposed inconsistencies between the organization's title and the internationalist tenor of its membership and policies. The editorial concluded, "It strikes us that as some sculptors seem to think that 'national' means international, what is needed is a Society of American Sculptors. The sooner it is founded the better."[38]

The *Herald*'s attacks were devastating to the NSS, the majority of whose members had not expected their resolutions to be so controversial. By the time of the next meeting, in late November, Hastings, Bartlett, MacMonnies, and several of those involved with the temporary arch had tendered their resignations from the organization. The NSS resolutions represented for them both a personal affront to their artistic judgment and a political abomination—a cause with which they refused to be identified. The NSS's passage of Calder's resolutions had made what for Bartlett had already been an increasingly bothersome professional situation completely untenable, and he severed his connections.[39]

The NSS continued to lobby for new designs for the permanent memorial. The

society also made every effort to ally itself with responsible civic groups whose patriotism was not in doubt (the American Legion, the Chamber of Commerce, the Merchants' Association of New York, the Federated Civic Associations of New York, and the New York Federation of Women's Clubs). The society endorsed a letter sent by the Municipal Art Society to the heads of several major civic and artistic organizations urging them to call for a competition and public exhibition, with a jury deciding the form of the permanent monument. But the sculptors could not ignore the gravity of the situation with which they were now confronted. They not only had to worry about the monument, but also how to dispel the rumors that the NSS was pro-German. Handwringing continued over a period of weeks. Janet Scudder argued for publishing an explanation of the initial resolutions condemning the arch idea. Robert Aitken disagreed, stating that while he opposed pro-Germanism as much as anyone, the society had already received enough bad publicity. Drawing more attention to the problem would certainly not help. Another member, architect Joseph H. Hunt, concurred. While he thought the original resolutions should be republished, he did not think any paper would actually do so. In his view, the mayor's subcommittee had managed to sway the press against the society.[40] Worse, it appeared to him that Bartlett, the society's former president, who had been present at the ill-fated November 1919 meeting, had helped to sabotage the society in the eyes of the press, presumably through distorted accounts of the sculptors' comments.

The late November resignation of several artistically prominent and influential members was a significant setback to the society. The *Herald*'s indictments and the backlash they precipitated proved all the more demoralizing for the artists since they had not intended their internal discussions at meetings to be on the record. But they were helpless to do much about the situation. Their strength as an organization had been considerably weakened.

The members of a joint art and executive committee of the Mayor's Committee on a Permanent War Memorial continued to move ahead with their plans. The committee ultimately did agree to hold an open competition, and invited artistic and patriotic societies to submit designs by early February 1920.[41] Three categories of general ideas were proposed: a memorial arch, a cenotaph, and a statue or sculptural group. But after six meetings, the jury of artists chosen by the committee concluded that no submission was "sufficiently meritorious" to be adopted.[42] In the end the jury decided that a memorial arch would work best to commemorate the "sacrifices made by our fellow citizens" during the war. The committee

deliberated about the architect, the design, and a suitable site throughout 1921, but decided to go with Hastings and his plans anyway. Indeed, given the committee's enthusiasm for Hastings's arch idea in the first place, it is questionable whether the jury had considered the alternatives seriously.

By 1922, however, when work on the memorial was about to begin, many of the immediate emotions about the war were beginning to fade. Attitudes had become closer to those expressed by Calder and the sculptors in 1919. But whereas in 1919 it was still generally assumed that a war monument would be primarily sculptural, by 1922 the architect's discussions about what a suitable monument should be had shifted away from this idea toward that of a living memorial. Hastings's plans now included not just an "Arch of Freedom," but an adjoining recreational memorial center with swimming pool, playgrounds, and running tracks, all planned for the site of the old Croton (lower) reservoir in the middle portion of Central Park, just north of the Ramble.

This shift in emphasis from ritualistic to recreational memorials was significant. It reflected a conviction, increasingly common after World War I, that memorials should honor the dead rather than glorify the ideals of war itself. For many, the most suitable way to do this was through a functional structure of a kind that author Charles Over Cornelius characterized as "serving the two-fold purpose of a memorial to the heroic dead through the constantly renewed tribute of the living."[43]

This conception of an active and community-oriented memorial appealed to many artists and architects, who saw in it a way to expand monument designs into larger, more ambitious City Beautiful architectural schemes. For them, functional memorials meant community centers, club houses, convention halls, amphitheaters, and bridges: sites of demure and passive civic activity. Such buildings remained stolidly genteel in conception. The architects thought of them as serving the entire community. Realistically, however, they would be likely to attract a limited clientele. At the very most, the architects expected the memorials to help shape the "right" kind of American citizenry.[44]

Compared to many of the memorial schemes proposed by his contemporaries throughout the country, Hastings's plans, with their playgrounds and swimming pools, were populist in their orientation. Yet at the same time, the scheme also remained consistent in a fundamental sense with the older genteel tradition of reform. The inclusion of playgrounds represented the influence of the earlier Progressive recreation movement. Playground advocates attempted to create good,

loyal citizenry through wholesome, orderly means by providing a structured play environment and appropriate forms of releasing energy on the part of immigrant and upper-class children alike.[45] Moreover, Hastings's basically axial Beaux-Arts plans conformed to the standard stylistic ideals upheld by proponents of the City Beautiful as part of a larger process of urban reform.

Ten years earlier these reform ideals and artistic designs were the bailiwick of upper-middle-class civic activists and beautifiers. Significantly, however, they were now also being coopted on the state and municipal levels by Tammany interests.[46] Indeed, Mayor John Hylan saw in the permanent war memorial a good opportunity to bestow favors upon his constituents. Hastings's plans must have been attractive to Tammany Hall, for his modified designs had the potential to serve a variety of the interest groups to whom Hylan hoped to please. From the mayor's standpoint Hastings's expansive arrangement would provide numerous new jobs in the New York construction industry. Its recreational facilities—becoming increasingly popular in any case—would satisfy the growing number of proponents of a functional, living memorial. Furthermore, the recreational memorial would make large empty park spaces useful, by providing a nice place for all city residents to go—members of the working class and immigrant slum dwellers included. This land would no longer function as the extended front lawn for exclusive Fifth Avenue and Central Park West residences.

The mayor's interest in the project resulted in added pressures to construct a popular memorial, but Hastings still wanted some stamp of professional approval. To bolster artistic support for his plan, he turned to the presidents of the city's various art organizations, including the current NSS president Hermon MacNeil, and asked them to sit on a committee of consultants to the project. Yet this move was an affront to the NSS, since MacNeil was to serve only as an individual rather than in his official capacity as president of the society. Unaffiliated individuals could be more easily persuaded to see both sides of the situation. They might even come around to see things from the vantage point of Hastings and the city. It was Hastings and the Mayor's Committee rather than the artists' organizations who were most likely to benefit from this sort of arrangement.[47]

In responding to Hastings's invitation, MacNeil tried to represent the sculptors' best interests. First he informed the architect of the "distinct rumors of antagonistic sentiment" among his colleagues regarding Hastings's procedures.[48] MacNeil then attempted to give more prominence to sculpture and to the poten-

tial contributions of the NSS artists by bringing up the old problem of the relation of sculpture to architecture. As MacNeil put it, a major part of the problem with the memorial was that Hastings, like many other architects, had given insufficient consideration to the valuable expressive role of sculpture, particularly of the human figure. Instead he had conceived the whole project too architecturally and formally. Sculpture came into the picture too much after the fact. Might it not be preferable, MacNeil suggested, to consider what sculptural method could best "interpret" this Great War—a method that would convey how different were the "means of warfare and the ideals for which the war was fought"—and to use architecture as a "binder for the sculpture" rather than the other way around.[49] Despite his reservations, however, MacNeil did serve on the committee and even approved the proposed plan. Thus the NSS was still locked out of official deliberations concerning the memorial.

The sculptors were tremendously upset by all of these developments. They felt betrayed by their former leaders. They believed that city officials were succeeding in discrediting them by getting the public to think that they were trying to manipulate the outcome of the project. They saw Hastings effectively "railroading" the project through. Admitting that sculptors as a group simply did not have the power to implement any changes directly, the society had to ask the New York City Chamber of Commerce to set up a committee to keep the city's arts organizations informed of what was going on.[50] "The situation has been going from bad to worse in the last few years," one member lamented; "the Fine Arts has not the support of the public it had ten or twenty years ago."[51]

By 1923, the focus of the larger debates had shifted substantially. The sculptural issues that MacNeil had brought up to Hastings were in many ways beside the point. By this time, the question had gone far beyond that of any individual group's participation, expertise, or control. Sculpture had become peripheral to the larger issue of site and purpose.

Hastings had selected the thirty-seven-acre lower reservoir, part of the old Croton system, which had become available for park use on the completion of the Catskill water system. In his view, few places in the city offered such a large, convenient, yet still undeveloped site. Moreover, as Hastings envisioned it, part of his monument would take the form of a museum for the display of war trophies. What more appropriate place to situate it than between the two other great museums, the Metropolitan and the Museum of Natural History?[52]

Yet contrary to Hylan's and Hastings's hopes and expectations, the proposed

multipurpose memorial extravaganza in the middle of the park was not to everyone's taste.[53] On learning of the plan, numerous civic organizations let out a storm of protest at the idea of transforming the natural landscape of Central Park into some sort of Coney Island, "a thronged and noisy entertainment resort." In such an environment, the meaning of the park—much less the meaning of the war—would be totally lost. As at Coney Island, the architecture and the sculpture would be diverted from their appropriate didactic purposes and used for mere pleasure. The *New York Times* wrote, "The triumphal arch beneath which our returning soldiers marched up Fifth Avenue is to be reproduced in marble and set down into the no-thoroughfare of a sylvan landscape—sylvan, that is, unless this monument to the valor of our dead is surrounded by the atmosphere of pink popcorn and hot dogs."[54] Despite the opposition, the mayor and the Board of Estimate went ahead and appropriated $600,000 for the permanent war memorial.[55]

The debates about the memorial continued, and Hastings revised his scheme once again (figs. 13.2, 13.3). He eliminated the swimming pool and running track,

13.2
Thomas Hastings, ground plan showing Metropolitan Museum and the American Museum of Natural History and intercommunicating road in relation to proposed war memorial, lower reservoir, Central Park, 1923. (From the Collection of the Art Commission of the City of New York, Exhibition file 1244-B.)

but he retained a good deal of open space for children's playgrounds. The new plan still maintained a formal design, with a 150-foot-long, 40-foot-deep memorial building at the north end of a lagoon. The structure consisted of an arched screen or low peristyle, with statues inside. A central arched niche formed the background for a sculpture group (depicted as Athena) surmounting a cascade, encircled by bronze sea horses (fig. 13.4). In the description he provided for the newspaper, Hastings indicated that various allegorical and historical groups would represent the Great War. Nevertheless, the NSS sculptors continued to be left out of the discussions of the plans, and of the considerations of who would do the work.

But even this new proposal, now backed by Commissioner of Plants and Structures Grover Whalen and by Park Commissioner Gallatin, met with considerable challenge. For one thing, the announcement of the new memorial plans coincided with various rumors that a $15 million music and art center and a memorial to former mayor John Purroy Mitchel, a radio station, and a portion of the subway, might also be built in the park.[56] Cultural institutions and monuments had encroached upon the park virtually since the time it was built. But matters were

13.3
Thomas Hastings, perspective view of proposed World War I memorial and lagoon, lower reservoir, Central Park, 1923. (From the Collection of the Art Commission of the City of New York, Exhibition file 1244-F.)

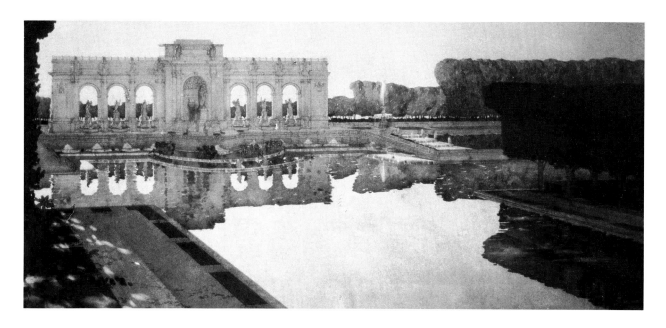

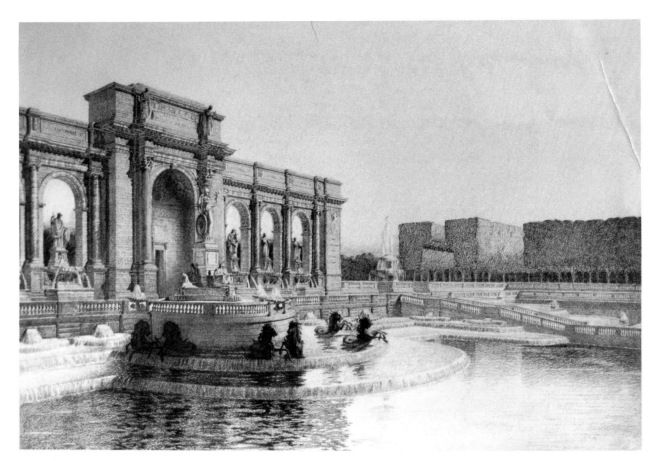

13.4
Thomas Hastings, proposed war
memorial and lagoon from water-
color drawing, lower reservoir, Cen-
tral Park, 1923. (From the
Collection of the Art Commission
of the City of New York, Exhibition
file 1244-E.)

being pushed a lot farther than in 1900, when landscape architect Samuel Parsons had protested the intrusion of the *Sherman* and other sculptural and architectural elements into Olmsted's and Vaux's original park design.[57] The ranks of the opposition had now swelled to include the City Club, the Fifth Avenue Association, the Merchants' Association Committee on City Plan, the Municipal Art Society, the New York Chapter of the American Society of Landscape Architects, the New York Chapter of the American Society of Civil Engineers, the Parks and Playgrounds Association, and the Chamber of Commerce. They objected to the use of park lands for anything other than "park purposes."[58]

Several matters were now at issue. The first was whether the playground, as a place of recreation, promoted the *kind* of activity suitably related to the more contemplative and leisurely recreational purposes of Central Park as it had been originally conceived. The second issue was whether any kind of memorial structure (with or without playgrounds) belonged anywhere in the context of the park's natural surroundings. From the point of view of many advocates of the new design, it constituted an enhancement and improvement of the natural landscape of the park, and was perfectly consistent with the notion of Central Park as a man-made landscape garden with certain formal design elements.[59]

As earlier, opponents contended that the park was not the place for such a memorial and that the new design, with its fountains bespeaking "frivolity and joyousness," was totally inappropriate for commemoration of the dead. The NSS joined the opposition in opposing the encroachment.[60]

Those in favor of the memorial had a very different opinion. They included veterans, Gold Star Mothers, Frederick MacMonnies, the secretary of the Central Trades and Labor Council, the former director of the Draft for the State of New York, and many municipal officials. Speaking on their behalf, benefactress Sophie Irene Loeb remarked caustically that the wealthy did not want the memorial because it would block their views of the park. Moreover, she commented in an interview, the "boys the memorial was intended to honor did not come from the houses overlooking the park but from beyond Third Avenue."[61] Other monument advocates shared her feeling that those opposing it were the wealthy, who had had little real contact with the war. The arguments had now polarized over the relative priority of the political and the aesthetic. Ironically, the artists' organizations, in the name of aesthetic propriety, were pitted against a broad popular constituency that demanded a memorial and playground.

Hylan, backed by the Tammany machine, defended his constituents, making it clear that he was more interested in improving the lot of the masses than were the civic groups. He had recognized that it was good politics to support a functional memorial with playgrounds in the park. Finally, however, he gave in to the opposition. After a wealthy state senator sought a referendum on the issue, Mayor Hylan called a halt to the project in 1924. Citing "pressure of business on the calendar," he postponed action until the next September, which effectively closed the memorial case.[62]

In the end, Hastings's monument and memorial scheme were dropped. But although the NSS had opposed it, the victory was bittersweet for the sculptors. Their opposition had been triggered by the fact that they had been locked out of the initial planning process. Their participation in matters they saw as central to their professional enterprise was no longer considered crucial or desirable either by government officials, influential architects, or some of the artists themselves. What an appropriate monument should be, the relation of sculpture to architecture, and even the matter of professional participation—issues that immediately should have involved the sculptors in public projects—had become subsumed by a larger political debate. Sculptural monuments were controversial, but the alternatives were even more so.

The fate of the World War I memorial during the early administration of Park Commissioner Robert Moses (1888–1981), the most powerful planner and builder in the history of New York City, epitomized the peripheral status of monuments within larger planning schemes of the 1930s. Like many reformers of the period, Moses strongly believed in the value of active recreation as a means of uplift and social control. The creation of parks and playgrounds was one of his top priorities. Monuments and sculpture, which could encourage only passive contemplation, were of relatively little interest to him.

In 1934 Moses learned of the $340,000 in funds earmarked for the Central Park war memorial, now lying dormant. He instructed city chamberlain Adolf A. Berle to look into the whereabouts of the money, but he had different plans for its use. He persuaded Berle that there was not enough money to build a war memorial arch and that, besides, a memorial "merely in stone" would not "meet the general desire of the persons most interested." Instead, Moses concluded, "war memorial" could mean "war memorial playground." He convinced the surviving donors to allow him to use the funds to build at least one playground per

borough. All would have "flagpoles with suitable inscriptions." Each would be "dedicated by the American Legion and appropriate veterans' organizations upon completion." The state supreme court granted permission, and Moses was able to purchase eight plots of land.[63] The city-built playgrounds had "colonial" brick field houses, wading pools, swings, slides, and jungle gyms. The debate over a Beaux-Arts civic war memorial had now become just a bad memory.

I4 The Decline of Civic Sculpture

New York City's Beaux-Arts public sculpture is a permanent record of a phenomenon that lasted only for a limited period of time. The production of these large civic projects was the outcome of a particular set of social, economic, political, and aesthetic forces that converged around 1900. These works were initiated and supported by a small number of powerful people, whose shared concerns the sculpture expressed. The professional self-image of sculptors grew out of, and depended upon, the encouragement and assistance of this urban elite.

The organizational structure that supported public sculpture in New York had largely weakened by the 1920s. As the cases of the Hall of Records, *Purity*, and Coney Island indicate, there were conflicts over the production and reception even of the earlier works. The sculptors' professional enterprise was never as entirely successful as they would have liked. What was significant during this earlier period was that many influential urban elites saw sculpture as a important aspect of civic culture. The First World War precipitated further breakdown in consensus on the subject of municipal art and a decline of the sculptor's already tenuous authority as a professional. The circumstances of *Civic Virtue* and the World War I memorial illustrate the problems that undermined large-scale public projects. In the case of *Civic Virtue*, inversions of interpretation exploded the sculptor's Progressive, middle-class myths. The World War I memorial suggested how peripheral sculpture and sculptors had become to the expression of significant public ideals and emotions. In both cases, the sculptors' values clashed with those of new constituencies, many of which supported Tammany Hall, and whose sensitivities and interests heretofore had not been an issue and had not been considered by the artists. Both examples reflected the extent to which municipal government support for public monuments had diminished, and sculptors' stature had waned.

This situation was just one manifestation of the larger breakdown, by the 1920s, of the social cohesiveness of the City Beautiful movement and of the cultural consensus it had promoted at the turn of the century. The events that affected sculptors reflected a broader shift from a society in which leadership was based primarily upon economic wealth and social status to one based on professional training and disciplinary identity.[1] In urban development, for example, the older generation of genteel Progressives were replaced by a younger group of college-educated men, like Robert Moses, who viewed themselves as scientific professionals. While these men received their training within the institutional framework of Progressive reform, many of them expressed different concerns when they came into positions of leadership in the twenties.

In the realm of planning, for example, this generation had different priorities from City Beautiful proponents. They considered their predecessors' idealistic visions to be superficial, and believed that such design techniques ignored the more immediate and significant social and economic problems of urban life. Attempting a more pragmatic approach to city planning, they sought healthful, efficient, and workable solutions to such problems as congestion and poverty. The organization of cities, the new planners argued, had to follow scientific, empirical principles, based on an understanding of physical structure and related economic, social, and physical conditions. The city had to be conceived, in Robert Murray Haig's words, as a "productive piece of economic machinery."[2] The metropolitan planners who developed the eight-volume Regional Plan for New York (1927–1931) thought in terms of social and demographic concerns, based on the realities of geography, population, and the marketplace. Compared to the concerns of the earlier architecturally oriented planners, civic art was of less immediate concern to them.

If civic art no longer occupied the same privileged position among city planners, neither did the artists. By the 1920s private planners in New York were working increasingly with political and corporate groups, while the artists and cultural organizations were being left behind. These circumstances had ramifications for sculptors. Earlier, at least some NSS sculptors had been involved in various stages of the municipal planning efforts. As mentioned earlier, Daniel Chester French had been a member of Mayor McClellan's New York Public Improvement Commission, and its 1907 report had made public sculpture an important priority. By the twenties, sculptors and civic sculpture played little part within the larger organizational context of city planning. Artists were brought in

as consultants during the preparatory stages of the regional plan, but they were clearly not at the cutting edge as they had originally expected to be.[3]

Significantly, architects did little to try to alter this situation. Like planners, they too were beginning to shift priorities, in a manner that ultimately produced a deterioration of their relations with sculptors. Of all the groups with whom sculptors had closely associated, architects had always been crucial for the production of their public work. Architects had placed value upon making sculpture an integral part of their designs. Major firms like McKim, Mead, and White had always sought to hire professionals and, to the extent that it was possible, to conform to NSS standards for working procedures—even if this meant circumventing set government rules. Architects had also played a major role in promoting public monuments, both as individuals and through their organizational activities.

Many of the official connections (such as the Art Commission and the Fine Arts Federation) established between sculptors and architects in the 1890s continued during and after the 1920s.[4] But increasingly, younger architects did not display the same commitment to promoting the sculptors, or to helping them obtain commissions. The rising cost of construction was an important consideration, as was the complexity of orchestrating sculptural production. Some architects were convinced that well-trained modelers or carvers could do the work just as well, and with fewer negotiations involved. Some felt that American sculptors were simply unqualified to execute the kind of work that they were looking for. A number of architects were put off by what they believed was the too-persistent attempts of the NSS to dictate artistic matters that were none of its business.[5] Still others were annoyed by sculptors' inefficiency. Even a member of the older generation like Thomas Hastings, while continuing to use sculpture in his designs, could show less interest, involvement, or respect for the NSS and its professional concerns. The gradual dissolution of the old ties helped make sculptors increasingly marginal to the realm of planning and in other artistic spheres. Sculptors were only too aware that this was happening. A major topic at the 1929 NSS meeting, for example, was the fact that sculptors and architects were "getting far apart."[6]

The sculpture atelier of the Beaux-Arts Institute of Design represented one indication of this rift. It proved that architects sought to create an established institutional context in which to control training of sculptors and production of architectural sculpture in a manner that would suit their needs without their hav-

ing to deliberate over artists. In 1911, the Committee on Education of the Society of Beaux-Arts Architects, through its spokesman, Lloyd Warren, invited the NSS to join in establishing classes for architectural sculptors. The classes would be administered along the same lines as those already set up for architects. Emulating the system used at the Ecole des Beaux-Arts in Paris, the Beaux-Arts Institute of Design would consist of a series of ateliers and design competitions judged by juries of acclaimed experts.[7]

There were only a limited number of monument and large architectural commissions available. Ornament modelers, however, could earn reasonably good money. Warren told the sculptors that such a school would put an end to the growing dependence upon European decorative artists. It would provide heretofore unavailable expert training for young American men hoping to enter architectural modeling firms.[8] The sculptors agreed that the proposed ateliers might create more demand for American-made sculpture. In the face of these circumstances, the NSS, whose members had earlier sought to distinguish themselves as elite, "fine art" sculptors, began to consider the benefits of linking up with the applied, decorative end of the trade. In 1912, they and the Society of Beaux-Arts Architects established a Studio for Decorative Sculpture, which a few years later became part of the Beaux-Arts Institute of Design. The school would assure a ready pool of qualified modelers and sculptors for the firms used by architects. What the NSS did not consider was that in the long run such training also meant it would no longer be desirable or necessary to make complicated arrangements like those used to create the sculpture for the Brooklyn Institute of Arts and Sciences, described in Chapter 9.

By the twenties, the Beaux-Arts Institute of Design was turning out highly skilled sculptors whose backgrounds and identities in many cases differed from those of their fine arts contemporaries. Many young men from poor or varied ethnic backgrounds found it more lucrative to work for modeling firms than as apprentices to sculptors.[9] Many architects were embarking upon projects that were sculpturally less ambitious, compared to those of an earlier period. At the same time, the widespread use of ornamental detail for the growing numbers of commercial and residential buildings in the city kept demand for ornamental modelers steady.[10] Finding that the sculptor/modelers suited their decorative needs, architects increasingly turned to the modeling firms, thus in many cases bypassing the need to hire individual sculptors. Thus despite all appearances, the Beaux-Arts Institute, which appeared to cement the ties between sculptors and

architects, actually signalled their breakdown.[11] Many architects no longer saw collaboration with independent sculptors as a crucial part of their professional activity.

The changes in city planning aims and in the preferences of architects coincided with the rising influence and diversity of new groups of art professionals and patrons, all of whom competed with older organizations. By the late twenties, these groups, who included the sponsors of the Whitney Studio Galleries and the founders of the Whitney Museum of Art and the Museum of Modern Art, represented a formidable institutional force. They posed a serious challenge to older societies like the NSS. A younger group of trained experts—critics, art dealers, gallery owners, and museum professionals—began to promote innovative modernist styles, and favored artists and conceptions of art different from those preferred by the older artists' organizations.[12]

The works of artists like Gaston Lachaise, Chaim Gross, and William Zorach exemplified the newer approaches. These artists depicted the human figure, but with highly schematized, simplified compositions compared to their Beaux-Arts colleagues. They and their supporters contended that aesthetic success depended upon sculpture's formal properties, the unique expression of an individual personality, rather than upon its subject matter, particularly narrative allegory.

The new institutional clusters that developed gradually redefined the meaning and purposes of sculpture. There was a growing rejection of the public realm of collective belief in favor of the private realm of individual, subjective meaning.[13] The interests of the new groups were more insular and private. In contrast to the artists involved with public art projects, they sought autonomy and avoided dealings with the municipal bureaucracy. Their galleries catered to a limited but growing new group of patrons. Independently, the individual collectors and galleries produced no immediate cultural changes between 1910 and 1920. But the activities of the modernists expanded, and by the twenties, they had gained much more widespread support. The establishment of the Museum of Modern Art represented the culmination of attempts to gain elite institutional support for vanguard art. But it was not until after 1945 that the alliance among pro-avant garde dealers, wealthy elites, and college-trained professional curators and directors attained the cultural dominance once held by the City Beautiful reformers and conservative artists.[14] It took the traumas of the Depression and the Second World War to produce conditions that would destroy the old foundations of cultural authority.

These shifts in city planning, architects' interests, aesthetics, patronage, and public acceptance all contributed to the erosion of support for ambitious public sculpture projects, especially government-funded art. Of the works that were commissioned, nothing was comparable in scope, scale, or quality to the series of sculptural projects created in the two-decade period before America's entry into World War I. During the twenties, the majority of public commissions were for small war memorials, most of which were flagpoles or tablets. The larger memorials usually consisted of a granite or limestone base or a large tablet, topped either by a single bronze female allegorical figure or by an image of a doughboy, or both, as in Augustus Lukeman's and Daniel Chester French's *Prospect Park Memorial* (1921), in Prospect Park, Brooklyn. Few of these smaller war memorial commissions were carried out by sculptors who had achieved a position of great eminence. While this meant that a few lesser-known sculptors received a chance to get at least one public sculpture commission, it also indicated a waning of earlier concerns about obtaining the best and most prestigious artists. Moreover, the numbers of such sculptural war memorial commissions dropped by the end of the decade.[15] Apart from war memorials, the Art Commission approved only about one or two statues or other sculptural groups each year between 1922 and 1929. Most of these projects were portrait statues, several of which had been commissioned before the war began.[16]

Many of the major prewar projects had been erected under the municipal auspices and with city money. Municipal involvement with civic sculpture substantially diminished by the late 1920s. Unlike Chicago, which had its own special private fund for public monuments (the B. F. Ferguson Monument Fund), the New York City government had never had a separate source of income to pay for sculptural projects.[17] The city's elite groups were no longer pressing the municipality to support large-scale, City Beautiful monument projects, as they had fifteen to twenty years earlier. With the pressure from these groups subsiding, with resistance to public monuments on the part of other groups mounting, and with municipal deficits increasing, the Tammany officials governing New York during this period were not inclined to spend city money on public monuments, buildings, or architectural sculpture.[18]

There were visible indications of this loss of municipal support. A grandiose, controversial plan to construct a monumental Beaux-Arts civic center around City Hall Park never materialized. The New York County Courthouse (figs. 14.1, 14.2), commissioned in 1912 and originally planned as part of the civic center

Guy Lowell, proposed New York County Courthouse, south elevation, 1914. (From the Collection of the Art Commission of the City of New York, Exhibition file 739.)

NEW YORK COVRT HOVSE

SOVTH ELEVATION SCALE ONE INCH EQVALS SIXTEEN FEET

scheme, was only completed at 60 Centre Street in 1926. Moreover, the Board of Estimate forced architect Guy Lowell to revise his original plans in order to cut construction costs from the $21 million initially projected to $7 million. To do so Lowell altered the highly ornate circular design that had won him the commission back in 1912. Hence his new pared-down building, which eliminated many of the "features not considered essential," included much less sculpture than had his 1912 plan.[19] We have seen that the World War I memorial, the one major project with which the municipal government was involved during the 1920s, left out the National Sculpture Society, and was never carried out.

The Theodore Roosevelt Memorial (fig. 14.3), a monumental new wing and installation of the American Museum of Natural History at 79th Street and Central Park West, was the exception that proved the rule. The memorial was the realization of the dream of museum president Henry Fairfield Osborn, an established member of the city's intellectual elite (and a nephew of J. P. Morgan), to commemorate his friend Theodore Roosevelt. It also gave him the chance to make

14.2
Guy Lowell, New York County
Court House, 60 Centre Street,
1926. (Photo, Michele H. Bogart.)

The building includes a pediment
depicting Justice with Courage and
Wisdom, and three roofline figures,
Law, *Truth*, and *Equity*, designed
by Frederick Warren Allen; apart
from these works, two other figures
adorn the building—those of *Justice*
and *Equity* designed by Philip Mar-
tiny for the Hall of Records twenty
years earlier and moved in 1959.
These stand inconspicuously in
niches to either side of the entrance.

up for an opportunity lost to him in the past. The development of the American
Museum in the early 1890s had coincided with that of the city's other major
cultural institutions. (Many of its most influential trustees were the same.) The
American Museum, like the others, had constructed a new building. But Osborn's
own tenure as president, beginning in 1905, had come too soon after the comple-
tion of the museum's fortresslike Romanesque structure, initiated by his predeces-
sor Morris K. Jesup. Osborn was thus not in a position to commission his own
monumental classic Beaux-Arts edifice in a style commensurate with his civic
aspirations until 1924, when the New York State Legislature gave the state au-
thority to erect a memorial to Theodore Roosevelt at the museum.

Designed by John Russell Pope, the memorial's facade consisted of a monu-
mental Beaux-Arts triumphal arch entranceway, topped with statues by James
Earle Fraser of the great explorers and naturalists Daniel Boone, John James Au-
dubon, Meriwether Lewis, and William Clark. Reliefs of animals by Edward Field
Sanford, Jr., adorned the lower sections of the facade to the left and right of the
entrance. Together, architecture and sculpture provided a heroic preparation for
the mythic truths about Nature and Manhood evoked in the inscriptions of Roos-
evelt's own words in the great entrance hall, and by the taxidermic tours de force

in Carl Akeley's African Hall.[20] One of the few major publicly funded civic architecture and sculpture projects begun in the 1920s, it represented a conscious attempt on the part of its institutional sponsor to hold on to the old values.

Although state funded, the Theodore Roosevelt Memorial was plagued by delays and financial problems on the part of the city, which prevented its completion until 1936. Fraser's equestrian statue of Roosevelt was not installed until 1940. In New York City, the Theodore Roosevelt Memorial was thus one of the last expressions of the turn-of-the-century City Beautiful aesthetic and of the social order that had supported such enterprises. Osborn had to fight very hard to get what he wanted. Symbolically, the new facade helped to affirm the museum's

social and civic importance alongside other institutions. But Pope's designs and the values they conveyed could hardly be seen as representative of the current tendencies in New York art or municipal government patronage.[21]

Changes in the sculptor's profession during the 1920s were partly the result of, and partly associated with, the fragmentation of older social and cultural power hierarchies. The death of the older generation of sculptors and the diversity of the new one were additional factors contributing to the breakdown of past traditions and ties that in previous years had made a civic art possible.

This period marked the passing of the generation of artists who been most influential in establishing a professional and organizational framework for the production of public sculpture, and who had created the first comprehensive sculptural program in America for the World's Columbian Exposition. Saint-Gaudens, Ward, and Bitter had died by 1916; Bartlett died in 1925. French no longer operated as dean of American sculptors as he once had.[22] MacMonnies refused to take on any more large public projects after his *Civic Virtue* debacle. He died in 1937. James Earle Fraser and Adolph Weinman—the slightly younger former students and assistants who had been working actively since the 1890s—did maintain an artistic presence in New York throughout the twenties. They maintained strong ties with the older Beaux-Arts architects and elites and continued to get commissions for such projects when these groups were in control of federal projects during the early years of the Depression.

The younger generation of artists, however, was not able to assume strong or visible positions of cultural leadership. They were a larger group and more diverse in ethnic background and personal interests. There were more women sculptors. The restricted market for large public projects in the city heightened competition within this larger pool of artists. While sculptors taught in New York's art schools and college departments, as a whole they did not develop strong ties to university circles. The cultivated gentility of a Daniel Chester French had been a key factor in helping sculptors forge ties with influential civic groups. Younger sculptors had found it harder to link up with wealthy individuals and professionals who shared the same ideals and aspirations.

The inability to get more public commissions and the new possibilities for patronage offered by new institutions and collectors led many younger sculptors to place greater value upon the personal, privately owned *objet d'art* than upon the creation of civic art.[23] This pragmatic response contributed to the general shift

in styles and aesthetic values already mentioned, which had been taking place since the early teens. The growing impact of modernism, which privileged the notion of self-expression of the unique individual, undermined the traditional notions of professional expertise, as well as the "universal standards" on which academic sculptors had depended to assert their authority. Younger artists like Zorach emphasized the representation of universal ideals. But the expression of these ideals was no longer through the representation of myths of progress and civicism or nationhood of the kind depicted in turn-of-the-century programs. It did not require adherence to a specific ("Beaux-Arts" classical) set of artistic techniques. According to the modernist canon embraced by many of them, the truth of artistic expression meant working sincerely, inspired by one's own individual feeling and according to one's own "original" standards.[24] When taken to its extreme, the rationale for stylistic individualism in art implied that all creative artists could be considered "experts." This emphasis reflected an important shift from the notions of professionalism and civic responsibility that had been crucial to the identity of artists at the turn of the century.

Corporate Patronage and Civic Sculpture

Government construction slackened during the 1920s, and offered sculptors few possibilities. New opportunities would have to come from the commercial sector, if from anywhere. Commercial development quickened its pace after World War I, and corporate businessmen now became the primary patrons of architecture. They commissioned younger architects like Raymond Hood, Harvey Wiley Corbett, and Steven Gmelin to design lavishly decorated, attention-getting skyscrapers whose monumentality and novelty both advertised business and touted a new era of consumer spending and commercial prosperity.[25] But corporations did not pick up where government architecture had left off in implementing a structured, unifying urban plan. Given the high prices of commercial property, each business focused on its own real estate holdings. Moreover, the commercial aesthetic in architecture did not give much of a role to inspirational sculpture or professional sculptors.

The low priority given to Beaux-Arts civic architectural and sculptural programs in commercial building was not a new phenomenon in New York. Didactic sculpture had played a relatively limited role in earlier commercial architecture, and eminent sculptors rarely took these commissions. Although most important

14.4
James B. Baker, Chamber of Commerce of the State of New York, 65 Liberty Street, 1902; Daniel Chester French, *DeWitt Clinton, Alexander Hamilton, John Jay*. (Courtesy of the New-York Historical Society, New York City.)

These statues were removed because of decay.

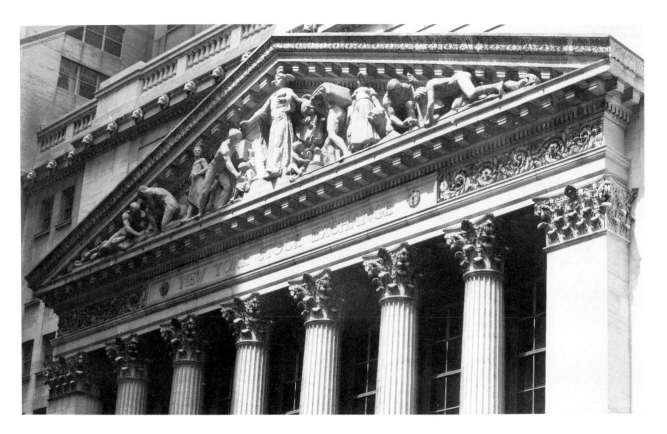

14.5
George B. Post, New York Stock Exchange, 8 Broad Street, between Exchange Place and Wall Street, 1903. Pediment: John Quincy Adams Ward and Paul Wayland Bartlett, *Business Integrity Protecting the Industries of Man*. (Photo, Michele H. Bogart.)

turn-of-the-century office buildings included some architectural sculpture, usually these were limited to a few classical caryatids, keystone heads, or gothic grotesques created by anonymous modelers or carvers. Only a few commercial buildings included major sculptural programs designed by prominent artists.[26] The Chamber of Commerce (1902; Liberty Street at Liberty Place, fig. 14.4) and the New York Stock Exchange (1903; Broad Street between Wall Street and Exchange Place, fig. 14.5) were among the exceptions, for which major works of allegorical architectural sculpture were commissioned from established, highly acclaimed sculptors. Daniel Chester French's figures of DeWitt Clinton, Alexander Hamilton, and John Jay stood prominently on pedestals between Corinthian columns on the facade of the Chamber of Commerce. For the Stock Exchange, John Quincy Adams Ward and Paul Wayland Bartlett created a monumental allegorical

305 *The Decline of Civic Sculpture*

14.6
Evelyn Beatrice Longman, *Genius of Electricity*, AT&T Building, 195 Broadway, 1915. (Reproduced with permission of AT&T Corporate Archive.)

pediment, *Business Integrity Protecting the Industries of Man*. Yet the identities of these exceptional organizations were intimately linked to the promotion of the civic community through commerce. Their members included many of the same elites (such as J. P. Morgan and Morris K. Jesup) who supported the city's most prestigious cultural institutions.[27]

A similar situation prevailed ten years later. In 1914, the American Telephone and Telegraph Company commissioned allegorical sculptures by the young Paul Manship (*The Four Elements*) and Evelyn Beatrice Longman for the corporation's new building at 195 Broadway, designed by William Welles Bosworth. Longman's design, *Genius of Electricity* (fig. 14.6), was selected in a limited competition in which her mentor, Daniel Chester French, was one of the judges. A monumental winged figure "poised" on a sphere grasps three bolts of electricity in his left hand. In his right hand he holds the end of a lead sheath cable "from which spring, instead of insulated wires, the swift symbols of its power—electric energy."[28]

But AT&T was one of the first of the giant corporations and a monopoly utility. Its decision to construct a new building was initiated in the early teens, when Progressive civic attitudes were still strong. AT&T president Theodore N. Vail's decision to hold a competition and to commission an allegorical figure reflected how seriously he conceived of the company's activities as a public service on the national level. (In contrast, earlier civic–minded businessmen believed that they had a responsibility to contribute to the public good, but on a much more individual basis.)

By the 1920s, however, corporate public relations men were making concerted efforts to present a new image of business that disassociated it from older progressive institutional structures, values, and practices. The corporate image was conceived as autonomous and separate from government, but working with it to advance private enterprise on the national level. The commercial skyscrapers of the 1920s reflected the new corporate values. They were "up-to-date," stylistically individualistic, and distinctive in their civic purpose compared to the architecture of earlier institutions. These slick, monumental buildings, with their relative absence of serious sculpture, were indicators of the corporate sector's determined commitment to represent itself as a smooth-running, specialized enterprise dedicated to satisfying the needs of the mass consumer. Moral lessons would be taught through advertising, not sculpture.[29]

The new zoning laws, which had a major impact on the styles of the new

commercial buildings, also help to explain the infrequency of large sculptural groups on these structures. Initiated by architects and reformers, and passed in 1916 with the help of real estate owners and local merchants, the legislation was intended to protect property values, to relieve congestion and retain light and ventilation in the streets, and to make the city a more attractive place. The 1916 law limited the height and bulk of buildings at the street line, but permitted them to rise into skyscrapers through the construction of setbacks. While professional planners emphasized the zoning aspects of the law, it was the setback formula that influenced architects, becoming what Carol Willis has described as the "impulse behind a vision of a modern skyscraper metropolis."[30] To the extent that this vision was ever realized, it was in the blocklike massing of commercial Art Deco buildings of the late 1920s. Their designs reflected corporate priorities with regard to sculptors and monumental sculpture. Architects like Hood, Corbett, Irving Chanin, and William Van Alen, who designed important commercial buildings in the late 1920s, turned to alternatives to the traditional figurative sculpture. Instead they used color patterns and ornament in modernist styles, such as angular, zigzag, rayonnating lines derived from Cubo-Futurist painting. Ornament could be produced cheaply and easily in polychromed terra cotta. The work could be done by sculptor/modelers working directly for the terra cotta and ornament shops without the need to bring in a specialized artist from outside.[31]

The growth of New York as a commercial center and the boom in commercial building put new financial and political pressures on architects. The demands of the broadening corporate clientele led them to emphasize pragmatism, efficiency, and functionalism both in design and in organizational practice. The new business climate reinforced architects' growing inclination to bypass professional sculptors. We noted that various architects objected to sculptors' attempts to control sculptural production. What made matters worse, in the opinion of some, was the fact that sculptors were not sufficiently well organized. Sculptors offered too little incentive for architects or corporate patrons to want to use their work. For sculptors to survive, said Harvey Wiley Corbett, they had to "put sculpture on the map." Corbett was one of the architects of Rockefeller Center and husband of sculptor (and NSS member) Gail Sherman Corbett. Sculptors were not good businessmen; they had not done enough to promote themselves.

Architects had to run an efficient operation, Corbett told the artists at an NSS meeting. They needed reliable workers to deliver the goods. The architect and the developer, under constant pressure from their clients, had to be certain that their

contractors would deliver materials and complete their jobs by the necessary dates. If one group of workers held things up there would be a snowballing effect. As an architect, Corbett remarked, he wanted to use sculpture. But his concern about time and efficiency usually led him to turn to a modelers' shop. Sculptors worked on their own, at their own speed, and in a more personal manner. They also had to subcontract others for carving or casting. This added too much additional time, costs, and complications to the work.[32]

Corbett at least made friendly overtures to the sculptors. By 1931 Raymond Hood, one of New York's foremost architects, was freely admitting his own shift in priorities. "There has been entirely too much talk about the collaboration of architect, painter and sculptor; nowadays, the collaborators are the architects, the engineer, and the plumber. . . . Buildings are constructed for certain purposes, and the buildings of today are more practical from the standpoint of the man who is in them than the older buildings. . . . We are considering comfort and convenience more than appearance and effect."[33] Hood's opinion was significant, not only because it typified the new functionalist outlook, but because Hood was a coarchitect of Rockefeller Center, one of the most elaborate civic artistic planning schemes in the history of New York City. His words provide an indication of the conflicting values that governed the production of sculpture for this extraordinary corporate-sponsored project.

Rockefeller Center

Rockefeller Center (figs. 14.7 to 14.11), with its comprehensive art scheme and landscaped gardens, meshed aspects of older City Beautiful ideals with contemporary corporate skyscraper styles, strategies, and practices. The scope of the complex surpassed that of any of the government-sponsored City Beautiful projects in New York City. Only with the creation of the Federal Triangle in Washington and with the implementation of the New Deal would the federal government undertake a project of comparable scale.

Previously planned monumental classical civic centers with sculpture were to be a showcase for government operations. By contrast, Rockefeller Center offered entertainment, corporate offices, and shops. Its art program, which included much sculpture, helped considerably to enhance the center's attraction as a commercial center. It also served an important instructional purpose: to celebrate the achievements of modern communications technology in the service of interna-

tional brotherhood. The project thus represented the culmination of 1920s corporate attitudes that business should be responsible for helping government perform public services.

The singular character of Rockefeller Center and its artistic program stemmed from its primary patron, John D. Rockefeller, Jr. (1874–1960). Rockefeller first became involved in 1928, when financier Otto Kahn approached him to ask his assistance in a plan to build a new Metropolitan Opera House. The building would be constructed on a site belonging to the trustees of Columbia University, between 49th and 50th streets and Fifth and Sixth avenues. It would face an open square that would be purchased with private funds and then donated to New York City.

The initial plan attracted Rockefeller for several reasons. An opera house was a good cause—an upright cultural institution that would serve the "right" clientele. It was clear that the New York City government (under Tammany mayor James Walker) was not willing or able to undertake any major genteel projects at this point. It seemed quite appropriate that one of the nation's top corporate leaders assume the civic responsibilities that government was disclaiming. The land was adjacent to property owned by his family, and the plans would help to improve the area. From Rockefeller's standpoint, the project was thus a good way to produce a "civic accomplishment" and make a good investment at the same time. He agreed to participate, anticipating that the Metropolitan Opera and Real Estate Company would be codevelopers.[34]

Obstacles arose over moving the opera house, and after the 1929 stock market crash the Metropolitan Opera rescinded its agreement. Left holding a long-term lease on the property, Rockefeller resolved to stay with the project despite the Depression. The challenge was to attract businesses and rental income. The success of the project took on new significance and urgency as an assurance of the power and endurance of American business, of its ability to survive despite temporary hard times.

The prospect of constructing a successful monumental commercial complex at this time would have seemed inconceivable to most businessmen. But John D. Rockefeller, Jr., one of the wealthiest men in the world, was not like any other businessman. For Rockefeller, commitment to social causes by no means ruled out continued involvement with long-term business and family investments. In Rockefeller Center, as it developed, he hoped to realize his belief that the pros-

perity of business—especially Rockefeller business—contributed to, and indeed, was inseparable from, social harmony and the betterment of mankind.[35]

Rockefeller, now in total control of the project, proceeded cautiously, as he often did, by selecting leading professionals as consultants. He brought in John R. Todd as developer, along with several large real estate companies. Todd hired his own architects Reinhard and Hofmeister. In addition, after consulting two of the nation's most eminent Beaux-Arts architects, John Russell Pope and William T. Aldrich, Rockefeller hired the architectural firms of Corbett, Harrison, and MacMurray, and Hood and Fouilhoux to develop plans.

Although the architects were well versed in the Beaux-Arts vocabulary, the stripped-down "functionalist" aesthetic of their designs represented the newer stylistic trends that emphasized spacial efficiency over surface design. Nevertheless, the architects' artistic backgrounds led them to see the value of incorporating sculpture and mural painting into an enormous commercial complex of this kind. Indeed, as with earlier City Beautiful projects, sculpture and mural painting were planned as an integral part of Rockefeller Center. Its skyscrapers would be adorned with relief sculptures easily seen at ground level, which would humanize and soften the strong vertical lines of the architecture (figs. 14.7, 14.8). During the initial building phase of Rockefeller Center (prior to World War II), fourteen sculptors received over sixty individual (counting each statue or panel) or thirty separate sculptural commissions (counting each area or theme). This amount surpassed anything done in New York during the previous decade.

Rockefeller then brought together an art advisory committee, consisting of some of the nation's most eminent museum directors and scholars, to consult with the architects on all aspects of the center's art program. This group chose the artists, but Rockefeller insisted upon having final approval.[36] Their choices were governed by pragmatic concerns that offer further evidence of the increasing difficulties that sculptors faced in getting architectural commissions. Rockefeller and Todd wanted experts who could operate as part of a professional team. Any sculptors and painters selected had to function in a businesslike manner, just like everybody else. Todd informed them that no delays, excuses, or individualistic displays of "artistic temperament" would be tolerated.[37] Given Rockefeller's and Todd's concerns, it is not surprising that most of the sculptors chosen by the committee—artists like Lee Lawrie, Leo Friedlander, Carl Jennewein, Attilio Piccirilli, and Albert Janniot—worked in a traditional style. Most of the center's

14.8
Plan for Sunken Plaza, Rockefeller
Center, with view of entrance to the
world's largest office building in
floor area, 1931. (Courtesy of the
Rockefeller Archive Center.)

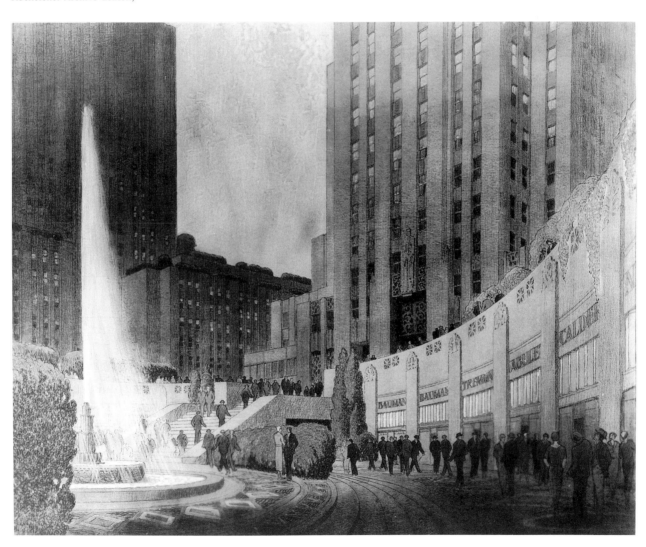

sculptors had worked on civic architectural sculpture projects previously and were trained to handle the complexities of such work.[38]

Like those earlier projects, Rockefeller Center's finished sculptural program (fig. 14.9) relied on "timeless" and unspecific classical allegorical imagery that the sculptors believed would link their works to the great art of the past.[39] But in style much of Rockefeller Center's sculpture departed from the flamboyant Beaux-Arts manner favored by turn-of-the-century artists. Instead it was "updated" to reflect recent artistic preferences. Some of the figures had elongated bodies that deviated from traditional classical norms of proportion. Much of the exterior decoration was rendered in schematized, simplified low relief. Gilding and bright polychromy on several of the sculptures gave them a flat, decorative, nonillusionistic appearance.

With regard to the scope and mode of presentation, the designers of Rockefeller Center and its sculptural program aspired to create the kind of unified and integrated artistic environment that years earlier had been envisioned by advocates of the City Beautiful. In a sense, the planners of Rockefeller Center achieved a more coherent thematic statement than is evident in any of New York's individual sculptural projects. Apart from the comprehensive themes of social, cultural, and economic progress presented at the nineteenth-century world's fairs, most previous programs could actually make statements only through a single building or monument. Many of these works expressed similar themes and values, but they were too geographically dispersed to constitute an integrated program on the order of those at the expositions. Rockefeller Center, on the other hand, was a single, self-sufficient environment. Individual but related sculptural messages, placed throughout the entire complex on separate buildings, combined to present broad but coordinated thematic statements.

Those thematic statements, with their emphasis on international understanding and brotherhood, were a direct outgrowth of John D. Rockefeller, Jr.'s own personal concerns. The Art Advisory Board brought in a special consultant, Scripps College philosophy professor Hartley Burr Alexander, to develop a complete thematic program. He was forced to revise his proposals several times before he could satisfy Rockefeller.[40] The program finally accepted was "New Frontiers and the March of Civilization." Divided into four phases, it depicted "man's progress toward the civilization of today, man's development in mind and spirit, man's progress along physical and scientific lines, and progress via the industry and character of the nation."[41]

14.9
Lee Lawrie, *Progress*, relief over 14 West 49th Street entrance, Rockefeller Center, 1937. (Photo, Michele H. Bogart.)

As represented through sculpture, the New Frontiers themes celebrated the international business and technological community as the foundation for all future advances in civilization, and sought to reinforce faith in its values and accomplishments. Thus, like earlier City Beautiful programs, Rockefeller Center's art served as a myth of progress and stability. Yet the center's sculptural scheme differed fundamentally from earlier programs in its emphasis in expressing the notion of progress. Earlier government-funded commissions used emblematic figures to express aspects of *knowledge* associated with particular ideals, activities, or places. Rockefeller Center's sculpture focused exclusively on the contributions of business and technology as an active *process* that resulted in products of benefit to mankind. For example, to depict the new communications technology of television for the 49th Street entrance of the RCA Building, Leo Friedlander represented, by means of bulbous, grotesquely scaled female personifications, Transmission Receiving an Image of Dancers and Flashing it through the Ether by means of Television to Reception, symbolized by Mother Earth and her child, Man (1933; fig. 14.10). Friedlander's rendering of Radio also emphasized process; a gap between the pylons of *Production* and *Reception* represented the "space through which transmission takes place." Similarly, in his image of *Wisdom*, over the main entrance of the RCA Building, Lee Lawrie showed a sage old man, as "creative power of the universe" (fig. 14.11). The figure traced with his compass the laws and cycles of the cosmic forces (which included light and sound, also personified in neighboring panels) onto the glass panel below, thus bestowing upon man and his activities the wisdom that makes radio and television possible.[42]

In New York City, Rockefeller Center remained unique as a lavishly decorated, privately sponsored, and permanent sculptural project. Corporate leaders did not follow in John D. Rockefeller, Jr.'s footsteps either before or after the Second World War. Rockefeller Center's celebration of systems, multinational business, and technological progress were indicative of the ideological direction public art would take in two major temporary projects of the 1930s, the 1933 Century of Progress Exposition in Chicago and the New York World's Fair of 1939—where business and corporate industries were now a significant presence. The fairs were the last of the major large-scale artistic enterprises to use the older Beaux-Arts planning schemes. But the new orientation of their corporate art patrons diverged markedly from Rockefeller. At the 1939 fair, for example, the "official" Board

14.10
Leo Friedlander, *Television*, RCA Building, Rockefeller Center, 1933. (Photo, Michele H. Bogart.)

14.11
Lee Lawrie, *Wisdom*, 30 Rockefeller Plaza, 1933. (Photo, Michele H. Bogart.)

of Design commissioners delegated commissions for government buildings and grounds to the more traditional and moderate artists. In contrast, the private corporations followed the leads they had taken with industrial designers in advertising, architecture, and product design. They chose vanguard artists, who would adapt the new stylistic idiom of the "machine aesthetic" to publicize the efficiency, stylishness, and scientific advancement of the contemporary corporation.[43]

The postwar institutional structure of the New York City art world shifted, with the supporters of the avant garde achieving control. Critics, artists, art professionals, and other spokesmen for the "dominant" new culture tolerated artistic diversity to the extent that it remained within the bounds of their own modernist canons. They appeared to internalize the emotional turmoil of the recent war. The artists created highly personal images and emphasized the artistic process as the path to self-expression. Discussion and criticism focused primarily on formal and technical issues rather than on the artist's success or failure in representing specific collective beliefs or emotions.[44] These newly influential cultural groups were disdainful of traditional forms of representation like public sculpture, which expressed what they considered to be anachronistic civic ideals. They were actively antagonistic toward academic art and toward older groups like the NSS.

To some extent the NSS brought this opposition upon itself as a consequence of the loss of consensus and authority it had encountered much earlier. Like the members of other artistically conservative art organizations, NSS members increasingly politicized style, to the point of equating modernism with Bolshevism. This vehement defense of stylistic orthodoxy had surfaced during the teens and reached a height during the Depression.[45] By the early 1950s it had alienated the society from all but the most conservative politicians, such as right-wing Senator George A. Dondero, and isolated members of other cultural groups. In total desperation, certain of the NSS's most vocal members, reversing the position the organization had taken during the Progressive Era, lobbied for the government to get out of the business of supporting art, on the grounds that all too often it was supporting Communist subversives. Some NSS members, like Wheeler Williams, were active supporters of Senator Joseph McCarthy. Not surprisingly, the organization was accused of right-wing extremism.[46]

But these activities were merely symptomatic of the social transformations with which academic sculptors had been contending for at least thirty years. By

the fifties, the position of traditional sculptors was weakened further by shifts in aesthetic theory and stylistic fashion. Subsequent interpretations of the art of the Beaux-Arts decades reinforced their diminished status by ignoring the older civic art or berating it as anachronistic kitsch. But as we have seen, stylistic developments are insufficient to explain the decline of an artistic enterprise that expressed the ideals and interactions of a broad range of social, political, ethnic, and professional elements. In framing this historical investigation of New York's turn-of-the-century public sculpture and monuments, I have sought a perspective that is unlikely to trigger sentimental dreams of a more civilized era in "Old New York." Those noble and elegant times did not exist. Stripped of nostalgia, and examined in their broader institutional context, the works discussed in this book acquire another significance. They are monuments to the challenges, the complexities, and the fragility of efforts to define, create, and retain the myth of civic community.

Abbreviations Used in Notes

AAA	Archives of American Art, Smithsonian Institution, Washington, D.C.
ACNY	Art Commission of the City of New York, City Hall, New York City
BI, MMWP, N-YHS	Brooklyn Institute of Arts and Sciences, McKim, Mead and White Papers, The New-York Historical Society, New York City
FFP, LCMD	Daniel Chester French Family Papers, Library of Congress Manuscript Division, Washington, D.C.
NSS Minutes	Minutes of the National Sculpture Society, National Sculpture Society, New York City
NYT	*New York Times*
USCH, CGP, N-YHS	U.S. Customs House, Cass Gilbert Papers, The New-York Historical Society, New York City

Notes

Introduction

1. See, for example, Barbara Haskell, *Claes Oldenberg: Object into Monument* (Pasadena, Calif.: Pasadena Art Museum, 1971), pp. 94–99; "In Memoriam, in Storage," *Art News* 85, no. 2 (February 1982): 13–14; Marshall Kilduff and Ed Iwata, "New Furor on Art at Moscone Hall," *San Francisco Chronicle*, 3 December 1981, p. 1; "The Moscone Sculpture," *San Francisco Chronicle*, 7 December 1981, p. 40. See also "Public Pans Art for Its Sake," *East Hampton Star*, 25 June 1987, pp. 1, 28; William E. Schmidt, "After Auspicious Beginnings, Public Art Finds Itself at Odds with the Public," *New York Times* (*NYT*), 2 November 1987, sec. A, p. 16.

2. Janet Malcolm, "Profiles: A Girl of the Zeitgeist, Part I," *New Yorker*, 20 October 1986, pp. 63–64.

3. See, for example, Grace Glueck, "Serra Work Stirs Downtown Protest," *NYT*, 25 October 1981, sec. C, p. 24; idem, "What Part Should the Public Play in Choosing Public Art?" *NYT*, 2 February 1985, sec. 2, pp. 1, 27; Douglas C. McGill, "Office Workers and Artists Debate Fate of a Sculpture," *NYT*, 7 March 1985, sec. B, p. 1; Arthur Danto, "Public Art and the General Will," *Nation*, 28 September 1985, p. 288; Calvin Tompkins, "Tilted Arc," *New Yorker*, 20 May 1985, pp. 95–101; Gary Indiana, "Debby with Monument: A Dissenting Opinion," *Village Voice*, 16 April 1985, pp. 93–94.

4. See, for example, Michael Gross, "Bergdorf's Party Toasts Pulitzer Fountain," *NYT*, 19 September 1986, sec. A, p. 26; "Across the street, Central Park, one of the world's great sculpture gardens," advertisement for Trump Parc, *NYT*, 25 June 1987, sec. A, p. 28; David W. Dunlap, "Adopt-a-Monument Program Takes in 13 Statues in New York City," *NYT*, 4 November 1987, sec. B, p. 3.

5. Wayne Craven, *Sculpture in America* (1968; rev. ed., Newark: University of Delaware Press, 1984), is the basic survey text of American sculpture. Major monographs and catalogs include James M. Dennis, *Karl Bitter: Architectural Sculptor, 1867–1915* (Madison: University of Wisconsin Press, 1967); Michael T. Richman, *Daniel Chester French: An American Sculptor* (New York: Metropolitan Museum of Art, 1976); Hudson River Museum, *The Sculpture of Isidore Konti* (New York: Hudson River Museum, 1975); John Dryfhout, *The Work of Augustus Saint-Gaudens* (Hanover, N.H.: University Press of New

England, 1982); Lewis I. Sharp, *John Quincy Adams Ward: Dean of American Sculpture* (Newark: University of Delaware Press, 1985). Fairmount Park Art Association, *Sculpture of a City: Philadelphia's Treasures in Bronze and Stone* (New York: Walker Publications, 1976), covers the public sculpture of a single city. Lewis I. Sharp, *New York City Public Sculpture by Nineteenth Century American Artists* (New York: Metropolitan Museum of Art, 1974), and Joseph Lederer, *All Around the Town: A Walking Guide to Outdoor Sculpture in New York City* (New York: Charles Scribner's Sons, 1975), provide capsule histories of a few select works. More recently, John Tauranac, *Elegant New York* (New York: Abbeville Press, 1985) has provided informative discussions of the histories of several of Manhattan's important statues, monuments, and architectural sculptures. Stephen Jacoby and Clay Lancaster, *Architectural Sculpture in New York City* (New York: Dover Publications, 1975) and Frederick Fried and Edmund V. Gillon, Jr., *New York Civic Sculpture. A Pictorial Guide* (New York: Dover Publications, 1976), are helpful pictorial sources. Margot Gayle and Michele Cohen, *The Art Commission and Municipal Art Society Guide of Manhattan's Outdoor Sculpture* (New York: Prentice Hall, 1988) is the most comprehensive guidebook.

6. Important studies include Daniel Robbins, "Statues to Sculpture: From the Nineties to the Thirties," in *200 Years of American Sculpture* (New York: David R. Godine and Whitney Museum of American Art, 1976), pp. 114–159; George Gurney, *Sculpture and the Federal Triangle* (Washington, D.C.: Smithsonian Institution Press, 1985); Timothy J. Garvey, *Public Sculptor: Lorado Taft and the Beautification of Chicago* (Champaign: University of Illinois Press, 1988); Vivien Green Fryd, "The Sculpture for the Capitol: Horatio Greenough's *Rescue* and Luigi Persico's *Discovery of America*," *American Art Journal* 19, no. 2 (1987): 16–39; idem, "Hiram Powers's *America*: 'Triumphant as Liberty and in Unity,'" *American Art Journal* 18, no. 2 (1986): 55–75.

7. See, for example, James Sloan Allen, *The Romance of Commerce and Culture* (Chicago: University of Chicago Press, 1983); Peter Dobkin Hall, *The Organization of American Culture, 1700–1900: Private Institutions, Elites, and the Origins of American Nationality* (New York: New York University Press, 1982); Robert E. Kohler, *From Medical Chemistry to Biochemistry: The Making of a Biomedical Discipline* (Cambridge: Cambridge University Press, 1982); Douglas Sloan, "Science in New York City, 1867–1907," *Isis* 71 (March 1980): 35–76; Thomas Bender, "The Cultures of Intellectual Life: The City and the Professions," in John Higham and Paul Conkin, eds., *New Directions in American Intellectual History* (Baltimore and London: Johns Hopkins University Press, 1979); Charles Rosenberg, "Towards an Ecology of Knowledge: On Discipline, Context, and History," Laurence Vesey, "The Plural Organized World of the Humanities," and Neil Harris, "Lamp of Learning," all in Alexandra Oleson and John Voss, eds., *The Organization of Knowledge in Modern America, 1860–1920* (Baltimore: Johns Hopkins University Press, 1979).

8. Kohler, *Medical Chemistry*, p. 2.

9. Robert H. Wiebe, *The Search for Order, 1877–1920* (New York: Hill and Wang, 1967).

10. Elites in New York cannot be defined as one single category. Historian David Hammack, for example, has divided social and economic elites into overlapping subgroupings based upon ethnicity, religion, wealth, and ancestry and culture. These groups would control "a very large proportion of Greater New York's wealth, prestige, cultural symbols, information, and other resources." David C. Hammack, *Power and Society: Greater New York at the Turn of the Century* (New York: Russell Sage Foundation, 1982), pp. 59; 65–79.

The elites discussed in this book—men such as Charles De Kay, Seth Low, and John DeWitt Warner—cut across a range of social, economic, and religious categories. Generally speaking, they were comfortably well-off, educated, genteel men, active as professionals in such fields as art, architecture, business, law, literature, politics, philanthropy, and theater. They shared a strong commitment to the public good, and saw themselves as uniquely qualified both to set the standards for that good and to implement change. Many of these men established social and professional ties through participation in civic organizations and exclusive clubs, such as the Century Association.

11. Paul Boyer, *Urban Masses and Moral Order in America, 1820–1920* (Cambridge: Harvard University Press, 1978), p. 179. On public culture, see Thomas Bender, "Wholes and Parts: The Need for Synthesis in American History," *Journal of American History* 73, no. 1 (June 1986): 126.

12. For discussion of advertisements as mirrors or distortions of American society, see Roland C. Marchand, *Advertising the American Dream: Making Way for Modernity, 1920–1940* (Berkeley: University of California Press, 1985), pp. xviii–xix, 164–167.

13. As a result of its broader alliances and involvement in civic activities during this period, the National Sculpture Society was in a position to market members' works through stores and exhibitions. Yet the society was unable to sustain its efforts to popularize small bronzes and garden sculptures, once broad support for public sculpture had diminished. See Michele H. Bogart, "American Garden Sculpture: A New Perspective," in Parrish Art Museum, *Fauns and Fountains: American Garden Statuary, 1890–1930* (Southampton, New York: Parrish Art Museum, 1985); Robbins, "Statues to Sculpture," pp. 115–117.

14. See, for example, Manrique Zago et al., *Buenos Aires y sus esculturas* (Buenos Aires: Manrique Zago Ediciones, 1981); Myriam Acevedo, *Marco Tobón Mejía* (Bogotá: Museo de Arte Moderno de Bogotá, 1986); Grand Palais, *La Sculpture Française du XIXème siècle* (Paris: Éditions de la Réunion des Musées Nationaux, 1986).

Chapter One

1. For information about American art patronage and about the early history of American sculpture, see Wayne Craven, "The Origins of Sculpture in America, Philadelphia 1785–1830," *American Art Journal* 9, no. 2 (November 1977): 4–34; Alan Wallach, "Thomas Cole and the Aristocracy," *Arts* 56, no. 3 (November 1981): 94–106; Neil Harris, *The Artist in American Society: The Formative Years, 1790–1860* (New York: Simon and Schuster, 1966), esp. pp. 88–122; 254–282; Michael E. Shapiro, "The Development

of American Bronze Foundries, 1850–1900" (Ph.D. dissertation, Harvard University, 1980).

2. Lorado Taft, *The History of American Sculpture* (1903; rev. ed., New York: Macmillan Co., 1924), pp. 3–4, 6–8; Wayne Craven, *Sculpture in America* (New York: Thomas Crowell, 1968), pp. 1–4, 55–58, 100–144; Albert TenEyck Gardner, *Yankee Stonecutters: The First American School of Sculpture, 1800–1850* (New York: Columbia University Press, 1945), pp. 7, 20, 44–51; Lillian Miller, *Patrons and Patriotism: The Encouragement of the Fine Arts in the United States, 1790–1860* (Chicago: University of Chicago Press, 1966), pp. 58–65; Jean Fagan Yellin, "Caps and Chains: Hiram Powers' Statue of 'Liberty,'" *American Quarterly* 38, no. 5 (Winter 1986): 798–826.

3. For discussion of the statue, see Craven, *Sculpture in America* (1968 ed.), pp. 151–153; Agnes Miller, "Centenary of a New York Statue," *New York History* 38 (April 1957): 167–176.

4. Frederick Law Olmsted to Richard Grant White, 23 July n.d., Richard Grant White papers, New-York Historical Society (NYHS); Frederic E. Church, Calvert Vaux, and Andrew H. Green, "Report of the Committee on Statues in the Park," in Frederick Law Olmsted, Jr. and Theodora Kimball, *Forty Years of Landscape Architecture*, 2 vols. (New York: G. P. Putnam's Sons, 1922–1926; Cambridge, Mass., and London: MIT Press, 1973), 1:491–492; Francis R. Kowsky, "The Central Park Gateways: Harbingers of French Urbanism Confront the American Landscape Tradition," in Susan R. Stein, ed., *The Architecture of Richard Morris Hunt* (Chicago: University of Chicago Press, 1986), pp. 79–89; David Schuyler, *The New Urban Landscape: The Redefinition of City Form in Nineteenth Century America* (Baltimore: Johns Hopkins University Press, 1986), pp. 92–100, 197 n. 8.

5. See Monumental Bronze Company, *White Bronze Monuments, Statuary, Busts, Statues, and Ornamental Art Work* (Bridgeport, Conn.: n.p., 1882); Marianne Doezema and June Hargrove, *The Public Monument and Its Audience* (Cleveland: Cleveland Museum of Art, 1977), pp. 33–34; [Charles Eliot Norton], "Something about Monuments," *Nation*, 3 August 1865, pp. 154–157. The popular prototypes were Randolph Rogers's *Sentinel*, commissioned in 1863 for Cincinnati's Spring Grove Cemetery, and Martin Milmore's *Soldiers' Monument* in Forest Hill Cemetery in Roxbury, Massachusetts.

6. See comments of Theodore Dreiser, "The Foremost of American Sculptors," *The New Voice*, 17 June 1899, p. 4.

7. On Ward's art and career, see Lewis I. Sharp, *John Quincy Adams Ward: Dean of American Sculptors* (Newark: University of Delaware Press, 1985).

8. Ward's *Seventh Regiment Memorial* for Central Park (done in collaboration with Richard Morris Hunt, who designed the pedestals) was a notable departure from the crudely modeled popular lead and granite figures. His other New York statues included *Shakespeare* (1870); *The Pilgrim* (1884) for Central Park; *George Washington* (1883) in front of the Subtreasury Building at Wall and Nassau streets; *William Earl Dodge* (1885) in Bryant Park; *Memorial to Alexander Lyman Holley* (1889) in Washington Square Park; *Horace Greeley* (1890), now in City Hall Park; *Henry Ward Beecher* (1891), now in Cad-

man Plaza in Brooklyn. See Sharp, *John Quincy Adams Ward*, pp. 44–47; cat. no. 38, pp. 165–166; 172–181; 209–212; 215–218; 230–235; 237–241. Among the patrons of *Indian Hunter* were Metropolitan Museum president Henry G. Marquand, painter John F. Kensett, and Congressman and Central Park Commissioner Henry G. Stebbins.

9. Warner was killed in an accident in 1896. On his work and career, see George Gurney, "Olin Levi Warner: A Catalogue Raisonne of His Sculpture and Graphic Works," 3 vols. (Ph.D. dissertation, University of Delaware, 1978.)

10. On the relationship between technique and personality, see Charles Caffin, *American Masters of Sculpture* (New York: Doubleday, Page, and Co., 1903), pp. x, 3; Detroit Institute of Arts, *The Quest for Unity: American Art between World's Fairs 1876–1893* (Detroit: Detroit Institute of Arts, 1983), pp. 156, 162. Anne Middleton Wagner, *Jean Baptiste Carpeaux: Sculptor of the Second Empire* (New Haven and London: Yale University Press, 1986), pp. 63–108, provides the most thorough account of French sculptors' training to date. See also Albert Boime, "The Teaching Reforms of 1863 and the Origins of Modernism in France," *Art Quarterly*, n.s., 1, no. 1 (Autumn 1977): 1–39; H. Barbara Weinberg, "Nineteenth Century American Painters at the Ecole des Beaux-Arts," *American Art Journal* 13, no. 4 (Autumn 1981): 66–70; idem, *The American Pupils of Gerôme* (Fort Worth: Amon Carter Museum, 1984), pp. 1–5; Alexis Lemaistre, *L'Ecole des Beaux-Arts dessinée et raconté par un elève* (Paris: Firmin-Didot, 1889), pp. 78–86, 375–82; Charles Garnier, *A Travers les Arts* (Paris: Hachette, 1869), pp. 184–186; Homer Saint-Gaudens, *The Reminiscences of Augustus Saint-Gaudens* (New York: The Century Co., 1913), 1:17.

11. Taft, *History of American Sculpture*, pp. 23, 256. Similar statements were made by Adeline Adams, *The Spirit of American Sculpture* (New York: National Sculpture Society, 1923), p. 89; and Caffin, *American Masters of Sculpture*, pp. v, vii–ix.

12. On Paris, see David Pinckney, *Napoleon III and the Rebuilding of Paris* (Princeton: Princeton University Press, 1958).

13. On the significance of such values in France, see Paul Tucker, "The First Exhibition, 1874," in Fine Arts Museum of San Francisco, *The New Painting* (San Francisco: H. F. de Young Memorial Museum, 1986), pp. 96–101. By 1874 Bartholdi also became known to Americans through his widespread travels and his reliefs for Henry Hobson Richardson's Brattle Street Church in Boston. On Bartholdi and *Liberty*, see essays in Pierre Provoyeur, June Hargrove, et al., *Liberty: The French-American Statue in Art and History* (New York: Harper and Row, 1986).

14. Marvin Trachtenberg, *The Statue of Liberty* (1976; rev. ed., New York: Penguin Books, 1986), pp. 30, 40.

15. Karl Bitter was one of the few who made known his opinions of the *Statue of Liberty*, writing in 1898:

Bartholdi's Statue of Liberty might be taken to so express the grandeur of this city as well as the spirit of our country, were it only placed in a more advantageous position where even so external a merit as its mere size could be sufficiently realized and appreciated. The enormous proportions of the port, however, prevent this, and, as seen from the city, the

effect of this work of art is largely lost. To fulfill its artistic purpose the statue should either be three times larger or nearer to a point from which it can be seen to advantage.

Bitter had an ulterior motive: that of pointing to the need for expert (sculptors') opinion in commissioning and placing works of sculpture. Karl Bitter, "Municipal Sculpture," *Municipal Affairs* 2, no. 1 (March 1898): 79–80.

16. June Hargrove, "The American Fund-Raising Campaign," in Provoyeur, et al., *Liberty*, p. 159.

17. Trachtenberg, *Statue of Liberty*, pp. 172–188.

18. This notion is discussed most explicitly in Peter Dobkin Hall, *The Organization of American Culture, 1700–1900: Private Institutions, Elites, and the Origins of American Nationality* (New York: New York University Press, 1982), pp. 214–251. For further discussion of the emphasis on national unity and related interpretations of the ideals of the American Revolution, see George Frederickson, *The Inner Civil War: Northern Intellectuals and the Crisis of the Union* (New York: Harper and Row, 1965), pp. 217–221; Michael Kammen, *Season of Youth: The American Revolution and the Historical Imagination* (New York: Albert Knopf, 1978), pp. 59–86; George Forgie, *Patricide in the House Divided* (New York: W. W. Norton, 1979); Brooklyn Museum, *American Renaissance 1876–1917* (New York: Pantheon Books, 1979).

19. This issue has been developed thoroughly in relation to a broad spectrum of fine and decorative arts in Alan Axelrod, ed., *The Colonial Revival in America* (New York: W. W. Norton, 1985). See especially Mardges Bacon, "Toward a National Style of Architecture: The Beaux-Arts Interpretation of the Colonial Revival," pp. 91–120; Celia Betsky, "Inside the Past: The Interior and the Colonial Revival in American Art and Literature, 1860–1914," pp. 241–277; and William B. Rhoads, "The Colonial Revival and the Americanization of Immigrants," pp. 341–361.

20. Taft, *History of American Sculpture*, p. 216.

21. See Layton Crippen, "Unsightly New York Statues," *NYT Magazine*, 7 May 1899, p. 4; Timothy J. Garvey, *Public Sculptor: Lorado Taft and the Beautification of Chicago* (Champaign: University of Illinois Press, 1988), Chapter 3.

22. See essays on Hunt in Stein, *Richard Morris Hunt*.

23. Biographies of these architects include Charles Moore, *The Life and Times of Charles Follen McKim* (1929; reprinted, New York: Da Capo Press, 1970); and Charles C. Baldwin, *Stanford White* (1931; reprinted, New York: Da Capo Press, 1976). Monographs include Leland Roth, *McKim, Mead, and White* (New York: Harper and Row, 1983); Richard Guy Wilson, *McKim, Mead, and White, Architects* (New York: Rizzoli, 1983). See also Wayne Andrews, *Architecture, Ambitions, and Americans* (New York: Harper and Brothers, 1955), pp. 152–204. For discussion of the relationships behind the creation of one major commission, see Mosette Glaser Broderick and William C. Shopsin, *The Villard Houses: Life Story of a Landmark* (New York: Viking Press, 1980), pp. 21–54.

24. Moore, *Life of McKim*, p. 57.

25. The architects did not consider republicanism and the aspirations to empire connoted by such imagery to be mutually exclusive. Richard Guy Wilson, "The Presence of the Past," in Brooklyn Museum, *American Renaissance*, pp. 38–45; Bacon, "Toward a National Style," pp. 91–120.

26. Moore, *Life of McKim*, p. 69. On the ideal of collaboration as a function of expansion of the architectural profession, see Joan Draper, "The Ecole des Beaux-Arts and the Architectural Profession in the United States: The Case of John Galen Howard," in Spiro Kostof, ed., *The Architect: Chapters in the History of the Profession* (New York: Oxford University Press, 1977), pp. 215–216, 225; Charles Moore, *Daniel Burnham: Architect, Planner of Cities* (Boston: Houghton Mifflin Co., 1921); Gwendolyn Wright, *Moralism and the Model Home: Domestic Culture and Cultural Conflict in Chicago, 1873–1913* (Chicago: University of Chicago Press, 1980), pp. 202–203, 212–217.

27. Saint-Gaudens, *Reminiscences*, 1:120–127, 133.

28. Louise Hall Tharp, *Saint-Gaudens and the Gilded Era* (Boston: Little, Brown, 1969), pp. 101–102; Broderick and Shopsin, *Villard Houses*, pp. 33–35; H. Barbara Weinberg, "John La Farge: Pioneer of the American Mural Movement," in *John La Farge* (New York: Abbeville Press, 1987), pp. 163–171; idem, "John La Farge and the Decoration of Trinity Church," *Journal of the Society of Architectural Historians* 33, no. 4 (December 1974): 328–329.

29. The complex history of Saint-Gaudens's creation of this monument is detailed in Lois Goldreich Marcus, "Studies in Nineteenth Century Sculpture: Augustus Saint-Gaudens (1848–1907)" (Ph.D. dissertation, City University of New York, 1979), pp. 35–75; Tharp, *Saint-Gaudens and the Gilded Era*, pp. 102–103, 106; Saint-Gaudens, *Reminiscences*, 1:162–163; Kathryn Greenthal, *Augustus Saint-Gaudens: Master Sculptor* (New York: Metropolitan Museum of Art, 1985), p. 91.

30. See John Wilmerding's introduction in John Dryfhout, *The Work of Augustus Saint-Gaudens* (Hanover: The University Press of New England, 1982), pp. x–xii; M. G. Van Rensselaer, "Mr. Saint-Gaudens' Statue of Admiral Farragut in New York," *American Architect and Building News*, 10 September 1881, pp. 119–120; Saint-Gaudens, *Reminiscences*, 2:266.

31. Richard Watson Gilder, "The Farragut Monument," *Scribner's Magazine* 22, no. 2 (June 1881): 161–167.

32. Caffin, *American Masters of Sculpture*, p. viii; see also Michael Kammen, *Season of Youth*, p. 83.

33. See entire file of correspondence in *Washington Arch* file, Old Mixed Files I and 205 II, McKim, Mead, and White archive, NYHS. For contemporary discussions and responses to MacMonnies's work for the *Soldiers' and Sailors' Arch*, see MacMonnies scrapbook, reel D245, fr. 30–54, AAA.

34. See Wilson, "The Presence of the Past," p. 41; Michael T. Richman, *Daniel Chester French: An American Sculptor* (New York: Metropolitan Museum of Art, 1976), pp. 43–44.

35. By the first decade of the twentieth century French was also a man of considerable

wealth. In 1904 he reported a net income of $55,241.76. In 1904, a full professor at a major university would make $5,000 a year. See Annual Statement, French Family papers (FFP), reel 22, fr. 663 (box 28), Library of Congress Manuscript Division, Washington, D.C. (LCMD).

It should be noted that sculptors generally earned much less money than what the amounts listed on their contracts would seem to indicate. These sums did not take into account sculptors' enormous expenditures. Sculptors often had to pay the carving companies directly. As George Gurney has noted, the artist also had to pay studio assistants, enlargers, plaster casters, life models, photographers, storage companies, and packing and shipping companies. He also had the cost of his materials, insurance, and inspection trips to worry about. See George Gurney, *Sculpture and the Federal Triangle* (Washington: Smithsonian Institution Press, 1985), p. 79.

36. The earlier German sculptors included Henry Baerer (born in 1837 in Hesse-Cassel) and Ernst Plassman (born in 1823 in Cologne). The late–nineteenth century generation included Karl Bitter (1867–1915), born in Rudolphsheim, Austria; Isidore Konti (1862–1938), born in Vienna, Adolph Weinman (1870–1952), born in Karlsruhe; Carl Heber (1874/5?–1956), born in Stuttgart; Albert Jaegers (1868–1925), born in Elbersfeld; and Frederick G. R. Roth (1872–1944), born in Brooklyn, but whose parents returned to Germany when he was two years old.

37. For information on some of these artists, see Beatrice Gilman Proske, *Brookgreen Gardens Sculpture* (Brookgreen Gardens, S.C.: Brookgreen Gardens, 1968), pp. 94–97; 120–125; 165–168.

38. Salary equivalents are calculated on the basis of Consumer Price Indexes (series E 135–166) in U.S. Bureau of the Census, *Historical Statistics of the United States, Colonial Times to 1970* (Washington, D.C.: Government Printing Office, 1975), pp. 210–211; and "Consumer Price Indexes by Major Groups: 1950–1984," in U.S. Bureau of the Census, *Statistical Abstract of the United States, 1986* (Washington, D.C.: Government Printing Office, 1985), table 795, p. 477.

39. On Bitter's early career, see James M. Dennis, *Karl Bitter: Architectural Sculptor, 1867–1915* (Madison: University of Wisconsin Press, 1967), pp. 15–36; Ferdinand Schevill, *Karl Bitter: A Biography* (Chicago: University of Chicago Press, 1917), pp. 7–24. See also Lewis I. Sharp, "Richard Morris Hunt and His Influence on American Beaux-Arts Sculpture," in Stein, *Richard Morris Hunt*, pp. 144–145.

40. Caffin, *American Masters of Sculpture*, pp. 204–205; Adeline Adams, *Spirit of American Sculpture*, pp. 113, 119; Joseph Walker McSpadden, *Famous Sculptors of America* (New York: Dodd, Mead, and Co., 1924); Taft, *History of American Sculpture*, pp. 456–461.

41. Moore, *Daniel Burnham*, p. 59. Four important recent discussions of the fair are David Burg, *Chicago's White City of 1893* (Lexington: University Press of Kentucky, 1976); Reid Badger, *The Great American Fair: The World's Columbian Exposition and American Culture* (Chicago: Nelson Hall, 1977); Alan Trachtenberg, *The Incorporation*

of America: Culture and Society in the Gilded Age (New York: Hill and Wang, 1982), pp. 220–230; Stanley Applebaum, _The Chicago World's Fair of 1893: A Photographic Record_ (New York: Dover Publications, 1980). See also Detroit Institute of Arts, _Quest for Unity_; James B. Campbell, _Campbell's Illustrated History of the World's Columbian Exposition_ (Chicago: James B. Campbell, 1893); Hugh Howard Bancroft, _The Book of the Fair_ (Chicago: Bancroft Co., 1893); Rossiter Johnson, ed., _A History of the World's Columbian Exposition_ (New York: D. Appelton, 1897).

42. Peter Dobkin Hall has discussed the late nineteenth century emphasis on vesting authority in the hands of an elite in _Organization of American Culture_, pp. 240–281. See also Burg, _Chicago's White City_, pp. 75–114; Badger, _Great American Fair_, pp. 113–129; Matthew Arnold, _Culture and Anarchy_ (1869; New York: Bobbs Merrill, 1971), p. 56. Richard Guy Wilson, "Conditions of Culture," in Brooklyn Museum, _American Renaissance_, pp. 27–37; Kermit Vanderbilt, _Charles Eliot Norton: Apostle of Culture in a Democracy_ (Cambridge: Harvard University Press, 1959), p. 3; Howard Mumford Jones, _The Age of Energy_ (New York: Viking Press, 1979), pp. 240–241.

43. Wilson, "Presence of the Past," pp. 39–57; Moore, _Daniel Burnham_, p. 47; Campbell, _Illustrated History_, p. 480; Frank D. Millet, "The Decoration of the White City," _Scribner's Magazine_ 12, no. 6 (December 1892): 692–709.

44. Daniel Burnham to Augustus Saint-Gaudens, 3 February 1891, 13 February 1891, 29 April 1891, 22 June 1891, in Augustus Saint-Gaudens correspondence, 1891–1913, LCMD; Burg, _Chicago's White City_, pp. 114–157; James L. Reidy, _Chicago Sculpture_ (Urbana: University of Illinois Press, 1981), pp. 22–40; J. H. Gest, "Sculptors of the World's Fair," _Engineering_ 5, no. 4 (July 1893): 409; William A. Coffin, "The Columbian Exposition 3: Fine Arts: Pictures by American Artists, Sculpture and Pictorial Decoration," _Nation_, 17 August 1893, p. 115.

45. Burg, _Chicago's White City_, pp. 120, 151–152; H. C. Bunner, "The Making of the White City," _Scribner's Magazine_ 12, no. 4 (October 1892): 398–417; "Editor's Study," _Harper's New Monthly Magazine_ 86, no. 513 (February 1893): 478–79; Dennis, _Karl Bitter_, p. 46.

46. In 1898 and 1900, 4 percent of the sculptor members of the National Sculpture Society were women; this figure rose to 10 percent in 1910, and to 19 percent in 1924. However, during this same period, only three women received commissions for public sculpture for New York City. Of these, only two were commissions to be installed on municipal property: Janet Scudder's _Japanese Art_ (1907) for the Brooklyn Institute of Arts and Sciences, and Anna Hyatt Huntington's _Joan of Arc_ (1915) for Riverside Drive at 93rd Street. The third sculptor, Evelyn Beatrice Longman, a protégé of French, won a competition sponsored by the American Telephone and Telegraph Company to create a statue for the top of its new building (see Chapter 14). See May Brawley Hill, _The Woman Sculptor: Malvina Hoffman and Her Contemporaries_ (New York: Berry-Hill Galleries, 1984), pp. 8–9; "Art as an Educational Force and as a Source of Wealth," pamphlet, ca. 1900; _Catalogue of the Second Annual Exhibition of the National Sculpture Society, 1895_; _Catalogue_

of the Third Annual Exhibition of the National Sculpture Society, 1898; "National Sculpture Society, Fine Arts Building," pamphlet, 1910; all in National Sculpture Society Papers (hereafter cited as NSS Papers), reel 490, fr. 262–263, 275, 334–335, 435–437, Archives of American Art (AAA); National Sculpture Society, *Contemporary American Sculpture, California Legion of Honor* (New York: National Sculpture Society, 1924), pp. xii–xiii. See also Michele H. Bogart, "American Garden Sculpture: A New Perspective," in Parrish Art Museum, *Fauns and Fountains, American Garden Statuary, 1890–1930* (Southampton, N.Y.: The Parrish Art Museum, 1985), n.p.; Janis C. Conner, "American Women Sculptors Break the Mold," *Art and Antiques* 3 (May–June 1980): 80–87. On separate spheres, see Rosalind Rosenberg, *Beyond Separate Spheres: Intellectual Roots of Modern Feminism* (New Haven: Yale University Press, 1982), pp. 13–22.

47. See Hill, *Woman Sculptor*, pp. 11–12; Jeanne Weimann, *The Fair Women* (Chicago: Academy Chicago, 1981), pp. 158–167.

48. According to his contract of 27 July 1891, French received $8,000 for this work. The cost of gilding was $2,413. See Daniel Burnham, *Final Report of the Director of Works of the World's Columbian Exposition* (1894), 4:7, Ryerson Library of Architecture, Art Institute of Chicago. For one response to *Republic*, see Gest, "Sculptors of the World's Fair," p. 436.

49. John J. Boyle's rectangular panels and semicircular tympanum for Louis H. Sullivan's Transportation Building glorified the evolution of transportation from the primitive litter, "an emblem of the poorest method of travel," to the modern ocean steamship, the locomotive, and the electric motor, "the acme of comfort and speed." Burnham, *Final Report* 4:7; Karal Ann Marling, *The Colossus of Roads: Myth and Symbol along the American Highway* (Minneapolis: University of Minnesota Press, 1984), pp. 19–25; Robert W. Rydell, *All the World's a Fair: Visions of Empire at American International Expositions, 1876–1916* (Chicago: University of Chicago Press, 1984), pp. 38–71.

50. Moore, *Life of McKim*, p. 119.

51. Burg, *Chicago's White City*, pp. 287–296; Gest, "Sculptors of the World's Fair," p. 409; Montgomery Schuyler, "Last Word about the World's Fair," *Architectural Record* 3, no. 3 (January–March 1894): 292; Adeline Adams, *Spirit of American Sculpture*, p. 99.

52. Burg, *Chicago's White City*, p. 298; Millet, "Decoration of the White City," p. 694; Adeline Adams, *Spirit of American Sculpture*, p. 90; Will H. Low, "The Art of the White City," *Scribner's Magazine* 14, no. 4 (October 1893): 504–512; Henry Adams, *The Education of Henry Adams* (1907; New York: Modern Library, 1946), p. 343.

53. Gest, "Sculptors of the World's Fair," p. 432. See also "The Decorative Sculpture at the Fair and Its Preservation," *Dial* 15 (November 1893): 255; William A. Coffin, "The Columbian Exposition 1: Fine Arts: French and American Sculpture," *Nation*, 3 August 1893, pp. 79–81; Montgomery Schuyler, "Last Word," pp. 296–299.

Chapter Two

1. Lois Marie Fink and Joshua C. Taylor, *Academy: The Academic Tradition in American Art* (Washington, D.C.: Smithsonian Institution Press, 1975), pp. 79–83. Augustus

Saint-Gaudens, Walter Shirlaw, Wyatt Eaton, and Helena De Kay (painter and sister of Charles De Kay) founded the group.

2. "Art as an Educational Force and a Source of Wealth," pamphlet, ca. 1900, NSS Papers, reel 490, fr. 251–254, AAA.

3. Frederick Ruckstull, "Origin and Early History of the National Sculpture Society," 1929, pp. 1–6, NSS, New York City.

4. On De Kay, see *National Cyclopedia of American Biography* (New York: James T. White, 1899), 9:206.

5. Ruckstull, "Origin and Early History," pp. 5–7.

6. Ibid., p. 8.

7. See appendices in Harvey A. Kantor, "Modern Urban Planning in New York City: Origins and Evolution, 1890–1933" (Ph.D. dissertation, New York University, 1971), for lists of members of the Municipal Art Society and the Fine Arts Federation during these years.

8. Members included Herbert Adams, Thomas Ball, George Grey Barnard, Paul Wayland Bartlett, George Bissell, John J. Boyle, Richard Brooks, George Brewster, Henry Kirke Bush-Brown, Alexander Milne Calder, Thomas Shields Clarke, William Couper, John Flanagan, Daniel Chester French, J. Scott Hartley, Eli Harvey, Henry Hudson Kitson, Frederick MacMonnies, Hermon MacNeil, Frederick Moynihan, W. Clarke Noble, William Ordway Partridge, Edward Clark Potter, Bela Pratt, Douglas Tilden, Lorado Taft, Bessie Potter Vonnoh, and John Quincy Adams Ward. Of the forty-one sculptor members of the NSS in 1895, twenty-one were not New York residents. See "Art as an Educational Force," reel 490, fr. 262–263; *Catalogue of the Second Annual Exhibition of the National Sculpture Society, 1895*, NSS Papers, reel 490, fr. 275, AAA.

9. In 1898, for example, the membership roles of the NSS included Henry Baerer, Clement J. Barnhorn, Theodor Bauer, Karl Bitter, Robert P. Bringhurst, Gustave Gerlach, Louis A. Gudebrot, Charles F. Hamann, Albert Jaegers, Frederic C. Kaldenberg, Ephraim Keyser, Isidore Konti, Henry Linder, Herman Matzen, Charles H. Niehaus, Frederic G. R. Roth, Rudolf Schwarz, Maximillian Schwartzott, Carl E. Tefft, Frederick E. Triebel, and Adolph Weinman.

10. May Brawley Hill, *The Woman Sculptor: Malvina Hoffman and her Contemporaries* (New York: Berry-Hill Galleries, 1984), p. 9.

11. Ruckstull, "Origin and Early History," p. 6; National Sculpture Society, *Constitution*, NSS Papers, reel 489, fr. 1050; and "Art as an Educational Force," reel 490, fr. 251–254.

12. The definitive explanation of the people and processes involved in large architectural sculpture projects is found in George Gurney, *Sculpture and the Federal Triangle* (Washington, D.C.: Smithsonian Institution Press, 1985), esp. pp. 66–84. See also "John Donnelly, 80, Noted Stone Carver, Dies," *NYT*, 12 July 1947, p. 13.

13. Journeymen were craftsmen who had undergone five of years of apprenticeship in the shop and who were thus qualified for admission into a union. See NSS Minutes, 12 May 1914; letter from Thomas Lo Medico to the author, 7 November 1983.

14. Ruckstull, "Origin and Early History," p. 11.

15. Theodore Dreiser, *The "Genius"* (1915; New York: Boni and Liveright, 1923), p. 107.

16. T. Dreiser, "The Foremost of American Sculptors," *New Voice* (17 June 1899), clipping in the John Quincy Adams Ward scrapbook, p. 14, NYHS. See also Gutzon Borglum to J. Q. A. Ward, 12 April 1904, Karl Bitter to Charles Lamb, 11 June 1904, and F. Edwin Elwell to Lamb, 26 September 1900, all in the John Quincy Adams Ward letters, NYHS. Expressions of disdain for the sculptors and the society can be found in William O. Partridge, "A National Sculpture Society," *Forum* 35, no. 4 (June 1904): 624–634. See William O. Partridge, "American Art and the New Society of American Sculptors," *Arena* 32, no. 179 (October 1904): 345–351; idem, "A National Sculpture Society," *Monumental News* 16 (May 1904): 289.

17. Council members in 1893 were Richard Watson Gilder, Richard Morris Hunt, Stanford White, Thomas P. Clarke, Thomas Hastings, Charles De Kay, John Williams, W. C. Hall, James S. Inglis, and Russell Sturgis. By 1896 the number of sculptors on the council expanded to six, with eight nonsculptors. Ruckstull, "Origin and Early History," p. 9; National Sculpture Society, *Constitution*, NSS Papers, reel 489, fr. 1050, AAA. On Robert Ellin, see Metropolitan Museum of Art, *In Pursuit of Beauty: Americans and the Aesthetic Movement* (New York: Metropolitan Museum of Art and Rizzoli, 1986), p. 425.

The society listed 51 sculptor members and 195 lay members in 1898. Minutes for 1910 state that there were 96 professional sculptor members and 186 lay members. In 1923, there were 98 sculptor members, 29 associate sculptor members, 100 lay members, and 7 life members. In 1926, there were 102 professional members, 46 associate members, and 134 lay members. See *Catalogue of the Second Annual Exhibition*, p. 14, reel 490, fr. 275–276; *Catalogue of the Third Annual Exhibition of the National Sculpture Society, 1898*, NSS Papers, reel 490, fr. 334–335, AAA. Minutes of the National Sculpture Society, New York City (hereafter NSS Minutes), 12 April 1910, 8 May 1923, 11 May 1926.

18. Charles De Kay, "Organization among Artists," *International Monthly* 1 (1900): 89–93.

19. Ibid., pp. 89, 93.

20. On Warner, see *National Cyclopedia of American Biography*, 9:114.

21. Founded in 1881 and incorporated in 1888, the Architectural League of New York aimed to promote architecture "and allied fine arts." It sponsored yearly exhibitions and competitions and awarded honors. See Architectural League of New York, *Officers, Committees, Members, Constitution, By-Laws, and Catalog of Library, 1899–1900* (New York: The Knickerbocker Press, n.d.); Architectural League of New York, *Fourteenth Annual Exhibition, 1898* (New York, [Architectural League of New York], 1898).

22. Richard Guy Wilson, "Architecture, Landscape, and City Planning, in Brooklyn Museum, *American Renaissance 1876–1917* (New York: Pantheon Books, 1979), p. 88; Kantor, "Modern Urban Planning," pp. 64–67.

23. Kenneth T. Jackson, "The Capital of Capitalism: The New York Metropolitan Region, 1890–1910," in Anthony Sutcliffe, ed., *Metropolis, 1890–1940* (Chicago: Univer-

sity of Chicago Press, 1984), pp. 319–337; Art Institute of Chicago, *The Plan of Chicago* (Chicago: Art Institute of Chicago, 1979); Thomas S. Hines, *Burnham of Chicago* (New York: Oxford University Press, 1974), pp. 141–196.

24. Jonathan Scott Hartley, "Sculpture as an Architectural Ornament," *Public Improvements*, 15 November 1899, p. 1.

25. Karl Bitter, "Municipal Sculpture," *Municipal Affairs* 2, no. 1 (March 1898): 73–97; Henry Kirke Bush-Brown, "New York City Public Monuments," *Municipal Affairs* 3, no. 4 (December 1899): 602–616; Charles Mulford Robinson, *The Improvement of Towns and Cities; or, The Practical Basis of Civic Aesthetics* (New York: G.P. Putnam, 1901), pp. 196–199, 216–220; "Art as an Educational Force," fr. 256; Charles Mulford Robinson, "Improvement in Civic Life," *Atlantic Monthly* 83, no. 500 (June 1899): 772–785; Michele H. Bogart, "In Search of a United Front: American Architectural Sculpture at the Turn of the Century," *Winterthur Portfolio* 19 (Summer–Autumn 1984): 151–176.

26. On the City Beautiful, see George Kriehn, "The City Beautiful," *Municipal Affairs* 3, no. 4 (December 1899): 594–601; National Sculpture Society, "From Battery to Harlem: Suggestions of the National Sculpture Society," *Municipal Affairs* 3, no. 4 (December 1899): 616–650; Robinson, *Improvement of Towns and Cities*; Edwin H. Blashfield, "A Word for Municipal Art," *Municipal Affairs* 3, no. 4 (December 1899): 582–593; Daniel H. Burnham and Edward Bennett, *The Plan of Chicago* (Chicago: Commercial Club, 1909); Jon A. Peterson, "The City Beautiful Movement: Forgotten Origins and Lost Meanings," *Journal of Urban History* 2, no. 4 (August 1976): 415–435; Kantor, "Modern Urban Planning," pp. 33–64. Some other recent discussions include Anthony Sutcliffe, *Towards the Planned City: Germany, Britain, the United States, and France, 1780–1914* (New York: Saint Martin's Press, 1981); Wilson, "Architecture, Landscape, and City Planning," pp. 75–109. For discussion of Progressivism vis-à-vis city planning and civic reform, see Mario Maniera-Elia, "Toward an Imperial City: Daniel H. Burnham and the City Beautiful Movement," in Giorgio Ciucci, Francesco dal Co, Mario Maniera-Elia, Manfredo Tafuri, *The American City: From the Civil War to the New Deal*, trans. Barbara Luigia La Penta (Cambridge: MIT Press, 1979), pp. 1–242; Paul Boyer, *Urban Masses and Moral Order in America, 1820–1920* (Cambridge, Mass.: Harvard University Press, 1978), pp. 128, 161–256; Gwendolyn Wright, *Moralism and the Model Home: Domestic Culture and Cultural Conflict in Chicago, 1873–1913* (Chicago: University of Chicago Press, 1980), pp. 202–203, 212–217.

27. On the McMillan Plan, see Jon A. Peterson, "The Nation's First Comprehensive City Plan: A Political Analysis of the McMillan Plan for Washington, D.C., 1900–1902," *Journal of the American Planning Association* 51 (Spring 1985): 134–150; Kantor, "Modern Urban Planning," pp. 67–68; Gurney, *Sculpture and the Federal Triangle*, pp. 37–41.

28. For discussion of the complex distribution of power in New York, see David C. Hammack, *Power and Society: Greater New York at the Turn of the Century* (New York: The Russell Sage Foundation, 1982).

29. Bitter, "Municipal Sculpture," pp. 73–97; "From Battery to Harlem," pp. 616–

650; Reform Club, *Officers and Committees, Members, Constitutions, By-Laws, Rules* (New York: [Reform Club of New York], 1899), p. 155, cited in Kantor, "Modern Urban Planning," p. 59. *Municipal Affairs* became the forum for demands for moral, aesthetic, and political reforms, with articles and bibliographies on cross-cultural subjects that included mural decoration, municipal sculpture, artistic street furnishings, and transportation systems.

30. Kantor, "Modern Urban Planning," p. 38.

31. Early MAS members included J. Q. A. Ward, painters Howard Russell Butler, Edwin H. Blashfield, and Frederick Crowninshield, AIA president E. H. Kendall, financier Perry Belmont, and banker Cyrus J. Lawrence. See Kantor, "Modern Urban Planning," p. 34.

32. Ibid., pp. 35–36.

33. On the Hunt Memorial, see Michael T. Richman, *Daniel Chester French: An American Sculptor* (New York: Metropolitan Museum, 1976), pp. 83–89.

34. Kantor, "Modern Urban Planning," p. 40. Other members included Bitter, architects Charles McKim, Charles Lamb, George B. Post; painters John La Farge, Will Low; Columbia University president and soon-to-be mayor Seth Low; and forester Gifford Pinchot.

35. Ibid.; Harvey A. Kantor, "The City Beautiful in New York," *The New-York Historical Society Quarterly* 57, no. 2 (1973): 153.

36. Fine Arts Federation papers, reel 614, fr. 179, AAA.

37. Sculptors were not the only ones who seemed threatened by the number of monuments sponsored by foreigners and different ethnic groups. After the *Columbus* went up, the *New York Times* observed that Columbus Circle had become "a sort of Mecca," where "troops" of "swarthy sons of the Sunny South wander about the bit of marble, looking it over with the deepest interest." "New Shrine for Italians," *NYT*, 28 November 1892, p. 2; "The Columbus Monument," *NYT*, 20 March 1892, p. 11; "Columbus Memorials," *NYT*, 13 June 1892, p. 10; John Tauranac, *Elegant New York* (New York: Abbeville Press, 1985), pp. 147–148.

The Spanish-Americans (whose sculptor would have been Fernando Miranda) were fered a site at the isolated southern end of Mount Morris Park at 120th Street and Fifth Avenue. They refused "this second class place," and never executed the project. "The Columbus Fountain: Spanish Americans Particular about Its Location," *NYT*, 20 December 1892, p. 2; "The Columbus Fountain," *NYT*, 22 December 1892, p. 8.

38. Letter from the National Sculpture Society to the Board of Parks, 22 July 1895, NSS, New York City.

39. W. W. Spooner, "Heine and the Germans," *NYT*, 7 July 1895, p. 25.

40. Ibid.; "Close of Heine Fair," *NYT*, 25 November 1895, p. 5.

41. Ruckstull, "Origin and Early History," pp. 16–19; "The Heine Fountain Offered," *NYT*, 21 March 1895, p. 3.

42. "A Small Coterie of American Sculptors," *NYT*, 19 November 1895, p. 8; "The

Question of a Site," *NYT*, 24 March 1895, p. 5; "Reject Heine Memorial," *NYT*, 19 November 1895, p. 8.

43. "Reject Heine Memorial," *NYT*, 19 November 1895, p. 8; "The Question of a Site," *NYT*, 24 March 1895, p. 5.

44. "In the World of Art," *NYT*, 24 November 1895, p. 23; "Heine and the Germans," *NYT*, 7 July 1895, p. 25; "Reject Heine Memorial," *NYT*, 19 November 1895, p. 8; "A Small Circle of Sculptors," *NYT*, 19 November 1895, p. 8 (reprinted from the *New Yorker Staats-Zeitung* of the same date); Jacques Mayer, "The Heine Monument," *NYT*, 21 November 1895, p. 4.

45. "Another Heine Chapter," *NYT*, 26 January 1896, p. 11. In his "Origin and Early History," p. 18, written over twenty years later, Ruckstull cited the NSS decision as a "capital mistake." According to him, the monument was not in fact artistically unworthy and, moreover, that the NSS committee met only once. He thus confirmed retrospectively that the society's objections were primarily political, rather than aesthetic.

46. "Appeal for the Heine Fountain," *NYT*, 10 December 1895, p. 8.

47. Ibid; "The Offer Withdrawn," *NYT*, 13 December 1895, p. 9; "Withdrawal of the Heine Memorial," *NYT*, 14 December 1895, p. 4. An art correspondent for the *Times* responded with some criticisms of his own, but very likely these also expressed the views of some NSS members. "The figure of the Lamia of the Rhine is most conventional," he wrote. "There is no delicate feeling for proportion in the various parts of the fountain in their relation one to another. And as a whole, there is a certain meagerness in the entire composition which hardly suits the object for which it was composed." "Herter's Heine Fountain," *NYT*, 15 December 1895, p. 17.

48. "Another Heine Chapter," *NYT*, 26 January 1896, p. 11.

49. "The Offer Withdrawn," *NYT*, 13 December 1895, p. 9.

50. "Another Heine Chapter," *NYT*, 26 January 1896, p. 11; "Site for Heine Fountain," *NYT*, 29 April 1896, p. 5; "Heine Fountain's New Site," *NYT*, 25 May 1896, p. 8.

51. "Heine Lorelei Fountain," *NYT*, 2 July 1899, p. 12; "Heine Memorial Unveiled," *NYT*, 9 July 1900, p. 10.

52. On consolidation, see Hammack, *Power and Society*, pp. 185–229.

53. John M. Carrère, "The Art Commission of the City of New York and Its Origin," *New York Architect* 2, no. 3 (March 1908): 2.

54. On Low, see Gerald Kurland, *Seth Low: The Reformer in an Urban and Industrial Age* (New York: Twayne Publishers, 1971).

55. Kantor, "Modern Urban Planning," pp. 41–42. Hammack, *Power and Society*, addresses the issues of political alliances among New York elites.

56. If the mayor or the Board of Aldermen requested it, however, the commission would not have to approve structures costing $250,000 or less. Kantor, "Modern Urban Planning," p. 43; Carrère, "Art Commission," p. 3.

57. "Art in Memorial Form," *NYT*, 3 November 1895, p. 28.

58. Hammack, *Power and Society*, p. 72. See also *The Century 1847–1946* (New

York: Century Association, 1947), pp. 363–413, for membership lists. On sculptors' family backgrounds and club memberships, see articles in the *National Cyclopedia of American Biography*.

59. Kantor, "City Beautiful," pp. 149–171.

60. Appointees included the five borough presidents, lawyer Francis Key Pendleton, a friend and the former vice presidential running mate of McClellan's father; painter John White Alexander; Frank Bailey, vice president of Title Guarantee and Trust in Brooklyn; George A. Hearn of Mutual Life Insurance Company; Daniel S. Lamont, former Secretary of War under McKinley; William J. La Roche, an entrepreneur and former Democratic state senator; architect Whitney Warren; and wealthy businessman Harry Payne Whitney. Samuel Parsons, Jr., landscape architect for the Parks Department, and Nelson P. Lewis, chief engineer of bridges, were the technical staff that, according to Harvey Kantor, did most of the real work of planning. Kantor, "City Beautiful," pp. 158–160.

61. For the specifics of the report, see New York City Improvement Commission, *Report of the New York City Improvement Commission to the Honorable George B. McClellan and to the Honorable Board of Aldermen of the City of New York* (New York: Kalkoff Co., 1907); Robert A. M. Stern, Gregory Gilmartin, and John Montague Massengale, *New York 1900: Metropolitan Architecture and Urbanism, 1890–1915* (New York: Rizzoli, 1983), pp. 28–34; Kantor, "City Beautiful," pp. 162–166.

62. Kantor, "City Beautiful," pp. 170–171.

Chapter Three

1. Alexander B. Callow, Jr., *The Tweed Ring* (New York: Oxford University Press, 1966), pp. 197–206.

2. Thomas S. Hines, *Burnham of Chicago* (New York: Oxford University Press, 1974), p. 127.

3. This information on construction procedures comes from Paul Starrett, *Changing the Skyline: An Autobiography* (New York and London: Whittlesey House, 1938), pp. 172–177. Additional information on construction can be found in William Aiken Starrett, *Skyscrapers and the Men Who Build Them* (New York: Charles Scribner's Sons, 1928).

4. Architects of federal buildings continued to select sculptors directly until the Section of Fine Arts shifted procedures and held competitions during the last phase of construction of the Federal Triangle in Washington, D.C. See George Gurney, *Sculpture and the Federal Triangle* (Washington, D.C.: Smithsonian Institution Press, 1985), pp. 292–402.

5. Founded in 1789, Tammany Hall was the name of the local Democratic organization. During the 1840s Tammany successfully broadened suffrage and its own political power base by appealing to the masses of new immigrants. Through a system of patronage, it retained its working-class support on into the twentieth century. The name Tammany became equated with political corruption when, during the 1860s, "boss" William M. Tweed took control of the organization and systematically extorted money from the city and the state.

6. "The Hall of Records Statuary," *NYT*, 14 June 1903, p. 7. See also Chapters 6 and 8, on the U.S. Customs House and the Brooklyn Institute.

7. See Gurney, *Sculpture and the Federal Triangle*, pp. 66–84.

8. The Hall of Records (discussed in Chapter 7) exemplified the problems that arose when the contractor was in charge of the sculptor and stonecarvers. Another case, which occurred in the private sphere, was Gutzon Borglum's experience with his work for the Cathedral of Saint John the Divine. In 1905 the architects Heins and La Farge commissioned Borglum to create models for statues for the Kings and Saint Columbia chapels and for the exterior and interior of the Belmont Chapel, the first portions of the church to be completed. To his consternation, Borglum learned that the architects would not permit the works to be carved on the grounds under his direction. Instead, the contractor sent the models to a Hoboken stoneyard to be blocked out by stonecutters and finished with machinery, along with the rest of the stonework. The sculptor was so distraught by the shoddy results that he protested to the press, threatening to seek an injunction and to renounce his authorship of the sculptures if conditions were not improved. He won the sympathy of the press and the congregation; a sculpture studio was established on the cathedral grounds, and many of the figures were redone. See "Artist Disowns Cathedral Statues," *NYT*, 3 April 1907, p. 2; Robert J. Casey and Mary Borglum, *Give the Man Room* (New York: Bobbs Merrill, 1952), pp. 87–91. On the history of the cathedral, see Robert A. M. Stern, Gregory Gilmartin, and John Montague Massengale, *New York 1900: Metropolitan Architecture and Urbanism, 1890–1915* (New York: Rizzoli, 1983), pp. 396–402; Edward Hagaman, *A Guide to the Cathedral Church of Saint John the Divine* (New York: Dean and Chapter of Saint John the Divine, 1965).

9. By 1911, many commercial modelers belonged to a specialized New York affiliate of Local 60 of this union, called Modelers and Sculptors of America, about which little documentation remains. See NSS Minutes, 6 November 1912; see also lists of shops and locals in *Plasterer* 9, no. 3 (March 1915): 16, and 27, no. 1 (January 1933): 32.

The Journeymen Stone Cutters was organized in 1884. The *Handbook of American Trade-Unions* notes that in 1915 two rival New York organizations, the New York Stone Cutters' Society and the Architectural Sculptors and Carvers' Association of New York, merged with the Journeymen Stone Cutters, "which thus became the only organization in the trade with jurisdiction over carvers as well as cutters." See U.S. Department of Labor, Bureau of Labor Statistics, *Handbook of American Trade-Unions*, (Washington: Government Printing Office, 1929), pp. 45–46, 49–50. Attempts to locate further information on the Architectural Sculptors and Carvers' Association have been unsuccessful.

10. For example, Karl Bitter, when director of sculpture for the Saint Louis Louisiana Purchase Exposition, was confronted by a labor dispute over whether the sculptors should have the right to finish off and repair the plaster statues done for the exposition. See transcript of speech enclosed in letter from Karl Bitter to Marie S. Bitter, 24 October 1903, Karl Bitter papers, reel N70–8, fr. 79, AAA. See also Frederick W. Ruckstull to Cass Gilbert, 14 July 1904, Ruckstull file, U.S. Customs House, Cass Gilbert papers, New-York

Historical Society (hereafter cited as USCH); Nathaniel Ruggles Whitney, *Jurisdiction in American Building Trades Unions*, Johns Hopkins University Studies in Historical and Political Science Series 32, no. 1 (Baltimore: Johns Hopkins University Press, 1914), pp. 1–180.

11. Charles Caffin, *American Masters of Sculpture* (New York: Doubleday, Page, and Co., 1903), pp. 179–181.

12. On Swallowtails, see David C. Hammack, *Power and Society: Greater New York at the Turn of the Century* (New York: Russell Sage Foundation, 1982), pp. 110–111.

13. Henry Kirke Bush-Brown, "New York City Public Monuments," *Municipal Affairs* 3 (1899): 602.

14. Karl Bitter, "Municipal Sculpture," *Municipal Affairs* 2, no. 1(March 1898): 79–97; Jonathan Scott Hartley, "Sculpture as an Architectural Ornament," *Public Improvements*, 15 November 1899, p. 25.

15. Frederick Ruckstull complained about lack of municipal support in "Municipal Art from an American Point of View," *Craftsman* 7², no. 3 (December 1904): 239–262; for a somewhat more optimistic view see also Karl Bitter, "Municipal Sculpture," pp. 73–94.

16. NSS, "General Code Governing Competitions in Design of National Sculpture Society, Adopted February 28, 1898," NSS Papers, reel 489, fr. 159–160, AAA; Frederick Ruckstull, "Origin and Early History of the National Sculpture Society," 1929, NSS, New York, pp. 20–25. Additional information and debate can be found in the NSS Minutes for the following dates: 7 November 1906, 13 February 1912, 13 May 1913, 10 February 1914, 14 April 1914, 12 May 1914, 9 March 1915. See also "New York Sculpture News," *Monumental News* 20 (June 1908): 441.

17. NSS, "General Code Governing Competitions in Design," fr. 159–160; NSS Minutes, 12 February 1912.

18. Ruckstull in his memoir referred to the Hahnemann monument incident in Washington, D.C., to indicate how divisive such competitions could be. Ruckstull, "Origin and Early History," pp. 20–25.

19. See, for example, Augustus Saint-Gaudens to Adolph Weinman, 6 May 1906 and 19 May 1906, Adolph Weinman papers, reel 283, AAA; Saint-Gaudens to Daniel Burnham, 19 October 1904, Augustus Saint-Gaudens papers, LCMD; Daniel Chester French to Henry F. Hollis, 6 December 1901, FFP, reel 1; French to R. Ross Appleton, 13 February 1914, FFP, reel 2; French to E. R. Harlan, 3 October 1914, FFP, reel 2.

20. Miranda, for example, protested the fact that Saint-Gaudens and French were called in to suggest sculptors for the decoration of the State Supreme Court, First Appellate Division. "There are several men who together assume the functions of a national art tribunal, and too often arrogantly pose as arbiters in both local and national affairs. I wish the architects and public could escape from their influence. It would further the interests of art." See "Sculptors Ask Competitions," *NYT*, 17 February 1897, p. 1.

21. These practices included making both small-size sketches (known as *bozzetti* or *maquettes*) and more finished quarter- and half-scale models. For discussion of sculptors' techniques, see Rudolph Wittkower, *Sculpture: Processes and Principles* (New York: Har-

per and Row, 1977), pp. 189–230; H. W. Janson's explanations in Janson and Robert Rosenblum, *Nineteenth Century Art* (New York: Harry N. Abrams, 1984), pp. 90–91, are also helpful.

22. For example, the fire chief, the Art Commission, and the commissioner of parks all had to approve Attilio Piccirilli's and H. Van Buren Magonigle's *Firemen's Memorial*, completed in 1913.

23. Daniel Chester French to E. R. Harlan, 3 October 1914, FFP, reel 2.

24. Louise Hall Tharp, *Saint-Gaudens and the Gilded Era* (Boston: Little, Brown, 1969), p. 320; "The Statue of Sherman," *NYT*, 31 July 1901, p. 6; "Report of Special Committee on the Sherman Statue and Pedestal," 10 June 1902, Sherman Monument file 26 collateral, Art Commission of the City of New York (ACNY), City Hall, New York City; Mabel Parsons, ed., *Memories of Samuel Parsons* (New York: G. P. Putnam's Sons, 1926), pp. 100–102; "Site of the Sherman Statue," *NYT*, 25 March 1902, p. 8; "General Sherman's Statue Unveiled," *NYT*, 31 May 1903, p. 3; Marcus, "Studies in Nineteenth Century Sculpture," p. 393.

25. "Firemen's Memorial Ready," *NYT*, 23 December 1909, p. 4; "Firemen's Memorial Almost Forgotten," *NYT*, 10 April 1910, p. 7; "The Firemen's Memorial," *NYT*, 10 April 1910, p. 12; "Fire Heroes Not Forgotten," *NYT*, 12 April 1910, p. 10; "New Design for Firemen's Memorial," *NYT*, 13 April 1910, p. 20; "New Sites for Firemen's Memorial," *NYT*, 20 April 1910, p. 3; Firemen's Memorial, exhibit 451A, submission 988, 14 December 1909; exhibit 451G, submission 1083, 7 June 1910; exhibit 451J, submission 1550, 13 August 1912, ACNY.

Chapter Four

1. "The Appellate Division Court House, New York," *Architects' and Builders' Magazine* 2, no. 4 (January 1901): 126.

2. See Supreme Court Appellate Division, First Department, *Courthouse History and Guide*, descriptive sections by Henry Hope Reed, Jr. (New York: New York State Bar Association, 1976), p. 1.

3. Mark Ash and William Ash, *The Greater New York Charter*, 2nd ed. (New York: Baker, Voorhis, and Co., 1901), sec. 204 and 205, pp. 121–122. The state statute was Chapter 553, 8 May 1895, enacted into law 7 April 1897. *Proceedings of the Commissioners of the Sinking Fund of the City of New York 1895–1897* (New York: Martin Brown Co., 1898), p. 516; New York State Legislature, *Laws of the State of New York, 120th Session* (New York: Banks and Brothers, 1897): vol. 2, Chapter 196, p. 173; *Commissioners of the Sinking Fund*, 9 August 1897, p. 1086.

4. John Tauranac, *Elegant New York* (New York: Abbeville Press, 1985), pp. 50–51.

5. See Supreme Court Appellate Division, First Department, *Courthouse History and Guide*; and Robert A. M. Stern, Gregory Gilmartin, and John Montague Massengale, *New York 1900: Metropolitan Architecture and Urbanism, 1890–1915* (New York: Rizzoli, 1983), pp. 222–224; Tauranac, *Elegant New York*, p. 51.

6. *Commissioners of the Sinking Fund*, 21 May 1896, p. 537; Sara Webster, "The

Architectural and Sculptural Decoration of the Appellate Division Courthouse," in New York Architectural League, *Temple of Justice* (New York: New York Architectural League, 1977), pp. 23ff.

7. Webster, "Decoration of the Appellate Division Courthouse," pp. 23–24.

8. *Commissioners of the Sinking Fund*, 6 December 1897, p. 1212; 22 December 1897, p. 1230.

9. The sculptors and painters subcontracted with Wills, but answered to Lord, Ruckstull, and Niehaus. The total estimated cost of the decorations excluding sculpture was $169,635. Wills estimated $308,633 for the cost of construction, thus leaving $160,700 for sculpture, not yet subcontracted at the point when these estimates were listed in October 1898. The sculptors' contracts have not been located, nor are there NSS minutes extant for this period. The total cost of the sculpture is recorded as $157,000. See James M. Dennis, *Karl Bitter: Architectural Sculptor, 1867–1915* (Madison: University of Wisconsin Press, 1967), p. 71; *Commissioners of the Sinking Fund*, 21 December 1898, p. 311; Supreme Court Appellate Division, First Department, *Courthouse History and Guide*, p. 2.

10. "Sculptors Ask Competitions," *NYT*, 17 February 1897, p. 1. Miranda, sculptor of the abortive Spanish-American sponsored statue of Christopher Columbus proposed for Fifth Avenue, then for Eighth Avenue, and 59th Street, had additional reason to feel hostile towards Saint-Gaudens. Saint-Gaudens had been on the committee responsible for approving the erection of Gaetano Russo's *Columbus* in Columbus Circle. Tauranac, *Elegant New York*, pp. 147–148.

11. Supreme Court Appellate Division, First Department, *Courthouse History and Guide*, p. 2.

12. Descriptions of the iconography can be found in Webster, "Decoration of the Appellate Division Courthouse," pp. 23ff.; "The Sculpture of the New York State Appellate Court Building," *American Architect and Building News*, 25 March 1899, p. 96; Supreme Court Appellate Division, First Department, *Courthouse History and Guide*; Dennis, *Karl Bitter*, p. 70–73; "Public Art in New York," *Municipal Affairs* 3 (September–December 1899), pp. 758–759.

Charles Lopez's *Mohammed*, as Muslim Law, which originally stood on the west end of the balustrade on the 25th Street side, was removed and put in storage in 1955 at the request of Egypt, Indonesia, Pakistan, and several other unidentified Muslim countries, who argued that Islam forbade the representation of humans in art. See Ira Henry Freeman, "Mohammed Quits Pedestal Here on Moslem Plea after 50 Years," *NYT*, 9 April 1955, p. 1; David Dunlap, "Embellished Courthouse Is Regaining Its Splendor," *NYT*, 23 May 1983, sec. 2, p. 3.

13. See, for example, "Sculpture and Decoration of the New York State Appellate Court Building," *American Architect and Building News*, 5 March 1898, p. 73; "The Appellate Division Court House," *Real Estate Record and Guide*, 3 June 1899, pp. 1042–1044.

14. Charles De Kay, "The Appellate Division Court in New York City," *Independent*,

1 August 1901, pp. 1795–1802; idem, "Organization among Artists," *International Monthly* 1 (1900): 91–92.

15. Jonathan Scott Hartley, "Sculpture as an Architectural Ornament," *Public Improvements*, 15 November 1899, p. 1.

16. Tauranac, *Elegant New York*, p. 53.

Chapter Five

1. On the eve of the Washington Centenary, when enthusiasm with memory and national unity reached new heights, White received commissions to design an arch as an appropriate symbol of the triumph of republicanism. The original *Washington Arch* was made only of wood, but it proved so successful that after the Centenary the distinguished citizens of the Washington Arch Committee (including Henry G. Marquand, Louis Fitzgerald, Richard Watson Gilder, and William Rhinelander Stewart) were determined to raise the money to make the arch permanent. As it turned out, this was one of the few times when efforts to make an impermanent New York monument permanent actually worked. The arch was completed in 1892, but the committee was only able to raise enough money for the arch, ornament, and spandrels. MacMonnies had made some sketches for two high relief groups representing Washington as the general of the Army at war and as the first president of the Republic at peace. The arch committee accepted the sketches, but then ran out of money to commission them. In 1912, the arch committee re-formed to raise subscriptions to construct the Washington groups. It became evident that the pressure to accept MacMonnies as sculptor had come primarily from White. With him now deceased, the committee felt under no obligation to hire MacMonnies. After claiming that the latter's designs had not been of "the right character" and that they did not want to deal with an artist living abroad, they chose Hermon MacNeil and Alexander Stirling Calder instead. Despite MacMonnies's acrimonious protest, both the committee and the firm of McKim, Mead, and White (who now supervised the work on the arch) insisted that there had been no binding agreement between the sculptor, the committee, or the architects in the first place. See *Washington Arch* file, Old Mixed Files I and 205 II, McKim, Mead, and White archive, NYHS.

2. Eakins was not an NSS member, and while O'Donovan belonged in 1895, he was no longer listed as a member in 1898. See "Art as an Educational Force and as a Source of Wealth," fr. 262; *Catalogue of the Second Annual Exhibition of the NSS*, p. 14, fr. 275, NSS Papers, reel 490, AAA. For more on these sculptures see "The MacMonnies Quadriga," *NYT*, 19 December 1898, in MacMonnies scrapbook, reel D245, fr. 33, AAA.

3. David Axeen, "'Heroes of the Engine Room': American 'Civilization' and the War with Spain," *American Quarterly* 36, no.4 (Fall 1984): 496; David F. Trask, *The War with Spain in 1898* (New York: Macmillan Publishing, 1982), pp. 68–91, 104; Moses King, *The Dewey Reception and Committee of New York City: An Album of 1,000 Portraits, Scenes, Views, Etc.* (New York: Moses King, 1899), p. 6.

4. See Axeen, "'Heroes of the Engine Room,'" pp. 481–502; Frank Friedel, "Dissent

in the Spanish American War and the Philippine Insurrection," in Samuel Eliot Morrison, Frederick Merk, and Frank Friedel, *Dissent in Three American Wars* (Cambridge: Harvard University Press, 1970), pp. 68–69; Richard E. Welch, Jr., *Response to Imperialism: The United States and the Philippine-American War, 1899–1902* (Chapel Hill: University of North Carolina Press, 1979), pp. 3–42; G. J. A. O'Toole, *The Spanish War: An American Epic* (New York: W. W. Norton, 1984), pp. 90–99.

5. King, *The Dewey Reception*, pp. 2–4.

6. Ibid., pp. 2, 4, 16.

7. Ruckstull, "Origin and Early History of the National Sculpture Society," 1929, p. 30, NSS, New York City.

8. Ibid.

9. Carol Willis, "Charles Rollinson Lamb," *MacMillan Encyclopedia of Architects* (New York: Free Press, 1982), 2:603.

10. Ruckstull, "Origin and Early History," pp. 30–32; J. Wilton Brooks, "The Dewey Arch," *Public Improvements*, 15 September 1899, p. 189; "Public Art in New York," *Municipal Affairs* 3 (September–December 1899): 755.

11. It was arranged that the comptroller would pay the bills on receiving vouchers signed by the "authorized representatives of the National Sculpture Society." Brooks, "Dewey Arch," p. 189.

12. Ibid.

13. King, *Dewey Reception*, p. 16; "For Dewey's Homecoming," *NYT*, 10 May 1899, p. 3.

14. Brooks, "Dewey Arch," p. 189.

15. New York City Board of Aldermen, *Proceedings*, 9 August 1899, p. 240, Municipal Library, New York City.

16. Ibid.

17. "Public Art in New York," p. 757. The Klee Brothers, a New York based ornamental modeling firm, executed the architectural work in staff.

18. Lamb initially modeled the arch upon the *Arch of Titus* in Rome. (This arch, commemorating the "taking of Jerusalem by Titus," shared the connotation of colonial "appropriation" and also happened to allow for a good deal of sculptural adornment.) Lamb ultimately redesigned the structure to include east-west transverse arches, like those of the *Arc de Triomphe* in Paris, in addition to the one massive opening. He also doubled the columns on the 24th Street side and repeated this motif in a colonnade of three sets of clustered columns, all adorned with sculpture, which extended north to 25th Street and south to 23rd Street. Brooks, "Dewey Arch," p. 190.

19. Ibid.

20. Ibid.; "Public Art in New York," pp. 755–757; Barr Ferree, "Dewey Arch, Part 1," *American Architect and Building News*, 13 January 1900, pp. 11–12; idem, "Dewey Arch, Part 2," *American Architect and Building News*, 20 January 1900, pp. 19–20; "The Dewey Arch," *Architects' and Builders' Magazine* 1, no. 1 (October 1899): 1–8.

21. Ferree, "Dewey Arch, Part 2," pp. 19–20.

22. On social Darwinism, see Paul E. Boller, Jr., *American Thought in Transition: The Impact of Evolutionary Naturalism, 1865–1900* (Chicago: Rand McNally Co., 1969), pp. 199–203, 217–226.

23. Ferree, "Dewey Arch, Part 1," p. 112; Marjorie P. Balge, "The Dewey Arch: Sculpture or Architecture?" *Archives of American Art Journal* 23, no. 4 (1983): 6.

24. "Public Art in New York," p. 757.

25. Ferree, "Dewey Arch, Part 1," pp. 11–12; idem, "Dewey Arch, Part 2," pp. 19–20; "Dewey Arch," *Architects' and Builders' Magazine*, pp. 1–8; and the numerous clippings in the Charles Lamb scrapbook, reel 497, fr. 290, AAA.

26. "Art as an Educational Force," fr. 236.

27. Balge, "Dewey Arch," p. 5.

28. Ibid., pp. 3–6.

29. "The National Sculpture Society and Split Contracts," *American Architect and Building News*, 12 August 1899, p. 49.

30. "The Triumphal Arch for the Dewey Celebration in New York." *American Architect and Building News*, 12 August 1899, p. 49.

31. Ibid.

32. "Where Are the Architects?" *NYT*, 2 September 1899, p. 6; Balge, "Dewey Arch," pp. 4–5.

33. "An Appeal to the Architects in Behalf of the Dewey Celebration," *American Architect and Building News*, 9 September 1899, p. 81.

34. In a review in *Scribner's*, 1899, Sturgis had praised the arch as a prime example of modern architectural sculpture, a decorative composition where sculpture controlled the scheme yet still contributed to a decorative, aesthetically pleasing whole. In his view, the arch had overcome the compositional difficulties encountered in Greek art, where, he claimed, sculpture had too little relation to the architecture, or in medieval art, where sculpture was overly subordinate. Russell Sturgis, "The Sculpture of the Dewey Reception in New York," *Scribner's Magazine* 26, no. 6 (December 1899): 765–768; idem, *The Appreciation of Sculpture* (New York: Baker and Taylor, 1904), p. 205, quoted in Balge, "Dewey Arch," pp. 4–5.

35. Balge, "Dewey Arch," pp. 4–5.

36. See "N.Y. Naval Arch Dead," *NYT*, 5 September 1900, p. 12. On the debates over the American presence in the Philippines, see Friedel, "Dissent in the Spanish American War," pp. 65–95; Welch, *Response to Imperialism*, esp. pp. 43–57; Robert L. Beisner, *Twelve against Empire: The Anti-Imperialists, 1898–1900* (New York: McGraw-Hill, 1968), pp. 113–132, 165–185.

Chapter Six

1. For discussion of the tariff, see F. W. Taussig, *The Tariff History of the United States* (New York: G. P. Putnam's Sons, 1903); Joseph F. Kenkel, *Progressives and Protection: The Search for a Tariff Policy 1866–1936* (Lanham, Md.: University Press of America, 1983), pp. 1–56; see also *The Port of New York: A Souvenir of the New York Customs*

House and Index of the Imports and Shipping Facilities of This Port (New York: n.p., 1893–1894), p. 9.

2. The collector had a significant voice in matters of bookkeeping, warehousing, and international trade. For statistics, see table, p. 38, in David C. Hammack, *Power and Society: Greater New York at the Turn of the Century* (New York: Russell Sage Foundation, 1982); see also Customs Brokers and Clerks Association, *The Gateway to the Continent: The Customs Service of the Port of New York* (New York: Customs Brokers and Clerks Association of the Port of New York, 1900); Laurence Schmeckbier, *The Customs Service: Its History, Activities, and Organization* (Baltimore: Johns Hopkins University Press, 1924), pp. 83–89. See also "Report to the Landmarks Preservation Commission," 9 January 1979, designation list 122, LP-1022, Landmarks Preservation Commission, New York City, p. 2; Bonnie Marxer and Heli Meltsner, "Historic Structure Report: Old Customs House, New York, N.Y.," Prepared by the Society for the Preservation of New England Antiquities, 1982, pp. 44–47. This detailed report can be found in the library of the New-York Historical Society, New York City.

3. There was political confrontation over the choice of location, between New York Republican reform factions and members of the Republican party machine, events that are discussed in Marxer and Meltsner, "Historic Structure Report," pp. 1–3.

4. For discussion of the Tarnsey Act, see Thomas S. Hines, *Burnham of Chicago* (New York: Oxford University Press, 1974), pp. 126–133; Sharon Irish, "Cass Gilbert's New York Custom House, Bowling Green" (M.A. thesis, Northwestern University, 1982).

5. On Gilbert, see Edgerton Swarthout, "Cass Gilbert," *Dictionary of American Biography*, supplement 1, p. 341.

6. Republican senator Thomas "Boss" Platt and his cohorts had hoped to secure the job for one of their favored architects, and thus get kickbacks through control of construction. On the controversy, see "Report to the Landmarks Preservation Commission," pp. 2–3; Irish, "Cass Gilbert's New York Customs House," pp. 10, 39–47; Marxer and Meltsner, "Historic Structure Report," pp. 1–8.

7. "Report to the Landmarks Preservation Commission, pp. 2–3; Irish, "Cass Gilbert's New York Customs House," pp. 10, 39–47; Marxer and Meltsner, "Historic Structure Report," pp. 1–8.

8. "Report to the Landmarks Preservation Commission," p. 4; Marxer and Meltsner, "Historic Structure Report," p. 106.

9. John Tauranac, *Elegant New York* (New York: Abbeville Press, 1985), p. 33; Marxer and Meltsner, "Historic Structure Report," p. 20.

10. Peirce had to post $1,150,000 as surety for an estimated $2,305,006 worth of work. John Peirce to Cass Gilbert, 13 October 1903, file Sculpture Miscellaneous, drawer 3, USCH.

11. Beuhler's firm, Beuhler and Lauter, had previously done the modeling work on the Union Club (formerly northeast corner of 51st Street and Fifth Avenue), a building designed by Gilbert and John Du Fais and completed in 1902.

12. Peirce to Gilbert, 19 May 1903, file Sculpture Miscellaneous, USCH.

13. Gilbert and Peirce had disagreed about whether the carving of the ornament should be done at the quarry or at the site. From the outset Gilbert insisted that all work had to be done at the site, where he could keep an eye on its progress and quality. Peirce, on the other hand, wanted the work to be done at the quarry in Hurricane Island, Maine. Gilbert believed giving Peirce drawings would permit him to have the carving work done right at the quarry instead of on the site, as he demanded. However, in late 1903 the New York construction industry was hit by widespread strikes, and Gilbert feared that the carving work might not get done if he insisted that it be done in New York; thus he ultimately capitulated to Peirce's request to have the work done elsewhere. See Gilbert to Peirce, 19 May 1903, 20 May 1903, Letterbooks; Peirce to Gilbert, 28 May 1903, file Sculpture Miscellaneous, USCH. See also Marxer and Meltsner, "Historic Structure Report," p. 79.

14. Peirce to Gilbert, 13 October 1903, file Sculpture Miscellaneous, USCH; Michael T. Richman, *Daniel Chester French: An American Sculptor* (New York: Metropolitan Museum of Art, 1976), p. 103.

15. Marxer and Meltsner, "Historic Structure Report," p. 105.

16. Ibid., p. 41.

17. Gilbert to Saint-Gaudens, 12 February 1903, Letterbooks, USCH.

18. Ibid.

19. Saint-Gaudens to Gilbert, 17 February 1903, file Sculpture Miscellaneous, USCH.

20. Kathryn T. Greenthal and Michael T. Richman, "Daniel Chester French's Continents," *American Art Journal* 8, no. 2 (November 1976): 49.

21. Frederick MacMonnies to Gilbert, 17 November 1900, box G; Augustus Saint-Gaudens to Gilbert, 16 March 1902, and 26 February 1903, box G; all in Cass Gilbert papers, LCMD. Interestingly, these letters were kept separate from other Customs House correspondence.

22. Solon Borglum to Gilbert, 5 February 1903, and Jonathan Scott Hartley to Gilbert, 25 February 1903, both in file Sculpture Miscellaneous, USCH.

23. Fernando Miranda to Gilbert, 25 March 1904, file Sculpture Miscellaneous, USCH.

24. Frederick W. Ruckstull to Gilbert, 19 May 1903, Ruckstull file, drawer 3, USCH; James M. Dennis, *Karl Bitter: Architectural Sculptor, 1867–1915* (Madison: University of Wisconsin Press, 1967), p. 277.

25. Gilbert to Ruckstull, 15 June 1903, Letterbooks, USCH.

26. Ruckstull to Gilbert, 15 June 1904, Ruckstull file, USCH; "Cass Gilbert Resigns and Sues World Fair," *NYT*, 28 April 1904, p. 1.

27. Gilbert to Ruckstull, 21 September 1903, Letterbooks, USCH.

28. See Gilbert to Louis Saint-Gaudens, 12 June 1903, Letterbooks; Peirce to Gilbert, 13 October 1903, file Sculpture Miscellaneous; Gilbert to Ruckstull, 21 September 1903, Letterbooks, all in USCH.

29. Gilbert to Peirce, 11 June 1903, Letterbooks, USCH.

30. The artists would receive scheduled payments: 10 percent after delivery and approval of the quarter-size sketch model; 40 percent on approval of the half- or full-size model; 20 percent on finishing the ten-foot, eight-inch statues in marble; and a final 30

percent once the work had been put into place and accepted by the architects. The contract stipulated that work had to be done within 200 miles of New York. For this the sculptors of the twelve attic figures would receive $5,000 for each (a sum that included the modeling and the carving); Karl Bitter, who modeled the group for the seventh story, would receive $11,000; Andrew O'Connor, sculptor of the cartouche, was allotted $4,000. French was to receive $54,000 for his four entrance groups. For information about contracts see Gilbert to Louis Saint-Gaudens, 12 June 1903, Letterbooks; Peirce to Gilbert, 13 October 1903, file Sculpture Miscellaneous; Gilbert to Ruckstull, 21 September 1903, Letterbooks; all in USCH.

31. Gilbert to Peirce, 11 June 1903, Letterbooks, USCH. This decision may well also been made in response to the controversies currently raging over the New York Hall of Records.

32. Louis Saint-Gaudens to Peirce, 4 July 1903, file Sculpture Miscellaneous, USCH.

33. Peirce to Gilbert, 7 July 1903, file Sculpture Miscellaneous, USCH.

34. James Knox Taylor to Gilbert, 3 October 1903, file Sculpture Miscellaneous, USCH.

35. According to Gilbert, Peirce's suggestions were just a scheme for him to receive a large advance payment while only paying out a small amount to the sculptors. Gilbert, note, 14 January 1904; Taylor to Gilbert, 4 September 1903, 2 October 1903; all in file Sculpture Miscellaneous, USCH.

36. Peirce to Gilbert, 13 October 1903, file Sculpture Miscellaneous, USCH.

37. Gilbert, the Treasury, and Peirce negotiated an agreement to modify the latter's contract to suit the government and to allow payment of the sculptors. These modifications were placed as a rider in the original specifications. See Acting Secretary of the Treasury to Peirce, 9 March 1904; Peirce to Gilbert, 16 February 1904; Cass Gilbert, note on page dated 7 January 1904, in Peirce to Gilbert, 13 October 1903; Taylor to Gilbert, 10 November 1903; all in file Sculpture Miscellaneous, USCH.

38. French found Adolph Weinman's assistance so indispensable that he included Weinman's signature alongside his own on the finished continent groups. See Richman, *Daniel Chester French*, p. 109. For a thorough account of the process of making architectural sculpture see George Gurney, *Sculpture and the Federal Triangle* (Washington, D.C.: Smithsonian Institution Press, 1985), pp. 65–84. Gurney discusses a later period, but the basic procedures changed little.

39. Ruckstull to Gilbert, 8 August 1903, Ruckstull file, USCH.

40. Ibid.

41. Ruckstull to Gilbert, 20 January 1904, Ruckstull file; see also Gilbert to Ruckstull, 9 February 1904, Letterbooks; both in USCH. Gilbert had suggested Ruckstull make pillars in the form of two square obelisks and include inscriptions in the Phoenician alphabet that would record why Phoenicia is considered a representative nation in maritime affairs.

42. See, for example, Ruckstull, "Origin and Early History of the National Sculpture Society," 1929, pp. 16, 31, NSS, New York City.

43. Johannes Gelert's statue of Denmark, for example, was in the plaster shop by April

of 1904. It was completed in marble by January 1906. See Gelert to Gilbert, 18 April 1904, Gelert file, drawer 3, USCH.

44. Peirce to Gilbert, 6 April 1904, file Sculpture Miscellaneous, USCH.

45. Greenthal and Richman, "French's Continents," pp. 52–53.

46. French, nervous that Peirce's setters were incompetent and that they might allow his groups to slip while French still bore responsibility, refused to let Peirce install the continents before receiving Gilbert's and Taylor's final approval. See memo dictated by Sheridan, 28 July 1903; Peirce to Gilbert, 25 January 1906; Peirce to Gilbert, 6 October 1906; all in file Sculpture Miscellaneous, USCH; Greenthal and Richman, "French's Continents," pp. 52–53.

47. See "Sculpture on the New York Customs House," *Monumental News* 18, no. 3 (March 1906): 203; Charles De Kay, "French's Groups of the Continents," *Century Magazine* 71 (1906): 418, 431.

48. "World's Greatest Customs House Will Soon Be Completed," *NYT*, 14 January 1905, Part 3, p. 3. See also Marxer and Meltsner, "Historic Structure Report," p. 108.

49. Gilbert to Grant M. Overton, 24 August 1916, file Sculpture Miscellaneous, USCH.

50. "World's Greatest Customs House," *NYT*, 14 January 1905, sec. 3, p. 3; De Kay, "French's Groups of the Continents," pp. 427–431.

51. Gilbert to Grant M. Overton, 24 August 1916, file Sculpture Miscellaneous, USCH.

52. Tauranac, *Elegant New York*, p. 35.

Chapter Seven

1. "Hall of Records Cornerstone Laid," *NYT*, 14 April 1901, p. 7.

2. Ibid.; John Tauranac, *Elegant New York* (New York: Abbeville Press, 1985), pp. 29–30.

3. Tauranac, *Elegant New York*, p. 30.

4. "John Rochester Thomas," in *National Cyclopedia of American Biography*, 9:329.

5. "The Political and Architectural History of the Hall of Records," *American Architect and Building News*, 1 July 1905, p. 1. For the history of the attempts to build a new city hall and a municipal building, see Robert A. M. Stern, Gregory Gilmartin, and John Montague Massengale, *New York 1900: Metropolitan Architecture and Urbanism, 1890–1915* (New York: Rizzoli, 1983), pp. 61–62; Tauranac, *Elegant New York*, p. 30.

6. "Trouble Among Architects," *NYT*, 6 May 1897, p. 3.

7. New York City Board of Aldermen, *Proceedings*, 9 August 1899, p. 246.

8. "Hall of Records Statuary," *NYT*, 14 June 1903, p. 7; "The New Hall of Records," *NYT*, 21 May 1899, p. 7; "The New Hall of Records," *NYT*, 26 May 1899, p. 3; "The New Hall of Records," *NYT*, 28 May 1899, p. 16.

9. "Hall of Records Statuary," *NYT*, 14 June 1903, p. 7.

10. Bush-Brown was the nephew and adopted son of sculptor Henry Kirke Brown. The

young Bush-Brown studied with his uncle and at the National Academy of Design before traveling to Paris and Florence in 1886 for three years' study there. He had then come into prominence for his *Indian Buffalo Hunt*, which he exhibited at the World's Columbian Exposition. See Leila Mechlin, "Henry Kirke Bush-Brown," *Dictionary of American Biography* (New York: Charles Scribner's Sons, 1944), supplement 2, 11:143–144; *National Cyclopedia of American Biography*, 10:374–375.

11. "Hall of Records Statuary," *NYT*, 14 June 1903, p. 7.

12. "Hall of Records Sculpture," *NYT*, 4 June 1903, p. 8; "Hall of Records Statuary," *NYT*, 14 June 1903, p. 7.

13. "Hall of Records Cornerstone Laid," *NYT*, 14 April 1901, p. 7.

14. New York City Board of Aldermen, *Proceedings*, 2 August 1899, p. 210, and 9 August 1899, p. 246. For discussion of Van Wyck's attempts to get Thomas and Peirce to resign and to get new designs and cost estimates, see Tauranac, *Elegant New York*, pp. 30–31.

15. This figure is based upon the original bid for the exterior $1,997,700, plus Thomas's revised figure of $1,900,000 for the interior, which he presented to Van Wyck after being told to cut interior costs. "The New Hall of Records," *NYT*, 21 May 1899, p. 7; Tauranac, *Elegant New York*, pp. 30–31; "Figure Wore a Hat," *New York Tribune*, 7 March 1903, p. 1.

16. "Horgan and Slattery Succeed J. R. Thomas," *NYT*, 12 September 1901, p. 5; Tauranac, *Elegant New York*, pp. 30–31.

17. As the *American Architect and Building News* described it, "Messers Horgan and Slattery obligingly reported—just, probably, as they were expected, perhaps instructed, to report" that over a million dollars could be saved by changing the "character and material of the interior finish." "History of the Hall of Records," p. 1; Tauranac, *Elegant New York*, p. 31.

18. "History of the Hall of Records," p. 1.

19. "The New Hall of Records," *NYT*, 21 May 1899, p. 7; Tauranac, *Elegant New York*, pp. 30–31; "Figure Wore a Hat," *New York Tribune*, 7 March 1903, p. 1.

20. "Thomas Estate to Sue City," *NYT*, 13 September 1901, p. 8.

21. 'Sculpture Contracts Stand," *NYT*, 18 June 1903, p. 6.

22. "Figure Wore a Hat," *New York Tribune*, 7 March 1903, p. 1.

23. Specification clauses enclosed with letter from Horgan and Slattery to Daniel Chester French, 18 November 1902, ACNY.

24. Martiny was to model two groups of three or more figures each for the Chambers Street (south) entrance; two seated figures for the Centre Street (east) steps; one group over the east and west doors in the Chambers Street vestibule (later given to Albert Weinert); and twenty-four single standing figures above the main cornice on the sixth floor (between the windows on the Centre Street facade and on the pavilions on Chambers and Reade streets). The two Chambers Street groups were to be carved in white Carrara marble; the others would be Hallowell granite. Specification clauses enclosed with letter from Horgan and Slattery to French, 18 November 1902, ACNY.

25. Marshall Everett, ed., *The Book of the Fair* (Saint Louis: Henry Neil, 1904), p. 490.

26. "Hall of Records Statuary," *NYT*, 14 June 1903, p. 7.

27. "Hall of Records Sculpture," *NYT*, 4 June 1903, p. 8.

28. Frederick Dielman to Alexander Phimister Proctor, ca. 11 April 1903, ACNY.

29. "Slattery Laid Trap," *New York Tribune*, 8 March 1903, p. 1.

30. See exhibitions 25F and 25N and inventory sheet, folder 25–1, Hall of Records files, ACNY.

31. Exhibit 25AJ, 1 April 1903, Hall of Records file, ACNY; "Figure wore a Hat," *New York Tribune*, 7 March 1903, p. 1.

32. "Figure wore a Hat," *New York Tribune*, 7 March 1903, p. 1; "Hall of Records Statuary," *NYT*, 14 June 1903, p. 7.

33. "Slattery Laid Trap," *New York Tribune*, 8 March 1903, p. 1.

34. See Hall of Records files, ACNY; "Action Kept a Secret," *New York Tribune*, 10 March 1903, p. 1.

35. "Slattery Laid Trap," *New York Tribune*, 8 March 1903, p. 1.

36. Horgan and Slattery to the Art Commission, 7 March 1903, ACNY; "Action Kept a Secret," *New York Tribune*, 10 March 1903, p. 1. The same article put it more ambiguously, observing that the "firm also denied that either member had made statements for publication."

37. "Action Kept a Secret," *New York Tribune*, 10 March 1903, p. 1.

38. Milo Maltbie to Horgan and Slattery, 27 January 1903, ACNY.

39. Thomas Tryon to Milo Maltbie, 10 March 1903, file 72, ACNY; "Figure Wore a Hat," *New York Tribune*, 7 March 1903, p. 1; "Hall of Records Plan," *NYT*, 12 March 1903, p. 8; "Action Kept a Secret," *New York Tribune*, 10 March 1903, p. 1.

40. French did not state reasons, but he may have considered bronze preferable because it endured the New York climate better than marble, and permitted greater detail, surface tonal variation, and compositional complexity than granite. Since the lower floor groups would be scrutinized more closely, detail would be especially important. Bronze figures would also provide a color contrast with the rest of the exterior.

41. Thomas Tryon to Milo Maltbie, 12 March 1903, file 72, ACNY.

42. Ibid.

43. Exhibits 25AO, 25AQ, 25AW, 25 AY, 28 November 1903, Hall of Records files, ACNY. See Peter Dobkin Hall, *The Organization of American Culture, 1700–1900: Private Institutions, Elites, and the Origins of American Nationality* (New York: New York University Press, 1982), pp. 217–222, for discussion of the post–Civil War emphasis on the relation between institutions, as achievements of a natural leadership of men of character, and the attainment of a national culture.

44. For discussions of the turn-of-the-century colonial revival and the emphasis upon the Anglo-Dutch heritage, see Alan Axelrod, ed., *The Colonial Revival in America* (New York: W. W. Norton, 1985).

45. For discussion of Hewitt and his underhanded dealings with the wire contractors

for Brooklyn Bridge, see Alan Trachtenberg, *Brooklyn Bridge: Fact and Symbol* (1969; Chicago: University of Chicago Press, 1979), pp. 101–107.

46. Explaining the symbolism of *Equity* and *Justice*, Martiny wrote that since the Corporation Counsel would be "one of the three principle bodies" to occupy this building, and since it was "supposed to be the legal advisor of New York to a certain extent," he had included attributes "such as the shield of New York and the sword ready to defend the law if same is not observed." Equity "signifying ideal justice, righteousness, etc., would characterize the two other corporations—namely the Court of Surrogates and Register." Martiny to Maltbie, 19 November 1904, ACNY. In 1959 these groups were moved to the front of the New York County Courthouse.

47. Thomas's rendering is illustrated in "The New Hall of Records," *NYT Magazine*, 21 May 1899, p. 3.

48. Exhibits 25FU, 25FV, 25FW, submission 322, 13 June 1905, Hall of Records files, ACNY; "Declined His Casts for Hewitt Statue," *NYT*, 17 March 1905, p. 6.

49. "History of the Hall of Records," p. 1.

50. Peirce to Horgan and Slattery, 7 March 1905, ACNY. Peirce's letter may have been deliberately set up by Horgan and Slattery as a way to pressure the Art Commission to speed up their decision.

51. Martiny to the Art Commission, 5 November 1905, ACNY.

52. In 1905, a new mayor, George McClellan, ordered the commission to review designs for $500,000 worth of changes (10 percent of which the architects would get as an additional fee) to the still unfinished interior of the Hall of Records. The mayor was empowered to make these demands. Having been pinned to the wall, commission members were not about to capitulate any further to the architects by passing Martiny's last groups quickly. "No Hall of Records for a Year More," *NYT*, 31 May 1905, p. 16; Maltbie to Edward M. Grout, Comptroller, 11 July 1905, ACNY.

53. Martiny to Robert de Forest, 20 December 1905, ACNY; exhibits 25FE, 25GB, 25GC, 25GD, submission 382, 26 December 1905, Hall of Records files, ACNY.

54. Howard Mansfield to the Art Commission, 18 January 1906, ACNY; submission 393, March 16, 1906; exhibits 25GI, 25GJ, submission 407, 13 March 1906; exhibits 25GE, 25GF, 25GG, submission 409, 13 March 1906; all in Hall of Records files, ACNY.

55. Exhibits 25GR, 25GS, submission 480, 18 September 1906, Hall of Records files, ACNY; I. N. Phelps Stokes, *The Iconography of Manhattan* (New York: Robert N. Dodd, 1926), 5:2067.

Chapter Eight

1. For an comparison of pre- and post-Civil War conceptions of "culture" and cultural institutions, see Neil Harris, "Four Stages of Cultural Growth: The American City," in *Indiana Historical Society Lectures, 1971–1972* (Bloomington: Indiana Historical Society, 1972), pp. 24–39; Thomas Bender, *New York Intellect* (New York: Alfred A. Knopf, 1987), pp. 119–205. See also Kermit Vanderbilt, *Charles Eliot Norton: Apostle of Culture in a Democracy* (Cambridge: Harvard University Press, 1959), p. 3; Richard Guy Wilson,

"Conditions of Culture," in Brooklyn Museum, *American Renaissance 1876–1917* (New York: Pantheon Books, 1979), pp. 27–37.

2. In the 1890s, for example, the Metropolitan Museum of Art abolished its recently established art classes for artisans and adopted a policy of educating the public through its collections. The implementation of this policy followed growing efforts by Columbia University to expand in the area of art education. It also coincided with a shift from collecting copies and casts to concentrating on works of Old Masters, and a cooling of the trustees' interest in purveying art to the masses after the 1883 trial of di Cesnola, the museum's director. The trial followed after Gaston Feuardent, an agent to whom di Cesnola had consigned works, challenged the authenticity of the di Cesnola collection of Cypriotic antiquities, which the museum now owned. A committee investigated the charges and concluded they were false. When di Cesnola published his own denial, Feuardent filed a libel suit against him. The New York papers sided with Feuardent, and although di Cesnola was vindicated, the suit was seen as an attack on the wealthy New York establishment who supported the Metropolitan. See Winifred E. Howe, *A History of the Metropolitan Museum of Art*, 2 vols. (New York: Metropolitan Museum of Art, 1913), 1:222–225, 248–252; Calvin Tompkins, *Merchants and Masterpieces* (New York: E. P. Dutton, 1970), pp. 62–68, 118.

3. See Tompkins, *Merchants and Masterpieces*, pp. 39–41; David C. Hammack, *Power and Society: Greater New York at the Turn of the Century* (New York: Russell Sage Society, 1982), pp. 188–192; John Michael Kennedy, "Philanthropy and Science in New York City: The American Museum of Natural History, 1868–1968," (Ph.D. dissertation, Yale University, 1968), pp. 35–37.

4. See Tompkins, *Merchants and Masterpieces*, pp. 188–190; John Michael Kennedy, "Philanthropy and Science," pp. 35–37, 43–46, 56–65.

5. See Mark Ash and William Ash, *The Greater New York Charter*, 2nd ed. (New York: Baker, Voorhis and Co., 1901), p. 350. Indeed, this municipal commitment proved crucial as far as sculpture was concerned. The New-York Historical Society (founded 1804), a smaller institution that owned its own property, had to raise $400,000 in private funds to build its new building. The campaign did not get underway successfully until men like J. P. Morgan joined the building committee. In this case the trustees and officials of the society decided exterior ornament was not a high priority. York and Sawyer's winning competition design of 1901 had no figurative sculpture. See Robert A. M. Stern, Gregory Gilmartin, and John Montague Massengale, *New York 1900: Metropolitan Architecture and Urbanism, 1890–1915* (New York: Rizzoli, 1984), p. 105; John Tauranac, *Elegant New York* (New York: Abbeville Press, 1985), pp. 262–264.

6. On the American Museum, see Stern, Gilmartin, and Massengale, *New York 1900*, pp. 370–371, 373; John Michael Kennedy, "Philanthropy and Science," pp. 88–90, 106–108.

7. The museum trustees happened to be in a good position to capitalize on the corrupt escapades of the Tweed era. President of the Board of Supervisors, boss William M. Tweed, impressed by the real estate moguls and financiers who supported the project, hoped (un-

successfully) to profit on construction by convincing the trustees to build a much more expensive and elaborate structure. He thus agreed to get legislative approval to have the Metropolitan's new building, along with that of the American Museum of Natural History, constructed on municipal property with city money. See Bender, *New York Intellect*, pp. 170–171; Tompkins, *Merchants and Masterpieces*, pp. 35, 40, 62–75; John Michael Kennedy, "Philanthropy and Science," pp. 43–46.

8. Thompkins, *Merchants and Masterpieces*, pp. 37–59, 69–75.

9. Paul R. Baker, *Richard Morris Hunt* (Cambridge: MIT Press, 1980), p. 442.

10. Baker, *Richard Morris Hunt*, p. 442. See also L. P. di Cesnola to Richard Morris Hunt, 20 April 1895, file B868 (1895) Wing D, Architect and Plans, Metropolitan Museum of Art Archives (MMAA).

11. Baker, *Richard Morris Hunt*, p. 443.

12. Karl Bitter to Richard Howland Hunt, 17 December 1897, and Richard Morris Hunt to Samuel McMillan, 20 December 1897, file B868 (1897), Wing D, Sculptural Work on Facade, MMAA.

13. See Bitter to Richard Howland Hunt, 17 December 1897, and Richard Morris Hunt to Samuel McMillan, 20 December 1897, file B868 (1897), Wing D, Sculptural Work on Facade, MMAA.

14. There were individual trustees who supported American sculpture. J. Q. A. Ward, of course, was one of them. On the recommendation of Stanford White, banker Edward Dean Adams and lawyer Joseph H. Choate had both paid for commissions for garden sculpture by Frederick MacMonnies for their estates in Sea Bright, New Jersey, and Stockbridge, Massachusetts; similarly, J. P. Morgan funded architectural sculpture by Adolph Weinman, commissioned by McKim, Mead, and White for Morgan's New York mansion. Apart from Ward, only Robert W. de Forest and Henry G. Marquand were trustees involved with other major public sculptural projects undertaken in the city: de Forest, through his activities as president of the Art Commission of the City of New York; Marquand, through his service on the Monument Committee of the *Washington Arch*. Trustees of the Metropolitan Museum are listed in Howe, *History of the Metropolitan Museum of Art*, 2:231–234. See also Michele H. Bogart, "American Garden Sculpture: A New Perspective," in Parrish Art Museum, *Fauns and Fountains: American Garden Statuary, 1890–1930* (Southampton, N.Y.: Parrish Art Museum, 1985), n.p. .

15. Hunt to Salem H. Wales, 30 June 1898; memo, 13 July 1898; Memo, 19 November 1898; all in file B868 (1898), Wing D, Sculptural Work on Facade, MMAA.

16. Bitter to L. P. di Cesnola, 2 April 1900, file B868 (1900), Wing D, Sculptural Work on Facade, MMAA.

17. Hunt to Salem H. Wales, 29 March 1900, file B868 (1900) Wing D, Sculptural Work on Facade (Hunt), MMAA; Albert Ten Eyck Gardner, "Those Blocks," *Metropolitan Museum of Art Bulletin* 11, no. 9 (May 1953): 254. See also Morrison H. Heckscher, "Hunt and the Metropolitan Museum," in Susan Stein, ed., *The Architecture of Richard Morris Hunt* (Chicago: University of Chicago Press, 1986), pp. 173–185.

18. Hunt to Wales, 29 March 1900, file B868 (1900), Wing D, Sculptural Work on Facade (Hunt), MMAA; Gardner, "Those Blocks," p. 254.

19. John Quincy Adams Ward to Salem H. Wales, 30 March 1900, file B868 (1900) Wing D, Sculptural Work on Facade (Hunt), MMAA; Gardner, "Those Blocks," p. 257.

20. Thomas Hastings to Wales, 6 April 1900, file B868 (1900), Wing D, Sculptural Work on Facade, MMAA.

21. For discussion of the *Soldiers' and Sailors' Arch*, see M. M. Graff, *Central Park, Prospect Park: A New Perspective* (New York: Greensward Press, 1985), pp. 181, 200–219; see also Frederick MacMonnies scrapbook, roll D245, fr. 30–54, AAA, for newspaper clippings about MacMonnies's sculptural groups for the arch. On Duncan, see David M. Kahn, "The Grant Monument," *Journal of the Society of Architectural Historians* 41, no. 3 (October 1982): 214–231.

22. See Brooklyn Institute of Arts and Sciences, *Prospectus for 1900–1901* (Brooklyn: The Brooklyn Institute, 1900), p. 13; Rebecca Hooper Eastman, "The Story of the Brooklyn Institute of Arts and Sciences, 1824–1924," pamphlet, (n.p., n.d.), pp. 1–13.

23. The department's advisory board included Charles McKim, William Mead, William Boring, John Carrère, Thomas Hastings, and A. D. F. Hamlin. Anyone could enter the first stage of the competition. A second competition consisted of the two winners of the first round and four firms who were invited to participate (McKim, Mead, and White, J. C. Cady, Parfett Brothers, and Carrère and Hastings). Two-stage procedures were seen as a way to assure good work while still going through the motions of an open competition. Usually one of the invited firms won the contest, and the Brooklyn Institute proved no exception. Judges A. D. F. Hamlin, Franklin W. Hooper, Robert S. Peabody (an old friend of Charles McKim), and Brooklyn architect George L. Morse selected McKim, Mead, and White as architects in May 1893. See Brooklyn Institute of Arts and Sciences, *Prospectus for 1900–1901*, p. 13; Eastman, "Story of the Brooklyn Institute," pp. 1–13.

24. Michael J. Kennedy was park commissioner for both Brooklyn and Queens, but by 1934, when Robert Moses became park commissioner for the entire city, New York had five separate park commissioners, one for each borough. Robert A. Caro, *The Power Broker: Robert Moses and the Fall of New York* (1974; New York: Vintage Books, 1975), p. 362.

25. Franklin W. Hooper to McKim, Mead, and White, 20 December 1902, box Museum, 405, Brooklyn Institute of Arts and Sciences, McKim, Mead, and White archive, NYHS (hereafter cited as BI).

26. New York City Department of Parks, *Minutes*, 23 July 1903, p. 233; Hooper to McKim, Mead, and White, 20 December 1902, 22 December 1903, 15 February 1904, 17 March 1905; A. Augustus Healy to McKim, Mead, and White, 17 February 1905; all in box 489, BI.

27. Saint-Gaudens, Ward, MacMonnies, and Bitter had at one time also been mentioned as possible candidates. The park commissioner, perhaps in order to appear to be carrying out a competitive process, had requested at one point (unspecified) that the institute's trustees recommend suitable sculptors. The trustees' minutes report that they consid-

ered these five, but even four years earlier it was clear that they planned to hire French. Minutes of the Board of Trustees of the Brooklyn Institute of Arts and Sciences, 9 February 1906, Brooklyn Museum Archives.

28. Hooper to McKim, Mead, and White, 19 January 1904, box 489, BI; Daniel Chester French to William R. Mead, 27 January 1905, file 6–20, BI.

29. McKim, Mead, and White would receive 5 percent of the total cost (as opposed to the 10 percent fees taken by Horgan and Slattery).

30. Undoubtedly Kennedy and other city officials were under continued pressure from the trade unions to promote fair competition and an equitable distribution of construction commissions.

31. Hooper to McKim, Mead, and White, 6 May 1905, box 6c-66, file 6c 1906, BI.

32. French to McKim, Mead, and White, 14 June 1905, file 6–20, BI.

33. French to McKim, Mead, and White, 20 January 1906, and 9 February 1906, file 6–2a, BI.

34. French to McKim, Mead, and White, 20 January 1906, and 9 February 1906, file 6–2a, BI.

35. McKim, Mead, and White to Michael J. Kennedy, draft enclosed in letter from Hooper to McKim, Mead, and White, 13 June 1905, box 6c-66, BI.

36. Hooper to McKim, Mead, and White, 13 June 1905, box 6–6c general, BI.

37. New York City Board of Aldermen, *Proceedings*, 26 December 1905, p. 1408.

38. Hooper to McKim, Mead, and White, 18 January 1907, file 6–2a, BI; French to McKim, Mead and White, 13 March 1907, FFP, reel 15.

39. French to Edward Clark Potter, 24 April 1907, FFP.

40. Memorandum from William Kendall, 8 October 1908, files 301.1 and 301.2, Brooklyn Museum sculptures, ACNY; French to McKim, Mead, and White, 16 June 1909, box 6c-66, BI.

41. Memo to Michael J. Kennedy, 30 August 1913, file 6–2a, BI.

42. Minutes of the Board of Trustees of the Brooklyn Institute of Arts and Sciences, 4 January 1907, Brooklyn Museum Archives.

43. Hooper to McKim, Mead, and White, 6 May 1905, and 8 April 1907, BI; French to Karl Bitter, 9 May 1907, FFP, reel 15; see also "The Museum's Statues," [Brooklyn Institute of Arts and Sciences] *Museum News* 6, no. 3 (December 1910): 34–36; Brooklyn Museum, *Handbook* (Brooklyn: Brooklyn Museum, 1967), p. 23; Lewis I. Sharp, *New York City Public Sculpture by Nineteenth Century American Artists* (New York: Metropolitan Museum of Art, 1974), p. 8; Report of the Director of the Brooklyn Institute of Arts and Sciences, 5 April 1905, and 10 May 1905, Brooklyn Museum Archives.

44. Hooper to McKim, Mead, and White, 2 March 1907, file 6–6 (2 of 3), BI; "The Museum's Statues," pp. 34–36.

45. "The Museum's Statues," p. 34.

46. Hooper to McKim, Mead, and White, 2 March 1907, file 6–6 (2 of 3), BI.

47. Ibid.; "The Museum's Statues," pp. 34–36.

48. Hooper to McKim, Mead, and White, 2 March 1907, file 6–6 (2 of 3), BI.

49. Hooper to McKim, Mead, and White, 8 April 1907, BI.

50. Daniel Chester French, "What the Greeks Contributed," 16 February 1907, FFP, reel 15.

51. French to Charles H. Dorr, 26 April 1913, FFP, reel 15; Hooper to McKim, Mead, and White, 29 June 1911, file 6–2, BI.

52. William Kendall to French, 19 October 1909, box 6c-66, BI; Hooper to McKim, Mead, and White, 29 June 1911, file 6–2, BI.

53. Richard Guy Wilson, *McKim, Mead, and White, Architects* (New York: Rizzoli, 1983), p. 180; Stern, Gilmartin, and Massengale, *New York 1900*, p. 88.

54. Hammack, *Power and Society*, pp. 209–214, provides the background for understanding these tensions in discussing the resistance to consolidation on the part of a group of Brooklyn's cultural and religious leaders. Harvey A. Kantor, "Modern Urban Planning in New York City: Origins and Evolution, 1890–1933" (Ph.D. dissertation, New York University, 1971), pp. 142–148, discusses Brooklyn's abortive attempt to gain more parity in the sphere of city planning. See also Elliott Willensky, *When Brooklyn Was the World: 1920–1957* (New York: Harmony Books, 1986), p. 20.

55. The Tilden Trust was a $5 million bequest set up in 1887 to "establish and maintain a free library in the City of New York and to promote scientific and educational objects." See Peter Dobkin Hall, "Philanthropy as Investment," *History of Education Quarterly* 22 (Summer 1982): 193, 200; John Bigelow, "The Tilden Trust Library: What Shall It Be," *Scribner's Magazine* 12, no. 3 (September 1892): 287–300; Stern, Gilmartin, and Massengale, *New York 1900*, p. 91.

56. Ash and Ash, *Greater New York Charter*, p. 350.

57. Phyllis Dain, *The New York Public Library: A History of Its Founding* (New York: New York Public Library, 1972), pp. 158–159. See also Michele H. Bogart, "Four Sculpture Sketches by Paul Wayland Bartlett for the New York Public Library," *Bulletin of the Georgia Museum of Art* 7, no. 2 (Winter 1982): 5–24.

58. Any practicing New York architect could enter the first competition, which called for sketches and designs, presented anonymously until the decisions had been made. A jury consisting of Billings, engineer Bernard Green, and Columbia professor William Ware selected twelve sets of plans from the applications. A committee of the library's Board of Trustees then asked six architects from the first group to participate in a second competition, along with six eminent New York architects whom they had independently invited. The jury then chose three plans from these twelve and submitted them to the trustees. They had the final choice of the architect. Dain, *New York Public Library*, pp. 158–159.

59. Ibid. See also Harry Miller Lydenberg, *History of the New York Public Library* (New York: New York Public Library, 1923), pp. 442–443, 448–450; 468–509, for details of construction.

60. Lydenberg, *History*, pp. 468–471; David Grey, *Thomas Hastings: Collected Writings* (Boston: Houghton Mifflin, 1933), p. 43; Dain, *New York Public Library*, p. 169.

61. See, for example, Daniel Chester French to Frank W. Cheney, 11 March 1907, FFP, reel 1.

62. Paul Wayland Bartlett to Suzanne Emmons, 6 December 1908, Paul Wayland Bartlett papers, box 1, LCMD.

63. Lydenberg, *History*, pp. 482, 507–508.

64. Ibid., p. 481.

65. MacMonnies received $25,000 for the modeling of his two large niche figures *Beauty* and *Truth*; Barnard received $20,000 for his pediment groups *History* and *Art*; Potter was paid $8,000 for modeling his two now-famous lions. Bartlett received $20,000 for modeling thirty-three-inch sketches, half-size plasters, and full size (eleven-foot) plasters for each of his six figures of *Philosophy*, *Romance*, *Religion*, *Poetry*, *Drama*, and *History*, which stand above the entrance frieze. This came out to about $3,300 for each. An additional $5,000 was allotted for carving, done by the firm of John Donnelly. See Lydenberg, *History*, pp. 507–509.

66. Bogart, "Four Sculpture Sketches," p. 13.

67. Ibid., p. 18.

68. The trustees wanted a more central location in downtown Brooklyn, but the comptroller and district residents wanted the library to stand on Grand Army Plaza near the Brooklyn Institute and Prospect Park. The city won out. See H. W. Frohne, "The Brooklyn Plaza and the Projected Brooklyn Central Library," *Architectural Record* 23, no. 2 (February 1908): 97–110; "Editorial," *NYT*, 30 September 1905, p. 8.

69. Stern, Gilmartin, and Massengale, *New York 1900*, pp. 97–98; "Failure to Complete Brooklyn Public Library Building," *NYT*, 9 September 1925, p. 3.

Chapter Nine

1. This chapter was first published as "*Maine Memorial* and *Pulitzer Fountain*: Patronage and Process," in *Winterthur Portfolio* 21, no. 1 (Spring 1986): 41–63. McKim, Mead, and White's work for Prospect Park began in 1888. The cornerstone for the *Soldiers' and Sailors' Arch* was laid in 1889. "Gallagher Gets the Contract," *NYT*, 6 March 1890, p. 8; Laura Wood Roper, *FLO: A Biography of Frederick Law Olmsted* (Baltimore: Johns Hopkins University Press, 1973), pp. 460–464; M. M. Graff, *Central Park, Prospect Park: A New Perspective* (New York: Greensward Press, 1985), p. 181; Leland Roth, *McKim, Mead, and White, Architects* (New York: Harper and Row, 1983), p. 180; David Schuyler, *The New Urban Landscape: The Redefinition of City Form in Nineteenth-Century America* (Baltimore and London: The Johns Hopkins University Press, 1986), pp. 185–186, 190.

2. "Maine Monument Faults," *New York Evening Post*, 17 May 1913, p. 6. An example of recent criticism of the *Maine Memorial* is that of *New York Times* critic Paul Goldberger, who described it as a "grand, if sentimental presence," in contrast to Gaetano Russo's *Columbus*, "looking as if he had been waiting since 1892 for a break in the traffic so that he might go somewhere more comfortable." Paul Goldberger, *The City Observed: A Guide to the Architecture of New York* (New York: Vintage Books, 1979), p. 181.

3. According to Charles Brown, circulation of the daily newspapers in New York in

1895 was about 2,000,000 among a population of about 2,800,000. Charles H. Brown, *The Correspondent's War* (New York: Charles Scribner's Sons, 1962), p. 11; Ochs quoted p. 19.

4. On Pulitzer's involvement in the Liberty pedestal campaign, See June Hargrove, "Power of the Press," in Pierre Provoyeur, June Hargrove, et al., *Liberty: The French American Statue in Art and History* (New York: Harper and Row, 1986), pp. 166–175.

5. In the case of the Liberty pedestal campaign, for example, it was clear that Pulitzer truly believed in the patriotic causes that he spoke for. Hargrove, "Power of the Press," p. 174.

6. See Brown, *Correspondent's War*, pp. 15–21. On the war itself, see David F. Trask, *The War with Spain in 1898* (New York: Macmillan Publishing, 1982).

7. The acquittal has remained unquestioned ever since. For accounts of Hearst's involvement with the Spanish-American War, see W. A. Swanberg, *Citizen Hearst* (New York: Charles Scribner's Sons, 1961), pp. 130–165. Ferdinand Lundberg, *Imperial Hearst: A Social Biography* (New York: Equinox Cooperative Press, 1936), provides a fascinating, but extremely biased, account.

8. Swanberg, *Citizen Hearst*, p. 44.

9. For some of these arguments, see Lundberg, *Imperial Hearst*, p. 81; Brown, *Correspondent's War*, pp. vi, 182–201, 442–449. See also Gerald L. Linderman, *The Mirror of War: American Society and the Spanish-American War* (Ann Arbor: University of Michigan Press, 1974), pp. 148–175.

10. "Thrilling Details of the Fight from the Only Newspaper Dispatch Boat That Was Present," *New York Evening Journal*, 2 June 1898, p. 3. Hearst's exploitation of the imprisonment of Evangelina Cisneros, a young relative of the Cuban president, exemplifies how he changed a minor episode into an overblown story of Cuban martyrdom. On winning Cisneros's release from the Spaniards, the *Journal* sponsored a huge rally for her at Madison Square Garden. See Brown, *Correspondent's War*, pp. 95–102, 447; Swanberg, *Citizen Hearst*, pp. 119–129.

11. "$50,000 Reward for the Detection of the Perpetrator of the Maine Outrage," *New York Evening Journal*, 17 February 1898, p. 1; "Honor the Men," *New York Evening Journal*, 19 February 1898, p. 1.

12. James Grant Wilson (1832–1914), author of several books and president of the New York Genealogical Society, had also been involved in the erection of the statues of Fitz-Greene Halleck and Columbus. John W. Keller, a reporter and editorial writer for several New York papers, was a major figure in the Tammany Society between 1899 and 1903. Swanberg, *Citizen Hearst*, p. 138; "Patriots," *New York Evening Journal*, 24 February 1898, p. 8; "Perpetuate," *New York Evening Journal*, 21 February 1898, p. 6. For more on the campaign, see Bogart, "*Maine Memorial* and *Pulitzer Fountain*," p. 48.

13. See "Maine Monument Faults," *NYT*, 17 May 1913, p. 6; Swanberg, *Citizen Hearst*, p. 163.

14. Judges were Hearst, Keller, J. Edward Simmons, Dr. George Shrady, James Grant

Wilson, Frederick Dielman, John La Farge, Walter Cook, and William O'Donovan. See "Maine Victims' Monument," *New York Tribune*, 9 November 1900, p. 3. See also Karl Bitter to Isidore Konti, 11 June 1900, Konti papers, reel 1210, fr. 588, AAA.

15. "Honors to the Maine Heroes," *New York Evening Journal*, 30 May 1913, pp. 1–2.

16. Maine Memorial, file 21–1, exhibit 21-AT, ACNY (hereafter Maine File); "Maine Shaft to Rise in Columbus Circle," *NYT*, 6 August 1911, p. 5; Maine File 21D, 14 April 1908.

17. Josef Vincent Lombardo, *Attilio Piccirilli: Life of an American Sculptor* (New York: Pittman Publishing, 1944), pp. 133–134; Swanberg, *Citizen Hearst*, pp. 214, 222, 230–38. *Maine* monument cocommitteeman Keller was an executive member of the Tammany Society from 1899 until 1903, during the years in which Hearst and Murphy still had their uneasy alliance.

18. Lombardo, *Piccirilli*, pp. 133–134.

19. Swanberg, *Citizen Hearst*, p. 290; Maine File 21U, 6 July 1910; exhibit 21D, 14 April 1908, Maine File.

20. Maine File 21U, 6 July 1910.

21. Maine File 21Y, 16 March 1911; Maine File 21U, 6 July 1910; Maine File 21 AA–AF.

22. "Preparing Monument Site," *NYT*, 24 July 1911, p. 6; "The Maine Monument," *NYT*, 25 July 1911, p. 6; "Central Park's New Monument," *NYT*, 23 July 1911, p. 8; Mabel Parsons, ed., *Memories of Samuel Parsons* (New York: G.P. Putnam's Sons, 1926), pp. 90–91, 100–102, 136; "The City Parks and the Monument Idea," *NYT*, 16 May 1913, p. 10.

23. "Maine Monument Faults," *New York Evening Post*, 17 May 1913, p. 6.

24. "Noted Men Are Here for Maine Tribute," *NYT*, 30 May 1913, p. 16; "Immense Throng Sees Monument to Maine Heroes Unveiled," *New York Evening Journal*, 31 May 1913, p. 3. The completed monument cost about $175,000.

25. For additional discussion of earlier debates over use of formal entrances to the park, see David Schuyler, *The New Urban Landscape*, pp. 96–100; Paul R. Baker, *Richard Morris Hunt* (Cambridge, Mass.: MIT Press, 1980), pp. 146–161; Brown, *Correspondent's War*, p. 445.

26. In the end, after much disagreement about the appropriate location, the soldiers' and sailors' monument site was changed to the present one of 89th Street and Riverside Drive. After all of this debate, the Stoughtons changed their design to one that closely resembles the Choragic monument of Lysicrates in Athens. Paul E. Duboy replaced MacMonnies as sculptor. See "The Soldiers' and Sailors' Monument for New York," *American Architect and Building News*, 4 December 1897, p. 76; "Further Tribulations of the Soldiers' and Sailors' Monument," *American Architect and Building News*, 1 January 1898, p. 1; John Tauranac, *Elegant New York* (New York: Abbeville Press, 1985), pp. 260.

27. Karl Bitter, "Municipal Sculpture," *Municipal Affairs* 2, no. 1 (1898): 92. See

also James M. Dennis, *Karl Bitter: Architectural Sculptor, 1867–1915* (Madison: University of Wisconsin Press, 1967), pp. 222–229.

28. Bitter, "Municipal Sculpture," p. 97.

29. NSS, "From Battery to Harlem," *Municipal Affairs* 3, no. 4 (December 1899): 633–635. In 1899 when Bitter presented his plan no decision had been made as to where to place the Sherman statue; in 1901, Saint-Gaudens and McKim were still trying to have it placed on the Central Park Mall. See also Dennis, *Karl Bitter*, pp. 222–229, 232; Tauranac, *Elegant New York*, pp. 149–150.

30. "Design for Plaza Fountain, Pulitzer Gift to City, on exhibition to Public Today," *New York World*, 21 January 1913, p. 3. On Pulitzer see W. A. Swanberg, *Pulitzer* (New York: Charles Scribner's Sons, 1967), esp. p. 413.

31. Dennis, *Karl Bitter*, pp. 232–233; Minutes of the Regular Council of the National Sculpture Society, 14 May 1912, National Sculpture Society, New York. The advisory committee was Daniel Chester French, Herbert Adams, and Jonathan Scott Hartley. The men to receive the next greatest number of ballots were Alexander Stirling Calder, Hermon MacNeil, Herbert Adams, and Adolph Weinman.

32. Dennis, *Karl Bitter*, p. 231.

33. Bitter to Ralph Pulitzer, 9 July 1912, Pulitzer Fountain, submission 1694, ACNY; Dennis, *Karl Bitter*, p. 235.

34. Ralph Pulitzer to Charles B. Stover, 14 October 1912, file 272, ACNY.

35. Ibid.

36. "Finer Park Plaza Is Planned with Pulitzer Fountain," *New York World*, 22 December 1912, p. 13.

37. "Designs for Plaza Fountain," *New York World*, 21 January 1913, p. 3; "Finer Park Plaza," *New York World*, 22 December 1912, p. 13.

38. "Designs for Plaza Fountain," *New York World*, 21 January 1913, p. 3; Dennis, *Karl Bitter*, pp. 13, 237.

39. Herbert Adams, Whitney Warren, Paul Cret, and Charles Adams Platt were the other jurists. Dennis, *Karl Bitter*, p. 237.

40. The projected cost of the fountain had been $27,000, with $10,000 set aside for the sculpture. The Art Commission file lists the final cost as $76,000.

41. A partial explanation might be that the Grand Army Plaza site abutted the mansion of Cornelius Vanderbilt II, whose niece, Frederica Vanderbilt Webb, was Ralph Pulitzer's wife. However, Joseph Pulitzer abhorred the Vanderbilt family and was extremely displeased with his son's choice of a wife. It seems unlikely that he would have gone out of his way to choose this spot specifically to please his daughter-in-law's family. Swanberg, *Pulitzer*, pp. 324–327.

42. Ibid., p. 149.

43. Ibid., p. 382; James Wyman Barnett, *Joseph Pulitzer and His World* (New York: Vanguard Press, 1941), p. 259.

44. While a younger Pulitzer had used the pages of the *World* for the purposes of

monument fund-raising and indirect advertisement, the Liberty pedestal campaign differed from that of Hearst's promotion of *Maine Memorial*: Pulitzer's efforts simply brought to fruition a project that had already been commissioned. The inspiration for *Liberty* did not arise out of circumstances nearly so suspect as those of *Maine Memorial*; nor did Pulitzer exploit the campaign to run for public office. Swanberg commented that the *World's* editorials could "handle with ridicule what the *Journal* sprayed with poison." Swanberg, *Pulitzer*, p. 280.

Chapter Ten

1. While sculpture is singled out in this discussion, the issues are also relevant to painting. At the same time, the public aspects of sculpture did bring into play a particular set of beliefs, institutions, and other circumstances that differed from those involved with easel painting. My concern here is to show the implications of these general theoretical and ideological issues for analyzing a specific art form—public sculpture—produced in New York at this particular historical moment. I am not trying to suggest that the issues considered in this chapter were totally unique.

2. See Roland Barthes, "The Reality Effect," in Tzvetan Todorov, *French Literary Theory Today: A Reader*, trans. R. Carter (Cambridge: Cambridge University Press, 1982), pp. 11–17; Sacvan Bercovitch, "The Problem of Ideology in American Literary History," *Critical Inquiry* 12, no. 4 (Summer 1986): 631–653, presents a similar argument with reference to literature.

3. Roland Barthes, "Myth Today," *Mythologies*, trans. Annette Lavers (New York: Hill and Wang, 1972), pp. 142–143.

4. The phenomenon I describe above is sometimes described as "cultural hegemony." For discussion of this concept in relation to American cultural history, see T. J. Jackson Lears, "From Salvation to Self-Realization: Advertising and the Therapeutic Roots of the Consumer Culture, 1880–1930," in Richard Wightman Fox and T. J. Jackson Lears, eds., *The Culture of Consumption: Critical Essays in American History, 1880–1980* (New York: Pantheon Books, 1983), pp. 4–5; idem, "The Concept of Cultural Hegemony: Problems and Possibilities," *American Historical Review* 90, no. 3 (June 1985): 567–593.

5. Barthes, "Myth Today, pp. 142–143.

6. On circumstantiality, see Edward Said, *The World, the Text, and the Critic* (Cambridge: Harvard University Press, 1983), pp. 31–53. For discussion of these issues with respect to painting and photography, see Norman Bryson, *Vision and Painting: The Logic of the Gaze* (New Haven: Yale University Press, 1983), pp. 52–66. On photography, see Roland Barthes, "The Photographic Message," in *Image-Music-Text*, trans. Stephen Heath (New York: Hill and Wang, 1977), pp. 15–31.

7. Barr Ferree, "The Lesson of Sculpture," *Craftsman* 7, no. 2 (November 1904): 122.

8. To understand the sculptors' concerns within this broader context of urban moral reform, see Paul Boyer, *Urban Masses and Moral Order in America, 1820–1920* (Cambridge: Harvard University Press, 1978), pp. 176–184.

9. Charles Blanc, *Grammaire des Arts du Dessin* (1867; Paris: E. Plon, 1880), pp.

332–342; Richard Shiff, *Cezanne and the End of Impressionism: A Study of the Theory, Technique, and Critical Evaluation of Modern Art* (Chicago: University of Chicago Press, 1984), pp. 70–98.

10. See Blanc, *Grammaire*, p. 343–344.

11. By realism in sculpture, I refer to artistic constructs that rely upon traditional modeling techniques to depict images similar to those supposedly perceived through vision or through the photographic lens. For discussion of the humanist emphasis on the individual as myth see Barthes, "Myth Today," esp. pp. 140–158.

12. The everyday, informal look occurred more often with portrait statues, like John Quincy Adams Ward's *Horace Greeley*, than with architectural sculpture, where sculptors retained a decorum that would be in keeping with the lines and formality of the architecture.

13. For discussion of the importance of detail, see Charles Caffin, *American Masters of Sculpture* (New York: Doubleday, Page, and Co., 1903), p. xi. See also Barthes, "Reality Effect," pp. 11–18.

14. Commentators interpreted this approach both as the representation of lifelike quality and as an expression of the individuality of both the artist and the sculptural subject. At the same time, they always took care to distinguish the idealized artistry of such naturalistic effects from the mundane, "the matter-of-fact." See discussion and bibliography in Detroit Institute of Arts, *The Quest for Unity: American Art Between World's Fairs 1876 and 1893* (Detroit: Detroit Institute of Arts, 1983), pp. 162–164.

15. See David Axeen, "'Heroes of the Engine Room': American 'Civilization' and the War with Spain," *American Quarterly* 36, no. 4 (Fall 1984): 481–502.

16. Lewis I. Sharp, *New York City Public Sculpture by Nineteenth Century American Artists* (New York: Metropolitan Museum of Art, 1974), p. 39. Such themes, of course, were not exclusively American. See, for example, Peter Fusco, "Allegorical Sculpture," and catalog entries by Marie Busco and Peter Fusco, in Peter Fusco and H. W. Janson, eds., *The Romantics to Rodin: French Nineteenth Century Sculpture in North American Collections* (New York: George Braziller, 1980), pp. 60–69, 116, 118–119.

17. With exceptions like Joan of Arc, women achieved the privileged status of "hero" only very infrequently. Even more rarely did they become the subjects of public portraiture. The depiction of women in public art generally remained limited to personification as allegory, which was the second way in which sculptors could represent significant ideas. Even then, women were rendered as allegory only when representing an idea that was not being linked to specific historical personages. These were virtually always men.

18. For discussion of this in the French context, see Fusco, "Allegorical Sculpture," pp. 63–65.

19. William Walton, "The New Municipal Building, New York, and Its Sculpture," *American Architect and Building News*, 15 March 1916, pp. 136–137.

20. Indeed, according to Paul Boyer, the concern for moral uplift through education was largely a rationale for the implementation of social controls. Boyer, *Urban Masses*, pp. 128, 161, 169; see also Peter Dobkin Hall, *The Organization of American Culture*,

1700–1900: Private Institutions, Elites, and the Origins of American Nationality (New York: New York University Press, 1982), pp. 249–261, 271–281.

21. Photographs showing people looking at monuments are insufficient evidence because dress is not a clear indicator of social class and observation does not necessarily reveal the specific emotional effect on the viewer. The study of postcards is also problematic. It is virtually impossible to determine with any reasonable accuracy how many postcards depicting monuments were produced at a given time.

22. The case of pageantry offers persuasive evidence that the relationship between allegorical representation and its meaning for viewers was problematic. See David Harold Glassberg, "American Civic Pageantry and the Image of the Community, 1900–1930" (Ph.D. dissertation, Johns Hopkins University, 1982); idem, "History and the Public: Legacies of the Progressive Era," *Journal of American History* 73, no. 4 (March 1987): 957–980.

My argument here differs somewhat from that presented by George Starr in "Truth Unveiled: The Panama Pacific International Exposition: Public Art at the Fair," in Burton Benedict, ed., *The Anthropology of World's Fairs* (Berkeley: Lowie Museum of Anthropology and Scolar Press, 1983), pp. 134–165. In his discussion of responses to the allegorical sculpture of the Panama-Pacific Exposition, Starr notes commentators' concerns that the general public might not grasp the significance of the images. However, he believes that Americans enjoyed what they knew to be good for them, that they actively sought to find the meaning of the complex allegorical programs of the fair, and that they believed that the labor involved in doing so was an indication of the works' worthiness and merit. He sees little conflict between the outlook of the artists and fairgoers.

Chapter Eleven

1. This chapter first appeared as "The Importance of Believing in 'Purity'," *Archives of American Art Journal* 24, no. 4 (1984): 2–8; and "Barking Architecture: The Sculpture of Coney Island," *Smithsonian Studies in American Art* 2, no. 1 (Winter 1988): 3–17. "Statue of Purity for Times Square," *NYT*, 5 October 1909, p. 1.

2. "It's a Huge Statue of Miss New York," *New York Herald*, 5 October 1909, p. 13.

3. "Plaster Purity Unveiled," *New York Sun*, 8 October 1909, p. 6.

4. "Purity Unveiled under 3 Aliases," *New York Herald*, 8 October 1909, p. 6.

5. "Plaster Purity Unveiled," *New York Sun*, 8 October 1909, p. 6. The Hudson-Fulton celebration commemorated the 300th anniversary of Henry Hudson's discovery of the Hudson River in 1609 and the 100th anniversary of Robert Fulton's successful application of steam to marine navigation in 1807. The statewide event was to promote a "historical awakening throughout the state," the "assimilation of foreign populations," "loyalty to established institutions," and "international friendship." New York City marked the event in late September with three weeks of elaborate parades and fireworks. The article presumably was referring to the numerous and enormous sculptural parade floats with themes that were similar to many civic sculptural programs; subjects included *History of New York*, a seated woman with a book, surrounded by a miniature colonial house and skyscraper, which symbolized Progress. The same groups of elites were involved in developing

them. Yet according to the official report the crudely rendered colossi were not intended to be "beaux-arts productions." See The Hudson-Fulton Celebration Commission, *The Hudson-Fulton Celebration 1909* (New York: J. B. Lyon Co., 1910), pp. 5–8; 25–26; 118.

6. Born in Bologna, Italy, Leo Lentelli worked in Rome before his arrival in New York in 1903. He became a U.S. citizen in 1912. Although later a respected artist, Lentelli clearly had no desire to be reminded of this early work. Neither his biographies nor his papers in the Archives of American Art mention this statue as part of his oeuvre.

7. "Statue of Purity for Times Square," *NYT*, 5 October 1909, p. 1; New York City Board of Aldermen, *Proceedings*, 14 September 1909, 3:829.

8. "Statue of Purity for Times Square," *NYT*, 5 October 1909, p. 1.

9. "Plaster Purity," *New York Sun*, 8 October 1909, p. 6; "Statue of Purity for Times Square," *NYT*, 5 October 1909, p. 1.

10. Commissioner of Accounts, *Annual Report for the Year 1903* (New York, n.p. 1904). Mark Ash and William Ash, *The Greater New York Charter*, 2nd ed. (New York: Baker, Voorhis, and Co., 1901), sec. 118, p. 63.

11. Alfred Connable and Edward Silberfarb, *Tigers of Tammany* (New York: Holt, Rinehart, and Winston, 1967), p. 246; Jane S. Dahlberg, *The New York Bureau of Municipal Research: Pioneer in Government Administration* (New York: New York University Press, 1966), pp. 1–28, 149–153; Robert A. Caro, *The Power Broker: Robert Moses and the Fall of New York* (1974; New York: Vintage Books, 1975), pp. 60–63.

12. "Plaster Miss Gotham Feels She's Miscast," *NYT*, 10 October 1909, p. 10. Borrowed from a political club emblem, the Tammany Tiger was popularized through the cartoons of Thomas Nast in *Harper's Weekly*, in which he depicted Tammany Hall as a predatory tiger devouring New York.

13. "Virtue Suddenly Invades Tenderloin," *New York World*, 6 October 1909, p. 3. See also "Concerning Purity: With Some Reflections on New York and Outlying Country," *NYT*, 17 October 1909, sec. 5, p. 11.

14. "White Lady of Times Square," *NYT*, 10 October 1909, p. 12.

15. "The 'Long Acre' Rodin," *NYT*, 9 October 1909, p. 8.

16. By "literal" message, I mean the titles of the work. "Symbolic" message refers to the basic connotation—eg., Power, Force—of the sculptural representation. I am not alluding here to the ideological premises that underlie such connotations. See Roland Barthes, "The Rhetoric of the Image," in *Image-Music-Text*, trans. Stephen Heath (New York: Hill and Wang, 1977), pp. 32–51.

17. My consideration of the possible public reception of this work has been helped by Roland Barthes, *Mythologies*, trans. Annette Lavers (New York: Hill and Wang, 1972); Terry Eagleton, *Literary Theory: An Introduction* (Minneapolis: University of Minnesota Press, 1983), pp. 67–69; Michel Foucault, "What is an Author?" in Josué Harari, *Textual Strategies* (Ithaca: Cornell University Press, 1979), pp. 141–159; Heinrich von Staden, "Nietzche and Marx on Greek Art and Literature: A Case Study in Reception," *Daedalus* 105 (Winter 1976): 91–93.

18. Much of my discussion of Coney Island is indebted to John Kasson, *Amusing the*

Million: Coney Island at the Turn of the Century (New York: Hill and Wang, 1978), p. 23; Robert W. Rydell, *All the World's a Fair: Visions of Empire at American International Expositions, 1876–1916* (Chicago: University of Chicago Press, 1984), pp. 60–68; Burton Benedict, "The Anthropology of World's Fairs," in Burton Benedict, ed., *The Anthropology of World's Fairs: San Francisco's Panama Pacific Exposition of 1915* (Berkeley: Lowie Museum of Anthropology and Scolar Press, 1983), pp. 53–59; Rem Koolhaas, *Delirious New York: A Retroactive Manifesto for Manhattan* (New York: Oxford University Press, 1978), pp. 23–65. Of related interest is Charles E. Funnell's *By the Beautiful Sea: The Rise and High Times of That Great American Resort, Atlantic City* (1975; New Brunswick: Rutgers University Press, 1983), esp. pp. 126–127 and plate xvii, top, on sand sculptors.

19. Kasson, *Amusing the Million*, pp. 29–36, 53–54, 57–86.

20. Ibid., p. 61; Rydell, *All the World's a Fair*, pp. 146–147.

21. "Frederic Thompson," in *National Cyclopedia of American Biography*, 19:105; Koolhaas, *Delirious New York*, p. 32. See Rydell, *All the World's a Fair*, pp. 89–90, for a discussion and an illustration of Thompson's Negro Building.

22. Frederic Thompson, "Amusement Architecture," *Architectural Review* 16, no. 7 (July 1909): 89; idem, "The Summer Show," *Independent*, 20 June 1907, pp. 1460–1463.

23. Thompson, "Amusement Architecture," p. 89. Thompson was also architect of the enormous pleasure palace, the Hippodrome (1905), formerly at Sixth Avenue between 43rd and 44th Streets. See Robert A. M. Stern, Gregory Gilmartin, John Montague Massengale, *New York 1900: Metropolitan Architecture and Urbanism, 1890–1915* (New York: Rizzoli, 1983), pp. 208–209.

24. Thompson, "Amusement Architecture," p. 87.

25. Ibid, p. 85; Koolhaas, *Delirious New York*, pp. 33–34.

26. Kasson, *Amusing the Million*, pp. 6–9, 63–68, 82, 105–109; Frederic Thompson, "Amusing the Millions," *Everybody's Magazine* 19 (September 1908): 378; idem, "Amusement Architecture," p. 89. Kasson has observed that only the very transience of the Luna environment and experience made it possible for Thompson's schemes truly to work. Both Thompson and Luna visitors assumed that behavior would return to its stable norm on leaving Coney Island. Ultimately the permanence of the prevailing social order had to be reaffirmed and reinforced.

27. Kasson, *Amusing the Million*, p. 82; Koolhaas, *Delirious New York*, pp. 38–51.

28. Marshall Everett, *The Book of the Fair* (Saint Louis: Henry Neil, 1904), p. 125; Mark Bennitt, ed., *The History of the Louisiana Purchase Exposition* (Saint Louis: Universal Exposition Publishing Co., 1905), p. 718.

29. On Creation as an angel, see Karal Ann Marling, *The Colossus of Roads: Myth and Symbol along the American Highway* (Minneapolis: The University of Minnesota Press, 1984), pp. 96–98.

30. The titillation was by no means unique; it was a standard feature of world's fair midways. Burton Benedict has discussed this, as well as the importance of gigantism as parody at world's fair midways, in "Anthropology of World's Fairs," pp. 53–59.

Chapter Twelve

1. Mrs. Crane's will made the front page of the *New York Times* when her daughter contested the fact that she had only been left $5, while the entire rest of the estate had been left to charitable institutions and to the City of New York. "Only $5 for Her Daughter," *NYT*, 4 October 1894, p. 1.

2. Robert de Forest to Joseph Haag, 21 March 1921, de Forest correspondence, ACNY.

3. NSS Minutes, 10 November 1908. "Memorandum *in re* Crane Fountain," de Forest correspondence, ACNY.

4. MacMonnies's contract (signed 3 May 1909) had no set time limit, but stipulated that he was to receive $5,000 on submitting the models, $20,000 on completion of the stonework, and a final $10,000 on acceptance of the work. Contract between the City of New York and Frederick MacMonnies, in Crane Fountain file, II–Corr (1902–1930), ACNY.

5. Seeks MacMonnies Fountain," *NYT*, 10 April 1914, p. 5; "Crane Fountain in Marble," *NYT*, 15 May 1914, p. 4; "Civic Virtue Row Takes on a New Twist," *New York American*, 25 March 1922, p. 4.

6. Crane Fountain, exhibit 822A, disapproved 30 November 1914, ACNY; "City Turns Down MacMonnies Work," *NYT*, 11 January 1915, p. 5.

7. Karl Bitter to MacMonnies, 14 October 1914 and 1 December 1914, Bitter file 436, ACNY. The Art Commission was especially scrupulous about works of art placed in the vicinity of City Hall. City Beautiful advocates had targeted the area as a model for the development of a monumental civic center, and the commission wanted to be certain that they could control any artworks placed around there to assure harmony with the overall City Beautiful scheme. For discussion of plans for the City Hall area, see Robert A. M. Stern, Gregory Gilmartin, and John Montague Massengale, *New York 1900: Metropolitan Architecture and Urbanism, 1890–1915* (New York: Rizzoli, 1983), pp. 61–64. Mac-Monnies was now back in New York, after leaving Giverny to escape the war.

8. Hastings planned a "circular marble fountain" with a "series of overflow basins." Crane Fountain, exhibit 822J, approved 24 December 1915, ACNY.

9. Michele Cohen, labels for exhibition *On City Hall, in City Hall*, October 1984 (hereafter cited as Cohen labels). See also Crane Fountain file, exhibit 822Z, 14 July 1922, ACNY.

10. Exhibit 822 A–D, disapproved 30 November 1914, ACNY; "'Civic Virtue Pagan,' Women Tell Hylan," *NYT*, 23 March 1922, p. 17; Cohen labels.

11. "'Civic Virtue Pagan,'" *NYT*, 23 March 1922, p. 17.

12. Theodore Roosevelt, *The Strenuous Life* (New York: The Century Co., 1900), pp. 2, 16, 42–44, 155.

13. "'Civic Virtue Pagan,'" *NYT*, 23 March 1922, p. 17.

14. "Civic Virtue Statue, a Youth with a Club Soon to Menace Sirens in City Hall Park," *NYT*, 26 February 1922, p. 19.

15. See Paul Boyer, *Urban Masses and Moral Order in America, 1820–1920* (Cam-

bridge, Mass.: Harvard University Press, 1978), pp. 193–204; Allan M. Brandt, *No Magic Bullet: A Social History of Venereal Disease in the United States* (New York: Oxford University Press, 1985), pp. 23–39. Raymond B. Fosdick, Jr., *John D. Rockefeller, Jr.: A Portrait* (New York: Harper and Row, 1956), pp. 137–140.

16. "Say Virtue Degrades Women," *NYT*, 16 March 1922, p. 13.

17. "The Quiz of Civic Virtue," *NYT*, 17 March 1922, p. 16. On feminism, see William O'Neill, *Everyone Was Brave. The Rise and Fall of Feminism in America* (Chicago: Quadrangle Books, 1969); William Henry Chafe, *The American Woman: Her Changing Social, Economic, and Political Roles, 1920–1970* (New York: Oxford University Press, 1972), pp. 3–132. Of related interest is Ellen Carol Du Bois, "Working Women, Class Relations, and Suffrage Militance: Harriot Stanton Blanch and the New York Woman Suffrage Movement, 1894–1909," *Journal of American History* 74, no. 1 (June 1987): 34–58.

18. The Art Commission had to fend off reporters who mistakenly thought that the commission had appointed MacMonnies. Assistant Secretary of the Art Commission to Robert de Forest, 16 March 1922, de Forest correspondence file, ACNY. See also "Home Again," *NYT*, 28 February 1922, p. 18.

19. "Hylan to Preside at Art Inquisition," *NYT*, 18 March 1922, p. 13; "Hylan Gives Heed to Statue Protest," *New York American*, 16 March 1922, p. 6.

20. Hylan's astute political calculations worked in his favor. During the hearing, certain women's groups embraced the mayor as the first to represent their interests. Some even suggested that MacMonnies's rendition of *Civic Virtue* be replaced with a statue of Mayor Hylan instead. "Hylan Put Forth as Civic Virtue Model," *NYT*, 6 April 1922, p. 19; "'Let John Hylan Pose for Civic Virtue,' Women Plead," *New York Daily Tribune*, 6 April 1922, p. 3; "Public Statues Vote to Bar Civic Virtue," *New York American*, 20 March 1922, p. 6; "Women Laud Mayor's Civic Virtue Stand," *New York American*, 23 March 1922, p. 3.

21. "Women Laud Mayor's Civic Virtue Stand," *New York American*, 23 March 1922, p. 3; "'Let John Hylan Pose,'" *New York Daily Tribune*, 6 April 1922, p. 3. Among those attending were members of the National Women's Club, Women's Christian Temperance Union, League of Women Voters, National Women's Party, Home Rule League, and Brooklyn Alliance Club. Some people also criticized the proportions of the Virtue figure. A Mrs. John Jerome Rooney said the legs of *Virtue* looked like those "a subway guard should have to jam people into cars."

22. "Civic Virtue," *NYT*, 17 April 1922, p. 6. Controversy was nothing new to Mac-Monnies. In 1893 he had acquired a national reputation as a result of the Boston Public Library trustees' outraged responses to the *Bacchante and Infant Faun* he had created for the library courtyard. That debate had arisen over the "realism" of the female figure and over the perceived impropriety of depicting her both naked and drunk. But at least that controversy had involved only a limited group of people. There was no question of misreading an allegory; MacMonnies never purported to be creating a didactic work. The exceptional prudishness of the Boston trustees became a joke among New Yorkers, and in a display of one-upmanship, the trustees of the Metropolitan Museum accepted the *Bac-*

chante. For *Bacchante* controversies, see MacMonnies scrapbook, MacMonnies papers, reel D245, fr. 68, AAA.

23. "'Civic Virtue Pagan,'" *NYT*, 23 March 1922, p. 17; "Criticism Absurd, Says MacMonnies," *New York American*, 26 March 1922, p. 4.

24. "Criticism Absurd, Says MacMonnies" *New York American*, 26 March 1922, p. 4.

25. "'Can't Alter Nature,' Says MacMonnies," *NYT*, 2 April 1922, p. 1.

26. "Hylan to Preside at Art Inquisition," *NYT*, 18 March 1922, p. 13.

27. "'Let John Hylan Pose,'" *New York Daily Tribune*, 6 April 1922, p. 3.

28. On whether the sirens were women, see Cohen labels.

29. "Hylan to Preside at Art Inquisition," *NYT*, 18 March 1922, p. 13; "Criticism Absurd, Says MacMonnies," *New York American*, 26 March 1922, p. 4.

30. "'Civic Virtue Pagan,'" *NYT*, 23 March 1922, p. 17.

31. "'Let John Hylan Pose,'" *New York Daily Tribune*, 6 April 1922, p. 3.

32. "Hylan Put Forth as Civic Virtue Model," *NYT*, 6 April 1922, p. 19.

33. "Hylan 54 Years Old," *NYT*, 21 April 1922, p. 13.

34. Robert Moses to A. Everett Peterson, 26 February 1941, exhibit AO, Crane Fountain file, ACNY.

35. On allegory as differentiation, see Richard Shiff, *Cezanne and the End of Impressionism: A Study of the Theory, Technique, and Critical Evaluation of Modern Art* (Chicago: University of Chicago Press, 1984), pp. 47, 83; idem, "Remembering Impressions," *Critical Inquiry* 12, no. 5 (Winter 1985): 442–447.

36. Harvey A. Kantor, "Modern Urban Planning in New York City: Origins and Evolution, 1890–1933" (Ph.D. dissertation, New York University, 1971), p. 310; Robert A. Caro, *The Power Broker: Robert Moses and the Fall of New York* (1974; New York: Vintage Books, 1975), pp. 84–85; 325–326. See also Joseph D. McGoldrick, "John F. Hylan," *Dictionary of American Biography*, supplement 2, 11:330–331.

Chapter Thirteen

1. An article (attributed to Charles Eliot Norton) in the learned journal *The Nation* urged Americans to be deliberate in selecting an appropriate form of commemorative expression of the Civil War. "There is no undertaking for which most people in the United States are less ready than this of building the monuments which they so earnestly desire to build." [Charles Eliot Norton], "Something About Monuments," *Nation* 1, no. 5 (3 August 1865): 154–157.

2. NSS Minutes, 14 October 1919.

3. Karl Bitter to Daniel Chester French, quoted in James M. Dennis, *Karl Bitter: Architectural Sculptor, 1867–1915* (Madison: University of Wisconsin Press, 1967) p. 268, n. 14.

4. Frederick Wellington Ruckstull, *Great Works of Art and What Makes Them Great* (New York: G. P. Putnam's Sons, 1925), pp. 536–537.

5. For discussion of anti-Germanism and other American responses to World War I, see David M. Kennedy, *Over Here: The First World War and American Society* (New York: Oxford University Press, 1980), pp. 24–25, 64–69; John Higham, *Strangers in the Land:*

Patterns of American Nativism, 1860–1925 (New York: Atheneum, 1963), pp. 244–245.

6. Conflating style with nationality, Henderson went on to blast the Germanic influence that produced the "neo-Greek sculpture that is rife about the lower part of the city," and which included "some caryatids in that vicinity, some groups on the municipal buildings [presumably those modeled by Albert Weinert (Hall of Records) and Adolph Weinman (Municipal Building)], and the portrait statues of Franklin and Gutenberg in front of the *Staats-Zeitung* building by [Ernest] Plassman." Helen W. Henderson, *A Loiterer in New York* (New York: George H. Doran, ca. 1917), pp. 246, 248–249.

7. In consultation with Bartlett and Attilio Piccirilli, Gilbert agreed to eliminate the word "Kiel" and the initials of Wilhelm II. Jaegers refused to do the work, arguing that he was not interested in camouflaging his original statue. He suggested that the government remove the statue for the remainder of the war or substitute a statue of Antwerp by the Belgian Constantin Meunier. But Gilbert intimated in a letter to the Treasury secretary that Jaegers admitted receiving honors from the German government in recent years and that he felt it would have been too embarrassing for him personally to make the changes. The Treasury secretary chose simply to have the cheaper, superficial changes made. See Cass Gilbert to L. S. Rowe, 25 October 1918; Albert Jaegers to L. S. Rowe, 28 October 1918; Jaegers to William McAdoo, 19 October 1918; all in USCH.

8. The committee consisted of Daniel Chester French, Cass Gilbert, Herbert Adams, Hermon MacNeil, and Augustus Lukeman. See NSS Minutes, 13 February 1918.

9. NSS Minutes, 9 April 1918, 14 May 1918.

10. NSS Minutes, 7 June 1918, 12 November 1918.

11. NSS Minutes, 12 November 1918.

12. NSS Minutes, 7 June 1918.

13. NSS Minutes, 15 July 1918.

14. NSS Minutes, 12 November 1918.

15. Ibid.

16. Ibid.

17. Carl Heber, a former pupil of Saint-Gaudens, had executed the sculptures *Spirit of Commerce* and *Spirit of Industries* for Carrère and Hastings's arch at the entrance to the Manhattan Bridge. Isidore Konti had recently worked with Hastings while completing Bitter's figure of Pomona. He was known as a moderate, and avoided drawing attention to his Germanic background. Frederick G. R. Roth to Isidore Konti, 19 April 1919, Isidore Konti papers, reel 1210, fr. 1008, AAA.

18. Paul Wayland Bartlett to Cass Gilbert, 5 January 1919, USCH. See also NSS Minutes, 12 November 1918.

19. "Free Will Gifts to Erect NY Arch," *Philadelphia Press*, 24 November 1918, and "Committee Chosen for Victory Arch," *New York Sun*, 20 November 1918, unpaginated clippings in Paul Wayland Bartlett papers, box 23, LCMD; Mayor's Committee on a Permanent War Memorial, *The War Memorial of the City of New York* (New York: n.p., 1923), p. 9 (hereafter cited as Mayor's Committee, *War Memorial*); NSS Minutes, 12 November 1918. Other members of Bartlett's committee included Thomas Hastings,

Grover Whalen, Frank Dowling, Daniel Chester French, Cass Gilbert, Eugene Gallatin, Alfred J. Johnson, Dr. George F. Kunz, William Kendall, Frederick MacMonnies, Lewis F. Pilcher, Philip Berolzsheimer, and Whitney Warren.

20. Thomas Hastings, "New York's Arch of Victory," *Architecture* 39, no. 4 (April 1919): 87–88.

21. "City Already Astir with Parade Spirit," *NYT*, 23 March 1919, p. 12.

22. "Ages Give Sanction to Arch of Victory," *NYT*, 23 March 1919, sec. 2, p. 1; "Fifth Avenue Glows with Light to Greet Heros," *New York Sun*, 23 March 1919, p. 1; "Parade Crowd Is Greatest in City's History," *New York Sun*, 26 March 1919, p. 1. See also "Der Triumphzug der heimgekehrten Krieger," *New Yorker Staats-Zeitung*, 26 March 1919, p. 1.

23. Mayor's Committee, *War Memorial*, p. 9.

24. NSS Minutes, 15 November 1919.

25. Hastings, "New York's Arch of Victory," p. 87.

26. See [Alexander] Stirling Calder, "Letter to the Editor," 2 June 1919, quoted in "New War Memorials," *NYT*, 8 June 1919, sec. 3, p. 2.

27. NSS Minutes, 15 November 1919.

28. Ibid.

29. Ibid.

30. "New War Memorials," *NYT*, 8 June 1919, p. 2.

31. NSS Minutes, 15 November 1919.

32. Ibid.

33. "Sculptors Oppose Permanent Arch as 'Rough on Germany,'" *New York Herald*, 17 November 1919, p. 3.

34. NSS Minutes, 15 November 1919.

35. On Wilson, see Thomas A. Bailey, *Woodrow Wilson and the Lost Peace* (Chicago: Quadrangle Books, 1944); idem, *Woodrow Wilson and the Great Betrayal* (Chicago: Quadrangle Books, 1945); Theodore P. Greene, ed., *Wilson at Versailles* (Boston: D. C. Heath, 1957); Charles C. McKee, Jr., *The End of Order. Versailles, 1919* (New York: E. P. Dutton, 1968), pp. 61–65; Charles DeBenedetti, *The Peace Reform in American History* (Bloomington: Indiana University Press, 1980), pp. 108–112. See also David M. Kennedy, *Over Here*, pp. 348–363.

36. "Sculptors Oppose Permanent Arch as 'Rough on Germany,'" *New York Herald*, 17 November 1919, p. 3.

37. Ibid.; "Wanted: A Society of American Sculptors," *New York Herald*, 18 November 1919, p. 10.

38. "Wanted: A Society of American Sculptors," *New York Herald*, 18 November 1919, p. 10.

39. NSS Minutes, 29 November 1919.

40. NSS Minutes, 29 November 1919, 9 December 1919.

41. NSS Minutes, 9 December 1919; Mayor's Committee, *War Memorial*, p. 9.

42. The jury consisted of Edward Robinson, Henry Bacon, James Earle Fraser, Jules

Guérin, Frank J. Mather, Jr., Benjamin W. Morris, Andrew O'Connor, John Russell Pope, Augustus Vincent Tack, A. Stewart Walker, Lawrence G. White, and Gertrude Vanderbilt Whitney. See Mayor's Committee, *War Memorial*, p. 10.

43. Charles Over Cornelius, "War Memorials, Part 2: Community Buildings for Large Cities," *Architectural Record* 47 (January 1920): 57. This attitude was also reflected in the writings of women sculptors like Janet Scudder. See Janet Scudder, *Modeling My Life* (New York: Harcourt Brace and Co., 1925), pp. 165, 292–293; Michele H. Bogart, "American Garden Sculpture: A New Perspective," in Parrish Art Museum, *Fauns and Fountains: American Garden Statuary, 1890–1930* (Southampton, N.Y.: The Parrish Art Museum, 1985), n.p.

44. For discussion of attempts to shape recent immigrants to current genteel standards of "Americanness" see Kenneth L. Ames, "Introduction," and William B. Rhoads, "The Colonial Revival and the Americanization of Immigrants," in Alan Axelrod, ed., *The Colonial Revival in America* (New York: W. W. Norton, Co., 1985), pp. 1–14; 341–361; David Harold Glassberg, "American Civic Pageantry and the Image of the Community, 1900–1930," Ph. D. diss., Johns Hopkins University, 1982, pp. 1–5, 87–120; Charles Over Cornelius, "War Memorials, Part 2," pp. 39–47.

45. On the playground movement, see Paul Boyer, *Urban Masses and Moral Order in America, 1890–1930* (Cambridge: Harvard University Press, 1978), pp. 240–251; Robert A. Caro, *The Power Broker* (1974; New York: Vintage Books, 1975), pp. 159–169; 237–238, 332–338; Dominick Cavallo, *Muscles and Morals: Organized Playgrounds and Urban Reform, 1880–1920* (Philadelphia: University of Pennsylvania Press, 1981).

46. Robert Caro discusses Tammany's cooption of reform and populism with reference to Al Smith in Caro, *The Power Broker*, pp. 121, 127.

47. Mayor's Committee, *War Memorial*, p. 14; NSS Minutes, 12 December 1922.

48. NSS Minutes, 19 December 1922.

49. Ibid.

50. NSS Minutes, 12 December 1922.

51. Ibid.

52. Mayor's Committee, *War Memorial*, pp. 12–16.

53. "Park Arch Opposed by Scenic Society," *NYT*, 1 July 1922, p. 16; "An Impossible Memorial," *NYT*, 14 July 1922, p. 12; "Memorial Planned for War Dead, Converting Central Park Reservoir," *NYT*, 19 November 1923, p. 10; "Gallatin Approves Park War Memorial," *NYT*, 23 December 1923, p. 14; "Objection Revived to Park War Memorial," *NYT*, 24 December 1923, p. 10.

54. "An Impossible Memorial," *NYT*, 14 July 1922, p. 12.

55. "City Votes $600,000 for Park Memorial," *NYT*, 20 July 1922, p. 16.

56. "Compromising the Park," *NYT*, 29 December 1923, p. 12; "Memorial in Park Advances a Step," *NYT*, 28 December 1923, p. 14.

57. Mabel Parsons, ed., *Memories of Samuel Parsons* (New York: G. P. Putnam's Sons, 1926), p. 102.

58. "Objection Revived to Park War Memorial," *NYT*, 24 December 1923, p. 10.

59. Ibid.

60. "Turn Central Park into Big Memorial Says Wanamaker," *NYT*, 1 April 1924, p. 1.

61. Ibid.

62. "Home Rule Bill May Protect Park," *NYT*, 14 April 1922, p. 19; "Mayor Calls Halt on War Memorial," *NYT*, 27 May 1924, p. 23; "A Respite for the Park," *NYT*, 28 May 1924, p. 22.

63. The war memorial playgrounds, each named after local servicemen, were: in Manhattan, Sauer Playground, 528 E. 12th Street, and McCray Playground, 47 W. 138th Street; in Brooklyn, Sheridan Playground, 80–100 Grand St; in the Bronx, Cittarone Playground, 188th Street and Hughes Avenue, and Zimmerman Playground, Barker Avenue, Olinville Avenue, and Britton Street; in Queens, Van Dohlen Playground, 138th Place, 91st St and Archer Avenue, Jamaica, and O'Connell Playground, 113th and 114th avenues; in Richmond, McDonald Playground, Forest and Myrtle avenues, West Brighton, and De-Matti Playground, Tompkins Avenue and Chestnut Street.

"Police War Fund to Buy Play Sites," *NYT*, 2 March 1934, p. 21; "Court Approves Use of $340,000 Police Fund; Says Playground Will Meet Donors' Wish," *NYT*, 20 March 1934, p. 25; "7 Play Sites Begun with Police Fund," *NYT*, 20 May 1934, sec. 2, pp. 1, 5; "Plans for Children's Playgrounds in the Five Boroughs of the City of New York," *NYT*, 20 May 1934, sec. 2, p. 5; "Mayor Dedicates Play Areas Today," *NYT*, 15 July 1934, pp. 1, 6. On recreation as social control, see Boyer, *Urban Masses*, pp. 240–251; David Glassberg, "Restoring a 'Forgotten Childhood': American Play and the Progressive Era's Elizabethan Past," *American Quarterly* 32, no. 4 (Fall 1980): 351–368. For a penetrating analysis of Moses's career, see Caro, *Power Broker*, esp. pp. 376–377.

Chapter Fourteen

1. See Thomas Bender, "The Cultures of Intellectual Life: The City and the Professions," in John Higham and Paul Conkin, eds., *New Directions in American Intellectual History* (Baltimore: Johns Hopkins Press, 1979), p. 187.

2. Harvey A. Kantor, "Modern Urban Planning in New York City: Origins and Evolution, 1890–1933" (Ph. D. diss. New York University, 1971), pp. 282, 296; Thomas Adams, *Outline of Town and City Planning* (New York: Russell Sage Foundation, 1935), pp. 23, 309; Thomas Adams, *Planning the New York Region: An Outline of the Organization, Scope and Progress of the Regional Plan* (New York: Regional Planning Association, 1927); Regional Plan of New York and Its Environs, *Regional Survey of New York and Its Environs*, 8 vols. (New York: The Regional Plan, 1927–1931). A helpful overview of the metropolitan planning movement and Garden City movement from an international perspective is Peter Hall's "Metropolis 1890–1910: Challenges and Responses," in Anthony Sutcliffe, ed., *Metropolis, 1890–1940* (Chicago: University of Chicago Press, 1984), pp. 42–50; see also in the same volume Kenneth T. Jackson, "The Capitol of Capitalism: the New York Metropolitan Region, 1890–1940," pp. 338–340.

Even in the 1890s, Benjamin Marsh had criticized City Beautiful plans as idealistic but superficial masks for larger social ills such as poverty that had not been sufficiently

confronted. See Michele H. Bogart, "In Search of a United Front: American Architectural Sculpture at the Turn of the Century," *Winterthur Portfolio* 19 (Summer–Autumn 1984): 170.

3. Kantor, "Modern Urban Planning," pp. 84, 90.

4. The percentage of sculptor membership in the Architectural League also remained fairly constant throughout the twenties. In 1915–1916, sculptors comprised 11 percent (60) of the total membership (528). In 1921 they comprised about 10 percent (73) of the total (752), and in 1927–1928 they were 12 percent (103) of the total membership (856). The percentage of Resident Active sculptor members was the same in 1928 as in 1915 (10 percent). Like the Art Commission and Fine Arts Federation, the league was established as an interdisciplinary group, and its constitution stipulated that a sculptor and a painter had to be vice presidents. Given the constancy of the percentages, and given that new members were admitted by election, it appears likely that a quota system was in operation. See Architectural League of New York, *Annual Report of the Officers and Committees of the Architectural League of New York* (New York: Architectural League of New York), for the years 1905 through 1929.

5. The 1926 controversies over the sculpture for the Episcopal Cathedral of Saint John the Divine exemplify these tensions. Like architects Heins and La Farge, whom he replaced, Ralph Adams Cram designed the cathedral with an abundance of sculpture, thus upholding the long, conservative tradition in ecclesiastical architecture. Problems arose when Cram decided to hire two Englishmen, John Angel and Henry Wilson, to create a large body of sculptural work for the cathedral's west front. A number of NSS members, including Augustus Lukeman and Attilio Piccirilli, protested Cram's hiring foreigners. Lukeman proposed a resolution that only American artists be employed on buildings with the "character of American national monuments" (as the cathedral was touted to be). Cram responded that any sculptor trying to "impose his work on the strength of his nationality rather than on the quality of his work" would be automatically eliminated from his consideration. He then proceeded to give Angel and Wilson the commissions. See "Trustees to Decide on Cathedral Art," *NYT*, 21 January 1926, p. 4; "Backs Cram on Art for the Cathedral," *NYT*, 22 January 1926, p. 19; "Lukeman Defends Native Sculptors," *NYT*, 23 January 1926, p. 4; "Assail Cram's View of American Art," *NYT*, 24 January 1926, p. 13; "Won't Bar Aliens on Cathedral Work," *NYT*, 25 January 1926, p. 11; Ralph Adams Cram, *My Life as an Architect* (Boston: Little, Brown, and Co., 1936), pp. 188–190.

6. Of the architect members of the NSS in 1923, the majority were those who had collaborated with sculptors in earlier years, including Henry Bacon, Cass Gilbert, H. Van Buren Magonigle, and Richard Howland Hunt. See National Sculpture Society, *Exhibition of American Sculpture* (New York: National Sculpture Society, 1923). See also NSS Minutes, 15 October 1929, 11 May 1920, 12 December 1922, 13 May 1924.

7. The Society of Beaux-Arts Architects (incorporated 1894) was a group of Ecole graduates who sought to keep up old contacts and to perpetuate French Beaux-Arts traditions and canons. See "Minutes of a Special Meeting of the Council of the NSS," 28

February 1911, p. 1, NSS, New York City; NSS Minutes, 6 November 1912, p. 3; James Philip Noffsinger, *The Influence of the Ecole des Beaux-Arts on the Architecture of the United States* (Washington, D.C.: Catholic University Press, 1955), p. 38.

8. Apprentice modelers worked for a five-year term in a modelers' shop preparing to become journeymen. In New York City, most sculptor journeymen aimed toward joining the Modelers and Sculptors of America (also known as the Society of Ornamental Modelers), which provided most of the men who worked in the city's commercial modelers' shops. The Modelers and Sculptors of America sought to guarantee wages and proper working conditions for sculptors and modelers working in the building trades. To join the union, a sculptor had to pass an examination that tested his skills of design and modeling. The modeling jobs were considered well-paying: according to one former modeler, Thomas Lo Medico, apprentices began work at $15 per week and were up to $90 a week by the fifth year of their term. Journeymen earned $100 per week "according to talent and dexterity." Both journeymen and apprentices worked a forty-four-hour week. Letter from Thomas Lo Medico to the author, 7 November 1983; telephone conversation with Thomas Lo Medico, 31 December 1983; "What the Sculptors Are Doing," *Monumental News* 27 (1915): 223.

9. For statistics on ethnic background of students, see Beaux Arts Institute of Design, *Annual Report 1920* (New York: Beaux Arts Institute of Design, 1920), p. 3.

10. Examples of these buildings and ornamental details can be seen in Rosemarie Haag Bletter and Cervin Robinson, *Skyscraper Style: Art Deco New York* (New York: Oxford University Press, 1975); Steven M. Jacoby and Clay Lancaster, *Architectural Sculpture in New York City* (New York: Dover Publications, Inc. 1975); Information on modelers comes from a telephone conversation with Thomas Lo Medico, 31 December 1983.

11. The ateliers remained popular among students, but after Warren's death in 1923, demoralization set in among the faculty, and between 1923 and 1925 the two successive heads of the department of sculpture quit. Beaux-Arts Institute of Design, *Annual Report 1923* (New York: Beaux-Arts Institute of Design, 1923), p. 6; idem, *Annual Report 1925* (New York: Beaux-Arts Institute of Design, 1925), p. 4. Enrollments in the sculpture school decreased, dropping from a high of 320 in 1921 to 200 by 1929. By 1932 enrollment was down to 160 and only 120 in 1934. In 1933–1934 the school suffered a net loss of about $13,600, and the next year the Board of Trustees decided to close the School of Sculpture for lack of operating funds. A pared-down version of the sculpture school reopened briefly in 1938, only to close again during the war. During the period it was open, the director of the Department of Sculpture was William Van Alen, an architect, best known for the Chrysler Building.

12. For discussion of the New York art market and modern art patronage around the World War I period, see William Innes Homer, *Alfred Stieglitz and the American Avant Garde* (Boston: New York Graphic Society, 1977); Judith Zilczer, *"The Noble Buyer:" John Quinn, Patron of the Avant Garde* (Washington, D.C.: Smithsonian Institution Press, 1978), p. 31–34; Roberta K. Tarbell, "Sculpture in America before the Armory Show," and "Impact of Vanguard Exhibitions in Paris and New York, 1908–1923," in Joan M.

Marter, Roberta K. Tarbell, and Jeffrey Wechsler, *Vanguard American Sculpture, 1913– 1939* (New Brunswick: Rutgers University Art Gallery, 1979), pp. 1–20. For other examples of indications of the growing presence of cultural and critical alternatives, see Francis Naumann, "The New York Dada Movement: Better Late Than Never," *Arts* 54, no. 6 (February 1980): 143–149; Wanda M. Corn, "Apostles of the New American Art: Waldo Frank and Paul Rosenfield," *Arts* 54, no. 6 (February 1980): 159–164; Daty Healy, "A History of the Whitney Museum of American Art, 1930–1954" (Ph.D. dissertation, New York University, 1960), pp. 12–151; Helaine Ruth Messer, "MOMA: A Museum in Search of an Image" (Ph.D. dissertation, Columbia University, 1979), pp. 11–95.

13. See Daniel Robbins, "Statues to Sculpture," in *200 Years of American Sculpture* (New York: David R. Godine and Whitney Museum of American Art, 1976), p. 158.

14. The museum's founders, trustees, and administrators represented a shift from the older elites who had been involved with New York's art institutions, and demonstrated the new impact of wealthy women collectors. College-trained art professionals like Philip Johnson also had an important impact both on the museum and on the subsequent trends of American art and architecture. On MOMA and its administrators and trustees, see Messer, "MOMA: A Museum in Search of an Image," pp. 11–120. For a sense of MOMA's impact on architecture, see William H. Jordy, *American Buildings and their Architects*, vol. 4, *The Impact of European Modernism in the Mid Twentieth Century* (New York: Anchor Press, 1976), pp. 79–80, 279–280; Henry Russell Hitchcock and Philip Johnson, *The International Style* (New York: W. W. Norton, 1966), Chapter 7.

15. The Art Commission approved nine designs for war memorials in 1921, seven in 1922, five in 1923, one in 1924, three in 1925, two in 1926, four in 1927, one in 1928, and two in 1929. Some of the figures were sculpture in the round (such as Karl Ilava's *107th Infantry War Memorial* at 67th Street and Fifth Avenue [1927]), and some were in low relief (such as Charles Cary Rumsey's *Victory* for the *Brownsville Memorial* in Zion Park, Pitkin and East New York avenues [1923]). For other war memorials, see Art Commission of the City of New York, *Annual Report* (New York: Art Commission of the City of New York), for the years 1915–1929. See also Joseph Lederer, *All Around the Town: A Walking Guide to Outdoor Sculpture in New York City* (New York: Charles Scribner's Sons, 1975), pp. 51, 60, 205, 229; Burchfield Center for Western New York Art, *Charles Cary Rumsey (1879–1922)* (New York: Buffalo State College Foundation, 1983), pp. 19–21.

16. For example, according to the Art Commission's annual report, the commission approved designs for three war memorials but for only one statue, that of the dog Balto for Central Park, erected with funds donated by schoolchildren. (Balto braved a raging blizzard to bring antitoxin serum to Nome, Alaska during a diptheria epidemic.) In 1926 the commission approved designs for a bust of Thomas Jefferson for a building at the City College, and for a *Discus Thrower*. In 1927 it approved a statue of an indian maid and faun for the Bronx Botanic Garden and, in 1928, memorials to politicians Andrew Green and John P. Mitchel. Four of the eleven works erected (as opposed to just approved) in New York City in 1926 were not war memorials: the statue of Samuel J. Tilden by William

Ordway Partridge in Riverside Park; the *Discus Thrower* (erected in Central Park but now removed); the memorial to Mayor William J. Gaynor in Cadman Plaza Park, begun before the war; and a Theodore Roosevelt memorial in Seaside Park, Brooklyn. All of the four works of art erected in 1927 were war memorials. By contrast, in 1914 alone the commission considered designs for such large projects as the *Civic Virtue* (installed 1922), the friezes and two sculptural groups for the Manhattan Bridge (installed 1916), three separate submissions for sculptures for the New York Public Library (installed 1916), the *Straus Memorial* (installed 1915), the *Dante Memorial* (installed 1921), and the two monumental groups for the *Washington Arch* (installed 1918). See Art Commission of the City of New York, *Annual Report*, for the years 1914–1929. For additional data, see Art Commission of the City of New York, *Catalogue of Works of Art Belonging to the City of New York*, 2 vols. (New York: Art Commission of the City of New York, 1909, 1920); Frederick Fried and Edmund V. Gillon, Jr., *New York Civic Sculpture: A Pictorial Guide* (New York: Dover Publications, 1976); Lewis I. Sharp, *New York City Public Sculpture by Nineteenth Century American Artists* (New York: Metropolitan Museum of Art, 1974); and Lederer, *All Around the Town.*

17. See Timothy Garvey, *Public Sculptor: Lorado Taft and the Beautification of Chicago* (Champaign: University of Illinois Press, 1988), Chapters 1–3. Ira J. Bach and Mary Lackritz Gray, *A Guide to Chicago's Public Sculpture* (Chicago: University of Chicago Press, 1983), makes note of which monuments were funded by the Ferguson Fund.

18. The Tammany administrations of mayors Hylan and James Walker (1926–1932), who governed New York City during the 1920s, were strongly criticized for their inefficiency and corruption. Little money was being spent on maintenance, and the city's older statues and monuments had fallen into disrepair. On the New York City economy during these years, see Charles Garrett, *The La Guardia Years: Machine and Reform Politics in New York City* (New Brunswick: Rutgers University Press, 1961), pp. 55–63, 80–81; Robert A. Caro, *The Power Broker: Robert Moses and the Fall of New York* (1974; New York: Vintage Books, 1975), pp. 324–332.

19. "The New York County Court House," *American Architect*, 3 December 1919, p. 683; "The New York Court House in Brief," *Architectural Record*, 1 July 1914, pp. 77–78; Robert A. M. Stern, Gregory Gilmartin, and John Montague Massengale, *New York 1900: Metropolitan Architecture and Urbanism, 1890–1915* (New York: Rizzoli, 1983), pp. 61–68; Lederer, *All Around the Town*, p. 34.

20. Donna Haraway, "Teddy Bear Patriarchy," *Social Text* 2 (Winter 1984–1985): 19–64; Board of Trustees of the Roosevelt Memorial, "The New York State Theodore Roosevelt Memorial Dedicated January 19, 1936," pamphlet, (Albany: J. B. Lyon, Co., 1936); Henry Fairfield Osborn, *History, Plan, and Design of the New York State Theodore Roosevelt Memorial* (New York: n.p., 1928).

21. By the early thirties the city had virtually no money. Any funds that were available for construction and civic projects all came through federal assistance, and much of that was allotted to Park Commissioner Moses. What sculpture was erected during these years was largely done by Frederick G. R. Roth, the sculptor for the Park Department, at Moses's

discretion. Roth created much of the sculpture for the animal houses at the Central Park and Prospect Park zoos. He was also the sculptor of *Balto* (1925; Central Park near 65th Street and Fifth Avenue) and of *Mother Goose* (1938; Rumsey Playground). See, for example, "Proposal to Carve Elephant Heads on Key Stones," exhibit BH, Prospect Park Zoo, file 832–6, ACNY.

22. Herbert Adams (born 1858) and Hermon MacNeil were last of this generation, passing away in 1945 and 1948, respectively.

23. Many of them turned to making fountain and garden statuary for private homes instead. See Michele H. Bogart, "American Garden Sculpture: A New Perspective," in *Fauns and Fountains: American Garden Statuary, 1890–1930* (Southampton, N.Y.: The Parrish Art Museum, 1985), n.p.

24. See George Gurney, *Sculpture and the Federal Triangle* (Washington, D.C.: Smithsonian Institution Press, 1985), pp. 322–332, for an example of how the privileging of individuality affected the production of William Zorach's *Benjamin Franklin* for the United States Post Office in the Federal Triangle.

25. On twenties' consumer culture, see Warren Susman, *Culture as History: The Transformation of American Culture in the Twentieth Century* (New York: Pantheon Books, 1984), pp. 99–105, 271–285. For discussion of the relationship of consumer culture, advertising, novelty, and modernist aesthetics and design, see James Sloan Allen, *The Romance of Commerce and Culture* (Chicago: University of Chicago Press, 1983); Jeffrey Meickle, *Twentieth Century Limited* (Philadelphia: Temple University Press, 1979); Rosemary Haag Bletter and Cervin Robinson, *Skyscraper Style*, p. 40; Dickran Tashjian, Dianne Pilgrim, and Richard Guy Wilson, *The Machine Age in America, 1918–1941* (New York: Harry N. Abrams, 1986).

26. Several buildings—including the Park Row building (1899; 15 Park Row), American Surety Building (1895; 100 Broadway), the Cable Building (1894; 621 Broadway), and R. H. Macy (1901; West 34th to 35th street, Broadway to Seventh Avenue)—had caryatids modeled by John Massey Rhind, who made a specialty of doing them. McKim, Mead, and White commissioned the young MacMonnies to model the pediment of the Bowery Savings Bank at 130 Bowery. In his early career, Bitter designed figures for the *Pulitzer* building and the Saint Paul Building (both destroyed), two commercial structures by his early patron George B. Post. But these commissions were done while these sculptors were just starting out, and few considered such work desirable as a long-term occupation. MacMonnies, for example, made it clear he viewed such decorative caryatid jobs as potboilers. By 1912 Cass Gilbert could not get Daniel Chester French, the man he wanted, to create a statue of Mr. Woolworth for one of two niches on the facade of the new Woolworth Building (1913; 233 Broadway). Although French suggested Herbert Adams, Charles Keck, Sherry Fry, and Evelyn Longman as suitable alternatives, Gilbert ultimately left both niches empty. Daniel Chester French to Cass Gilbert, 20 September 1912, Cass Gilbert papers, Woolworth Building, Architectural Modeling and Sculpture file, NYHS. See also Stanford White to Frederick MacMonnies, 4 February 1895 and 27 Feb-

ruary 1895, copybook 12, Stanford White papers, Avery Library, Columbia University, pp. 345, 420–421; James M. Dennis, *Karl Bitter: Architectural Sculptor, 1867–1915* (Madison: University of Wisconsin Press, 1967), pp. 38, 64–68.

27. John Tauranac, *Elegant New York* (New York: Abbeville Press, 1985), pp. 10–13. Grand Central Station was a third major Beaux-Arts commercial structure initiated at the turn of the century, although it was not completed until 1914. It was crowned by an enormous sculptural group symbolizing "the glory of commerce:" Mercury "surrounded by mental and physical energy," Minerva and Hercules. Most American sculptors would have jumped at the chance to have this commission, described by the *New York Times* as the largest in the world. But even at a time when enthusiasm for civic sculpture was at a height, architect Whitney Warren chose to hire a Frenchman, Jules A. Coutan—a clear sign that American sculptors had not achieved unconditional support for their work. See "Would Make Grand Central Station a Grand Public Monument," *NYT*, 15 March 1903, p. 13; Whitney Warren, "Grand Central Terminal," *Real Estate Record and Builders' Guide*, 5 January 1913, p. 32; "World's Largest Sculptural Group for New York," *NYT Magazine*, 14 June 1914, pp. 8, 9; Stern, Gilmartin, and Massengale, *New York 1900*, pp. 34–40; Deborah Nevins, ed., *Grand Central Terminal, City within a City* (New York: Municipal Art Society, 1982), pp. 11–18.

28. The statue is now in the lobby of the AT&T building at 550 Madison Avenue. On Longman's statue, see Dorothy Thorne, "Electricity," *Review*, in "Genius of Electricity" file 1013. This article and all of the following are in the AT&T Co. Historical Archive, New York City: "'Spirit of Communication' Statue Continues Role as Famous Symbol in Art," Media Relations News Release, AT&T Corporation, n.d.; "Elec," *195 Bulletin* (April 1954), p. 7; Kenneth P. Todd, ed., *A Capsule History of the Bell System* (New York: AT&T, n.d.), pp. 21–47. See also Frances Seaver to A. C. Heaphy, 5 January 1915; William Welles Bosworth to Marc Eidlitz and Sons, 29 July 1914, 4 June 1915; Frances Seaver to A. C. Heaphy, 4 April 1914; Seaver to unnamed correspondent, 30 April 1914.

29. On advertising, see Roland C. Marchand, *Advertising the American Dream: Making Way for Modernity, 1920–1940* (Berkeley: University of California Press, 1985), pp. 206–284.

30. Carol Willis, "Zoning and Zeitgeist: The Skyscraper City in the 1920s," *Journal of the Society of Architectural Historians* 45 (March 1986): 50. On the Chanin Building see Walter Agard, *The New Architectural Sculpture* (New York: Oxford University Press, 1935), p. 50; Richard Guy Wilson, "Architecture in the Machine Age," in *The Machine Age in America*, pp. 154–155, 162–167.

31. There were exceptions. Sculptors like Lee Lawrie and René Chambellan who worked in an more streamlined, "updated" classical manner continued to find a demand for their work. These artists simplified the planes of their forms, abstracting them to look more archaic, angular, and "geometric," and finding their inspiration in the more primitive and currently popular styles of Archaic Greek, Etruscan, and Mayan sculpture.

Terra cotta ornament had been used on commercial buildings (as opposed to major

public buildings) since the 1880s. However, architects preferred stone to terra cotta for major public buildings and sculpture. There is little evidence that sculptors ever considered terra cotta modelers a professional threat. By the late twenties, however, with so few large-scale sculptural programs being built, and with terra cotta becoming more popular as exterior cladding, terra cotta ornament largely displaced sculpture. On terra cotta, see New York Architectural Terra Cotta Company, *Terra Cotta in Architecture* (Albany: Riggs Printing Co., 1891); Walter Geer, *The Story of Terra Cotta* (New York: Tobias A. Wright, 1920); Sharon Darling, *Chicago Ceramics and Glass* (Chicago: University of Chicago Press, 1979), pp. 164–201.

32. Corbett's comments are found in NSS Minutes, 15 October 1929, 8 December 1931. See also NSS Minutes, 11 May 1920, 12 December 1922, 13 May 1924. For a general contractor's response to the growing costs and complexities of the building trade, see William Aiken Starrett, *Skyscrapers and the Men Who Build Them* (New York: Charles Scribner's Sons, 1928), esp. pp. 286–296; Paul Starrett, *Changing the Skyline. An Autobiography* (New York and London: Whittlesey House, 1938), pp. 164–177. See also Walter H. Kilham, Jr., *Raymond Hood, Architect* (New York: New York Architectural Book Publishing Co., 1973), p. 19.

33. S. J. Woolf, "An Architect Hails the Rule of Reason," *NYT Magazine*, 1 November 1931, p. 6, quoted in Tony Roberts, "Daily News Building," Report to the New York City Landmarks Preservation Commission, 28 July 1981, designation list 145, LP-1049, p. 5, Landmarks Preservation Commission, New York City.

34. Raymond B. Fosdick, Jr., *John D. Rockefeller, Jr.: A Portrait* (New York: Harper and Brothers, 1956), p. 263; Myer Kutz, *Rockefeller Power* (New York: Simon and Schuster, 1974), pp. 14–50.

35. Fosdick, *John D. Rockefeller, Jr.*, pp. 1, 186, 262–266.

36. On the committee, see Carol Herselle Krinsky, *Rockefeller Center* (New York: Oxford University Press, 1978), p. 15.

37. Walter Kilham, *Raymond Hood*, p. 125; Timothy J. Garvey, "Lee Lawrie: Classicism and American Culture, 1919–1954" (Ph.D. dissertation, University of Minnesota, 1980), p. 180.

38. The greatest number of commissions went to Lee Lawrie, who had long-standing ties with several of the architects. Lawrie had refined his talents of harmonizing sculpture and architecture to the point where many of the most eminent architects (like Cram, Hood, and Corbett) saw him as uniquely qualified to take on the entire eclectic range of architectural sculptural styles from modern classic to modern. On his ties to these architects, see Garvey, "Lee Lawrie," pp. 179–182.

A few of the more "advanced" sculptors who received commissions appear to have been helped out by the intervention of Abby Aldrich Rockefeller, John D. Rockefeller, Jr.'s wife, and a founder of the Museum of Modern Art. For example, William Zorach and Robert Laurent, who each received commissions for a single statue for Radio City Music Hall, had been recommended by Music Hall designer Donald Deskey. He made his choice based

on the advice of art dealer Edith Halpert, art consultant to Abby Rockefeller. Isamu Noguchi, whose commission for the Associated Press Building was stylistically the most avant garde, obtained it through a special competition. Alan Balfour, *Rockefeller Center: Architecture as Theater* (New York: McGraw Hill, 1978), pp. 99, 148. Diane Tepfer in conversation with the author provided information concerning Halpert and her relation to Abby Aldrich Rockefeller.

In one sense Rockefeller himself, as well as in his relation to his wife, Abby Aldrich, symbolized the shifting directions of patronage and the tension between corporate sponsorship of older versus newer artistic styles. Rockefeller personally preferred more traditional styles, but at the urging of his wife, to whom he was devoted, he became a major benefactor of the Museum of Modern Art. As such he was instrumental in promoting diversity of styles.

39. Garvey, "Lee Lawrie," pp. 195–196.

40. On Alexander and the sculptural programs, see ibid., pp. 182–191.

41. Ibid., p. 190. For a complete list of the art of Rockefeller Center, see Corporate Communications Department, Rockefeller Center, *Art Digest*, pamphlet, 1982.

42. Garvey, "Lee Lawrie," pp. 191–195, 225; Krinsky, *Rockefeller Center*, pp. 144–145; Corporate Communications Department, Rockefeller Center, *Art Digest*, pp. 20, 24–25.

43. These artists, who included Alexander Calder, Isamu Noguchi, Henry Billings, and Robert Foster, creatively manipulated materials such as light, glass, stainless steel, magnesite, and plastic into cubist, constructivist, streamlined, and machine-like images. See Joan M. Marter, "Modern American Sculpture at the New York World's Fair, 1939," in Marter, Tarbell, and Wechsler, *Vanguard American Sculpture*, p. 141; Sculpture, Running Costs List, 5 January 1937, Lee Lawrie papers, box 36, World's Fair file, LCMD.

44. Serge Guilbaut has described in ideological terms one aspect of this tendency with regard to the emergence of Abstract Expression as a dominant culture and style. See Serge Guilbaut, *How New York Stole the Idea of Modern Art: Abstract Expressionism, Freedom, and the Cold War* (Chicago: University of Chicago Press, 1983). For examples of this influential criticism, see Harold Rosenberg, "The American Action Painters," and "Everyman a Professional," in *The Tradition of the New* (1949; New York, Toronto: McGraw Hill, 1965), pp. 23–39, 58–73; Clement Greenberg, "Avant Garde and Kitsch," and "The New Sculpture," in *Art and Culture* (Boston: Beacon Press, 1961), pp. 3–21, 139–145.

45. Frederick Wellington Ruckstull, *Great Works of Art and What Makes them Great* (New York: G.P. Putnam's Sons, 1925), p. vii; idem, "Additional History of the National Sculpture Society," unpublished manuscript in the files of the National Sculpture Society, New York City, pp. 1, 7. Comments such as the ones made by Elizabeth King Black, a member of the National Women's Party, were not uncommon. Responding to those who objected to *Civic Virtue*, she questioned whether "some of those opposing the MacMonnies statue . . . are not Bolsheviks at heart, who want to destroy art, history and religion." Quoted in "'Let John Hylan Pose for Civic Virtue,' Women Plead," *New York Daily Tri-*

bune, 6 April 1922, p. 3. See also American Artists Professional League, "War Cry," pamphlet in Wheeler Williams file, box 13, Lee Lawrie papers, LCMD; Guilbaut, *How New York Stole the Idea of Modern Art*, p. 4.

46. See Gary O. Larson, *The Reluctant Patron: The United States Government and the Arts, 1943–1965* (Philadelphia: University of Pennsylvania Press, 1983), pp. 43, 58–60, 88, 95–96, 124, 130–132, 140, 253–255. Harriet Freitag Senie, "Studies in the Development of Urban Sculpture: 1950–1975" (Ph.D. dissertation, New York University, 1981), discusses NSS activities in New York City during this period.

Index